MW01069745

Networks of Touch

Perspectives on Sensory History

Books in the Perspectives on Sensory History series maintain a historical basis for work on the senses, examining how the experiences of seeing, hearing, smelling, tasting, and touching have shaped the ways in which people have understood their worlds.

Mark M. Smith, General Editor
University of South Carolina, USA

EDITORIAL BOARD
Camille Bégin
University of Toronto, Canada

Martin A. Berger
Art Institute of Chicago, USA

Karin Bijsterveld
University of Maastricht, Netherlands

Constance Classen
Concordia University, Canada

Kelvin E. Y. Low
National University of Singapore, Singapore

Bodo Mrozek
University of Potsdam, Germany

Alex Purves
University of California, Los Angeles, USA

Richard Cullen Rath
University of Hawai'i, USA

Networks of Touch

A Tactile History of Chinese Art, 1790–1840

Michael J. Hatch

LIBRARY OF
CONGRESS
SURPLUS
DUPLICATE

The Pennsylvania State University Press
University Park, Pennsylvania

Library of Congress Cataloging-in-Publication Data

Names: Hatch, Michael (Michael J.), author.
Title: Networks of touch : a tactile history of Chinese art,
 1790–1840 / Michael J. Hatch.
Other titles: Perspectives on sensory history.
Description: University Park, Pennsylvania : The
 Pennsylvania State University Press, [2024] |
 Series: Perspectives on sensory history | Includes
 bibliographical references and index.
Summary: "Explores the transformative shift in nineteenth-
 century Chinese art, where artists used touch to
 establish a genuine connection with the past, challenge
 stagnant artistic norms, and foster deeper human
 connections"—Provided by publisher.
Identifiers: LCCN 2023030591 | ISBN 9780271095578
 (hardback)
Subjects: LCSH: Art, Chinese—19th century. | Tactile
 art—China—History—19th century. | Calligraphy,
 Chinese—History—19th century. | Inscriptions, Chinese.
 | Rubbing—China—History—19th century.
Classification: LCC N7344 .H37 2024 | DDC
 709.5109/034—dc23/eng/20230804
LC record available at https://lccn.loc.gov/2023030591

This publication is made possible in part by the Barr Ferree
Foundation Fund for Publication, Department of Art and
Archaeology, Princeton University.

Copyright © 2024 Michael J. Hatch
All rights reserved

Published by The Pennsylvania State University Press,
University Park, PA 16802–1003

The Pennsylvania State University Press is a member of the
Association of University Presses.

It is the policy of The Pennsylvania State University Press to
use acid-free paper. Publications on uncoated stock satisfy
the minimum requirements of American National Standard
for Information Sciences—Permanence of Paper for Printed
Library Material, ANSI Z39.48–1992.

TO MY PARENTS,
WILLIAM AND JILL HATCH

Contents

Illustrations

Acknowledgments

Research for this book began in earnest during a leave from my teaching position, which I spent at the Metropolitan Museum of Art as the 2017–18 Andrew W. Mellon Postdoctoral Fellow in the Department of Asian Art. I owe great thanks to the entire department for hosting me and making their resources available, but in particular, Joseph Scheier-Dolberg saw to it that I had access to more than I could have hoped for. Our spring 2018 trip to China to view paintings, calligraphy, inkstones, and teapots in various state, provincial, municipal, and private collections made this book what it is.

Claudia Brown and Janet Baker first introduced me to the Roy and Marilyn C. Papp Collection of Chinese Painting at the Phoenix Museum of Art when I was a graduate student, and then they invited me back to talk about this book project for the 2018 Papp Lectures in Chinese Art. Their generosity over the years, as well as that of the Papps, gave me my fundamental understanding of early nineteenth-century art. Over the last few years, I was invited to give talks on this material at a number of other venues, including Western Michigan University, Ohio State University, and the University of Chicago's Visual and Material Perspectives of East Asia Workshop. Thoughtful colleagues and audience members at each institution helped me refine my thoughts.

The participants of a 2019 summer workshop Michele Matteini and I co-organized, "Painting in China Around 1800," at the Institute of Fine Arts, NYU, and the Metropolitan Museum of Art, were wonderful agents for change in my thinking. Tobie Meyer-Fong, who gave the keynote address there, also offered feedback on my graduate dissertation, though she was under no professional obligation to do so. Her comments helped me find my way to this book. Michele Matteini did me the great kindness of reading a full draft of this book at the stage when everything seemed tangled up. Mary Gladue passed her eyes over early chapters and gave me confidence to move forward. Weitian Yan was generous enough to look over my translations and prevent me from making some very silly mistakes. All faults and fancy remaining in the book are my own.

At my home institution, Miami University, luck granted me supportive colleagues in Andrew Casper, Pepper Stetler, Jordan Fenton, and Annie Dell'Aria, as well as an Art Department chair, Rob Robbins, and a College of Creative Arts dean, Liz Mullenix, who allowed for my research leave in 2017–18 and again in the fall of 2021, when I finished my manuscript. Miami's College of Creative Arts helped fund early work on this book with a 2017 summer research appointment, and Miami's Humanities Center offered an invaluable book proposal workshop in January 2017 that set me on the right path.

Earlier versions of chapter 2 and chapter 3 were published as "Outline, Brushwork, and the Epigraphic Aesthetic in Huang Yi's Engraved Texts of the Lesser Penglai Pavilion (1800)," *Archives of Asian Art* 70, no. 1 (April 2020), and "Epigraphic and Art Historical Responses to Presenting the Tripod, by Wang Xuehao (1803)," *Metropolitan Museum Journal* 54 (2019). I am grateful to both publishers for allowing me to use some of that material here.

Many parts of life were made more complicated over the last few years, and I am thankful to people who took the time during trying times to help me get necessary books and images: Martin Heijdra, Wang Yifeng, Kim Wishart, and the unsung heroes of OhioLink and Interlibrary Loan. The Barr Ferree Publication Fund at Princeton University's Department of Art and Archaeology generously provided subventions for image rights and printing.

Thank you to the Perspectives on Sensory History series editor Mark Smith and to my editors, Kathryn Yahner and Archna Patel, as well as their editorial assistant, Maddie Caso, for seeing promise in this project. When I began my first draft, I had a few Asia-focused publishers in mind, but discovering this sensory history series in the late writing stages was a turning point. I am thrilled to have my book in conversation with the other scholarship of this series and to know that my interest in writing Chinese art history through a sensory history lens has found equal footing as a sensory history about Chinese art. To the two anonymous peer reviewers, your generous engagement with the manuscript helped me untangle more than a few knots, and I only hope I did justice to your time and efforts. Thank you.

I will never be able to show enough appreciation to my graduate mentors. Jerome Silbergeld, Susan Naquin, and Cary Liu did more than should be expected to help me define my thinking, and their advice still shapes what I do. Along the way, various forms of aid and insight came from Jonathan Hay, Arnold Chang, Freda and Chris Murck, Howard and Mary Ann Rogers, Carol Conover, Patricia Berger, James Cahill, Jane DeBevoise, Michael and Dong Cherney, Andrew Watsky, Robert Bagley, Benjamin Elman, and Dora Ching. Friendship and advice from Yaron Aronowicz, Wai Yee Chiong, Jeff Edelstein, Katie Grube, Marius Hauknes, Jun Hu, Frances Jacobus-Parker, Zoe Kwok, Michelle Lim, David Russell, Greg Seiffert, Stephanie Tung, and Amelia Worsley, as well as my old China Guardian Auctions workmates, kept me on course. Thank you also to George Pitcher (1925–2018), Ed White, and Michael Carroll for creating "the gang," a support system unto itself. Sincere apologies to anyone I have neglected to list here. I hope I showed better appreciation for your generosity at the time you gave it.

Lastly, my own family network helped in all the indirect ways that are crucial to maintaining momentum in a project like this. I still feel posthumous encouragement from Richard C. Hatch (1925–2014), whose memory reminds me to be humble, open, and good-humored. Katie, Chris, Max, and Thomas supported

me by being there, even if they were farther away than I wished they were. The encouragement of Emily, Lauren, Serena, and Beatrice likewise grounded me. To Bill and Jill, to whom this book is dedicated, thank you for your support. I never doubted it was there, and the older I get, the more I realize how rare parents like you are. And to Josh, who will have to endure whatever project comes next, more thank yous than I can give for as long as I can give them.

Introduction

In 1835, an itinerant monk and epigraphy scholar named Liuzhou (1791–1858) visited the city of Suzhou to call on the governor of Jiangsu Province, Chen Jian (1786–1839). The governor, like many of his peers, collected antiques, and he had a particular affinity for clay bricks from the Han dynasty—rough earthenware blocks decorated with mold-cast inscriptions, geometric patterns, or linear images of animals and figures. Bricks with inscriptions were the most highly prized because they recorded archaic writing styles. Their simple rectilinear texts stood out from the fired clay in thin, ragged ridges to name early regnal dates and sometimes people or places. Over the late eighteenth and early nineteenth centuries, calligraphic taste among elites had shifted to favor the writing styles found on such objects because they were considered to be unpretentious, forceful, and honest.[1] Chen Jian had a marvelous collection of early bricks, and Liuzhou had come to help him document them (fig. 1).

The handscroll Liuzhou provided to Chen archived twelve of his most prized bricks in a series of ink rubbings. But rather than using the common approach of rubbing the inscription face of each brick in a linear sequence of flat impressions down the handscroll, Liuzhou implemented a relatively new process for depicting antiquities called "full-form" or "composite" rubbing (*quanxing ta*), a technique specially formulated to convey the three-dimensional nature of an object in a two-dimensional format. Liuzhou began with renderings of the text-bearing faces of each brick, which he carefully arranged at right angles to each other, overlapping them in a way that obscured the inscriptions in favor of a more engaging composition. After Liuzhou completed this stage of the work, Chen gathered a group of selected friends—fellow collectors, monks, and various of his favored aides—inviting them each to add a painting to one of the twelve rubbings laid out in the composition. When they had finished, Liuzhou added

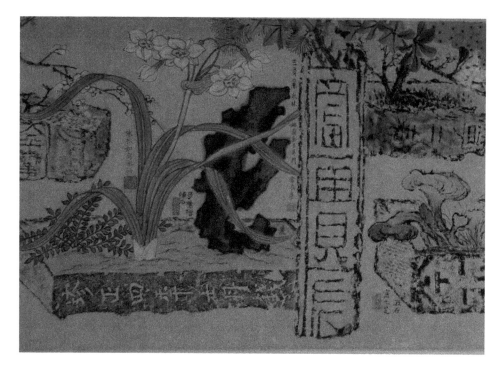

Fig. 1 Liuzhou et al., *Floral Offerings in Ancient Bricks* (detail), 1835. Composite rubbings of ancient bricks with in-painted flowers by various artists. Ink and color on paper, 25 × 141 cm. Zhejiang Provincial Museum.

selective impressions of each brick's sides to create spatial depth, often in-painting to smooth out transitions. The overall image presented Chen's collection as a fictional garden of flourishing "potted scenes" (*penjing*) that appeared to nest within or stand in front of one another in a unified picture plane that gently receded away from the viewer, as if revealing a desk in his study on which he curated his choice antiques for optimal viewing and gardening pleasure. The small floral compositions his friends brushed on top of, and stemming from, the rubbings transformed their ink surfaces from a collection of archival documents into a verdant scene. Through a variety of painting styles, and representing a full range of diverse auspicious flora, Chen's friends concretized their connections with him, and with one another, while gaining the cultural capital associated with the study of these remnants from the ancient past.

The novelty of such images may not be apparent to a modern viewer. But for early nineteenth-century elite audiences, Liuzhou's hybrid rubbing-paintings were startling and evocative. Ruan Yuan (1764–1849), a political juggernaut of the early nineteenth century and a patron of Liuzhou, described the surprise of seeing one of these full-form rubbings done for him: "From it one can see the form of the entire bronze . . . looking at this is as if looking at the original vessel." Elsewhere, he marveled, "the dimensions [of the image] are true; I've held the original [bronze] in my hands."[2] Ruan's comments stand out because

within the literati arts, images rarely aimed to reproduce a sense of visual reality, much less a tactile one.[3] But in these productions, the sense of touch was paired equally with vision to convey the pleasures of real interactions with antiquities.

Full-form rubbings challenged the boundaries between real and fabricated, an ambivalence that audiences embraced. As prints made by direct contact with an object's surfaces, they were perceived to be truthful documentary records done with an apparent minimum of artificial interference. But as pictures, they forced viewers to grapple with their nearly opposite effect—the obvious manipulation of the rubbings to produce fictional scenes with spatial and affective dimensions. This unification of archival technologies with painterly processes in a single image confirmed direct sensory experience while encouraging imaginative projection, uncanny properties that made Liuzhou's pictures ideal devices for literati networking. The enthusiastic inscriptions and colophons added to them by elite Qing-dynasty scholars attest to their dual roles of commemorating relationships to the revered objects of the past and providing a format to bond individuals in contemporary networks of friendship and obligation.

How then did such hybrid rubbing-paintings come to be? How could two such vastly different methods of image-making cohere in the same artwork without viewers experiencing a sense of disjuncture?[4] Furthermore, what are the implications of Ruan Yuan's claim that these images reproduced and verified the combined senses of vision and touch? How did such appeals to the sensing body operate within the literati arts, which have been primarily interpreted through their various modes of historical and textual citation? To understand the complex set of perceptual and intellectual interactions Liuzhou's images demanded of their viewers requires stepping back one generation further, to the turn of the nineteenth century, when a shift in aesthetics began to occur. While Liuzhou's work is remarkable, it was not the isolated product of individual genius. It developed as part of a larger cultural phenomenon that emerged beginning in the late eighteenth century, a shift in visual thinking instigated by the importance and popularity of epigraphy.

Liuzhou's work, like that of many of his contemporaries, presumed a fundamental visual, historical, and cultural knowledge of ancient inscriptions. The early nineteenth-century popularity of epigraphy (*jinshi xue*) grew from the larger philological turn of the mid- to late eighteenth century, often described with the phrases "evidential research" (*kaozheng xue*) or "Han (dynasty) learning" (*Han xue*). This move toward philology as the intellectual bedrock for elite culture reordered the priorities of scholarship, politics, history, and even epistemology in China for the eighteenth and early nineteenth centuries. Authors were expected to forgo the kinds of abstract metaphysical rhetoric made popular by Song- and Ming-dynasty scholars in exchange for evidence-based arguments grounded in sources that had been verified by the assiduous study of textual recensions and concrete material inscriptions. Through close comparisons of

the features of early language, including etymology, phonology, and grapholology, eighteenth-century scholars sought to pare the many competing versions of classical texts to their most authentic meanings and to cast extraneous or false interpretations aside. These revisions were political by nature, because the classical texts being amended also provided the fundamental rhetoric for elite social interaction and bureaucratic advancement.[5]

Ancient inscriptions in stone, metal, and clay, like the ones Chen Jian collected and Liuzhou documented, proved invaluable to scholars engaged with the philological turn because of their material durability, which gave greater historical certainty to the forms of language cut or cast into them. As philological networks expanded in the eighteenth century, hundreds of scholars produced thousands of tomes of text describing these concrete early sources of language and reproduced tens of thousands of rubbings taken from original objects, circulating them for comparison among scholars throughout the empire.

The proliferation of interest in these objects instigated an epigraphic aesthetic—an appropriation of the stylistic, material, and tactile features of ancient inscribed objects like steles, bronzes, and clay bricks, as well as of their reproductive technology, rubbings—in the work of late eighteenth- and early nineteenth-century artists, scholars, and artisans. This book describes that epigraphic aesthetic in full for the first time, from its late eighteenth-century roots in philology to its blossoming across the spectrum of early to mid-nineteenth-century elite visual and material cultures, including the brush arts of calligraphers and painters, as well as the crafts of teapot makers and inkstone carvers.[6]

As with practitioners of evidential research, those who took part in the epigraphic aesthetic aimed to critically engage with existing canons by means of a return to the exemplary forms of the ancients. Ruan Yuan's essays recuperating a "northern" genealogy of calligraphic brushwork from the obscuring effects of the dominant "southern" school of calligraphy (chapter 1) may be the clearest expression of this challenge to existing canons, but evidence of widespread efforts to reimagine literati taste in this period can be found across media: from Huang Yi's focus on decaying stone material over calligraphic legibility in his printed reproductions of classical stele rubbings (chapter 2) to the rise among painters of a new "awkward" aesthetic based in epigraphic sources rather than the brushwork of past painters (chapter 3); from Chen Hongshou's emulations of ancient inscriptions in his seal carving, finger painting, and teapot making (chapter 5) to the subtle critique of inherited brushwork traditions posed in Ruan Yuan's treatise on marble landscape screens from Yunnan Province (chapter 6). Articulating these changes brought on by the epigraphic aesthetic refutes long-standing scholarly presumptions of creative stagnancy in early nineteenth-century Chinese literati art.[7] With these historical biases put aside, how do we understand the arts of this period? What realizations can we bring to the study of literati arts more broadly speaking?

Over the course of these chapters, careful attention to the epigraphic aesthetic's effects across a range of materials reveals this generation's remarkable interest in the sense of touch. This sensory turn stemmed directly from the popularity of rubbings to document and exchange knowledge about epigraphy. A rubbing's usefulness to scholars ostensibly lay in its accurate and largely unbiased replication of an ancient carved or cast text. However, a rubbing's nature was not linguistic. Instead, rubbings replicated the experience of surface contact with an object. Capturing inscribed language was incidental to this process of archiving surface. As a consequence, rubbings made information about text inextricable from information about its material support, compressing the two in a single textured plane of monochromatic ink, a moment of suspended apprehension that did not separate cognition and sensation.[8] As a result, when connoisseurs pored over rubbings, they read them both linguistically and tactilely, looking for authenticity in the forms of ancient words as well as the traces of their material decay. Likewise, when scholars, artists, and artisans engaged with the epigraphic aesthetic in the production of new artwork, they replicated both the textual forms and the material effects recorded in rubbings, emphasizing the sense of touch in particular to capitalize on its direct appeals to viewers.

Each chapter of this book points toward a slightly different use of touch and is situated within a different range of material and interpersonal possibilities. Collectively, the chapters show that the production and reception of early nineteenth-century visual and material culture among elites relied on what can best be described as tactile thinking—a form of direct apprehension that conjoined sensory perceptions with cognitive processes. For this generation, to touch was to understand. Liuzhou's full-form rubbings (chapter 4) manifest this trend most conspicuously, but across the arts of the late eighteenth and early nineteenth centuries, literati increasingly relied on tactile references to verify historical or textual knowledge (chapters 1 and 2), to establish a sense of immediacy between images and their audiences (chapters 3 and 4), and to create greater intimacy among members of elite social networks (chapters 1, 2, 4, and 5). Tactile thinking guided the arts and culture of the early nineteenth century, creating a generation of elites that handled their relationships with one another through tasteful references to a new vocabulary of touch grounded in the authoritative language and surfaces of the past—a generation of tactful literati.[9]

To tell this story of the epigraphic aesthetic, its challenges to artistic canons, and the generational turn toward tactile thinking with some degree of focus, the following chapters gather their materials from one network of elites loosely centered around the public servant Ruan Yuan, one of the most influential government officials of the early nineteenth century. His career included terms as governor or as governor-general of six different provinces and the eventual title of grand secretary in the Qing imperial palaces in Beijing.[10] He was also a prolific author and scholar responsible for writing, editing, compiling, or

publishing nearly ninety books and essays on history, literature, geography, phonetics, and, of course, epigraphy.[11] Ruan published at least twelve works on epigraphy during his career, including individual object studies, collection catalogs, and the production of major provincial epigraphy catalogs in three of the locations where he served: the twenty-four volume *Epigraphy Gazetteer for Shandong Province*, the eighteen-volume *Epigraphy Gazetteer for Zhejiang Province*, and the sixteen-volume *Record of Epigraphy in Guangdong*. Ruan's resources and influence enabled him to fund large-scale scholarly projects, but they could only be enacted with the help of a network of talented scholars, and his various friends, artists, scholars, and aides constituted one of the best-developed hubs of epigraphic exchange in the early nineteenth century. As Ruan advanced in the Qing bureaucracy, he accumulated a broad network of more than four hundred associates. Of those, at least sixty were employed directly as aides, assistants, editors, authors, researchers, and artists in the production of his published works.[12] They, in turn, depended on Ruan to establish their own networks and reputations. A well-placed mentor was key to maintaining privilege, especially in the early nineteenth century, a period of diminishing opportunities for the sons of elite families.[13] If the epigraphic interests of this generation can be centered around any one individual, Ruan Yuan is a worthy candidate.[14]

Chapter 1, "Calligraphy's New Past," explores Ruan Yuan's central position in the proliferation of epigraphy studies and the subsequent epigraphic aesthetic that resulted from it in the late eighteenth and early nineteenth centuries. Particular focus is given to his application of epigraphic data toward a rethinking of the calligraphic canon. Beginning with his development as a scholar, chapter 1 goes on to trace the significant role epigraphy studies played in his career, including his sponsorship of other epigraphy scholars, the use of epigraphy for scholarly networking, and the production of epigraphically inspired art objects to concretize personal relationships. Epigraphy was more than an academic predilection for this generation. It was a visual and scholarly language through which elites communicated their taste and erudition to one another. Within networks such as Ruan's, bronzes and stones served both as sources for the comparative study of early written language and also as personal gifts, objects of civic generosity, or inspiration for the production of more things. When landmark birthdays occurred, private studios were erected, or important books were published, then new seals or headboards were carved in archaic script styles and given as gifts. When ancient tombs or shrines were repaired, new steles were inscribed in emulation of old steles and erected to honor the event. Inscribed objects were the means by which Ruan Yuan's network of scholars secured their personal relationships and their public personas.

Ruan's work culminated in two essays, "Southern and Northern Schools of Calligraphy" and "Northern Steles and Southern Letters," which summarized the radical changes he and his peers enacted on the established calligraphic

canon by means of so many anonymously engraved stones from the deep past. The celebration of anonymity was groundbreaking in calligraphic culture, as it decoupled the general style of the text from the personal biography of the calligrapher, allowing for an entirely new canon that drew its authority from direct contact with antique objects.[15] Ruan's essays also offer the clearest articulations of the terms and logic of the early nineteenth-century epigraphic aesthetic and therefore provide a conceptual foundation for the book's subsequent chapters, which explore the various visual and material cultures produced under the spell of ancient inscribed objects.

Material knowledge rose to the fore among epigraphically influenced scholars because the authenticity of early texts was largely established through close attention to their supports. Epigraphy specialists scrutinized corrosion, erosion, chipping, and fracturing in all types of stone and metal as key features for properly dating an object. Was the wear on the stone or bronze consistent throughout? Were there areas that had been retouched or altered over the years? Did extant objects accord with historical records of their texts as found in classical rubbings or other published records? Chapter 2, "Obliterated Texts," addresses such material fixations through a close reading of Huang Yi's (1744–1803) book *Engraved Texts of the Lesser Penglai Pavilion* (1800). The book reproduced woodblock-printed images of Huang's renowned collection of antique rubbings from famous ancient steles, adding transcriptions as well as the texts of various commentaries and colophons appended to the original rubbings by friends like Weng Fanggang (1733–1818) and Ruan Yuan. For his printed reproductions of the rubbings, which were themselves reproductions of the stone steles, Huang made the peculiar choice to use an outlining technique. This decision focused visual attention to the edges of characters, where the material signs of degradation in stone were most pronounced, signaling the authenticity of the original inscribed texts through evidence of their material age. But at times, Huang's fascination with reproducing the destruction of the text's material support created illegible, amoeba-like forms, nullifying the words and highlighting a dominant, tactile interest in the surfaces of the object. Furthermore, the hollow shapes created by this technique lacked a simulacrum of calligraphic brushwork, emptying the inscriptions of any implied relationship to a specific calligrapher's body. Huang's prints, when seen in relation to Ruan Yuan's essays, point to a generational desire to vacate established genealogies of calligraphic style in favor of new canons based on the material authority of anonymous ancient sources.

The ragged-edged features of Huang's prints found their way into the styles of contemporaneous calligraphers, but the overt fascination with aged surfaces and archaic forms moved beyond a single medium. Chapter 3, "Epigraphic Painting," extends the discussion of the epigraphic aesthetic from calligraphy to its fellow brush-based art, painting. From the late eighteenth and early nineteenth centuries on, paintings and colophons by Jin Nong (1687–1764), Luo Ping

(1733–1799), Huang Yi, and Qian Du (1763–1844) reveal the purposeful manipulation of brushwork in landscape and figure paintings to allude to the material properties of inscriptions and images found in ancient stone and metal. The ideal quality pursued by painters and epigraphy connoisseurs was the "antique and awkward" (*guzhuo*), a descriptor that further tested the dominance of canonical literati styles and was applied both to the art of the past and the present. "Antique and awkward" art, sometimes described as just "awkward/unstudied" (*zhuo*), bypassed the affectations inherent in citations of canonical brush masters and instead sought a direct path to the principles of the ancients. To focus this discussion, chapter 3 centers on a handscroll painting that would at first glance appear to manifest none of the obvious traits of an epigraphic aesthetic. Made for Ruan Yuan in 1803 by the landscape painter Wang Xuehao (1754–1832), *Presenting the Tripod at Mt. Jiao* commemorated Ruan's donation of an important inscribed Han-dynasty bronze to a temple in Zhenjiang. Wang painted the monochromatic landscape image in the canonical "orthodox style" of early Qing-dynasty painters like Wang Hui (1632–1717) and Wang Yuanqi (1642–1715). But as the later colophons added to the painting show, when viewers saw this landscape, they not only viewed it through the lens of orthodox lineages of brushwork in landscape painting; they also visualized the surfaces of the bronze at the center of the narrative, suggesting that the epigraphic aesthetic affected a comprehensive shift in the perception of early nineteenth-century art.

Collectively, these first three chapters describe changes in the core literati practices of calligraphy and painting, where the effects of the epigraphic aesthetic were primarily, and perhaps most, evident. Scholars and artists reoriented the brush-based arts of calligraphy and painting toward new canons of style grounded in the material features of these authoritative early bronze, stone, and clay objects. Calligraphers changed character composition by adopting the orthography of early inscribed or cast texts, and they made material references to the textures of broken stone or corroded metal surfaces to signal their relationship to authentic epigraphy sources. In painting, purposefully archaic compositions harkened back to early modes of image construction, while dry, stippled brushmarks simulated the material qualities of worn stone and metal surfaces recorded in rubbings of ancient objects. But the epigraphic aesthetic was not just a stylistic choice. It affected deeper changes in the literati arts.

The subsequent three chapters extend the description of the epigraphic aesthetic beyond the brush arts to explore its intermedial aspects and to reframe it around a preoccupation with touch. Because close description and analysis of ancient inscribed objects lay at the heart of epigraphy studies, direct contact between scholar and object was prioritized. If direct contact could not be had, then a facsimile that came as close as possible to replicating touch, such as a rubbing, would also do. In many ways, the reduplicative technology of rubbings acted as the prime image model for early nineteenth-century artists and scholars,

challenging brushwork's long-standing role as the principal bearer of stylistic authority among literati. As images born immediately from their object referents, rubbings could be appreciated as corporeal manifestations of antique objects and have been described in scholarship as shed skins or as akin to relics.[16] However, as this book argues, rubbings are best described as suspended perceptions of touch, as acts of direct apprehension made available for the sensation of other viewing bodies.

Touch was essential to both the culture of rubbings and the classical brushwork traditions of calligraphy and painting, yet the sensation of touch was constructed and perceived quite differently in each. Whereas a viewer saw brushwork as a set of the artist's bodily traces left suspended in ink and paper, they understood rubbings as direct facsimiles of touch with an object's surfaces. Through one, audiences reconstructed the physical experiences of another person. Through the other, they bypassed human bodies altogether to touch the material world directly. This nineteenth-century reorientation of touch away from the bodily traces of canonical artists and toward the direct surface sensations of art objects not only enabled early nineteenth-century artists and scholars to move beyond stagnant brushwork genealogies; it also allowed them to more easily move between mediums, to conjoin previously separate image-making practices, and to reassert the role of the senses as a primary means by which audiences could engage with artworks. To begin to understand the developments of this tactile thinking, chapter 4, "Tactile Images," offers an artistic biography of the aforementioned Liuzhou, the so-called epigrapher-monk, focusing in particular on his new mode of making rubbings, the "full-form" or "composite" style. Full-form rubbings shifted the nature of rubbings back toward the realm of painting by adding dimensionality, which established the surrounding paper as a scene in which events could occur. When combined with in-painted figures, composite rubbings compressed the difference between two very different representational schema, taking advantage of the visual and tactile qualities of each to create new hybrid images that asserted the role of direct sensory experiences.

But what then happens to the viewing conventions of each medium? How factual was a composite rubbing with painted figures or flowers to an epigraphy aficionado? For a viewer accustomed to the principles of viewing brushwork as the transmission of the artist's thoughts and bodily gestures, did these images qualify as paintings? Are these even the right questions to ask? Perhaps the defense of medium-specific principles mattered very little to this generation. At least this is the case for Chen Hongshou (1768–1822), the subject of chapter 5, "A Tactful Literatus." Chen was a former aide and mentee of Ruan Yuan, and his work best exemplifies the turn toward touch that epigraphy inspired in the literati arts. His artistic explorations began with seal carving and calligraphy and then grew to include painting. When Chen moved on to his own government career as a minor official in Zhejiang Province, he developed a close connection to the

nearby potters of Yixing, and to Yang Pengnian (fl. early nineteenth century) in particular. Collaborating with these artisans, Chen and his coterie of friends, many of them also Ruan Yuan's aides, produced customized teapots inscribed with their calligraphy and paintings. When his teapots are considered alongside his finger painting and seal carving, tactility rises to the fore as a guiding sense for his artistic production, while the brushwork canons that dominated older literati image-making fall to the side.

The last chapter, chapter 6, "The Limits of Touch," turns to a book written by Ruan Yuan later in his career, *Paintings in Stone*, and to several works of art by Qian Du to describe examples of early nineteenth-century literati artistic practice that would, at first glance, appear to stand in counterpoint to this generation's tactile thinking. Ruan Yuan's book celebrated the absence of human touch in the naturally occurring "stone paintings"[17] cut from Dali marble in Yunnan Province, crediting their creator as the heavens themselves. At the same time, he had these immaculate images inscribed with poems for friends that compared their textures to the brushwork of canonical literati painters. How then could these stones be both untouched by man and also reflective of paintings by the best of men? An analysis of his text and the Dali stones he gave as gifts offers a lens through which to understand the relationship of touch to perception and to the larger epistemological principles that framed the production and reception of art among early nineteenth-century literati. Likewise, the work of Qian Du, a close friend of many of the central practitioners of the epigraphic aesthetic, refrained from emphasizing touch above the other senses. Instead, Qian Du's work demonstrates an evenly distributed interest across the senses, prompting us to imagine early nineteenth-century tactile thinking as part of a spectrum of sensory experience to be found in the literati arts, and perhaps even at the heart of it. By testing the limits of touch, and of this book's argument, the last chapter explores the larger implications of tactile thinking on the field of Chinese art history.

As a history of touch in early nineteenth-century Chinese art, this book links the study of Chinese art history with sensory history, a relative newcomer among the methods of Chinese studies.[18] Over the last generation, historians of the Western world have produced a substantial volume of work that historicizes the senses, allowing us to understand the ways that period-specific values were articulated through and imposed on the body, and revealing the importance of the senses to the construction of identity, the production of knowledge, and the organization of society.[19] These studies also demonstrate the variability of the premodern senses. While we may experience phenomena in the present through physiological processes of vision, hearing, smell, taste, and touch that we have in common with historical actors, the social and cultural constructions of our senses differ, often substantially. So what was touch within a premodern

Chinese sensorium? And what do we make of the emphasis on touch in the arts of the early nineteenth century?

While the collected chapters of this book aim to answer the second question, any response to the first question is complicated by several factors. For one, to describe a premodern discourse of the senses may overstate their conceptual importance. This is true at least within early Chinese thought of the Warring States period (475–221 BCE), when many of the formative concepts of Chinese philosophy took shape. No specific theory of the senses existed among thinkers of this period. Instead, early references to sensation can be found primarily in discussions of knowledge and ethics. When the senses were discussed in these texts, their number and nature were variably defined. Often, references to eyes and ears alone could stand in for sensory activity at large, while touch was frequently left unmentioned. Following from this, existing sensory histories of Chinese culture primarily focus on vision and sound, whereas a cultural history of touch has yet to be written.

One common arrangement of the full spectrum of senses relied on the metaphor of five sensory officials (*wu guan*), which were governed by the heart-mind (*xin*). In this bureaucracy of the body, each sensory capacity affiliated itself with a bodily location, from which it differentiated (*yi* or *bian*) the phenomena of the world through the acts of affinity (*hao*) or knowing (*zhi*). Eyes had an affinity toward understanding color and form, just as the ears did sound. Smells were the objects of the nose, and the mouth comprehended flavors. The "bones, body, and skin" (*gu ti fu*) understood "cold and hot, smooth and sharp, light and heavy," and sought "pleasure and ease." This is the aspect that corresponds most closely to what we might call a sense of touch. The heart-mind presided over these sensory officials and further differentiated discourses, reasons, and affects.[20]

The sensations that these sensory capacities experienced existed in their own right as relational dynamics between subject and object, not as the unchanging properties of one or the other.[21] Furthermore, sensory perceptions were not the raw materials from which knowledge was constructed, because knowledge was not conceived as a collection of concepts abstracted from experience and ordered into principles by the rational mind. Instead, both sensation and knowledge were directly perceived in a manner that did not separate body and mind. Perceptions were likewise conceived as acts of correspondence with the world, achieved through resonances with the fundamental relational patterns (*li*) that structured it.[22] Noble people distinguished themselves by the ability to know these structural patterns and relay them to others, whether in the form of an essay, a poem, a painting, or any other mode of literati textual and material culture. By nature, these forms suspended the perceptions of their makers, even while their authority was based in citational practices that elevated textual knowledge to a prime position.

The ethical dimensions of the senses are clear in early texts. Discussions of sight and sound often carried with them negative connotations of indulgence or wonton behavior, pointing to the fact that sensory perceptions were as social and political as they were personal.[23] The tactile realm of the "bones, body, and skin" had additional political and social dimensions, as its object was "pleasure and ease" (*yu yi*). Among early Chinese thinkers, pleasure was primarily an ethical concern, a fact clearly underscored by the rhetorical pairing of pleasure in opposition to anxiety or insecurity, rather than its typical counterpart in Western epistemology, pain. The action of taking pleasure (*le*) directed itself toward experiences that sustained the long-term well-being of the body, the family, or the state, and not toward the pursuit of selfish, short-term joys.[24] If touch was the sensory mechanism most directly affiliated with the politics of pleasure in classical Chinese thought, then the rise of tactile thinking as a result of epigraphic aesthetics in early nineteenth-century literati art also indicates this generation's preoccupation with feeling its way toward new social and ethical relations with each other and with the past.

Unlike sight, sound, smell, or taste, touch had no privileged location or organ among early thinkers. It was perceived not just in the hand but by the whole body, across its outer surfaces and within its inner structures.[25] This dispersion of the site of sensation makes touch the hardest sense to track over various developments in Chinese sensory thinking. In Chinese visual culture, to find touch, one often finds the body in general or, more specifically, traces of the body. In its earliest forms, the term trace (*ji*) described a footprint, the mark of a moving body's contact with the world. Both the tangibility and the suspended action of a trace were important to its early valences, and the term was adapted by Buddhists, neo-Confucians, antiquarians, and literati alike.[26] Each culture imagined connection with the bodies of the past through evidence of physical contact suspended in relics, carved words, brushmarks, or other intermediaries. This ability of one body's touch to remain sensible in material form for the appreciation of another body distinguished touch from the other major senses, sound and vision. Contact was less fleeting, more concrete, and, moreover, vision and sound always stood separate from the body. Touch confirmed presence and bridged the distance between one body and another, even, and especially, across time.[27]

Between early discussions of the senses and the later period described in this book, any number of genealogies of touch exist. The fundamental structures of sensation may have been established in the early texts of the Warring States period, but naturally, the role of perception in relation to knowledge did not remain unchanged through the subsequent intellectual shifts of classical, medieval, and early modern China. The introduction of Buddhism in the Later Han dynasty (25–220), and the revivals of Confucian thought in the Song dynasty (960–1279) and Ming dynasty (1368–1644), referred to collectively as neo-Confucianism, marked the greatest inflection points in theories of knowledge and

sensation until the seventeenth and eighteenth centuries. Each mode of think-
ing brought such varieties of new discourses for understanding the body and its
relationship to the mind that summarizing them would require separate books.[28]

To the seventeenth- and eighteenth-century proponents of evidential research
and Han learning whose writings spurred the developments described in this
book, the aspects of Buddhist and neo-Confucian epistemologies that deserved
the greatest criticism were the privileging of the immaterial over the concrete
and the reliance on the heart-mind to intuitively perceive underlying principles
of the world. As Yan Yuan (1635–1709) put it, "Principles are only empty words;
how could they exist in things?" For Dai Zhen (1724–1777), "[By] describing
empty abstractions as if they were concrete things . . . later scholars were thus
unable to gain any knowledge about actual, existing concrete things." These
seventeenth- and eighteenth-century materialist approaches reconsidered the
classical positioning of sensation as a relation that existed between the self and
the world. When it came to the senses, Dai wrote, "Taste, sound, color are in
things and not in us." While Dai left touch out of his array of sensations, Yan
Yuan elaborated on it specifically, saying, "Things can be explained only by the
tangible handling of them."[29] To sense the physical properties of a thing, and to
handle it, specifically, was to understand it.

This generational turn toward touch was entangled with other modes of
artistic production that suspended the body's tactile sensations. In painting and
calligraphy, the verb to touch or caress with the hand (mo) was popularized from
the late medieval period onward as an act of copying, particularly the copying
of a canonical master's work. Through the hand, and with brushwork (bi) as
intermediary, painters or calligraphers felt their way back to the intentions and
the knowledge of a respected historical figure. Likewise, when painters from
the late Song dynasty onward called attention to the surfaces of their images
through a tactile emphasis on brushwork and texture, they created transsubjec-
tive sites for the physical projection and definition of self.[30] More recent to the
period of this book, artisans of the late Ming and early Qing dynasties designed
the surfacescapes of decorative objects to engage the sense of touch as it existed
throughout a viewer's body, including its proprioceptive and affective dimen-
sions.[31] Surface contact, across media, provided the means for connection and
projection. While each of these modes of touch remained important around 1800,
the rise of epigraphy, and its primary tool, the rubbing (ta), shifted the terms
of surface connectivity. Broken into its two individual components, the word
"rubbing" places a hand alongside a stone, drawing our attention to Yan Yuan's
emphasis on "tangible handling," specifically, the contact between a scholar's
body and a stone or metal object from the deep past.

In sensory histories of the early modern Western world, touch must often be
reclaimed from the obscuring effects of a sensory hierarchy that elevated vision
above the "lesser" senses from the nineteenth century onward. Vision has long

been considered the principal sense associated with the rational mind, Enlightenment-era ideals, and modernity. Yet, as sensory historians have shown, the nonvisual senses have been just as central to the development of modernism in its various manifestations.[32] In Chinese art, modernity is likewise closely affiliated with vision. Recent studies of early twentieth-century Chinese painting describe the emphasis that advocates of modernization placed on optical vision and sketching from life.[33] While the modern visual bias certainly affects histories of early modern Chinese art, a textual bias has arguably asserted greater distorting effects, making the role of the senses themselves the real reclamation project for a sensory history of the period.

Existing frameworks of interpretation in the study of Chinese literati art tend to focus on the textual aspects of an artwork, including its inscriptions, colophons, and especially the citational dimensions of brushwork genealogies. This follows from the roots of literati art beginning in the Song dynasty, when gentleman artists distinguished their work from that of artisans by disavowing similitude in favor of images that conveyed the underlying principles of the world. Their paintings diagrammed the world as much as they depicted it and were closely affiliated with the arts of writing.[34] The merits of a textual approach to the interpretation of literati art have often enabled Chinese art historians to differentiate this field of study from its early modern European counterparts and even elevate it to conceptual art avant la lettre. However, this has also created an artificial divide between the intellectual and bodily pleasures of experiencing an artwork. Just as the early nineteenth-century literati described in this book sought a renewal of the past through tactile information, this book aims to recenter the body in the production and reception of Chinese literati art and thereby repair later anacrhonicistic divisions between the mind and the body. In this respect, it is part of a growing trend in Chinese art history, exemplified by Jonathan Hay's *Sensuous Surfaces* (2010) and Dorothy Ko's *The Social Life of Inkstones* (2017). Hay's application of affect theory to early modern Chinese decorative arts enables a new manner of understanding surface decoration as a medium in its own right, one that "thinks with" its audience without separating cognition from sensuous pleasure.[35] Ko describes the craft of inkstone carving in the seventeenth century as a fundamentally embodied practice of material knowledge that was conjoined with the textual cultures of *wen* (writing, literature, civility). In doing so, she argues that the cultural positions of artisan and scholar began to blur from the seventeenth century onward, as artisanal knowledge increased in popularity among scholars and as scholarly work became more craft-like. These shifts presaged the rise of evidential studies in the eighteenth and nineteenth centuries, the intellectual trend that shaped the scholarly world of this book's primary actors.[36] Both Hay and Ko highlight the agency of the art object in crafting culture and individual identity, and both works foreground the bodily nature of knowledge as the conjoining of sensory and textual

understandings.[37] This book explores similar ideas within a spectrum of classical literati art forms—calligraphy, painting, seal carving, teapot manufacturing, and full-form rubbings—that are so intertwined with textual knowledge that, until now, their sensory appeals have gone largely unacknowledged. While a full sensory history of literati art would be beyond the scope of any book, by following the particular emergence of tactile thinking in this generation, surprising features emerge to liberate the literati arts from their text-bound narratives and to introduce larger questions about the nature of literati knowledge on the cusp of modernity in China.

One last note on the term "literati" will be useful before starting. Throughout the book, I use the term literati to refer broadly to those members of the educated elite who negotiated their relationships with peers through references to a shared knowledge of classical Chinese texts and artworks. The English term is convenient, even if it may be somewhat anachronistic, as the closest Chinese term for this, *wenren* (lit. "lettered person"), was only sometimes used as an identifier among early nineteenth-century elites. The term *ru* (roughly, "Confucian," but encompassing more than just adherence to Confucian thought) had more traction as a group identifier among philologists and government officials of the eighteenth century but lacks the dimensions of class and education conveyed by the word literati.[38] A general skepticism toward the cohesiveness of literati identity has been expressed among art historians, particularly in relation to Yuan-dynasty painting history.[39] More recent scholarship points to the blurred distinctions between the social statuses of craftspeople and literati in the increasingly commercialized world of early modern China.[40] Taking heed of the porous nature of this term, I nevertheless retain it in following chapters, as it is the best descriptor for those who contribute to a culture in which social capital was built by means of objects that cited a shared knowledge of classical history, literature, and the arts.

Calligraphy's New Past

In the winter of 1793, the recently appointed education commissioner of Shandong Province, Ruan Yuan, arrived in Qufu. Ruan was there for many reasons. As education commissioner, his main responsibilities were to oversee Shandong's Confucian academies and to ensure the integrity of the local examinations, a crucial juncture in the pipeline of success for aspiring young Chinese elites. He was also responsible for officiating the rituals that followed the passing of the Duke of Yansheng, the senior male descendant of Confucius. This included transference of the title to the next duke, Kong Qingrong (1787–1841), an event set to take place at the shrine of Confucius in Qufu on the eighth day of the eleventh month of 1793. Though he did not yet know it, he would meet his future wife there, Kong Luhua (1777–1833), sister of the new Duke of Yansheng.[1]

But for Ruan, the shrine of Confucius was not just a site for official business, rites of state, or even matchmaking. Its impressive collection of ancient inscribed monuments attracted an equal, and perhaps greater, measure of his attention. Ruan Yuan had recently come under the sway of epigraphy studies, an extension of the dominant eighteenth-century intellectual turn toward linguistic research, or philology.[2] Ruan's mentors taught him to use inscriptions from the past to scrutinize the development of early written language, which in turn provided evidence to correct long-held misconceptions about the fundamental texts of Chinese culture—the Classics and the dynastic histories. Qufu's inscribed stones spanned China's earlier dynasties, and Ruan knew many of their texts word for word, their surfaces mark for mark. Well before arriving under official auspices, he had intimately studied these inscriptions in the form of ink-rubbed impressions taken from their surfaces, and he had even incorporated their stylistic elements into his own calligraphy.

The *Yi Ying Stele* was a particular favorite. First engraved and erected in 153 CE for audiences of the Eastern Han dynasty, it was associated in Ruan Yuan's time with the unification of China under Confucian values during the Han dynasty, and with Confucian genealogy, ritual, and piety in particular. The original inscription commemorated a petition to the Han court written by the descendants of Confucius and local administrators (including Yi Ying, the name by which the stele is often known) asking to establish an official governmental position, "Clerk of the Hundred Tablets," in Qufu. The clerk would be responsible for the maintenance of proper Confucian rites as well as all necessary ritual implements. The petition was successful, and the first title of "Clerk of the Hundred Tablets" went to Kong He, a descendant of Confucius.

Rubbings of the *Yi Ying Stele* (fig. 2) had been in circulation since the Ming dynasty, and Ruan certainly would have owned one, as it had become a prime model for the study of clerical script during the Qing dynasty. Clerical script, the public calligraphic style of Han- and Wei-dynasty monuments, had, after a long period at the margins, ascended to dominate the calligraphy of many late eighteenth- and early nineteenth-century scholars, artists, and officials. The style was by no means unified, which was part of its appeal. Each early stele seemed to display its own variations on word structure and orthography. Knowing the many permutations of clerical script found on available early stone and metal sources became an all-consuming obsession for scholars at this time.

When Ruan copied a selection of the *Yi Ying Stele* text in brush and ink on paper (fig. 3), it was not simply an academic act. It also helped reinforce a positive impression of his character among contemporaries. Brushing out the words anew, Ruan paid homage to the original Han-dynasty event while emphasizing his own commitment to Confucian ritual, to proper imperial channels of communication, and to a reverence for the traces of past officials who also valued those things. Considering Ruan's eventual marriage to a member of the Confucian lineage, the content of this inscription may have been yet another reason he decided to copy the calligraphy in his own hand.

For contemporary audiences educated in literati material culture, Ruan's *Yi Ying Stele* calligraphy signaled his virtue in its content but also in its style. Comparing the traits of Ruan's clerical script with his short signature in running script at the bottom left of the paper reveals the bold contrast antique characters made with more common manners of writing. The larger *Yi Ying* script words are boxy, symmetrical, and stable, extending from the center equally to the edges and corners of the imagined square of space allotted to each character. Horizontal strokes take precedence over vertical ones, drawing out the shape of words and giving them low centers of gravity. When long, downward diagonal strokes are called for, they dominate, extending and expanding, as they end in dramatic, plump points in the bottom left and right quadrants of a character. In

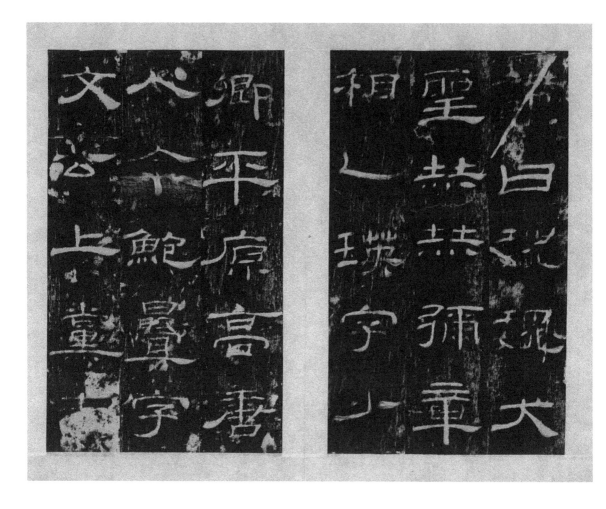

contrast, each word of Ruan's signature in running script, "Yuntai, Ruan Yuan," tilts up and to the right, appearing as if it were about to slide off the lower left corner of the composition in comparison to the clerical-script characters. Their brushstrokes are slimmer, and their overall distribution of strokes creates taller, leaner words. One style is formal and austere, the other light and casual. One style could be associated with strength, practicality, and endurance, the other with affectation and dandyism.

Ruan's selection of just twenty-nine words from among the over five hundred characters preserved on the stele is telling. It comes from the section of the official letter to the emperor in which the author of the request, Kong Lin, cites the approval of his superiors in this endeavor—the administrator of Lu, named Yi Ying, and the district magistrate, named Bao Die. In their praise of the plan, Kong wrote, Yi Ying and Bao Die had also referred to Confucius with the especially poetic phrase, "That great towering sage whose radiance pervades all." Ruan Yuan's calligraphy begins with these eight words and is followed by characters that list a shorthand biographical sketch for each of the officials, including ranks,

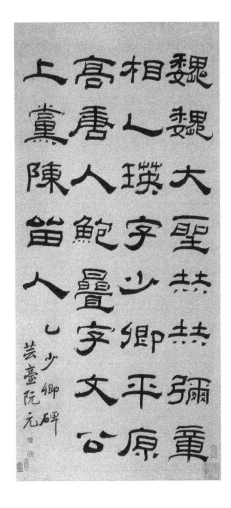

Fig. 2 (opposite)
Rubbings of the *Yi Ying Stele*,
early twentieth-century rubbing
of a monument dated to 153
CE. Mounted as an album, ink
on paper, 24 × 14.5 cm. Special
Collections, Fine Arts Library,
Harvard University.

Fig. 3
Ruan Yuan, calligraphy after
the *Yi Ying Stele*, in clerical
script, late eighteenth or early
nineteenth century. Ink on
paper, 123 × 57.2 cm. Hong Kong
Museum of Art. Photo supplied
by the Hong Kong Museum of
Art.

names, hometowns, and sobriquets. Ruan chose words that demonstrate a properly functioning Confucian civil system based on ritual, in which an honorable request by a local worthy is amplified by the officials within the bureaucratic chain of command until it reaches the emperor's attention and is acted upon rightly. While he does not say so directly, Ruan's choice may well have expressed the sentiment, "would that current governance were so smooth."

Coming into one's own as a public servant in 1790s China was a complex and frustrating affair. The Qianlong emperor had reigned for nearly sixty years, expanding the empire's territory and wealth drastically during the middle of the eighteenth century. But by this later stage of his rule, he was less engaged in political decision-making and was under the influence of the charismatic palace servant Heshen (1750–1799), who used that influence to accumulate power and manipulate the bureaucracy. Corruption and factionalism were rampant, and the governmental engine of the Qing dynasty was inefficient and overtaxed. Still, young elites coveted a place in this system. It was the primary means to ensure personal success as well as the only method to enact change within the

country aside from revolution. Maintaining strength of character within the Qing bureaucracy depended on choosing the right friends as well as projecting the correct image, skills Ruan Yuan learned through his early education and mentorship.

While Ruan Yuan's public career has received thorough description in English and Chinese scholarship, his role as a patron of the arts, and in particular as an advocate for calligraphic change, deserves closer attention.[3] Mentions of Ruan's name in art history inevitably relate to his essays "Southern and Northern Schools of Calligraphy" and "Northern Steles and Southern Letters," first drafted around 1810 and published in 1823. These texts stand out in the history of early nineteenth-century art for their commitment to a critique of the status quo. They summarized findings built upon two generations of epigraphy research to articulate the aesthetic zeitgeist Ruan saw happening around him in the late Qianlong and Jiaqing periods: a reordering of the calligraphic canon around direct material knowledge of ancient inscriptions.[4] Describing the path that brought Ruan to write these essays is the first step toward a new understanding of early nineteenth-century visual and material cultures. In particular, the story of Ruan's development as an epigraphy expert reveals the central role epigraphy played in social networking for the early nineteenth century's scholarly elite and the features of the resulting epigraphic aesthetic by which they communicated this consanguinity.

Ruan Yuan's Early Career and Evidential Research

Ruan Yuan was born in Beihu, Jiangsu Province, on the outskirts of the wealthy metropolis of Yangzhou, a city synonymous with the largesse of the Qing dynasty's eighteenth-century golden age. Ruan's family was gentry class but was not distinguished or wealthy. Nevertheless, his mother, who was responsible for his education, saw to it that he had good tutors, and he eventually excelled in his studies, taking first place in his prefectural-level examination in 1784. Xie Yong (1719–1795), who oversaw the various provincial examinations as education commissioner for Jiangsu Province from 1784 to 1786, took notice of the young man's talents and brought Ruan under his wing. Like most eminent career bureaucrats, Ruan's career began with success in the local examination system but was only solidified through a network of elite patronage.

Ruan went on to take first place in the 1786 Jiangsu provincial examinations, where he was noticed by an even more established government official, Zhu Gui (1731–1807), tutor to the heir apparent, the eventual Jiaqing emperor. Xie and Zhu invited Ruan back to the capital in 1786, where his integration into the elite classes of government officials began. As he waited to take the final set of metropolitan and palace exams, Xie and Zhu introduced Ruan to some of the capital's finest scholars and most distinguished government officials.

This period from 1786 to 1793 shaped Ruan's career definitively. Ruan's new friends and mentors opened his eyes to the scholarship of Dai Zhen and the world of philology, along with its exacting principles of evidential research.[5] Over the previous generation, a swell of interest in the analysis of early language had risen to dominate intellectual priorities. The primary goal of this philological research was to return the early documents upon which Chinese cultural authority was founded to their most authentic forms. Shared knowledge of the classic Confucian texts and their commentaries underpinned social and governmental interactions in imperial China. But according to the thinking of many eighteenth-century scholars, misunderstandings had accumulated over millennia of textual recensions due to scribal error, textual fragmentation, and interpretive biases.

In part, these researchers were reacting against the kinds of metaphysical discourses that had been popularized in the Song (960–1279) and Ming (1368–1644) dynasties, which many believed played a significant part in the decline of the Ming empire. Dismissing such thinking as filled with interpretive fancy, scholars of the eighteenth century sought to strip away the frivolous influences of their predecessors by thoroughly vetting the earliest versions of the Classics.[6] This was accomplished through the principles of evidential research. Concrete observations drawn from original texts and authentic inscribed objects from the past, when conducted on a large scale, enabled the level of comparative analysis that allowed scholars to identify period-specific linguistic traits by which other sources could be verified. Only by agreeing on what constituted the true words of the ancients could scholarly discourse move forward. In the words of Dai Zhen, "The Classics provide the route to the Way. What illuminates the Way is their words. How words are formed can only be grasped through philology and paleography. From primary and derived characters, we can master the language. Through the language we can penetrate the mind and will of the ancient sages and worthies."[7]

This intellectual turn to philology instigated an epistemological shift in this generation. Empirical evidence became the proper foundation for intellectual debate, and inscribed antiquities, once authenticated, were considered among the most reliable forms of evidence. As Qian Daxin (1728–1804) put it in his introduction to Bi Yuan's *Record of Bronze and Stone [Inscriptions] from Shaanxi*, "The study of bronze and stone inscriptions is the back and bones of the study of the *Classics* and the *Histories*. . . . Writings on silk are damaged after a while; printing on paper loses its authenticity as it circulates; only bronze and stone inscriptions, which originated over a thousand years ago, still reflect the true features of the ancients. The concrete learning of the *Classics* and *Histories* lies therein."[8] Under this logic, cast bronzes, carved stone steles, and other ancient text-bearing objects rose in status from collectible antiquities to indispensable documentation of true voices from the past. Researchers

gathered all traces of early language found on ancient inscribed or cast objects and compared them with those found in the earliest printed editions of important texts. When they found discrepancies between the physical evidence and the textual record, whether in semantics, orthography, or style, the physical evidence often held precedence due to its material solidity. Using clues from these concretely dated objects, evidential researchers could build arguments that redated and sometimes entirely refuted the authenticity of relied-upon recensions and commentaries for canonical texts. This made evidential research and epigraphy political by nature. By shifting interpretations of the foundational texts of Chinese philosophy, history, and politics, scholars gained new authority over the very fabric of culture, allowing them to take the upper hand in debates at court and beyond.[9]

Throughout the Qing empire, and particularly in the wealthy cities of the lower Yangzi River region, evidential research scholars formed collaborative networks of intellectual exchange during the late eighteenth century. They traded rare books, manuscripts, and epigraphic resources with one another in an effort to expand the corpus of evidence through which knowledge of the past could be verified. Officials with wealth and position sponsored unemployed but talented scholars to undertake much of this work, creating complex networks of obligation that gave the sons of prestigious families purpose when government positions were not available to them.[10] Xie Yong and Zhu Gui incorporated Ruan Yuan into one such network. During his time in the capital as a Hanlin scholar, Ruan was introduced to a host of influential late eighteenth-century literati who prioritized evidential research methods and the use of epigraphy in particular, including Wang Chang (1725–1806), Qian Daxin, Bi Yuan (1730–1797), Gui Fu (1736–1805), Shao Jinhan (1743–1796), Wang Niansun (1744–1832), Hong Liangji (1746–1809), Sun Xingyan (1753–1818), and Yi Bingshou (1754–1816). Through his participation in this network, Ruan became a practiced evidential researcher and an enthusiastic epigraphy scholar.

As a Hanlin scholar in the capital, Ruan was assigned to several important imperial cultural projects that combined the skills of epigraphy research and evidential studies, including the Qianlong emperor's project to carve an authoritative version of the *Stone Classics*. The *Stone Classics* were the earliest imperially produced edition of the thirteen foundational Confucian texts and took the form of a set of steles inscribed during the Xiping era (175–83) of the Han dynasty. Later editions were carved in the Three Kingdoms period, the Tang dynasty, and the Song dynasty. By the eighteenth century, few fragments of the early stones still existed, and epigraphy scholars prized early rubbings of them because they granted as direct a point of access to the foundations of Confucian thinking as was possible. Qianlong aspired to produce a complete recarving of the *Stone Classics*, taking into account the discrepancies of all the various editions, with Ruan assigned to collate the section titled *Classic of Rites and Ceremonies*.[11]

Epigraphy and evidential research surrounded Ruan at this time, priming him for his later cultural projects. He was working directly with important epigraphy scholars like Wang Chang, who was then compiling and editing his *Epigraphy Collectanea*, a major 160-volume contribution to the field. In his free time, he explored nearby cultural sights, taking outings to the capital suburbs to see steles with Sun Xingyan. He wrote poems and inscribed inkstones inspired by ancient inscribed bricks. While awaiting his first official assignment, Ruan was also given the enviable role of helping compile the revised catalog of the imperial art collection, the *Precious Collection of the Stone Moat*, giving him firsthand experience of many historical masterpieces of Chinese painting and calligraphy. But even in this work, he could not help but think in the terms of an epigraphy scholar. When he spent time cataloging a Song-dynasty copy of Gu Kaizhi's (345–406) *Nymph of the Luo River*, he described it as "antique and awkward," like the "Han dynasty carved stone images" of the Wu Family Shrines.[12] Already, Ruan was understanding the history of the brush arts through references to ancient inscribed stones.

Shandong

The first two postings Ruan received outside of the capital, as education commissioner for Shandong Province (1793–95) and education commissioner for Zhejiang Province (1795–98), positioned him at the social nexus of each province. Education commissioners met local elite families through any number of interactions, including touring local academies, leading the official examinations of their sons for service, and conducting public rituals on behalf of the court. The job also included responsibility for provincial cultural heritage in its purview. In this respect, Ruan chose to flex the power of his network and position by contributing to the field of epigraphy scholarship in particular, directing the production of the *Epigraphy Gazetteer for Shandong Province* and the *Epigraphy Gazetteer for Zhejiang Province*.

These books were not inevitabilities, nor were they easy to produce. At twenty-four and eighteen volumes, respectively, the *Gazetteers* required the compilation, fact-checking, editing, and analysis of more materials than any one scholar could hope to achieve in a lifetime. To produce these multivolume tomes, Ruan Yuan turned to the network he had cultivated on his way up the bureaucratic ladder. He succeeded Weng Fanggang as education commissioner for Shandong Province, and it was through Weng that Ruan was likely introduced to many of the local epigraphy scholars that would help him complete his first gazetteer.[13] As Ruan explored Shandong's material traces of the ancient past, he sought expertise from this established and renowned network, including Huang Yi (1744–1802), He Yuanxi (1766–1829), Qian Yong (1759–1844), Duan Songling (1745–1800), and Wu Yi (1745–1799).

His interactions with Huang Yi in particular helped inspire Ruan to start work on the *Epigraphy Gazetteer for Shandong Province*. Huang Yi had been based in the city of Jining since 1777 as a district magistrate in the office of the eastern branch director general of the grand canal. During that time, he made it his pastime and obsession to travel through the immediate region scouting out and accumulating the various undocumented remnants of Shandong's archaic past. Over his two decades there, he accumulated a collection of epigraphic materials that was celebrated throughout the country. It included various fragments of ancient stone steles as well as many comparative materials, like antique rubbings of early monuments. Above all of these, though, it was his rediscovery, documentation, and reconstitution of the original stones of the Wu Family Shrine complex during the 1780s that made him a celebrity within epigraphy circles.[14]

Huang had been a close friend of the outgoing education commissioner, with whom he shared a mutual passion for collecting early inscribed materials. In the fall of 1793, just as Ruan began his posting, and before the idea of an epigraphy gazetteer crossed his mind, Huang Yi had already begun to make inroads with the young commissioner, reaching out to Ruan to tell him of the need to properly house a newly discovered ancient stone piece, the *Xiping Second Reign Year Stele Fragment*.[15] Huang stumbled across the broken stele section by the Si River, beyond Qufu's eastern city gate, where he had wandered to escape the din of his own fiftieth birthday festivities. One of his staff made a rubbing of the stone's heavily worn text, enabling him to better read the date of 173 CE (fig. 4). Elated to discover the age of the inscription, Huang reached out to the incoming Ruan at the local Confucian academy, requesting the stone be moved to the nearby Confucian shrine. It still stands there today, further inscribed with Ruan's own record of the events surrounding its discovery.

The younger Ruan began to rely on the older Huang to further his awareness of Shandong's epigraphic heritage. Late in 1794, just as fall was turning to winter, Ruan Yuan traveled to Caozhou for official business and decided to stop by Jining on the way, where Huang Yi hosted him for an evening gathering. As Ruan Yuan later recounted, it was this visit to Jining to see the collection of steles and rubbings Huang Yi had brought together that acted as the catalyst to inspire his own epigraphy scholarship, starting with the *Epigraphy Gazetteer for Shandong Province*. Huang Yi toured Ruan around the engraved monuments housed at the Jining Prefectural School and then showed him his many albums of antique rubbings. As Ruan leafed through them, he added modest commentaries to several leaves.[16] The rubbings were made in the Tang and Song dynasties but had been produced from even more ancient steles of the Han and Wei dynasties. One delicate set of rubbings of the *Fan Shi Stele* that Huang showed Ruan had survived from the Song dynasty, the conception period of epigraphy studies. As he handled these cut and remounted ink images, Ruan mentally reconstituted the pages into a whole stone stele, envisioning the ancient monument that would

Fig. 4 Rubbing of the *Xiping Second Reign Year Stele Fragment*, nineteenth-century rubbing of a monument dated to 173. Ink on paper, 75.4 × 76.2 cm. National Palace Museum, Taiwan.

have stood at about his height. Reflecting on his time spent with Huang Yi's collection, an idea started to form. He left Jining committed to a new project, a publication that fully assessed the ancient stone and metal cultural resources in Shandong Province.[17]

When Bi Yuan arrived to Shandong in 1795 to serve briefly as governor, Ruan Yuan appealed to him to lead the project. Bi Yuan had just completed two similar epigraphy projects in Shaanxi and Henan Provinces, the *Guanzhong Epigraphy Gazetteer* and the *Zhongzhou Epigraphy Gazetteer*. But Bi Yuan demurred, claiming old age and a lack of energy in the face of the weighty responsibilities of office. He had just been demoted as a result of a perceived mishandling of the

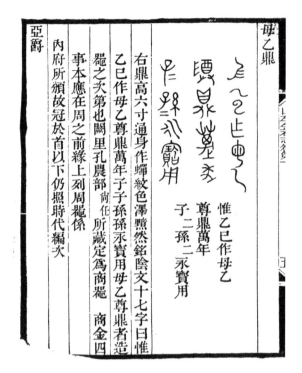

Fig. 5　*Epigraphy Gazetteer for Shandong Province*, vol. 1, 5b, published 1797. Woodblock print on paper, 24 cm. Harvard Yenching Library.

suppression of the White Lotus Rebellion and was nearing the end of his career. To start Ruan off on his project, Bi Yuan sent him copies of his previous gazetteers as examples. Ruan then began to gather materials and soon reached over 1,300 rubbings to begin sorting.[18]

The twenty-four volumes that resulted included over three thousand entries and was the sum of many scholars' work. Ruan Yuan appointed the Hangzhou native Zhao Wei (1746–1825) head researcher and writer. Primary editors included Duan Songling (1745–1800), Wu Yi, He Yuanxi, and Zhu Wenzao (1735–1806). More help came via consultations with Huang Yi and Zhan Wenmai, each of whom had drafted smaller local epigraphy gazetteers that Ruan incorporated into his project. Workers were commissioned to travel around the province to take rubbings of known monuments that had not yet been recorded. The collections of Gu Chonggui, Gui Fu, Jiang Fengyi, Lu Sheng, Li Yijin, Li Dongqi (fl. late eighteenth century), Kong Shangren (1648–1718), and Niu Yunzhen were also consulted.[19]

The gazetteer made no grand claims about the nature of epigraphy in Shandong Province or at large. Neither did Ruan's following gazetteer project for Zhejiang Province. Instead, and in keeping with evidential research values, both scholarly works compiled well-edited facts about the individual objects from which larger arguments might be constructed by readers. The Shandong gazetteer proceeded in chronological and typological order, with the slight exception of the first entry, which concerned a set of ten Zhou-dynasty bronzes presented by

the Qianlong emperor to the Confucian shrine at Qufu in 1771.[20] Following this entry, volumes one through six covered all cast-metal objects with inscriptions, including ritual bronzes from the Shang through the Yuan dynasties, mirrors from the Han through the Tang dynasties, and seals from the Han dynasty through the Yuan dynasty. Volumes seven through twenty-four proceeded similarly for inscribed stone monuments from the Qin through the Yuan dynasties. Each entry included a title, an illustration (for the cast inscriptions), a transcription of the object's text, and brief commentaries (fig. 5). Upon the first printing of the gazetteer in 1796, Ruan sent a copy to Qian Daxin, requesting an introduction. Qian's essay placed Ruan's gazetteer in the larger historical context of epigraphy scholarship stretching back to the Song dynasty and emphasized the usefulness of epigraphic resources for evidential research, writing, "Although over a thousand years have passed, the dots and strokes [of the ancients] can still be differentiated and their differences and similarities can be debated; the longevity of stone and metal inscriptions also has great usefulness for the study of the Confucian classics and dynastic histories."[21]

Zhejiang

After completing his three-year posting in Shandong, Ruan was reassigned to the city of Hangzhou to take up the position of education commissioner of Zhejiang Province (1795–98). This move took him from one hotbed of epigraphic research to another. While his previous post in Shandong located him at the geographical source of many ancient inscribed stones prized by epigraphy scholars, Zhejiang was at the heart of epigraphy's reinvention as a new visual and material aesthetic. In mid-eighteenth-century Hangzhou, scholars like Ding Jing (1695–1765) and artists like Jin Nong had begun developing new styles of seal carving and brushwork that made visual references to epigraphy.[22] Though they had passed away by the time Ruan arrived in Zhejiang, Hangzhou painters of the following generation built their own reputations in relationship to Jin Nong and Ding Jing, elaborating on the aesthetic they established. The artist Luo Ping painted two portraits of Ding Jing and Jin Nong that alluded directly to the epigraphic interests of both artists (see chapter 3), frequently showing these paintings to potential clients to advertise his connection to them. The painter Qian Du emulated painted albums by Jin, who knew his father. Qian Du liked to tell the story that Jin Nong held him as a child, implying an almost saint-like transference from one generation to another via direct physical contact.[23] Likewise, Ding Jing's scholarship and virtuosity in seal carving later inspired an entire lineage of seal carving, the Xiling Seal Carving Society.[24] Epigraphy was central to Hangzhou's cultural vitality, and Ruan Yuan intended to harness this by setting an epigraphic ambition in Zhejiang that mirrored this work in Shandong: a comprehensive provincial gazetteer of ancient cast and inscribed monuments.

In Ruan's years as education commissioner in Zhejiang, his network of lite-rati friends and aides blossomed. Hangzhou natives already made up a large portion of the academic network he had built. His mentors Zhu Gui and Xie Yong grew up there, and many of his aides in Shandong were from Hangzhou as well, including Zhao Wei, Huang Yi, He Yuanxi, Chen Hongshou, and Jiang Fengyi. Theoretically, Ruan Yuan could not fraternize with the local gentry in his position as education commissioner, as it might compromise the neutrality of his position.[25] In practice, impartiality was hard to accomplish and in fact was openly flouted.

Despite this density of talented friends in Zhejiang, Ruan's *Epigraphy Gazetteer for Zhejiang Province* took longer to realize than its predecessor. Although the initial work on the gazetteer began in 1796, while Ruan was education commissioner, it was not until decades later, in 1824, while Ruan Yuan was serving in Guangdong as governor-general, that it was finally published. Once he was appointed governor of Zhejiang in 1799, Ruan's more pressing duties eclipsed his scholarly ambitions. He had less time to work on epigraphy stud-ies or any of the other Zhejiang-focused cultural projects he began as education commissioner. Ruan summed up his Zhejiang cultural projects in his introduc-tion to *Epigraphy Gazetteer for Zhejiang Province*:

I spent a long time in Zhejiang and have traveled its famous mountains and its great rivers, recording nearly all of it. More than a thousand poems by Zhejiang natives became the publication *Record of Zhejiang's Envoys*. My visits to the tombs and graves of the kings, princes, and sages of Zhejiang were gathered together and edited as *Record of the Preserved Historical Sites of Zhejiang*. What energy I had left I applied to metal-and-stone carvings, seeking them in remote and distant loca-tions to make rubbings, which were then carved into the book, *Epigraphy Gazetteer for Zhejiang Province*. I was aided at that time in seeking out and visiting sites to do textual research on them by Zhao Wei and He Yuanxi, with the gentleman Xu Zongyan from the Department of War also cross-examining the text and adding to it. All of this was gath-ered together, edited and left for over a decade. In the fourth year of the Daoguang reign, while I was in Guangdong, the eighteen *juan* were edited . . . in under two months . . . gathering into one book all the carved metal and stone from the Qin dynasties through the end of the Yuan so that those who love antiquity might themselves get something out of what is examined herein.[26]

As Ruan Yuan would later reflect, the decade he spent in Hangzhou as gover-nor of Zhejiang Province (1799–1806, 1807–10), expanded his scholarly network and enabled the production of large-scale scholarly projects. His political and

his cultural projects required large staffs of aides to compile, edit, and proof, and without them, his work would not have come to fruition. Likewise, without Ruan Yuan, many gifted scholars may never have evolved beyond the minor role of local tutor. The population growth over the late eighteenth century, combined with limited corresponding expansion in the bureaucratic structure, meant there was an oversaturation of well-educated scholars in relation to the number of government-service positions for which they were trained. This led to a robust practice among employed scholars of hiring unemployed but qualified aides (*muke* or *muyou*) for side projects such as the cataloging of local monuments with ancient inscriptions. There was a geographic specificity to the strategy of hiring aides. For instance, when Ruan Yuan was transferred to Hangzhou as governor, he asked Hangzhou natives such as Chen Wenshu (1771–1843) to accompany him. These people, in turn, introduced Ruan to other qualified assistants and scholars from their local network. As a result, during his time in Zhejiang, Ruan's literary and cultural production garnered him praise throughout the empire. While there, he published *Biographies of Mathematicians and Astronomers, The Zhushu Thirteen Classics with Collation Notes, Summary of Rare Books Left out of The Four Treasuries Project,* and *Record of Zhejiang's Envoys.*[27]

Among the first efforts toward expanding his local scholarly reputation as governor was the establishment of a library and lecture hall for Confucian scholars that he named Explicating the Essence of the Classics Residence. The school was located next to Shengyin Temple, on the island of Mt. Gu, along the northern edge of West Lake, in Hangzhou. Would-be examination candidates came here to be educated in the scholarly traditions of philology, Han learning, and evidential research.[28] As Ruan Yuan wrote in his "Record of Explicating the Essence of the Classics Residence," "The path of the sages of the past exists in the Classics. However, the Classics cannot be understood without commentary, and the Han scholars' commentaries come closest to the revered sages. We pursue [the Classics] from the vantage of Song scholarship in order get back to the Tang, the Jin and the Wei, and then to the Han, and thus recover the truth [of the ancients]. One often comes across defects, as the commentary of the ancients are scattered and hard to verify."[29]

For Ruan and his colleagues, evidential studies were about verifying the true words of ancient sages and of clearing away the clutter and confusion added in later printings and interpretations. Ruan had already undertaken some of this work in his previous post, which he was sure to mention:

When I was the education commissioner for Zhejiang, I assembled scholars at the foot of Mt. Gu on West Lake in order to create the hundred and eight volumes of *Compiled Commentaries on the Classics and Ancient Texts.* Now that I am governor of Zhejiang, I have repurposed the fifty

rooms I used for that project, so that the elected students of Zhejiang may study the commentaries here, titling it, Explicating the Essence of the Classics Residence. I take the words "essence" and "residence" from the name for the residences of Han dynasty students, and the words "explicating the classics" so that we do not forget the work of our forbearers as we create new knowledge.[30]

As Ruan emphasized in his other publications, Han-dynasty scholarship on the Classics served as the prime model for later Qing-dynasty scholars. The school was dedicated to the legacies of Xu Shen (30–124) and Zheng Xuan (127–200), Han-dynasty writers whose work ensured the continuity of Confucian Classics from the Warring States period. Xu Shen wrote the *Shuowen jiezi*, the first dictionary of Chinese language and the subject of dozens of evidential scholars' careers in the eighteenth and nineteenth centuries. Zheng Xuan was among the first scholars to try to reconcile the "Old" and "New" texts of the Confucian Classics, work that many Qing-dynasty scholars were continuing.[31] These two were scholarly heroes among Ruan and his peers.

As Ruan Yuan came into his own as an influential official, he drew on scholars of his generation as well as the network of older, established philologists that had enabled both his rise and that of his mentors. Ruan met senior scholars such as Wang Chang and Sun Xingyan through Zhu Gui, and they followed the young governor to Zhejiang to become the first lead lecturers at the Explicating the Essence of the Classics Residence.[32] Ruan's project of constructing and establishing a school to promote the values of evidential research in Hangzhou would be a precursor to his more famous academy, the Sea of Learning Hall, built in Guangzhou later in his career, while serving as governor of Guangdong and Guangxi Provinces.[33]

Ruan's responsibilities as governor were much broader than those in his previous position as provincial education commissioner. His primary concern was to eradicate piracy along the coast. Ruan's solutions involved a stricter accounting of provincial residents through the household-reporting system (*baojia*), a method of local registration used to keep track of eligible males for local militia (*tuanlian*). He also redesigned warships to be larger so that they could carry newly designed cannons that were also bigger. These proactive and innovative solutions made Ruan the target of late eighteenth-century factional politics that pitted Manchu officials against Han Chinese officials.[34]

Ruan's efforts as governor also involved the development of many new strategies to ensure the economic and political stability of Zhejiang. He instigated social welfare programs to curb female infanticide, built reform houses for the poor, and repaired failing examination halls. Other responsibilities included flood control, general infrastructure, and managing granary supplies in times of surplus and starvation. To complicate matters, the imperial budget was highly

strained at the time, and the funding for piracy suppression as well as social welfare could not be taken from tax revenues. To solve budgetary restraints and issues of trust in imperial institutions, Ruan Yuan turned to private fundraising among wealthy merchants and local families and brought in local gentry to replace corrupt provincial-level officials.[35]

In retrospect, Ruan Yuan's tenure as governor is emblematic of a shift to local governance during the Jiaqing reign.[36] This would prove to have various repercussions on the stability of the empire during the middle and late nineteenth centuries. The stirrings of tensions that would result in the Opium Wars were also plain during Ruan's later posting in Guangzhou. Luckily for Ruan, none of these tensions reached the level of crisis during his appointments.[37] Instead of having to deal with the problems that would later destabilize and then break the Qing empire, Ruan Yuan was able to manage the difficulties that came his way with shrewd use of talented aides and by training himself in the necessary skills to keep the localities under his care well fed and organized. In the minds of Ruan and his peers, these practical adaptations were rooted in sound understandings of classical culture. Though later critics would conflate the antiquarian and epigraphy projects of the period with retardataire thinking that set up the Qing dynasty for failure, to these scholar-officials, the past was a tool for better management of the present.[38]

Friends in Stone

While the expansion of Ruan's cultural and political network in Hangzhou can be understood almost entirely through the textual accounts left by him and his aides, art objects also concretized these events, often in more personal ways. According to his own published memoirs, dozens of paintings, seals, inscriptions, and calligraphies marked the events of Ruan's life in Hangzhou. During this time, he received paintings by established Hangzhou artists like Xi Gang (1746–1803) and Fang Xun (1736–1799), as well as up-and-coming painters like Qian Du and Wang Xuehao. After Ruan established the Explicating the Classics Residence, he commissioned three paintings by Xi Gang and Wang Xuehao of famous sites in Zhejiang, including the Hall of Firsts, which sat on West Lake as part of the new academy. To it, Ruan added both his own account of the school's founding in neat standard script and a letter with a set of imperial poems transcribed by the renowned calligrapher and grand councillor Liu Yong (1719–1805) (fig. 6).[39]

Ruan also made calligraphy to be carved as various new material objects, including wooden title boards for the studios of friends, new stone steles for public cultural sites, and new inkstones for friends. His words were cut into a stele to commemorate repairs to the tomb of Yu the Great at Huiji as well as on a 1799 tablet inscription for Zhang Tingji's (1768–1848) studio, Residence of the Essences of Eight Bricks, named after Zhang's prized collection of ancient

Fig. 6 Handscroll commemorating Ruan Yuan's building of Explicating the Essence of the Classics Residence on West Lake, with paintings by Wang Xuehao and Xi Gang, calligraphy by Ruan Yuan and Liu Yong. Ink and color on paper, 23.8 × 228.5 cm. Tianjin Museum. Image provided by Tianjin Museum. Details, right to left, following handscroll format, from Wang Xuehao, *Landscape*, 1799; Liu Yong, calligraphy, 1801; Xi Gang, *Hall of Firsts*, 1800; Ruan Yuan, *Record of the Explicating the Classics Residence*, 1801.

Han- and Wei-dynasty inscribed bricks. He gave ancient bronze seals as gifts to friends, and new seals were carved in antique styles for him.

When Ruan ascended to his first governorship, his disciple Chen Hongshou presented him with a hand-carved seal, cut with the words "Lesser Langhuan Immortal Hut" in archaic seal-script calligraphy (fig. 7). This studio name was one that Sun Xingyan gave to Ruan Yuan just before Ruan left to serve in Shandong. Sun's calligraphy of these same words had been inscribed in seal script into a placard for Ruan's study there.[40] Chen Hongshou therefore reinforced Sun's gift with his own, using the same style of calligraphy to further intertwine the objects. Chen would become one of Ruan's right-hand men over the next decade, and this seal was an early concrete sign of their burgeoning friendship.

The practices of presenting customized paintings, seals, inkstones, placards, and calligraphy among literati were centuries old by Ruan's time. Commemorative gift giving was an integral part of the social courtship that elites used to cement their networks of personal and professional relationships. These objects, especially when inscribed with references to a spectrum of classical allusions, acted as placeholders for specific social events, giving concrete forms to the experiences that bonded elites while also burnishing the scholarly reputations of those involved.[41] Within Ruan's network, references frequently incorporated

citations of epigraphic style, a fact that expands our understanding of epigraphy's increasing importance for networking in this generation. Analysis of two specific examples demonstrates the subtle ways that epigraphic sources found their ways into literati gift-giving culture.

When Ruan ascended to his first governorship, grand councillor Liu Yong gave Ruan three things. First, he wrote the calligraphic preface for Xi Gang's painting *The Inkstone Registry*, which recorded Ruan's growing collection of inkstones. Second, he accompanied his calligraphy with the gift of a new inkstone. Last, he wrote a poem that was then inscribed on that inkstone:

Duke [Ruan's] writings are like jade and gold.
His painted scrolls and records of inkstones stir feelings of tranquility.
Through this treasured inkstone, friends in stone find each other.
Loyal and upright, we grind against the inkstone, us two men of the same
 heart and mind.
I travel toward you, sir, because our fellowship bridges the depths.
Forever, I praise your seas of learning, your forests of writings.[42]

Liu was forty-five years Ruan's senior and outranked Ruan in both bureaucratic seniority and imperial favor. Just a few months earlier, at the direct request of the Jiaqing emperor, Liu completed the high-pressure task of compiling the official dossier against the denounced minister of the Qianlong reign, Heshen.

Fig. 7 Chen Hongshou, *Lesser Langhuan Immortal Hall* seal for Ruan Yuan, 1797. Stone, 2.1 × 2.1 × 3.5 cm. Shanghai Museum. From Lai Suk Yee, *Art of Chen Hongshou*.

The events of Qianlong's death and Heshen's fall from grace effectively marked the end of the Qing golden age. Despite the gulf in age and importance between the two, Liu's words glowed with praise and compliments for Ruan's erudite contributions to literati culture. The poem also artfully tied together Xi Gang's painting about inkstones and the gift of the new inkstone, achieving the goal that was central to both objects: a mutual celebration of the "friendship in stone" of "two men of the same heart and mind" who were "loyal and upright."

The phrase "friendship in stone" had deep cultural roots as a metaphor for strong interpersonal bonds. Poets as early as the Jin dynasty (266–420) used the phrase "friend in stone" to allude to an unflappable friendship. The calligrapher Mi Fu famously bowed in reverence to his "brother stone," one of the more canonical examples of a long and storied history of lithocentric anthropomorphism in Chinese literature and arts. Yet for early nineteenth-century literati, the cultural and material dimensions of the man-as-stone metaphor were different. To those men, to be "linked in stone" also meant to share a passion for the study of ancient inscribed and cast objects, the obsession that defined the social and material cultures of their generation.

Ruan Yuan used the phrase when he contributed a similar inscription just four years later to the side of his friend Guo Lin's (1767–1831) new inkstone, embellishing the sentiment with Han-dynasty clerical script (fig. 8): "[The poet] Bai Juyi was born on the twentieth of the first month, just like you and I. Since 1767 [Guo Lin's birth year], whether on the rise or in decline, we are linked by

Fig. 8 *Portrait Inkstone of Guo Lin*, 1803. Back inscription by Guo Lin, side inscriptions in clerical script by Ruan Yuan and Yunfeng. Carved stone, 18.5 × 11.7 × 2.6 cm. Tianjin Museum. Image provided by Tianjin Museum.

fate. [As it says in *The Book of Changes*], 'with the determination of a stone, his virtue brings good fortune.' Isn't this the true demeanor of a gentleman?"

Through prosperous times and lean ones, Ruan wrote, he and his friend could rely on each other. The inkstone would remind Guo of that. Inkstones, like their kindred literati art forms of painting and calligraphy, linked individuals through their capacity to bear the paratexts that recorded memories of specific interactions and relationships.[43] Whenever Guo put his inkstick to the wetted surface of this stone to grind out new ink, Ruan's words, inscribed in his distinct calligraphy style, would be there. The two were connected in time and space first by a shared birthday and now by the durable words cut into this rock.

At the time of his inkstone inscription for Guo, Ruan had already started work on the *Epigraphy Gazetteer for Zhenjiang Province*. Guo Lin, for his part, was primarily remembered by posterity as a poet. But over the previous year, he began to compile his own modest contribution to the field of epigraphy—the slim two-volume *Supplement to Studies in Epigraphy*, started in 1802 and completed between 1811 and 1813.[44] Moreover, their "friendship in stone" was a product of the extended network of epigraphy scholars employed by Ruan Yuan. Guo Lin's closest friends included several of Ruan's primary aides, people responsible for the compilation and editing of his published studies on ancient stone and metal objects.

Two more inscriptions accompanied Ruan's, attesting to Guo's popularity—one by a friend, along the right side, and the other by a relative, along the edge of the working face. But the central text on this object was Guo Lin's own short commentary etched into the presentation side of the inkstone in his characteristic standard script calligraphy and situated just above his portrait. Guo wrote, "A stone is discarded by insensitive men just as a man is wasted by the foolish heavens. Whether by the insensitive or the ignorant, be it men or the heavens, I may be detested based on my appearance, but my body and bones are yet unyielding; grind away at this unyielding nature and still I remain, continuing my sighs for eternity."

In his inscription, Guo Lin mobilized the literati trope of lamenting wasted talent through a multivalent metaphor that merged the body of the inkstone with his own body. A stone, like a man—a man such as Guo Lin—possesses raw potential. Someone who is sensitive to such potential might craft the stone for use, just like the heavens or an emperor might craft a man for service. But potential often goes unrecognized, whether it be in the stone or in the man. This is a test of the gentleman's true qualities. How does one endure under such circumstances? Guo Lin's answer is to persist in one's obdurate nature. Grind ink against this stone, against me, he says, and all you will hear in response is the sound of my enduring sighs, the sound of ink being made to produce more words such as these. To drive home the tactile metaphor of the man in the stone, Guo Lin's portrait is cut under his inscription. In it, he pinches his fingers together to play with the ends of the ties on his cap as a slight smirk passes over his face, under his abnormally large, perhaps even "detestable," nose.

The emergence of these bodily and characterological concerns in the inscribed poems and images on inkstones coincided with the nature of the object. The full appeal an inkstone made to its audiences was not activated by seeing its inscribed images or reading its engraved texts alone. Physical touch was crucial. The primary function of an inkstone was to provide a surface on which a scholar pulverized inksticks to produce ink, the raw material necessary to write the words that proved scholars' erudition to their social network. As Guo Lin milled inksticks against the top side of this stone, slowly adding drops of water to create a deep, viscous black fluid, the image of his face, cut under the image of his own handwritten calligraphy, smiled contentedly on the object's reverse side, watching himself at the task of "grinding away at this unyielding nature." Guo Lin's choice of verb, to "grind," evoked not only the production of ink but also the worn patina that touch and time ("an eternity") brings to stone, a substance that survives and endures. The bodies of men, stones, and words commingled in Guo Lin's inkstone, creating an object of self-fashioning that called out to the body of its viewers to be touched and to be thought of through touch. This tactile thinking drew directly from calligraphic theory, the subject of Ruan's most enduring work concerning the study of epigraphy.

Calligraphy's New Past

The many forms of Ruan's contributions to epigraphy research included multivolume catalogs of reference materials, specialized academies grounded in curricula of philology and epigraphy, the sponsorship of gifted scholars, and the production of the various art objects that bound these networks together. But it was his two essays, "Southern and Northern Schools of Calligraphy," and "Northern Steles and Southern Letters," that may have had the greatest impact on epigraphy scholarship. The essays were drafted in 1810–11, just after Ruan completed his final term as governor of Zhejiang Province, though they were not published until 1823, when they appeared in his literary collection *Collected Writings from a Room for Grinding Away at the Classics*. Marshaling a lifetime's worth of research on epigraphy, Ruan's essays accomplished two central goals: the reinstatement of a forgotten historical lineage of calligraphy, which he called the "northern" school, and a demonstration of the value of working from real objects from the deep past in order to rectify such historical obfuscations as the neglect of the northern school. In the process of making these points, Ruan conjoined theories of calligraphic brushwork and evidential research to provide what amounts to the clearest articulation of the epigraphic values that affected all the arts of his generation.[45]

In "Southern and Northern Schools," Ruan began with a rhetorical question: "How can we return to the ancients when the various currents and schools have become muddied and confused with all these changes and transformations of calligraphy so that we cannot trace them back to their sources?" His question reflected the central concern of philology and evidential research—the excavation of truth from the ancient past despite the muddling effects of time and inaccurate recensions. His answer, put simply, was that close attention and comparative study of a wide array of ancient inscribed artifacts revealed the real genealogies of calligraphy. He continued:

> For twenty years now, I have been paying close attention to stele stones of the south and north, and confirming them in the official histories. Traces of the flow of [two] schools are apparent among them. The southern school has the airs of the Eastern Jin dynasty. It is free and loose, refined and exquisite, and has been preserved in [handwritten] letters, where the strokes of characters are so abbreviated as to make them incomprehensible. The northern school on the other hand is that of the old methods of the heartland, and is constrained and strict, as well as awkward and rough. It can be found most often now on [carved] steles and placards.[46]

While this particular excerpt seems to take a balanced view of the two schools, Ruan's allegiances lay with the northern school, and his declaration of

its existence was, according to his essay, a hard-fought truth. After listing the historical practitioners of each lineage explicitly, he went on to argue that this history had been forgotten beginning with the Tang-dynasty imperial preference for calligraphy by Wang Xizhi (303–361) and his son Wang Xianzhi (344–386), the prime examples of a southern style of calligraphy. By the Song dynasty, he argued, "Scholars were ignorant of the difference between southern and northern schools. They thought the calligraphers of the early Tang all followed the tradition of Wang Xizhi and Wang Xianzhi." What's more, Ruan said, the calligraphers who maintained northern styles during the Tang dynasty, such as Ouyang Xun (557–641) and Chu Suiliang (598–658), were slowly misremembered by historians as being of the southern set. But a close look at their work, he argued, disabuses us of this idea. As he put it, "*The History of the Tang* says that Ouyang Xun began by studying Wang Xizhi's calligraphy, later surpassing it in ruggedness and strength. [His] calligraphy was squared, trued, strong, and straight, and was in actuality of the northern school. Examining the Wei and Qi steles that exist today, with their strong and true compositions, shows his style comes from them."

Making a similar point about Chu Suiliang, he wrote, "When Yu Shinan died, emperor Taizong proclaimed that there was no longer anyone to talk about calligraphy with, and Wei Zheng recommended Chu Suiliang, saying: 'When Suiliang puts brush to paper, it is vigorous and strong, and he has a deep reception of Wang Xizhi's forms.' . . . [But Wei's] recommendation was of the man, not of the calligraphy. Actually, Chu's method was based on the northern school."

While the running script calligraphy of Wang Xizhi and Wang Xianzhi constituted the prime models for centuries of calligraphers, Ruan argued that before the end of the Tang dynasty, their styles were not yet dominant. Until that point, it was still the northern styles of clerical script that were preferred among important calligraphers like Chu and Ouyang. One of the many ways this was evident to Ruan was that early histories of calligraphy felt obliged to record Wang Xizhi as a practitioner of clerical script rather than of running script, the manner for which he was later made famous.

Ruan expanded on this in his second essay, "Northern Steles and Southern Letters," implying that Wang's clerical style was lost after the Tang: "In the Tang it was customary to say that if one was not good at clerical script then one was not a calligrapher. Although Emperor Taizong of the Tang admired the calligraphy of Wang Xizhi, especially his model letters, such as *Preface to the Orchid Pavilion Gathering*, when he compiled the biography of Wang Xizhi, he only said, 'He was good at clerical script, and was the zenith of calligraphers past and present,' without a single comment about his regular script or running script. Yet Wang Xizhi's clerical script is nowhere to be seen [today]."

Ruan's objections to the southern school therefore stemmed from its dominance at the expense of nearly all knowledge of the northern school. But they

extended beyond this to broader characterological and material concerns. The styles of the southern school were also displeasing, because they relied on cleverness and beauty in their appeals to the viewer. The northern school styles, on the other hand, were squared, strict, and disciplined. For Ruan and his colleagues, these stylistic descriptions conveyed personal affects and were open to moral judgments. A calligrapher who used the "clever and appealing" style of the southern school of calligraphy was, by nature, a showy person. In contrast, someone who used the "awkward/unstudied and rough" style of the northern school was said to have a more restrained personality. In the early nineteenth century, and among Ruan's friends, the personal character associated with the northern style was preferred. It was seen as more authentic, honest, and less affected.

Characterological interpretation of stylistic choice featured in calligraphic theory from its earliest periods, dating at least to *Battle Formation of the Brush* (seventh century, attributed to Lady Wei, fourth century), a text that established the bodily vocabulary for viewing calligraphy. The directionality and path of brushwork was its "bone." The spread of ink from that line, an effect of relative time and pressure of the brush spent in a given location on the paper, was brushwork's "flesh."[47] This made calligraphy tactile by nature, as the "bones, skin, and body" were the organs of touch in early Chinese concepts of the senses, which perceived not just surface textures but movement as well. Making calligraphy involved the transference of the artist's body into a metaphorically material body that was also sensed through touch. Viewing calligraphy was the imaginative projection of oneself into the body of the calligrapher by means of a tactile reimagining of the gestures, pressures, timing, and intent of their marks, which still pulsed with the life of their maker, even hundreds of years later. These tactile dimensions of calligraphy were historically informed. While reembodying the calligrapher, viewers felt through their various choices made to amplify, reject, or hybridize previous calligraphic styles. Reading a calligrapher's skill and knowledge alongside their historical biography was a means to understand their personal character.

To reuse a historical style meant borrowing both that person's physical and historiographic demeanors. The calligraphy of Yan Zhenqing (709–784), a Tang-dynasty general known as much for his steadfast Confucian values as his rough and sturdy style of calligraphic brushwork, is a classic example. Later Song-dynasty scholars like Ouyang Xiu incorporated the calligraphic style of this morally upright Tang-dynasty statesman into their own calligraphy. By doing so, they associated themselves with Yan's persona, shielding themselves to some degree from criticisms of their own personal characters.[48] In Ruan Yuan's day, the same tactics of persona building through stylistic reference were used, but the primary material sources were different.

Viewing brushwork by means of rubbings taken from worn stone engravings or corroded cast-metal objects from the deep past involved different forms

of imagination than viewing calligraphy done in ink, brush, and paper or silk. For one, the person behind the carved or cast brushwork was rarely identifiable. Without a particular body to reimagine or a biography to correlate with the style, the characterological qualities of inscribed or cast calligraphy were even more open to projection by the viewer. But secondly, paper and silk were absorptive materials and were sensitive to the slight timing, pressure, and gesture of the body wielding the brush. By contrast, the carved stone or cast metal of epigraphic sources stood separate from the original calligrapher's bodily gestures by several degrees of material transfer. Anonymous and separated from the calligrapher's body, an inscribed source relied for its authenticity on its material truth above all.

This material argument affected perceptions of the southern school lineage in particular. As Ruan Yuan and his peers all recognized, examples of calligraphy by the Wangs and their inheritors were handed down in the form of handwritten texts on paper and silk, but verified original copies no longer existed. Their organic material supports had deteriorated over the years, so the few extant examples considered to be the direct traces of these early southern school calligraphers were in fact bastardized later versions. At best, Qing-dynasty calligraphers used examples that had been copied in the Tang dynasty. At worst, they followed hackneyed or even forged attempts at the Wangs' style from the more recent past. But examples of the northern school were found mostly on carved objects, where they could still be found in their original forms. The material durability of stone created relatively unimpeachable provenances for the styles of calligraphy found on them, and therefore they were more accurate reflections of original ancient calligraphy.[49]

As Ruan continued his argument, he connected this material thinking with the decreased popularity of clerical script, the style most often found on ancient inscribed objects:

> Ancient stones were inscribed in order to record the merits of emperors and kings, or to remember the virtues of scholars and officials, and were created for the benefit of history. Thus the calligraphy of the ancients could never be transmitted without metal and stone. Model letters began with governmental bureau script on silk scrolls, as recorded in the *Shuowen jiezi*. In later periods, each piece of silk and every half sheet of paper was collected as an ink trace and all were considered model letters. With the valuing of model letters, characters completely transformed into standard, running, and cursive styles, without a return to the ancient ideas of clerical script.

A return to the true ideas of the ancients was the hope of all philologists, and understanding clerical scripts from carved and cast monuments was a primary means of accomplishing that. This chain of reasoning led to one of the most

conspicuous manifestations of the epigraphic aesthetic in Ruan's generation—the revival of clerical-script styles (see fig. 3). Clerical script was associated with the unification of China under Confucian rule in the Han dynasty. It was lauded for the psychologically charged visual characteristics of being "square and true, vigorous and strong," with "character structures that are base and awkward, and brush methods that are energetic, upright, vigorous, and strong." And it offered a more direct path of transmission from the past to the present than other celebrated styles, because its material supports were less compromised.

In "Northern Steles and Southern Letters," Ruan was explicit about the rejuvenation of these old styles in his generation, writing, "the lost methods of the ancients still exist, and can be found in a return to clerical script." For Ruan, the humbler the model of clerical script, the better. Taking aim again at the southern tradition and the dominance of Wang Xizhi's style, he wrote, "Bricks from the tombs of Eastern Jin commoners were produced by the hands of potter-artisans. The traces of characters on them are relatively close to clerical and seal script, and are quite different than [Wang Xizhi's] *Preface to the Orchid Pavilion Gathering*, a fact that is unalterable, even by those who promote the stylishness [of the Wang style]."

Prizing Han-dynasty clerical-script calligraphy found on steles from the deep past and often made by unknown artisans allowed evidential research scholars and epigraphy aficionados to divorce calligraphy from the overdetermined biographical interests and the overused characterological exemplars that all but defined the art form at that point. Separating the appreciation of calligraphy from the appreciation of the biography of the person who brushed it, they neutralized calligraphic forms to convey their own values. Those values—"coarse and simple" or "antique and awkward," for example—were identified in anonymous sources like carved stele, objects that gained authority through the material signs of age rather than through association with the names of celebrated calligraphers. The cleaving of calligraphic ideas from the bodies of specific calligraphers by means of material logic was a direct challenge to both the names that made up the calligraphic canons, like Wang Xizhi, and to the primary modes of viewing their work.

As Ruan drew his first essay to a close, he reinforced the methodological point at the center of his argument—hard material objects were the means by which the study of calligraphy and the truth of the classical past could be revitalized: "Only through [consideration of] stone and metal [sources] alongside the official histories can one gain a view of the separation and unity of these two schools. . . . The scholar with the clever gaze is able to shake off the vulgar and the popular to see the essence of the northern school and defend that which Ou and Chu once saw, searching through the ancient works of the Northern Wei and the Qi dynasties so that the many ancient methods of the Han and the Former Wei dynasties are not obscured by vulgar calligraphy. Wouldn't this be excellent?"

And this excellent work is exactly what Ruan saw happening among his peers in the early nineteenth century, when a transition to northern school styles of clerical script, grounded in concrete experiences of specific objects, was occurring in calligraphy.

In Ruan Yuan's generation, epigraphy research was a primary means of social and political networking. A visual language that suited that network, an epigraphic aesthetic, evolved from the abundance of epigraphic materials in circulation. As Ruan's own calligraphy in clerical script shows, it became popular to practice the antique styles of calligraphy found on these objects. Newly carved objects put archaic styles to use as well, drawing from the authority of the past to cement the relationships of the present. Using the epigraphic aesthetic, calligraphers of the late eighteenth and early nineteenth centuries forged a new stylistic genealogy that bypassed the trite and ostentatious southern styles.

As the following chapter will show, references to northern school styles of clerical script extended beyond character orthography to include the material features of the ancient bronzes and stones into which these words were cast and cut. Early nineteenth-century brushwork in ink on paper or silk began to emulate the material degradation of ancient stone and bronze surfaces, features gleaned directly from rubbings. The importance of rubbings to the epigraphic aesthetic cannot be understated. By replicating the surface topographies of ancient objects in a way that fused the perception of their texts with that of their materiality, the technology of rubbings further directed tactile attention away from the bodily traces of canonical calligraphers, refocusing it toward the material bodies of objects. The term "awkward" (*zhuo*), often used by Ruan Yuan in his essays, would become a chief aesthetic ideal of this generation. It encompassed the ideals of authenticity of self as well as material authenticity sought by early nineteenth-century scholars looking to the deep past for the means to stabilize the uncertain present.

Obliterated Texts

After Ruan Yuan left Shandong in 1795, his friends there continued to produce epigraphy scholarship, just as they had before his arrival and even though the grand project of the *Epigraphy Gazetteer for Shandong Province* was complete. One such later project, Huang Yi's *Engraved Texts of the Lesser Penglai Pavilion* (1800), stands out from the others due to the strange quality of its illustrations, which leave much to the imagination. In each woodblock-printed image, columns of ghostly forms drift in and out of legibility (fig. 9). While sometimes dozens of words march on in lines of entirely sensible classical prose, at other times amoeba-like blobs are all that exist, explicitly marking the absence of meaning. Occasionally, the boundaries of two characters are captured in the act of merging, stretching across the implied divisions of proper word spacing to create conjoined mutations of language. The shapes illustrated in *Engraved Texts* beg the question of what exactly a viewer is supposed to see in these images.

The ten sets of images around which this five-volume book was built are palimpsests. They compressed the traces of several forms of reproduction into single outline images. To view any of the pictures in the book is to understand that, while one is looking at a woodblock print dated to 1800, one is simultaneously seeing a visual record of several older objects and surfaces. There were the rubbings that the prints reproduced, images made by direct contact of paper to an inscribed stone surface and then tapped with an ink pad to produce a picture of the inscription in negative (fig. 10). Those rubbings were in turn images of the surfaces of ancient inscribed steles, stone monuments that bore the texts of official edicts or encomia for notable individuals (fig. 11). In the case of the rubbings Huang Yi reproduced, all of the original monuments had been erected during the Han–Wei periods (ca. second century BCE–third century CE). Finally, there was also the calligraphy of the anonymous scribes that predated each stone

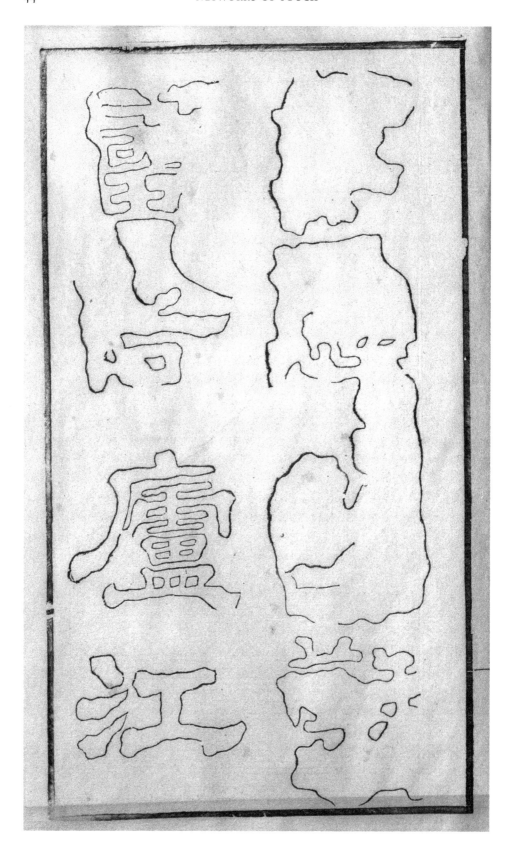

Fig. 9 (*opposite*) Reproductions of the *Fan Shi Stele* rubbings from Huang Yi, *Engraved Texts of the Lesser Penglai* Pavilion, vol. 4, fig. 9b, 1800. Woodblock print on paper, h. 31 cm. The Metropolitan Museum of Art, New York, Thomas J. Watson Library.

Fig. 10 Rubbings of the *Fan Shi Stele* owned by Huang Yi, thirteenth century. Ink on paper, mounted as an album, 34 × 34 cm. Palace Museum, Beijing. Photo provided by the Palace Museum.

monument. Every step in this chain had its own material conditions, and Huang Yi's book condensed these material traces into single outline images.

Sometimes the paths traced by Huang Yi's outlines managed to begin in one place and end again in that same place, defining a continuous boundary around the calligraphic image recorded in the original rubbings. The word images presented in such cases are clear and strong, albeit characterized by undulating edges and the occasional knobby permutation. Other times, while a complete outer boundary was accomplished, no inner articulations can be found, and the tracing line simply builds an impregnable wall around the space where a word ought to be, a crater in linguistic signification indicating a gap in the material record. Most often, the copyist's stroke was interrupted in some way or another. Thin lines waver, twist, and then break off their paths entirely, splitting the boundaries of

Fig. 11 *Fan Shi Stele*, 235. Carved stone, 96 × 67.2 cm. Small Stele Hall, Jining Municipal Museum, Shandong Province, China. Photograph by the author.

the words open so that inner form and outer ground bleed into one another in an undifferentiated void. Each discontinuity acknowledges an uncertainty in the process of understanding the original rubbings. Does this change in ink represent the edge of a brushmark carved in the stone, the elevated surface of the uninscribed stele stone, or someplace in between? The tracing line breaks when no clear answer presents itself.

A close analysis of these prints, and of the motivations of the scholar who produced them, reveals how the reproductions of *Engraved Texts* achieved a visual equivalent to Ruan Yuan's liberation of brushwork genealogies (see chapter 1). The hollow forms created by Huang's outline technique emptied the inscriptions of any simulacrum of calligraphic brushwork, dissociating them from the possibility of being read in the terms of classical calligraphy. In classical brushwork theory, marks were read as indexical to a calligrapher's bodily gestures and thoughts. But Huang's images were indexical to sets of rubbings and by extension to sets of original stones. They therefore replaced a relationship to bodily gesture with an attention to the signs of material degradation, evacuating the old canon of calligraphic brushwork to create a new kind of brushwork, one based in the authority of a direct and tactile contact with concrete materials.

Huang Yi's Epigraphy Scholarship

Engraved Texts of the Lesser Penglai Pavilion was the culminating publication of Huang Yi's career, and the roots of its production lay in a life story that was typical of many literati in the late eighteenth and early nineteenth centuries. Due to the increasingly narrow possibilities for men of a certain education and status, Huang and his peers often achieved renown not through important imperial service but through cultural contributions that were dependent on the interest and support of a network of other well-positioned scholars like Ruan Yuan and Weng Fanggang.

Huang Yi was born in the Qiantang district of the wealthy city of Hangzhou at the height of Qing-dynasty prosperity. His father, Huang Shugu (1710–1751), was well connected among the city's cultural elite and counted among his friends the most renowned painter-calligrapher of the period, Jin Nong (1687–1764), as well as the era's most prominent seal carver, Ding Jing, with whom Huang Yi trained as a young man.[1] From an early age, Huang Yi was drawn into a network of scholars and officials who were passionate about epigraphy scholarship, the study of ancient objects and the scripts cast or cut into them. Though his father died when Huang Yi was just eight, those family connections were maintained, and by his mid-twenties, he was already beginning to gain a reputation as a gifted scholar in the field of epigraphy studies and its related art form, seal carving. In this period, he carved personal seals for preeminent painters such as Luo Ping (1733–1799) and Xi Gang (1746–1803).[2]

No records indicate that Huang Yi ever sat for the examinations that would have made him eligible for government service. Instead, as with many scholars of this generation, he made his way in the world by serving variously as an aide to government officials and as a tutor, work that brought him in his early years to Hunan and Hebei Provinces. It was not until 1776, at the age of thirty-three, that he gained a governmental title through the sponsorship of Zheng Zhijin (fl. late eighteenth century), for whom he had been serving as an aide. Thereafter, he continued on a career path that brought him to Jining, in Shandong Province, where he held various positions related to stewardship of the Grand Canal until his death in 1802, at the age of fifty-nine.[3] From his position in Jining, Huang Yi kept up correspondences with the informal network of epigraphy scholars that spanned the empire in the mid- to late Qing dynasty, including Qian Daxin (1722–1804), Weng Fanggang, Gui Fu, and Ruan Yuan.

As Huang Yi traveled through Shandong Province in the late eighteenth century, he may have occasionally looked up to see the mountains or the open skies of the landscape around him. But more often than not, the dirt, the rivers, and the rocks drew his attention. He trained his eyes to the sides of the road, for both work and pleasure. His job as the local magistrate responsible for waterways meant he was obligated to inspect the transportation and regulatory infrastructure of Shandong's major rivers and lakes. But he searched the ground hardest for the things he valued more than bridges or dikes—fractured monuments with broken words. The more broken the words, the stranger they appeared, the better. Illegibility and stylistic irregularity meant authenticity to Huang. In one characteristic, he saw the record of time's effect on stone; how water, wind, and wear had pulverized the carved forms of the characters. In the other trait, he saw a calligraphic style unaffected by artifice and free of obligation to canonical lineages.

Roadside discoveries of ancient monuments were regular events in Huang Yi's life. His most passionate hobby was to go on scouting missions through the local landscapes of Shandong and nearby Hebei to find these carved fragments from the past. He memorialized these trips in several sets of painted and inscribed albums that helped make his name among his peers as well as among later art historians.[4] In his inscription to an album leaf in one of these albums, "Finding a Stele at Mount Liangcheng" (fig. 12), Huang Yi described one instance of this familiar event in his life:

Carved Han dynasty images are often found among the various Buddhist temples of Liangcheng Mountain in Jining. But sadly, not a single [inscribed] character [has been discovered]. I've suspected this area must have old [inscribed] steles though, and in the fourth month of 1792, while returning from an inspection of the embankments of Sishui county I spotted three characters carved in stone along the roadside: "Zhu," "Jun,"

Fig. 12 Huang Yi, "Finding a Stele at Liangcheng Mountain," from *Finding Steles*, late eighteenth century. Album leaf from a twelve-leaf album, ink on paper, 17.5 × 51 cm. Tianjin Museum. Image provided by Tianjin Museum.

and "Zhang." The clerical-script style was antique and awkward, [and so] I had no doubt it must be a ruin from the Han dynasty. I had the fragment relocated to the prefectural academy to preserve it, and attendant censor Jiang Qiushi believes they must have been written in the early period of the Eastern Han dynasty.[5]

The structure of the modest landscape image Huang painted to accompany this record makes his focus clear. He barely depicts mountains and sky. The patterns of the ground, the stippled grasses and hexagonal boulders, only set a background of simple textures. A captivating landscape image was irrelevant to the story being told. Texture and composition were a backdrop against which the rarer shapes of the Han-dynasty stones could be identified as unique. A medium-toned, wet, gray brushwork defines forms throughout the image. But it is varied in a few spots, where a darker second outline highlights areas of narrative focus, as in the scene of discovery tucked behind a small hillock at the center of the scene, where two scholars stand over three rectangular stones.

Huang Yi's inscription directs our attention to the stones as well, telling us something his painting does not. It emphasizes the factors that mark this stone and its inscription as distinct from others. The "antique and awkward" qualities of its clerical script meant for Huang there was no doubt this stone was an authentic "ruin from the Han dynasty." Huang used the same language to describe clerical script from the Han as Ruan Yuan did when he wrote about his theories on calligraphy. Likewise, the formal qualities of the stone inscriptions that were important indicators for Huang included their state of ruination and their lack of the overt display of brushwork skill associated with established canonical calligraphers.

Huang Yi's friend, the prominent official Weng Fanggang, who served as his unflagging collaborator in all things epigraphic, pushed this attention even

further in the opening line of the poem he added after Huang's inscription: "Chancing upon worm-eaten rocks, he follows their pathways, like those traders from the northwest. Whose *bafen* style script of the Han do we copy in these words, 'Zhu,' 'Jun,' and 'Zhang'?"[6]

Weng's metaphor evokes Huang Yi's passion for ancient texts through the adjective "worm-eaten," conjuring up the image of a bookworm, an insect driven by ignorant hunger to consume text and paper without discernment, leaving pathways of destructive desire that cut through the logic of words to make them illegible. Like Huang, Weng celebrated both the material accidents of history that lead to the text's illegibility and the anonymity of early inscriptions.

Weng follows this metaphor with a rhetorical question: Who wrote the words on these stones? He knows there is no answer, and like Huang, he celebrates that fact. Anonymity of early texts helped early nineteenth-century scholars break old genealogies of brushwork in order to form new ones (see chapter 1). Attention to the illegibility of these texts contributed to this same end. Through the struggle to interpret illegible words, scholars opened texts to new interpretations and shifted authority to the material conditions of the object as the site of knowledge.

These values—a questioning of overly demonstrative brushwork styles associated with canonical calligraphers and the celebration of material ruination in ancient inscribed texts—were fundamental to early nineteenth-century epigraphic research and its contingent material cultures. While such concerns appear from time to time in Huang's paintings, they reached their fullest visual manifestation in the book project he was developing at this time, *Engraved Texts of the Lesser Penglai Pavilion.*

Engraved Texts of the Lesser Penglai Pavilion

Printed in its complete form in 1800, Huang's book was impressive for its effort to duplicate, in true-to-life scale, ten choice selections from his private collection of ancient rubbings.[7] The reproduced rubbings dated from between the Tang dynasty (618–907), when Huang's album of the *Wu Family Shrine Images* was made, and the early Qing dynasty, when his rubbings of the *San Gong Mountain Stele* were made.[8] Each of the ten sets of rubbings was reproduced in the same format. First came a set of outline images, tracing the boundaries of the words recorded in each of Huang Yi's albums. Then an effort was made to transcribe the original words into coherent texts, although the incomplete nature of the original source materials resulted mostly in accumulations of sentence fragments. After the transcriptions, selected commentaries by the scholars within Huang's epigraphic exchange network were also included.

The original rubbings of Huang Yi's collection were mostly cut and remounted as albums (see fig. 10). At the margins and in the pages following each album,

important scholars and friends left colophons, sometimes simply to attest to having seen the rubbings, other times offering more complete assessments of a rubbing's importance or debating the readings of certain words, the archaic forms of which were no longer in contemporary use. Just as Huang's book was designed to provide more readers access to these singular traces of the past, his choice to reproduce many of the marginal notes from the original albums gave readers access to the debates of preeminent epigraphy scholars of the period. For many readers, seeing the reproductions in *Engraved Texts* was as close as they could come to either viewing the original rubbings or being in the company of the renowned scholars who debated the authenticity and the meanings of the texts in their inscriptions. Huang's book was as much an account of the interactions within his social network as it was a record of one of the best collections of early rubbings of important monuments.

Huang Yi's fellow scholars praised him for his efforts to grant wider access to rubbings that were otherwise limited in circulation. Qian Daxin's preface for *Engraved Texts* begins by establishing Huang's position within the field of epigraphy studies at the time: "Comparing all of those throughout the country who research the essences of characters in stone and metal, there are about twenty or so who are truly addicted to it and who can actually authenticate their essences; foremost among them is Gentleman Huang Qiu'an of Qiantang."

Qian Daxin's preface goes on to list the wondrous rubbings reproduced and discussed in the book:

> In [Huang Yi's] collection there are: a Song-dynasty copy of the fractured characters of the *Stone Classics*, the *Chengyang Lingtai*, [rubbings of] the *Stele of Yuan Pi* of the Northern Wei dynasty, . . . and of the *Fan Shi* [*Stele*], each carved in outline method, engraved in wood. To allow Confucian scholars of today to be able to see the rare traces of Cai Yong seventeen hundred years later is truly a joyful thing for the art world. What's more, these are pieces that exist nowhere else. Like rare bronzes from the past; the older they are, the more precious.[9]

As Qian concludes, he likens the value of Huang Yi's original rubbings to the other major source of epigraphic inscriptions, rare bronzes. He also calls specific attention to Huang's mode of reproduction, the technique for copying called "double-hook method" (*shuanggou fa*), generally translated as "outline method." While Huang's book shared many similarities with previously published collections of epigraphic materials, his choice of outline method technique was curious and notable. It distinguished *Engraved Texts* visually from other illustrated books concerning epigraphy and drew attention from several commentators.

Huang Yi's friend Weng Fanggang, who wrote many commentaries for the individual entries of Huang's book, also penned a short title page inscription in

clerical script that included a direct reference to outline method. It stated simply, "Huang Yi of Qiantang has collected these early transmissions of epigraphic materials in *Engraved Texts*, carving them in outline method so that other gentlemen might similarly find affinity with them."[10]

Even contemporaneous scholars writing beyond the scope of Huang Yi's book highlighted his use of outline method. When Wang Chang included an entry on Huang Yi in his *Biographies of Poets across These Lakes and Oceans*, he noted: "[While] serving in Jining [Huang Yi] sought out and excavated Han-dynasty steles all around Jiaxiang, Jinxiang, and Yutai, including many of the carved *Wu Family Ancestral Shrine* images. In outline method he produced for the world what he had seen of the Han-dynasty *Stone Classics* and the *Fan Shi* and *San Gong Mountain* steles. Although he was not a distinguished official, he did gain great status because of his *Engraved Texts of the Lesser Penglai Pavilion*."[11]

Qian, Weng, and Wang all made room in the midst of their encomia to mention the technique used for these reproductions, outline method. While outline method was used to copy famous examples of calligraphy as far back as the Tang dynasty, Huang's innovation was to reproduce the technique in woodblock print format, designed to produce distinctive images to suit the needs of contemporary scholars of similar "affinity."

Outline method was lauded for its descriptive accuracy above all. An early description of *the* copying method was recorded by Jiang Kui (1155–1221) in his *Record of Extended Commentary on Calligraphy* (1208). Jiang's description demonstrates that outline method's priorities revolved around attention to materiality and to setting a properly ambivalent boundary line that existed in correct balance between the inner figure of the word and the outer ground against which it was set:

> In writing characters, the most important thing to consider is extending beyond the demeanor [of the original], and in carved calligraphy in metal and stone it is easy to neglect this. In making a outline copy (*shuanggou*) one must capture the ink halo [of the original] without going outside the [form of the] word. Whether one fills within the outline of the character (*kuotian*) or uses vermilion to back the word, one must maintain the true fat and lean of the original body of the word, although thinner is better, [because] when it comes to the stage when the workers carve it, when they smooth out and arrange the tracing copy, the thin places will become a little thicker.[12]

Jiang Kui described the use of outline method to transfer a piece of written calligraphy onto a carved stele, encouraging particular attention to the physical properties of each material, from the absorption of the copyist's ink into the paper to the expansion of the paper when it was drawn taut to prepare it for

carving. If the copyist's brushline was clumsy and the paper too absorbent, the inked boundary line might bleed outward, expanding the "halo" of the original and warping the form of the character in inaccurate ways. Setting an outline was thus a matter of creating a mark that properly negotiated the boundary between the inside and the outside of the original forms without "extending beyond the demeanor" of the original word. A good outline took into account proper material understanding to avoid imposing distortions. It was a line that did its best work when it was barely noticeable.

The outlined reproductions in Huang Yi's *Engraved Texts* differed from the directives of Jiang's description in one crucial way, however. Normally, outline method was only the first step of a two-part process. Once outlines were traced of the image to be copied, they were conventionally filled in with ink (*tianmo* or *kuotian*). The final product thus simulated an original piece of calligraphy; characters appeared to be composed of intersecting brushstrokes in black against a plain ground, though in fact they were painstakingly traced and in-painted.[13] When Huang Yi reproduced his collection of early rubbings in woodblock prints, he used only the first step, outline method. The resulting figures therefore did not resemble fully brushed characters, only the ghostly craters where such words once existed. Thin, discontinuous lines exactly traced the ruined shapes recorded in the rubbings and, by extension, the original worn topography of the stones. Some words came through this process shaken but legible, whereas other words quivered, zigzagged, and ultimately broke into strange, open fragments, disintegrating the difference between figure and ground to produce perfectly accurate nonsense. This process conveyed precise readings of the degradation of material surfaces and only incidentally captured the language of the inscribed text, the ostensible focus of antiquarians.[14]

Prior to the publication of Huang Yi's book, rubbings reproduced in woodblock print simulated real rubbings by unifying the continuous black ground against which the white figures of language stood (fig. 13).[15] Alternatively, some reproductions presented black figures on a white ground, carrying out the full technique of outline and in-fill to create a simulacrum of normal calligraphy (fig. 14). Both of those methods increased the legibility of the rubbing texts. The outlines of Huang Yi's images, left at the first stage of outline, were instead conceived as a set of marks that delineated the boundaries of the space in a material where primary calligraphic brushmarks had once been reinscribed. Although the difference between a facsimile of calligraphy that only presents brushstrokes as outline figures and one that presents full simulacra of brushstrokes may seem to be inconsequential, the two modes represent contrasting conceptual approaches to viewing calligraphy—as brushwork or as image.

In classical calligraphic brushwork theory, viewing was not just a question of appreciating formal technique. From its earliest phases in the Six Dynasties period, calligraphic theory also revolved around the ways that brushmarks could

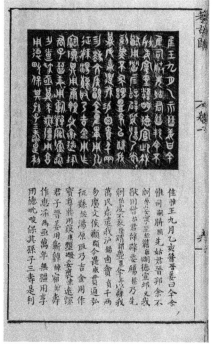

Fig. 13　Reproductions of rubbings from the Jinjiang tripod published in Lü Dalin (ca. 1047–1093), *Illustrated Investigations of Antiquity*, 1092. Woodblock print on paper, 24.1 × 15 cm. From Huang Sheng, *Yizhengtang chongxiu kaogutu* (1752), vol. 1, fig. 6b. Getty Research Institute.

Fig. 14　Reproductions of a stele inscription dated 1239, as published in Weng Fanggang, *Yuedong jinshi lue*, 1771 (1889 ed.), supplementary vol. 1, fig. 7a. Woodblock print on paper, 13.3 × 10 cm. The University Library, University of Illinois at Urbana-Champaign.

transmit the traces of the calligrapher's physical and mental states. Following the gesture, stroke, and direction of calligraphic brushwork was a matter of reconstructing the actions and decisions of each mark as it came together with others to form words and ideas. Reading a text brushed by hand was therefore also a process of reembodying the mental and spiritual state of mind of the person who gave form to those words. Ultimately, calligraphy was a criterion for judging a person's character.[16]

But Huang's outlines carried no such psychological obligations. As a method of mark making designed to describe the boundaries of calligraphic figures, the lines of outline method lacked the characterological depth generally granted to the brushwork of calligraphy. One sign of this was the absence of the word brushmark (*bi*) from Jiang's description of outline method. A copyist using this method was not creating ideal brushwork. Instead, their set of marks traced the boundaries where ideal brushwork had once been inscribed in a material support. These outlines were technical tools, not calligraphy. Their job was to objectify the brushmarks of calligraphy and flatten them into bounded but vacant images.

Huang Yi never justified his choice of this technique to his readers or his deci-
sion to leave the fragile outlined boundaries unfilled.[17] He made use of a common
classical technique that supported his evidential research values of unbiased
presentation and precise material description (see chapter 1). But in the process,
Engraved Texts also focused the attention of a generation on the boundary line
between figure and ground. Scholars such as Weng Fanggang, Qian Daxin, and
Wang Chang were explicit about mentioning Huang Yi's use of outline method
because it had not been used outside of direct copying or transferring before that
time.[18] Yet during the nineteenth century, after the publication of *Engraved Texts*,
it became a common way of describing rubbings (and also seals) in woodblock
form, one that directed viewers to a new way of looking at calligraphy, reduc-
ing brushwork to empty figures by means of a technical draftsman's line.[19] To
understand the choice of this reproductive strategy and its relationship to the
priorities of epigraphic studies, a close reading of one example from *Engraved
Texts* will be useful.

The *Fan Shi Stele*

The reproductions of the *Fan Shi Stele* rubbings (see fig. 9) were the seventh set
of images reproduced in *Engraved Texts* and the only set made from a Wei-dy-
nasty (220–65) stone. The original stele was erected in 235 as a formal public
document and monument, a declaration of the character and service of a promi-
nent statesman, as announced on the head of the stone: "Stele of Commandery
Governor Fan of Lujiang" (see fig. 11).[20] In this original format, the large stone
would have loomed over its audiences, and in its day, the writing cut into the
stele would have been understood less as an opportunity for calligraphic appreci-
ation than as a visualization of the authority of Han-dynasty Confucian values.[21]

The original *Fan Shi Stele* was lost soon after the end of the Song dynasty,
so for centuries it was known to scholars only through later rubbings and early
transcriptions of its text. Rubbings were the primary means of reproducing and
circulating the texts of ancient monuments when scholars could not see orig-
inal monuments in person, and these rubbings became prized objects in their
own right. Rubbings were made by affixing wetted paper to the surfaces of stone
monuments with carved inscriptions. Once the paper was spread and contoured as
closely as possible to the topography of the stone, a flat ink pad was tapped along
the paper. Depressed areas stayed white, and raised surfaces were made black,
providing an image of the original carved text in negative. This method repro-
duced the experience of facing an object through the facsimile of its actual surface,
unlike other printing technologies, which involved reversals or mirrorings.

Rubbings were used as a means of reproducing the texts and carvings of steles
as early as the Northern and Southern dynasties (420–589).[22] But their produc-
tion drastically increased in the Song dynasty with the rise of antiquarianism

in scholarly communities and at court. Objects with prime examples of Han-dynasty clerical-script calligraphy were among the most popular to reproduce in rubbing format, and the clerical style experienced a revival among literati at this time.[23]

Rubbings operated on the same logic as relics: having touched the original object, they linked their viewers to things, people, and events from the past. They were understood to convey the information of the original stone surface to the viewer with nearly exact accuracy, transferring the true dimensions of its shallow carvings, as well as all spaces in between, into a flattened and portable format. As such, it was important that they convey a sense of the carved stone's material nature. Efforts were made to record each rocky detail of the surface in subtle grading of ink tones, including natural textures, accumulated pockmarks, chipped edges, and every minor site of damage. These sites of damage became landmarks that helped differentiate and date various new rubbings taken as the stones aged and accumulated even more damage. Marking and recording the nonlinguistic elements of the stele was therefore part of the importance of the rubbing, as it was these elements that gave the rubbing material authenticity.[24]

Early rubbings could often be more valuable to scholars than the original monuments because they frequently recorded sections of the stone inscriptions that had deteriorated over time to the point of illegibility.[25] In some cases, as when the locations of original monuments were lost to memory or when the stones were destroyed by natural or manmade causes, rubbings were the only record of important inscriptions.

Huang Yi originally acquired his set of *Fan Shi Stele* rubbings (see fig. 10), estimated to be from the thirteenth century, from the old collection of the famous bibliophile Zhao Guolin (1673–1750). For years, it stood as an authoritative trace of the original stele. Then, in 1778, Cui Rushi (fl. late eighteenth–early nineteenth centuries) found a broken piece of inscribed stone along a waterway embankment in the Longmen neighborhood of Jining, to the southwest of the Jining prefectural school, and identified it as the top portion of the *Fan Shi Stele*.[26] A decade later, in the late spring of 1789, a local Jining epigraphy aficionado, Li Dongqi, rediscovered the original bottom section of the *Fan Shi Stele* at the base of a wall while making rubbings near a memorial archway to the west of the Jining prefectural school.[27]

Those fragments were then reunited and compared with the thirteenth-century rubbing. By Huang Yi's calculation, some 180 characters were recorded in the rubbing that were no longer a part of the original stones. The rubbing and the recovered fragments therefore held competing means of authority over the text and its linguistic forms. New rubbings were made from the excavated stones and spread widely (fig. 15). But demand also existed for the earlier, more complete description of the stele as seen in Huang Yi's rubbings, hence their reproduction in his *Engraved Texts*.

Fig. 15 Rubbing of the *Fan Shi Stele*, after 1787. Ink on paper, 100 × 66 cm. Courtesy of Special Collections, Fine Arts Library, Harvard University. Shown here in approximate relation to the original stone stele.

Fig. 16 Transcription of the text of the *Fan Shi Stele* rubbings, as published in Huang, *Engraved Texts*, vol. 4, fig. 1a, 1800. Woodblock print on paper, h. 31 cm. The Metropolitan Museum of Art, New York, Thomas J. Watson Library.

The rubbings of the *Fan Shi Stele* as accounted for in *Engraved Texts* consisted of forty-two pages of images divided into three sections: one for the top portion that bore the stele title, one for the body of the text, and one for the smaller characters inscribed on the reverse side of the stele. These images were followed by a partial transcription of the text, with legible words written in their modern print equivalents, square markers to denote completely illegible characters, and the word lacking (*que*) inserted for larger sections of missing text where breaks and gaps in the stone occurred (fig. 16).

Efforts were made throughout *Engraved Texts* to record sites of damage with the same exactness as undamaged areas. The majority of the words in the other nine sections were relatively legible, reproduced in black outline figures against a white ground. Occasionally, the end of a stroke might be entirely truncated. Here and there, outlines around words might be broken or two outer lines would refuse to meet to complete the head of a brushstroke. But in the images of the *Fan Shi Stele* in particular, the outline figures disintegrated so severely that they became illegible. Sometimes a blasted-out crater stood in the place where a word once was. Other times, words were dismembered, only able to hint at their prior meaning with the vague gesture of a broken radical abutting the stump of something that was no longer language. In several cases, the sloughing outline of one figure joined together with the distorted shape of the subsequent figure, creating a meaningless conjunction of empty words (see fig. 9).

The line of these outline images is tentative and exploratory. It imagines the contours of the original stone carvings by navigating the topographical variations in ink recorded in the original rubbings, following those ink impressions wherever they go, even into linguistic madness. As viewers, we can no longer see these images as calligraphic. There are no brushstrokes to trace. Instead, we follow the probing path of the outline along the recorded surfaces of the rubbings, guided by the same question as the copyist: Is this edge the ruined remainder of a carved brushstroke boundary or just the broken surface of aged stone?

The openness of these forms provided opportunities for scholars to debate the meanings of the square markers left in the transcription. As such, printed versions of ten colophons by prominent literati followed the *Fan Shi Stele* transcription, taking up the task of debate and interpretation. Those scholars included Lu Wenchao (1717–1796), Weng Fanggang, Zhang Xun (fl. late eighteenth century), Zheng Jitang (fl. late eighteenth century), Bi Yuan, Yan Zhangming (1731–1789), and Huang Yi himself.[28] Their colophons offered opinions on difficult passages, interpreted what was legible, and filled in what was not with educated arguments supported by multiple citations of historical minutiae.

Sometimes colophon writers directly corrected one another. Zhang Xun used the last portion of his colophon to correct what he saw as a misreading of the *Fan Shi Stele* text as it was recorded in Hong Gua's 1167 *Supplement on Clerical Script*. Zhang Xun wrote, "Where '探賾研機' is written on the stele, Master Hong says the word 賾 is in fact the word 賾, which it is not," a statement Zhang followed with citations from several sources to prove his point. He concluded, "In this stele, the word 賾 should be matched with its meaning in the ancient edition of the *Xi Ci Commentaries on the Book of Changes*. The word's appearance as 賾 comes from the later edition [of that book]." Then, immediately following Zhang Xun's colophon, Weng Fanggang added a corrective to Zhang's judgment, writing:

> [Zhang's] colophon here says that the word is 賾, not 賾. This is reasonable. However, his interpretation of the meaning as 至, to arrive, is not correct. The word 賾 from the *Xi Ci Commentaries on the Book of Changes* is written as 冊 in the *Jiujia* edition of that book and as 賾 in the *Jing* edition, wherein its meaning is interpreted as "feeling." [The Han-dynasty scholar] Yu Fan interpreted 賾 to mean "beginning." . . . Both of these explanations match with the meaning of the word that precedes 賾 here, which is 探. Thus one should not refer to the *Shuowen jiezi* [to understand the meaning of this word].

The colophon writers of *Engraved Texts* formed involved arguments and counterarguments by mustering citation after citation of early classical texts and other epigraphic materials, all to justify their own interpretations of individual

words found in Huang Yi's rubbing of the *Fan Shi Stele*. This same attention to detail was also applied to the material history of the rubbings themselves. After writing his rebuttal of Zhang Xun's colophon, Weng Fanggang added another colophon to explain his dating of the rubbings to the Song dynasty: "At the beginning of this album of mounted rubbings is the seal, 都省書畫之印. This seal was used for authenticating and collecting by the Yuan-dynasty court, and so these rubbings are doubtless from the Song dynasty. Additionally, the areas of broken or missing sections for individual words are fewer than what is recorded in Hong Gua's book." With this last piece of evidence, Weng implied that Huang Yi's rubbings were even more complete than the ones Hong Gua (1117–1184) was using in 1167, making it the most comprehensive version of the *Fan Shi Stele* text in existence.

Other colophons recounted the rediscovery of the original stele and the provenance of the rubbings. For instance, Weng Fanggang's first colophon began with the story of his friend Gui Fu sharing information about the rubbings: "In the summer of this year, Gui Fu from Qufu wrote to tell me that he had seen a trimmed and mounted copy of the *Minister Fan [Shi] Stele* in the collection of Master Guo of Licheng with three hundred and thirty legible words. Formally, the calligraphy fell somewhere between the *Heng Fang Stele* and the *Han Ren Stele*, but it was not like Cai [Yong's] calligraphic style, as Li Sizhen had said it was."

Weng went on to describe in great detail the debate over the author of the stele and its relation to the calligraphic legacy of Cai Yong (132–192), the calligrapher of the *Stone Classics* who many mistakenly thought had also brushed the words of the *Fan Shi Stele*. Weng argued against the impulse to attribute the calligraphy to any specific author, saying that the stele dates were too late for Cai Yong to have been the calligrapher and that the style differed too much from the *Stone Classics* for them to be by the same author, despite what previous scholars had thought.

By including all of these colophons, *Engraved Texts* offered its readers a variety of viewpoints rather than providing one author's singular perspective on the *Fan Shi Stele*. Together, the colophons that Huang Yi reprinted conveyed important insights about historiography, linguistics, and materiality from this network of scholars for the reader to weigh and compare. They could take in all the opinions and then look at the reproductions to make their own comparisons and interpretations. Refusing to offer the reader one single authoritative understanding, Huang Yi kept to the values of evidential research, which demanded that knowledge be verified through detailed comparative, analytic, and evidence-based methods.

Likewise, by using outline method, Huang presented his rubbings with a descriptive strategy that purported to show the forms of the rubbings with as little bias as possible. No prejudgment of a word's meaning is given. Instead, his lines trace the boundary between form and ground with a generous ambivalence,

unwilling to fully commit to a strict differentiation of the two as a full rubbing or calligraphic simulation would. In the most broken of his outline figures, even the fundamental question of which side of the line presents inner form and which stands as outer ground is unclear. Rather than presenting images that increased the legibility of the texts they reproduced, the amoeba-like forms that evolved from Huang Yi's choice of isolated outline method described the material deterioration of their referents with such precision that they often left the texts in illegible states. In these moments, the destroyed cells of words sit neutralized and in full equilibrium with their environments, the proud remains of autopsied language.

Tactile Bodies

Huang Yi's choice to focus on using outline method alone to reproduce his collection of early rubbings, albeit only a slight deviation from more normative modes of reproduction, indicates an important shift in attention toward tactile thinking.[29] His prints are best understood not as descriptions of calligraphic texts but as images that explored the surfaces of material objects. They did not convey the qualities of bodily gesture that distinguished the appreciation of calligraphic brushwork because they focused instead on a moment of contact between the contours of a stone and a rubbing. Whereas in classical calligraphy theory, marks were read as indexical to a calligrapher's body and thoughts, these ghostly palimpsests were indexical to the bodies of broken stones and the skins of old rubbings. In this transfer, it was the surface signs of the stone's degradation, not the brushwork or the text itself, that granted the images authority. Through time's obliteration of stone, Huang Yi's generation hollowed out the forms of the past to refill them with a new brushwork paradigm based in tactile imagination and grounded in the material thinking at the heart of this generation's visual culture.

Existing scholarship on Huang Yi has emphasized his role in the evidential studies movement of the late eighteenth century and has highlighted his drive to search out direct experiences with original stones rather than relying on rubbings alone, as earlier epigraphy scholars did.[30] The circulation of his paintings that illustrate trips to the countryside in search of stele fragments has also been read as an indicator of the rising importance of personal and private networks of scholarship in this period.[31] By publishing authoritative and materially grounded histories of ancient language within private networks, scholars can interpret evidential research as a subversion of official circuits of knowledge and a questioning of the hegemonic forms of cultural memory that the Qing court had exerted over history and literature throughout much of the eighteenth century.[32] However, by orienting our understanding of Huang Yi's contributions to visual and material culture around his fascination with the tactile appeals of

Fig. 17 Reproductions of the *Wei Jun Stele* rubbings and the *Zhao Jun Stele* rubbings, as published in Huang, *Engraved Texts*, vol. 2: Wei Jun, fig. 2b, and Zhao Jun, fig. 5b, 1800. Woodblock print on paper, h. 31 cm. The Metropolitan Museum of Art, New York, Thomas J. Watson Library.

destroyed stone surfaces, the affective dimensions of his work in all of these areas rises to the fore.[33] Dissolution of boundaries and conspicuous absences of meaning highlighted history's fragmentary nature. Within these physical gaps in the record, the loss of textual knowledge could be embodied and negotiated as sensory knowledge.[34] Compressing multiple material forms into thin outlines, the images of Huang's *Engraved Texts* encouraged the reader to touch the surfaces of the past and to trace with a finger the porous edge that exists between carved meaning and raw material, between history and its absence.

When contextualized alongside Ruan Yuan's celebration of clerical-script calligraphy found on steles from the deep past and made by unknown calligraphers or carvers, the open forms of the *Engraved Texts* images become part of a larger impulse among this generation of calligraphers—the evacuation of overdetermined hagiographies from calligraphic practice. The question that the images of Huang Yi's *Engraved Texts* seem to be grappling with is how to claim the authority of the past without being burdened by it—how to stage a "death

Fig. 18 Xi Gang, detail from *Couplet in Clerical Script*, 1794. Pair of hanging scrolls, ink on paper, each 124.3 × 24.3 cm. Freer Gallery of Art, Smithsonian Institution, Washington, DC: Gift of Robert Hatfield Ellsworth in honor of the 75th Anniversary of the Freer Gallery of Art, F1997.44.1-2.

Fig. 19 Zhao Zhiqian, detail from *Couplet in Standard Script*, mid- to late nineteenth century. Pair of hanging scrolls, ink on paper, each 131.5 × 32.8 cm. Freer Gallery of Art, Smithsonian Institution, Washington, DC: Gift of Robert Hatfield Ellsworth in honor of the 75th Anniversary of the Freer Gallery of Art, F1997.61.1-2.

Fig. 20 Wu Xizai, detail from *Couplet in Clerical Script*, 1850s. Pair of hanging scrolls, ink on paper, each 177.2 × 39.5 cm. Freer Gallery of Art, Smithsonian Institution, Washington, DC: Gift of Robert Hatfield Ellsworth in honor of the 75th Anniversary of the Freer Gallery of Art, F1997.57.1-2.

of the author," so to speak. Serendipitous moments in the reproductions highlight this effect, as when all that can be read on one rubbing page is a singular enigmatic word. On one page "death / the passing of time" (*shi*)—stands alone, run through with breaks in the continuity of its long strokes, as if embodying all the concerns of epigraphy scholarship. On another page, "and/furthermore" (*er*) lies in the middle of a page, its first two strokes obliterated and with no characters preceding or following it, leaving the equivalent of an ellipsis, an open form standing in for the eternal omission of context or meaning (fig. 17).

The reuse of clerical-script styles may have been the clearest signs that Huang, Ruan, and their peers were harnessing the rising epigraphic aesthetic to personal effect in their calligraphy. But subtler material signs also manifested in ways that echoed Huang's tactile attention to the materiality of the rubbings

and, by extension, the degraded stone surfaces from which they came. This occurred particularly at the edges of brushmarks. Through a manipulation of ink viscosity, paper-surface sizing, and slow brush movements, nineteenth-century calligraphers allowed ink to bleed beyond the boundaries of the brushstroke (figs. 18, 19, and 20). The rippled halos and jagged edges these techniques created around brushmarks broke down boundaries between figure and ground in a visual language that paid homage to the disintegrated stone surfaces from which they came. Such stylistic touches depended on the same material interest in the deterioration of ancient stones that motivated Huang Yi to use outline images in his *Engraved Texts* and may well have been directly adapted from his prints. Within the development of epigraphically inspired calligraphy over the nineteenth century, the broken edges of Huang's emptied forms offered calligraphers signs of material authority that could be reinhabited with new brushwork.

As the next chapter will demonstrate, these changes in brushwork were not just limited to calligraphy but extended to painting, the other major brushwork-based tradition in China. An epigraphic aesthetic was building across the arts over the eighteenth century and into the nineteenth century. Taking advantage of the existing brushwork paradigm that linked painting and calligraphy, the epigraphic aesthetic moved easily from the "awkward" and "vigorous" styles of calligraphic brushwork celebrated by Ruan, and the tactile surfaces emphasized by Huang Yi, into the brushwork and compositions of painting.[35]

Epigraphic Painting

The epigraphic aesthetic did not stop with the transformation of calligraphy's brushwork. The brushwork of late eighteenth- and early nineteenth-century painting also took on new visual and rhetorical vocabularies that directly referenced the study of ancient stone and metal. The citation of a carved stone or bronze was sometimes explicit—a painted image of a stele or ancient tripod, for instance. Sometimes it was more material or abstract—broken lines and scumbled texturing borrowed from rubbings of decayed metal or stone to create figures or landscapes. As a questioning of the brushwork canon carried over from calligraphy into painting, fundamental ideas about the nature of images in literati art began to shift as well.

Compare two paintings, each done for Ruan Yuan in 1803 (figs. 21 and 22). Both could be described as epigraphic paintings, as both commemorated interactions with specific ancient objects. One shows Ruan's donation of a Han-dynasty bronze tripod to the Dinghui Temple at Mt. Jiao, an island in the middle of the Yangzi River, near the city of Zhenjiang. The monochromatic handscroll opens to a landscape scene that illustrates Ruan and his comrades ferrying this bronze on a small boat from the shore to the island temple. The other painting, also a handscroll, portrays Ruan in his "Jigu (Accumulated Antiquities) Studio," seated together with his friend Zhu Weibi (1771–1840) and his nephew and adopted son, Ruan Changsheng (1788–1833), as they catalog the bronzes of Ruan's personal collection. Both paintings follow the brushwork and composition conventions of their respective genres. The landscape wraps the event of Ruan's donation in a larger topography that is both geographically specific, in the sense that it shows the distinctive scenery of Mt. Jiao, and ahistorical, in that the landscape is composed of interwoven visual citations to the brushwork of past literati landscape masters from differing eras (more on this to come). The figure painting,

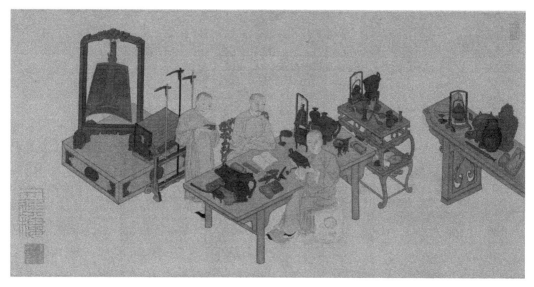

Fig. 21　Wang Xuehao, *Presenting the Tripod at Mt. Jiao*, 1803. Handscroll, ink on paper, 33.5 × 89.5 cm. The Metropolitan Museum of Art, New York. Purchase, Friends of Asian Art Gifts, 2015.

Fig. 22　Zhou Zan, *Accumulated Antiquities*, 1803. Handscroll, ink and color on paper, 67.5 × 33.8 cm. National Library of China.

by contrast, is colorful and precise, depicting the specific facial features of each man among the individually painted objects of Ruan's collection. In keeping with the portrait genre, gestural brushwork is minimized in favor of crisp outlines and smooth washes that assert very little of the artist's presence. The descriptive nature of the image takes precedence here, with both the objects and the men as the subjects of the portrait.

Aside from sharing a date and patron, another important feature unites these paintings—rubbings of bronze inscriptions were added to both images. To the landscape, one rubbing of the bronze at the center of the narrative, the

Dingtao tripod, was added by a later viewer. To the parade of ancient bells, axes, mirrors, tripods, inkstones, coins, and seals painted in Ruan's portrait, ninety-one ink impressions taken directly from the surfaces of his collection objects were appended. Ruan commissioned the portrait painting with this format in mind, adding short catalog-like entries to every rubbing. The painting depicted the visual surfaces of the bronzes in an interactive scene, while the appended rubbings allowed each specific antique inscription to be directly felt by the viewer. Each mode of depiction helped verify and enliven the other, producing a more holistic understanding of his collection in a self-verifying and portable archive.[1] However, the portrait painting of Ruan Yuan reveals that, beyond legibility and visibility, the image operated through references to tactility that were just as crucial to its effectiveness. Both Zhu Weibi and Ruan Changsheng are shown in the process of handling bronzes, lifting them to feel their heft and caress their surface patinas, an act that is redoubled in the inky touch of each rubbing cataloged after the painting.

When this tactile thinking is brought to bear on Wang Xuehao's landscape painting for Ruan Yuan, how does the immediate tangible evidence of an appended epigraphic rubbing then relate to the bodily dimensions of the brushwork genealogies that defined literati painting? After exploring some further dimensions of the epigraphic aesthetic in painting circa 1800, this chapter turns to a sustained analysis of Wang Xuehao's landscape painting to understand how the prominence of epigraphy affected tactile changes in the reception of painting among early nineteenth-century literati.

Antique and Awkward

One clear sign of the relationship between epigraphy techniques and painting methods was the explicit interest painters of the time had in the use of "double outline" technique, the same method Huang Yi used in his *Engraved Texts* reproductions. Taking the technique beyond copying calligraphy rubbings, artists such as Jin Nong prescribed its use for images of bamboo (fig. 23).[2] In Jin Nong's 1760 inscription on a bamboo painting, he claimed Wang Wei (701–761), the revered classical sage of painting, was the first to use "double outline" method in painting. Jin goes on to describe a decline in the use of outline through the Song and Yuan dynasties in favor of splashed-ink methods of bamboo painting, creating a nearly parallel argument to Ruan Yuan's claims about the northern style of brushwork in calligraphy history. Crediting himself with a revival of the technique in the Qing dynasty, Jin wrote: "In his bamboo paintings, Wang Wei of the Tang Dynasty used the double outline method. In the Yuan [dynasty, artists] only followed the Song masters. Recently, I tried to imitate the idea of Wang Wei. These [paintings of mine] can cause viewers to sigh with admiration for this gentleman [bamboo], with its hollow heart [humility] and noble sections [loyalty]."[3]

Fig. 23 (*left*) Jin Nong, *Bamboo in Shuanggou Method*, 1762. Hanging scroll, ink and color on paper, 105.4 × 54.5 cm. Sichuan Museum.

Fig. 24 (*above*) Huang Yi, detail from *Seeking Verses Among Autumn Mountains*, ca. 1800. Ink on paper, 69.4 × 25 cm. Seattle Art Museum. Gift of the Asian Art Council in memory of Ann Woods, 2008.21. Photograph: Elizabeth Mann.

Bamboo had a long tradition as a cipher for the characteristics of the ideal gentleman.[4] As Jin described it, the basic physical properties of the plant were metaphors for the upright gentleman whose heart was "hollow," or humble, a condition that also communicated the Buddhist and Daoist values of nonattachment and inaction. Jin Nong extended this tradition back to the eighth century and connected outline method to the metaphor of the bamboo-as-gentleman. The outline technique also emphasized the physical structure of the bamboo plant, in which hard outer walls frame hollow inner cores. Each section of painted bamboo created a rectangular boundary around a blank section of paper that read both as the surface of the bamboo and as the empty, unpainted, humble heart of the plant itself.

Huang Yi's painting *Seeking Verses among Autumn Mountains* (fig. 24) is a more typical example of the epigraphic aesthetic in painting. Like many of Huang's landscape works, it depicts a scene from his expeditions through the landscape in search of old steles.[5] Here, he playfully adapted the common literati painting title of "strolling while reciting verses in the landscape" to his passion

for "seeking [inscribed] verses" in the broken steles of the past. Dry and raspy marks barely delineate the contours of the mountains, figures, and buildings. At most, forms are described with two layers of brushwork—one light-gray underpainting and one black overpainting—with each application as stippled and broken as the other. The concrete boundaries of the landscape's stony constructions disperse in the substrate of the paper through Huang's evanescent brushwork. While the painting inscription describes the work as being done in the style of the Qing-dynasty painter Lu Fei (1719–after 1778), and the use of dry brushwork techniques has a long history, as exemplified in the work of painters such as Ni Zan (1301–1374) or Hongren (1610–1663), the context of Huang Yi's life's work makes plain the connection to the material surfaces of rubbings. His brushwork mimics the broken surfaces of the steles he searched out, rubbed, and conveyed to the readers of *Engraved Texts* in outlines.

The use of dry, fractured lines that barely solidified into brushmarks was directly associated with epigraphy studies through a particular phrase frequently used to describe the ideal qualities of an authentic ancient stele: antique and awkward (*guzhuo*).[6] These were the same words Huang Yi used when he wrote about his painting *Finding a Stele near Liangcheng Mountain* (see fig. 12): "Judging from the archaic and awkward clerical script calligraphy there is no doubt that the inscription must be from Han times."[7] For Huang Yi, it was the "antique and awkward" qualities of a stele's script that first allowed a connoisseur to positively identify it as Han-dynasty calligraphy. Just as Ruan Yuan's essay ended with a celebration of the "awkward" calligraphy of his generation, Huang and his peers prized "antique and awkward" qualities in painting as well.

The painter Qian Du, Huang Yi's younger contemporary, was also fond of using this phrase. In his book *Songhu's Reflections on Painting*, Qian Du attached the qualities of the "awkward and antique" to a set of stone-carved figures from the Han dynasty, writing, "In making large figures [in one's paintings], one must grasp the antique and awkward concepts of the stone carvings of the Wu Liang [family] shrine."[8] Ruan Yuan wrote nearly this same sentiment after seeing the Gu Kaizhi painting *Nymph of the Luo River* in the imperial collection. The second-century Wu Family Shrine stones were discovered and promoted chiefly by Huang Yi, and images of an early set of Wu Family Shrine rubbings were also reproduced in outline method in his *Engraved Texts*. As Qian Du never mentioned a journey to visit the site, it was likely through a form of reproduction such as Huang Yi's that he would have grasped "the antique and awkward concepts" he found in those carvings.

Most histories of Chinese painting frequently, and rightly, compare the landscapes of both Huang and Qian to other past landscape painters. Huang Yi's painting is said to be within the lineage of the so-called "Four Wangs" of the Qing dynasty, painters who celebrated and consolidated Dong Qichang's (1555–1636) lineage of canonical painting masters.[9] Qian Du's landscape style

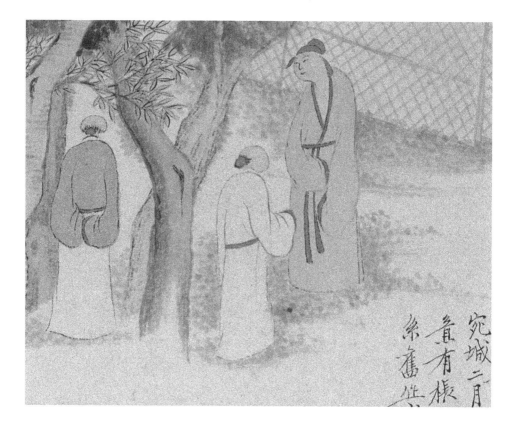

and figures are understood to draw directly from the Wu School painters of Ming-dynasty Suzhou, and in particular those of Wen Zhengming (1470–1559), a painter Qian Du often cited directly.[10] But comparing Qian Du's figures with those of the Wu Family Shrine as reproduced in *Engraved Texts,* one sees immediate formal correspondences that reinforce an alternative genealogy based in epigraphic sources (figs. 25 and 26). The figures in both have the same rounded shoulders and chins. Heads turn at the same three-quarter angle and share facial features such as the willow-leaf mouth and curved nose. The robes and sleeves hang with the same weight, conveying a sort of doughiness that is intentionally awkward and gives the cloth a sense of heft. Beyond the basic shapes of Qian Du's figures, his epigraphic interest is even more pronounced in the way he outlined each body. Delineating each figure in dark, fractured lines that are thin and raspy, he seems to have drawn his inspiration directly from the same broken outlines that defined Huang Yi's reproductions of rubbings.

Use of epigraphically derived outlines to establish a lithocentric authenticity existed in the figure painting of the late eighteenth century as well. In 1762, the painter Luo Ping made a portrait of Ding Jing (fig. 27), and at around the same time, he painted another companion portrait of his mentor, Jin Nong (fig. 28). The deliberately heavy, dark, and awkwardly accentuated lines that Luo Ping

Fig. 25 (*opposite*) Qian Du, detail from *Figures and Landscapes*, 1822. Album, ink and color on paper, 22.8 × 33.5 cm. Shanghai Museum.

Fig. 26 Detail of a figure from a reproduction of Tang-dynasty rubbings of the Wu Family Shrines, as published in Huang, *Engraved Texts*, vol. 1, fig. 7a. 1800. Woodblock print on paper, h. 31 cm. The Metropolitan Museum of Art, New York, Thomas J. Watson Library.

used to define the robes of each man seem to take on an animated quality all their own, as if the figures, whose bare bodily contours are painted in a contrasting thin, dry, light-toned line, were being worn by their clothes rather than the other way around. The quality of line used to describe the folds of Ding Jing's and Jin Nong's robes was uncommon, and Luo Ping chose this style of brushwork because it directly referenced the cut rock surfaces that Ding Jing spent his time investigating and cataloging and from which Jin Nong developed his distinctive style of calligraphy, "lacquer script." For a contemporaneous viewer, following the dark ink rhythms of the creases and folds in each robe would have been like running a hand over an organically deteriorating and roughly hewn stone surface.

Luo Ping's painting also makes visual allusions to a set of steles carved with Guanxiu's (832–912) *Sixteen Arhats* paintings, which were housed at that time in the Shengyin Temple near West Lake in Hangzhou. Emperor Qianlong had first been taken with the paintings in 1752, and in 1762, he had these paintings copied in sets of steles and distributed to eighteen monasteries throughout China. It was from these reproductions that the images of the Arhats were disseminated to a larger population. Luo Ping, who may have seen the Arhat steles in their original location or in Qianlong's reproduced forms, drew particularly

Fig. 27 Luo Ping, *Portrait of Ding Jing*, 1762–63. Ink and color on paper, 108.1 × 60.7 cm. Zhejiang Provincial Museum.

Fig. 28 Luo Ping, *Portrait of Jin Nong*, before 1782. Ink and color on paper, 113.7 × 59.3 cm. Zhejiang Provincial Museum.

from the image of the Arhat Bakula for his portrait of Ding Jing. The elongated neck, which Yuan Mei (1716–1798) describes in his inscription to the painting as "crane-like," is one of Bakula's defining physiognomic features. Luo Ping seems to have blended this with attributes of the Arhat Nagasena, whom Guanxiu depicted with his hands clasped in prayer under his chin, a feature that Luo Ping transformed by placing these clasped hands over a walking cane. The portrait of Jin Nong alludes to the fourth Arhat, Nandamitra (fig. 29), who was shown in the Guanxiu images making a pinching gesture while reading a sutra text.[11]

The allusions were not just iconographic; they were also material. The heavy dark outer lines of each painted figure's robes directly emulated the kinds of

marks cut into stone surfaces to depict the Arhat images that Ding Jing and Jin Nong directly studied. Through these visual allusions, Luo Ping simultaneously imagined Jin Nong and Ding Jing as reembodiments of the Arhats, as inheritors of a classic tradition of religious painting through Guanxiu, and as figures whose bodily forms physically reflected the stone sources that they analyzed. The specific gestures of each figure further emphasized the tactility of this academic interest in carved and cast surfaces.

Throughout his later life, Luo Ping brought these portraits with him wherever he traveled, and the visual allusions to stone surfaces were evident to his audiences. For the poet Yuan Mei, who inscribed both of Luo Ping's portraits, the brushwork allusions to the stone surfaces of steles were plain.[12] On the Ding Jing portrait, he wrote:

Fig. 29 *Nandimitra*, after a set of paintings of the sixteen Luohans by Guanxiu recarved in 1757, nineteenth century. Ink rubbing, 137.8 × 69.9 cm. The Metropolitan Museum of Art, New York. Gift of Miss H. C. Wagner, 1959.

> [In] this extremely antique portrait of Longhong, he is depicted as if [his] shadow is about to fly away.
> Peering at the engraved stele, he extends his crane-like neck; leaning on a staff, he sits on a mossy stone.
> This reclusive gentleman transcends the world; and is a great commoner in the midst of men.
> He seems to seek the tadpole characters of ancient times; residing in the temple of Cangjie.[13]

Yuan Mei described Ding Jing as in the midst of analyzing an engraved stele, although the painting shows no such object. Instead, the thing positioned directly in Ding's line of vision was Luo's six-character inscription in archaic seal script, "Portrait of Gentleman Ding Jing." These words were designed to slip between ontological registers, figuring both as an image of the stone text that Yuan Mei

imagined Ding Jing to be analyzing and as the inscription on the object of the painting itself, further underscoring a parallel between the image and a stele surface.[14] Yuan Mei echoed this in his poem with an evocative description of the image, "depicted as if the shadow is about to fly away." A shadowless image was one without spatial illusion, one that announced its flatness proudly and, to Yuan Mei, one that was also "antique in the extreme."

Yuan Mei's inscription on Luo Ping's painting of Jin Nong, done at the same time as the Ding Jing inscription, similarly embraced a series of allusions to stone and the body. Describing Jin Nong, he wrote:

> He was a Gan Shi squandering gold, dined on jade like Li Yu.
> Who used ore of gold to cast an image of his deeds?
> It was disciple Luo of Twin Peaks who washed his hands in the Milky Way
> and then sketched this portrait.
> How mournful is his antique visage; Jin's strange robes are all a-flutter.
> He is firm in his ambitions, and his spirit rushes like the wind.
> He holds a palm-leaf scripture, seeming both to read and not read.
> Whiskers curled and scraggly, his open eyes gaze fixedly.[15]

The accumulation of historical eccentrics referenced by Yuan Mei included Han Shi, a Daoist character who wasted masses of gold to find an alchemical means of manufacturing it, and Li Yu, an official from the Northern Wei dynasty who ate powdered jade to prolong his life. In the first allusion, Yuan portrayed Jin as a typically impractical scholar, one who disregarded wealth in favor of principle. But in the second allusion, the ingestion of stone to gain immortality had a parallel activity in Jin's study of stone inscriptions to produce new kinds of calligraphic texts. These lithocentric themes continued in Yuan Mei's poem through an allusion to the process of casting as a mode of fixing an image of Jin Nong's deeds, an allusion immediately contrasted with the description of Luo Ping's brushwork as drawn from the stars. Yuan went on to describe the image of Jin Nong made from these ore-cast and celestial sources as "antique," "strange," and "a-flutter," adjectives that set the scene for Jin Nong's studious attention with eyes that "gaze fixedly" at the Sanskrit text in his hands that he seemed "both to read and not read."

Both of Luo Ping's portraits were identified by Yuan Mei with stone or metal surfaces, and in both cases, the brushwork was read through these analogies. To further compound the epigraphic aesthetic that these readings indulged in, each figure was imagined as contemplating an ancient text, straining through the distance between the present and the past to glean meaning from archaic forms of writing. This theme of legibility and the aestheticization of the difficulty of reading ancient texts united networks of epigraphy scholars of the late eighteenth and early nineteenth centuries (see chapters 1 and 2).

Painters with direct connections to the aesthetics of epigraphy frequently produced raspy, broken, and awkward brushwork to signal their affiliation with the authority of ancient inscribed and cast objects. This brushwork was often most pronounced at the boundaries of figures, whether in the outlines of bamboo, the contours of mountains, or the robes of reclusive gentlemen. But not all painters within this sphere of influence chose the new epigraphic brushwork. Painters like Wang Xuehao continued to promote the so-called southern school of landscape painting, a dominant and orthodox brushwork lineage that paralleled Ruan's southern school of calligraphy. Despite this, the dominance of the epigraphic aesthetic in the nineteenth century created opportunities to imagine paintings like Wang's in relation to the surfaces of ancient cast objects rather than to a brushwork genealogy of past painters.

Presenting the Tripod

When Ruan Yuan turned forty years old, he held a birthday celebration along the embankment at the Qiantang River where it met Hangzhou Bay. It was the twentieth day of the first month in 1803, and Ruan Yuan was halfway through his first term as governor of Zhejiang Province. One set of gifts he received that day was a collection of poems by friends, each written to harmonize with the classical poem "First White Hair," written by Bai Juyi (772–846) on the occasion of his own fortieth birthday.[16] Another gift was a modest landscape painting in handscroll format, *Presenting the Tripod* (see fig. 21), by Wang Xuehao, a painter he had known for almost a decade.

The painting documented an event that had occurred just a few months earlier, when Ruan Yuan donated an ancient bronze ritual vessel called the Taoling tripod to the Dinghui Temple at Mt. Jiao, near the Yangzi River city of Zhenjiang.[17] Ruan Yuan's philanthropic deed occasioned responses in a variety of media and was recorded in dozens of contemporaneous private writings and local histories.[18] Wang Xuehao's landscape was the only painting to represent the event in visual terms.[19] Given the nature of the event commemorated, it would make sense for the painting to somehow carry an air of the epigraphic aesthetic developing at the time. Yet it did not. Wang's painting and his collected writings make clear that he preferred citations to the brushwork conventions of painting associated with seventeenth- and early eighteenth-century painters such as Wang Hui and Wang Yuanqi, advocates of the so-called orthodox lineage of southern literati painting.

Two later colophons, dated to 1845 and 1860, attest to the efficacy of Wang's painting in eliciting passionate responses from other nineteenth-century viewers. But surprisingly, neither set of comments focused on the original purpose of the image, as a document of Ruan Yuan's donation to the Dinghui Temple. Instead, both men responded to the handscroll by imagining entirely different images.

After viewing Wang's landscape in 1845, Ouzhuang (fl. nineteenth century) went on to talk about images rubbed directly from the surface of the ancient bronze tripod that Ruan presented, an object that Wang Xuehao had barely depicted in the painting. In 1860, Zhang Xianghe (1785–1862) saw Wang's painting and was inspired to describe it in relation to a genealogy of other famous landscape paintings. The author of each colophon drew upon different aspects of the painting to make their imaginative leaps, but in each case, a viewer looked at one image, a painting of a historical event, only to respond by visualizing entirely different images.

Close attention to the history of this tripod, Wang's painting, and its colophons presents a case study by which to understand the intertwined cultures of epigraphy and literati painting and, specifically, the tactile nature of their respective appeals to the body. To covet a rubbing of the surface of a famous bronze such as the Taoling tripod, as Ouzhuang did, was to desire to be closer to the famed object itself. Antiquarians treasured bronzes as relics of the classical past, and rubbings carried the aura of their presence by suspending experiences of surface contact in the transitional material of paper and ink.[20] Likewise, as Zhang Xianghe's later inscription to the painting shows, viewing a painting such as Wang Xuehao's could equally satisfy a desire to better understand the painter, a familiarity achieved by following the traces left by the artist's body in the accumulated brushmarks of the image. Both modes of viewing relied on different technologies, but both aimed at a reembodied presence through touch—of the tripod and of the painter—to produce an intimacy with the past.

The Tripod

It is uncertain how the Taoling tripod, the object at the center of Wang Xuehao's painting and from which Ouzhuang's rubbing was created, came into Ruan Yuan's possession. Although Ruan Yuan explained its role as a significant early ritual vessel in at least two separate writings, its acquisition is mentioned in neither. Instead, his interest in the object was focused on promoting its historical significance and the admirable qualities of the calligraphy cast onto it.

His 1804 publication of collected studies on ancient cast and inscribed objects, *Inscriptions on Bells, Tripods, and Bronze Vessels from the Jigu Studio*, explains his donation of the Taoling tripod to the Dinghui Temple as such: "When I obtained this tripod, I thought that because Mt. Jiao has only the tripod of the Zhou dynasty, if this Han tripod could accompany it, then it [the older tripod] would increasingly be added to the sections on poems and events in the Classics and dynastic histories. Therefore, I sent official documentation to Zhenjiang prefecture in Dantu county that entrusts [the tripod] to the temple at Mt. Jiao to treasure forever."[21]

According to this account, an older, Western Zhou dynasty (1046–771 BCE) bronze vessel needed the company of a Western Han dynasty (221 BCE–9 CE)

bronze to gain greater renown. Ruan Yuan's statement about pairing the two objects for posterity's sake glossed over more recent reasons to choose Mt. Jiao. Since the Song dynasty, when both Mt. Jin and Mt. Jiao became celebrated travel destinations, Mt. Jiao in particular was known as a prime site for the study of ancient stone inscriptions.[22] The fame of these mountains increased in the eighteenth century as well, when temporary palaces and stele pavilions were constructed there for the Qianlong emperor's southern inspection tours.[23] Ruan's gift therefore compounded an existing local history of epigraphic study at Zhenjiang.

But these justifications only hint at the deeper epigraphic thinking that brought these tripods together. In a poem written to celebrate his donation of the Taoling tripod, Ruan Yuan elaborated on the marriage of the two vessels, emphasizing their calligraphic value through a series of comparisons.

> In one corner of the Jade Mountains a spring tide flows, and in the middle a
> Zhou dynasty tripod separates the clouds from the cliffs.
> With ten lines of ancient text, it shines upon the river waters . . .
> In a thousand years ancient seal script turned into clerical script, as recorded
> in the carved inscriptions of the Western Han.
> I have a Han cauldron of fifty inscribed words, cast in Qian of Yumi County,
> offered by Dingtao.
> The Hall of Sea Clouds is filled with ancient trees, and here two cauldrons
> make their first acquaintance behind bolted doors.
> It is like adding the autumn rites of the palace to the Zhou ceremonies or
> recording the biographies of Bangu and Cao Zhi among the events of
> the Han.
> Cangjie's seal-script characters are broken like the night cries of ghosts, and
> the *bafen* clerical style does not resemble that of the kingdoms of the
> Zhou dynasty.
> Each rippling stroke and each hard downward stroke runs deep in this liquid
> stone, concealed together like the immortals You and Chao.[24]

Ruan Yuan began his poem by identifying the Zhou tripod with the island of Mt. Jiao, where it was located, in the middle of the "spring tide" of the Yangzi River.[25] The metaphor of a tripod rising from the river to separate land and sky references the story of the "Nine Tripods," mythical vessels cast at the founding of the legendary Xia dynasty. Possession of these was emblematic of the right to rule and of the virtue associated with that right. At the end of the Zhou period, as the virtue of rulers waned, the tripods were said to have disappeared into a river. After the unification of China under the Qin dynasty (221–206 BCE), legend had it that the tripods revealed themselves again briefly, rising up from the river only to disappear again under the waves, evading the first emperor's

grasp—a sign of his lack of virtue.[26] In Ruan Yuan's poem, the Zhou tripod at Mt. Jiao, rising from the Yangzi River, is analogous to those legendary tripods, symbols of integrity and sovereignty.

After establishing the merits of the Zhou vessel, Ruan Yuan reduces the long and complicated historical transition from the Zhou dynasty to the Han dynasty to a calligraphic event: "In a thousand years ancient seal script turned into clerical script, as recorded in the carved inscriptions of the Western Han." And when it comes to describing the vessels, one from each end of the historical spectrum the poem has just established, it is the texts cast into their surfaces that mark them as special.[27] "I have a Han cauldron of fifty inscribed words," Ruan continues, expanding on his calligraphic theme and reinforcing it with references to ancient texts. With the "Zhou ceremonies," he alludes to the *The Book of Rites*, and the "events of the Han" refer to the *History of the Later Han*.

As the poem draws to a close, Ruan continues to compare the calligraphy on the two vessels. The "seal-script characters" on the Zhou vessel, "broken like the night cries of ghosts," do not resemble "the *bafen* clerical style" of the Han vessel; "each rippling stroke and each hard downward stroke runs deep in this liquid stone, concealed together like the immortals You and Chao." Paragons of moral purity, (Xu) You and Chao(fu) were legendary hermits, each of whom refused the offer of the throne from the fabled emperor Yao.[28] Ruan Yuan, through poetic analogy, presents the styles of the tripod inscriptions as reifications of the virtuous hermits' upright behavior.

But it was not only in his poem that he lauded the texts of these bronze vessels. He also applied the mind of an evidential researcher to both tripods, which he listed in the catalog of his private collection (fig. 30). Beginning with reproductions of the inscriptions, he went on to write concise reports of the number of words they contained and to locate each in a specific historical and geographic context.[29] These determinations were made using methods of linguistic comparison and relied on evidence drawn from other early philological and calligraphic texts. For the Taoling tripod, Ruan Yuan combed through various ancient sources to identify its original recipient as Liu Kang (d. 23 BCE), son of Emperor Yuan (r. 49–33 BCE) and father of Emperor Ai (r. 7–1 BCE) of the late Western Han dynasty.[30]

The dating of the older vessel, the Xuzhuan tripod, was a complicated affair and had been written about extensively by the scholars Dai Zhen and Weng Fanggang. Dai Zhen used the inscription on the Xuzhuan tripod to redate a poem from the *Classic of Poetry*, one of the primary Confucian texts that all scholars were expected to master. By drawing evidence from a multitude of supporting texts and making complex comparisons of the early use of specific words, Dai Zhen showed that the poem had been written in the reign of King Xuan (r. 827–782 BCE) rather than in that of King Wen (r. 1056–1050 BCE).[31] Adjusting the dating of this poem by two hundred years, Dai rectified history and showed that the

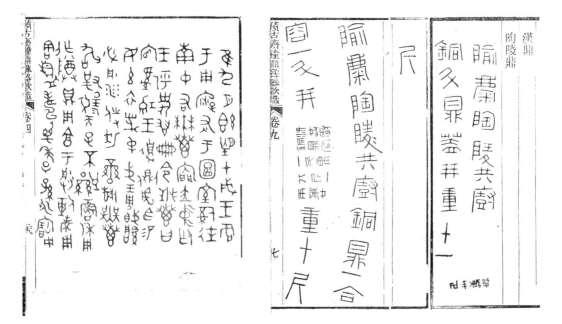

Fig. 30 Reproductions of the Xuzhuan tripod inscription and the Taoling tripod inscription, as published in Ruan Yuan, *Jiguzhai zhongding yiqi kuanzhi*, vol. 4, 28a, and vol. 9, 6b–7b, 1879 republication of 1804 edition. 30 cm. Getty Research Institute.

earliest commentaries on the *Classic of Poetry* had been leading scholars astray about this fact for over a millennium. Weng Fanggang's treatise followed Dai Zhen's and, similarly, focused on the linguistic and calligraphic characteristics of the inscription to establish its correct date.[32]

In his own writings on the Xuzhuan tripod, Ruan condensed the work of Dai Zhen and Weng Fanggang and added an enticing anecdote about the bronze's more recent history. As Ruan Yuan explained in *Inscriptions from the Jigu Studio*, "The monk Xingzai recorded in the *Mt. Jiao Gazetteer* that the tripod was transferred here from the Wei clan of my own hometown [Yangzhou], so that when Yan Song took power he could not obtain it." Yan Song (1480–1567), a powerful prime minister during the reign of the Jiajing emperor (r. 1521–1567), accumulated a massive collection of wealth, including many artworks and antiquities. After he was disgraced and cast out of court, the state absorbed his vast collection and cataloged it as *A Record of the Waters of Heaven Melting the Iceberg*.[33] During Yan Song's tenure as prime minister, the owners of the Taoling tripod, the Wei family, hid the tripod at Mt. Jiao rather than allowing the covetous Yan to claim it. Their donation of this valuable object was an act of political defiance. Ruan Yuan's donation of the Taoling tripod, almost three hundred years after the Wei clan donated the Xuzhuan tripod, therefore followed a precedent of benevolent donation of antiquities to Mt. Jiao.[34]

Although a parallel with the Wei clan's circumstances would have been available to him, it does not appear that Ruan Yuan donated the Taoling tripod to

make a direct political statement. For Ruan, whose intentions were academic and civic-minded, the merits of these bronzes were calligraphic, as evidenced by the structure of his entries on each vessel. For each entry, facsimiles of the inscriptions came first and were followed by a succinct description of the vessel in terms of the number of characters, followed by arguments about dating and authenticity based in the comparative textual evidence that focused on context, language, and style.

Ruan Yuan's deep involvement in the study of inscriptions on ancient cast and engraved objects stemmed from the usefulness of these texts as source materials in the field of evidential research (see chapter 1).[35] This partly explains why so much attention was lavished on studying the inscriptions on these objects from both linguistic and stylistic perspectives. As Dai Zhen and Weng Fanggang showed in their work, an inscription like the one on the Xuzhuan tripod allowed scholars to question canonical interpretations of historical texts like the *Classic of Poetry*, a practice fraught with possible social and political ramifications.[36]

The Taoling tripod was just one of many significant ancient bronzes owned and promoted by Ruan Yuan, and his preeminence in the field of epigraphy is attested to by the fact that at least ten leading scholars, many of them Ruan Yuan's friends and aides, wrote poems about his gift of this one object. Each of them followed his precedent and compared the two bronze vessels at Mt. Jiao in metaphorical terms that called attention to the objects' antiquity and inscriptions. Hong Liangji wrote, "How is it that the Tao Mausoleum resembles the Chang Mausoleum forever more, one the frightening flood water to the other's flying sea spray? These old affairs are now sunken and fused together with the flowing waters; and so it is useless to speak of what is plain, even to the ears on tripods and braziers."[37] Hong's lines reiterate themes found in Ruan's own poem, including the connection between tripods and water, and the pairing of the two vessels in terms that highlight the effects of time and the elements on ancient inscriptions.

Later in the nineteenth century, other prominent scholars and officials continued to promote cultural narratives surrounding the Taoling tripod, which had gained an excited following among passionate collectors and scholars of ancient inscriptions. Moved by Ruan Yuan's gift, they offered their own antiquities to the temple at Mt. Jiao. For example, in 1830, an ancient bronze drum was donated to the temple by Zhang Jing, then director general of waterways in charge of the Grand Canal, which emptied into the Yangzi River at Zhenjiang, near Mt. Jiao.[38]

The Painting

The short monochromatic handscroll that Wang Xuehao painted for Ruan appears at first to be a straightforward commemorative painting. As the image is revealed from right to left, the artist's inscription appears in the upper right corner, setting the scene with a simple declaration: "Image of *Presenting the Tripod at Mt. Jiao*, 1803, first month, done for Governor Ruan Yuan—Wang

Xuehao." The information Wang Xuehao listed was succinct: action illustrated, location, date, and the names of the painter and the recipient. The painting was thus first presented to viewers as a visual document of a historical event.

The image begins from the right with a depiction of the characteristic topography of Mt. Jiao. A well-known saying from the Song dynasty compared Mt. Jiao to the nearby Mt. Jin, just upriver: "At Mt. Jin, the temple winds around the mountain; at Mt. Jiao, the mountain winds around the temple." From the Song dynasty onward, depictions of these mountains followed this description, with Mt. Jin represented as a sharp peak capped by a pagoda and temple buildings, and Mt. Jiao rendered as a smaller rounded mountain, buttressed by a few low buildings along the water.[39] As a viewer progresses through the painting, past Mt. Jiao to the center of the image, a boat on the water carries seven figures gathered around two tables, one of which supports the large tripod at the center of the painting's narrative. Last, still further left, a cluster of buildings and a slender pagoda represent the city of Zhenjiang, a major trading hub in imperial China located at the intersection of the Grand Canal and the Yangzi River, just upstream from Mt. Jiao. Along the shore, a group of scholars watches the tripod's progress toward the temple.

Wang thus constructed the composition to pivot around the boat's journey, framing and describing this transitional moment when Ruan Yuan's donated tripod moved from the private space of his collection to the consecrated space of the temple. It did so in a reverse temporal progression, first revealing the tripod's future home of Mt. Jiao and then its past point of departure from Zhenjiang. But the image itself moves beyond simple documentation of the event to take advantage of common landscape painting techniques and conceits that further animate the scene.

In the style of the many so-called orthodox painters before him, Wang painted the scene for Ruan in brushmarks that flick and quiver with nervous energy, as if barely able to coalesce into depictions of concrete objects (fig. 31). In the mountains, these oscillations can be seen in dynamic combinations of drybrush texturing over fleeting sections of wet wash. In other areas, such as at the rooflines, two layers of ink—one light gray, the other dark gray—are painted purposefully out of register with one another to activate the contours of form. This was entirely intentional. Viewers were supposed to see how each stroke was made and sequenced. In doing so, Wang Xuehao revealed his painterly process as a series of gestural and compositional decisions made before finally settling into the construction of form.

This sense of a balancing act between defining forms and breaking away from them echoes the composition as a whole, which expands and contracts around the center scene. At the core of the image, the boat facilitates the main action of the tripod's journey. Wang presented that event from an elevated perspective and framed it on an open field of water, implying the water as the raw material of

Fig. 31 Detail from Wang Xuehao, *Presenting the Tripod at Mt. Jiao*, 1803 (fig. 21).

the paper rather than painting it. The horizon above bows away from the scene, containing the boat's travel in an arc of expanding space that extends upriver into faint gray washes. He repeats this framing of the central scene in a parabolic curve at the sides as well, where the shorelines of Zhenjiang to the left and the island of Mt. Jiao on the right bracket the event at the center of the painting. The boat thus appears to be suspended in midtravel, isolated on an empty but dynamic plane of water that pushes against its physical boundaries. Through these dramatic brushwork and framing devices, Wang focuses viewer attention on the narrative scene his painting celebrated, the passage of the Taoling tripod across the Yangzi River to its new home at Dinghui Temple at Mt. Jiao.

By the time Wang Xuehao painted *Presenting the Tripod*, he had known Ruan Yuan as an important patron and friend for a decade. Of the more than four hundred names that have been associated with Ruan's larger scholarly network, Wang Xuehao primarily served by creating visual responses to Ruan's cultural endeavors. But Wang was not the only painter on whom Ruan relied. He was one of dozens of painters who sometimes made artwork for the prominent official. Judging from the variety of artists Ruan patronized, his taste was stylistically diverse and included many of the major landscape and figure painters of the late eighteenth and early nineteenth centuries, including Xi Gang, Fei Danxu (1801–1850), Qian Du, and Gu Luo (1763–1837).

Wang Xuehao first became part of Ruan Yuan's network in the 1790s. Among the earliest paintings he made for his patron was a 1794 work that responded to Ruan Yuan's poem cycle describing famous locations in Shandong in penta-syllabic quatrain, "Eight Poems on the Scholarly Bureaus of Shandong."[40] Over the next two decades, Wang painted at least six more times for Ruan, including paintings of West Lake in Hangzhou, a painting of one of Ruan Yuan's garden pavilions, and a collaborative portrait of Ruan Yuan.[41] As late as 1817, Wang Xuehao was still making references in his painting inscriptions to the impact of his time spent with Ruan Yuan.[42] The two appear to have been close as well. Because they took the provincial-level civil service exams together in 1786, they sometimes referred to one another in inscriptions using the terms "my same year" or of the "same season."

While Ruan Yuan was an important patron in Wang Xuehao's early paint-ing career, according to contemporary accounts, Wang was far from dependent on Ruan. Wang passed the same provincial-level civil service exams as Ruan Yuan, making him eligible for the final metropolitan examinations in the capi-tal and for some levels of government work. But he did not pursue civil service as a path to success. Instead, he traveled widely through the Qing empire before settling in Suzhou, where he enjoyed broad popularity among the scholarly elite at the time. His work was often associated with the landscape paintings of Wang Yuanqi and with the three other painters surnamed Wang (together, the "Four Wangs") who achieved fame during the Kangxi reign (1661–1722). Later scholars grouped his work together with the paintings of the "Lesser Four Wangs" of the eighteenth century, the stylistic and literal descendants of the "Four Wangs."[43]

Wang Xuehao was considered one of the most prominent scholar-painters of the early nineteenth century, but very little scholarly or literary output can be attached to his name. There are no published writings aside from a single short treatise on painting, titled *Shannan's Discussions on Painting*, a text that is in keeping with the general understanding of early nineteenth-century painters as conservative and grounded in a necessary though sometimes binding relation-ship to the great painters of the Kangxi era.[44] For instance, in his treatise, Wang reaffirmed the connections between his work and that of the "Four Wangs" of the early Qing dynasty, quoting both Wang Hui and Wang Yuanqi directly. Rather than rote repetition of their ideas, however, Wang offered his own interpretation of these past masters, writing, "Wang Hui once said, 'Some ask, what is literati painting? And I say, it can be encompassed by a single word, writing.' What is most pertinent about this is that characters should be written, and not traced. Painting is just like this, as soon as one begins to trace in painting, it becomes coarse and mechanical."[45] In an explanation of a quote by Wang Yuanqi, Wang Xuehao likewise reinforced the benefits of engaging with past painters but on one's own terms: "Wang Yuanqi once said, 'Not taking antiquity as your teacher is like walking at night without a candle.' I have benefited from my meetings

with the true traces of the ancients. I look to them to advance my own pursuits, seeing how they use the brush, how they accumulate ink, place and arrange, exit and enter, lean and shift. Then I must make it come from my own (brush) head, and the longer I work at it, the closer I come to them."[46] Wang Xuehao was plainly an artist that paid homage to influential painters of the past, but he was also critically engaged with their ideas, offering his own interpretations of them for early nineteenth-century audiences. He presented past paintings not as templates to copy but as objects that catalyzed one's own thoughts.

These excerpts also reveal that Wang Xuehao established his understanding of classical paintings through a reimagination of the bodily actions of the painters that produced them. This made viewing brushwork a fundamentally tactile action, as the classical Chinese sense of touch was distributed across the body and included gesture and motion. Through this reconstruction of a painter's touch, viewers reinhabited the body and mind of a canonical master, hoping to approach their heart-mind. Yet this was also a textual model, through its association with writing and its practices of stylistic citation. Wang's vocabulary of traces, gestures, writing, and the heart-mind was not new. It can be found among the earliest metaphors used to describe the brushwork of calligraphy and painting in the Six Dynasties period (220–589).[47] His viewing of paintings as actions of the body, along with his self-conscious references to the ideas of important early Qing-dynasty painters like Wang Yuanqi and Wang Hui, placed his work in the lineage of canonical scholar-painters. And it was this same manner of thinking about painting that Zhang Xianghe adopted when he saw *Presenting the Tripod* in 1860 and added his colophon to the work.

A Brushwork Response

In his colophon to Wang Xuehao's painting (fig. 32), Zhang Xianghe avoided discussion of the key event depicted, Ruan Yuan's donation of the tripod.[48] Instead, he wrote about the painter, the painter's relationship with Ruan Yuan, and the position of the painting within an art historical lineage of other paintings and painters. Zhang Xianghe began his colophon by describing three paintings done for Ruan Yuan by Wang Xuehao: "*Lake Zhu Thatched Hut* is of a zither being played in a landscape, is written on the back of sutra paper, and is especially clear and bright, similar to Huichong's (965–1017) handscroll of *Spring in Jiangnan*. *Presenting the Tripod at Mt. Jiao* is in his mature texturing style and resembles the brush concepts of the previous generation's Dong Bangda (1699–1769) and Wang Chen (1720–1797). *Langhuan Immortal Hall* is laid out via bamboo and rocks and follows the path of Wen Boren."

With these references to painters and paintings of the past, Zhang located Wang Xuehao's paintings for Ruan Yuan within an art historical lineage of images and painters from the eleventh century (Huichong), the sixteenth century (Wen

Fig. 32 Zhang Xianghe, colophon to Wang Xuehao, *Presenting the Tripod at Mt. Jiao*, 1803 (fig. 21), 1860. Ink on paper, overall handscroll dimensions with mounting: 35.6 × 967.7 cm.

Boren), and the eighteenth century (Dong Bangda and Wang Chen). With each of these comparisons, Zhang emphasized a different admirable quality of Wang's work. Zhang's genealogical approach also rested on bodily metaphors of viewing that were similar to those that underpinned Wang Xuehao's commentaries on painting. Although not all the works Zhang mentions survive, there are enough comparable works to allow us to begin to understand how Zhang saw Wang Xuehao's painting through the artwork and the bodies of other painters.

The whereabouts today of the first of these comparisons, Huichong's handscroll *Spring in Jiangnan,* are uncertain, as are those of Wang's painting *Lake Zhu Thatched Hut.* All that can be known for certain about *Spring in Jiangnan* is that it was a well-celebrated painting. Various later copies of Huichong's work were painted by artists such as Wang Hui, and two poems were written about the work by Su Shi (1037–1101), an association that would have aligned Wang Xuehao's work with the origin figure of the scholar-painter genre.[49]

While neither painting is available today, a painting attributed to Huichong, *Sandy Shoals and Misty Trees* (fig. 33), allows us to speculate on some of the "clear and bright" aspects that Zhang Xianghe identified in the work of both painters. *Sandy Shoals and Misty Trees,* a small landscape in album leaf format, uses compositional strategies similar to Wang's *Presenting the Tripod at Mt. Jiao.* For instance, both construct a regression from foreground to background whereby the shorelines from opposite sides of the river overlap and diminish toward the horizon. Likewise, the top of each embankment in Huichong's *Sandy Shoals and Misty Trees* is left unpainted, indicating the reflection of sunlight, a technique also used in the peaks of Wang's *Presenting the Tripod at Mt. Jiao* and one that perhaps comes closest to the "clear and bright" features that enamored Zhang Xianghe.

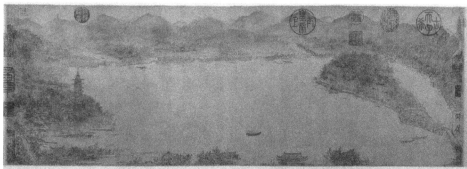

Fig. 33 Attributed to Huichong, *Sandy Shoals and Misty Trees*, ca. 1000. Album leaf, ink on silk, 24 × 24.5 cm. From Hatch, "Epigraphic and Art Historical Responses." Liaoning Provincial Museum.

Fig. 34 Attributed to Li Song, *West Lake*, ca. 1200. Handscroll, ink on paper, 26.7 × 85 cm. Shanghai Museum.

To keep with Zhang's eleventh-century comparison, in both composition and technique, Wang's *Presenting the Tripod at Mt. Jiao* bears a remarkable resemblance to the painting *West Lake* (fig. 34), attributed to Li Song (fl. 1190–1230). Both are of a similar scale, and both show a landscape centered around a void of unpainted paper, understood as water by Chinese landscape painting conventions. At the center of each painting, a boat is suspended between an island on the right and the shoreline on the left. In each painting, a pagoda crowns the leftmost bank. Both images are also constructed in the literati fashion, by means of loose accumulations of monochromatic ink washes and brushmarks. Although Zhang Xianghe makes no mention of Li Song's painting, it seems likely that Wang Xuehao's composition either drew upon it directly or took some inspiration from a later derivative of it.

Zhang's next comparison was between *Presenting the Tripod at Mt. Jiao* and the "brush intentions" of Wang Chen's and Dong Bangda's work (figs. 35 and 36). Here, Zhang's emphasis was not on composition or theme but on the more abstract quality of "brush intentions" (*biyi*), a phrase that prioritized the painter's conceptual direction for the artwork, from composition to positioning and executing of each individual stroke. Indeed, the quivering and intentionally misaligned brushmarks that defined Wang Xuehao's painting can also be found in the canonical work of both Wang Chen and Dong Bangda. In the work of all three artists, landforms and trees are built up through accumulations of feathery brushwork, dry-on-wet contrast, and loosely composed forms.

"Brush intentions" was a topic that Wang also discussed in his short treatise, *Shannan's Discussions on Painting*, which, uncoincidentally, Zhang Xianghe edited and published in 1876. Wang Xuehao wrote, "When intention is there, the brush follows. It can't be set ahead of time. Only capable scholars can achieve this." For painters in the literati tradition, brushmarks were indexical to the mind of the painter. To say, as Zhang Xianghe did, that Wang Xuehao's paintings followed the brush intentions of earlier painters meant that Wang's mind found accord with theirs. But it also meant that the movements of his body and hand resonated with theirs. As Wang went on to say, "In all painting, when you begin you must think in terms of brush, and when you are arranging the composition, you must think in terms of ink. This is what the ancients called placing the brush with your gut and arranging the composition with a refined heart-and-mind." Wang's bodily metaphors here situated the actions of the brush within the "gut" of the painter and saw composition as a product of the heart-mind, the organ that coordinated the knowledge of sensory perceptions. For Wang Xuehao, as for Zhang Xianghe after him, both viewing and making painting were embodied processes under the guidance of the heart-mind. To make a painting in these terms, as Wang Xuehao urged readers of his book to do, or to view a painting in these terms, as Zhang Xianghe did in his colophon, was to see the image as a series of gestures that indexed traces of the painter's body and mind.

Fig. 35 Wang Chen, *Landscape*, 1788. Folding fan mounted as an album leaf, ink and color on paper, 18.1 ×
51.4 cm. The Metropolitan Museum of Art, New York. Bequest of John M. Crawford Jr., 1988.

Fig. 36 Dong Bangda, "Landscape," from *Album of Landscapes in the Style of Twelve Song and Yuan Painters*,
eighteenth century. Album leaf from a fourteen-leaf album, ink and light color on paper, 21.8 × 32.5 cm. Iris &
B. Gerald Cantor Center for Visual Arts at Stanford University, Gift of Marybee Chan Booth.

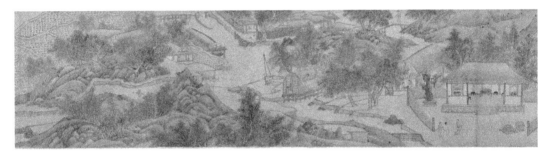

Fig. 37 Wang Xuehao, *Langhuan Immortal Hall*, 1804. Handscroll, ink and color on silk, 28.2 × 83.8 cm. From Hatch, "Epigraphic and Art Historical Responses." Collection of Michael Shih, Taiwan.

Fig. 38 Wen Boren, *Thatched Hut at Southern Springs*, 1569. Section of a handscroll, ink and color on paper, 34.8 × 713.5 cm. Palace Museum, Beijing. Photo provided by the Palace Museum.

In his last comparison, Zhang continued to place Wang Xuehao's work in a stylistic lineage of painters, writing that *Langhuan Immortal Hall* (fig. 37) "followed the path" of the sixteenth-century painter Wen Boren (1502–1575), particularly in the manner of organizing the landscape around clusters of bamboo and trees. Zhang did not name a specific painting by Wen Boren, but *Thatched Hut at Southern Springs*, from 1569, makes for a good comparison (fig. 38). In both images, pathways meander among tilting buildings, and waterways bend through the environment. There are also resemblances between Wen's style and Wang's in terms of the light tones of the color washes and the complex stacking of diverse spaces into a single cohesive scene. But to follow the "path" of Wen Boren was not just descriptive of literal methods for painting pathways in a landscape. This comment positioned Wang as a disciple of Wen Boren, as a student of his style of painting and manner of being, as someone who followed in the footsteps of a mentor who came before him.[50] The same language was also reflected in Wang Xuehao's earlier citation of Wang Hui, in which he compared neglecting the ancients with "walking at night without a candle." For both Wang Xuehao and Zhang Xianghe, as well as Wang Hui before them, paintings were the pathways left by the bodies and minds of previous masters.

The comparisons Zhang made in his colophon understood Wang's painting in terms of stylistic predecessors and placed Wang in a genealogy of art histori-cally significant painters and paintings. This habit was well established in earlier histories of painting in China. But such rhetorical gestures were not just about superficial resemblances or claiming the authority of the past. To say that Wang's work resembled the "brush intentions" and "followed the path" of his predeces-sors aligned him conceptually and physically with an art historical genealogy in a way that carried over into the viewing of such paintings. As Zhang Xianghe's colophon to *Presenting the Tripod* attests, viewing Wang Xuehao's painting was not just about seeing an image. While viewing the image as a series of gestural actions and compositional decisions made by the painter, Zhang traveled through Wang's image to reinhabit the "brush intentions" and compositional pathways of painters that had come before him, from the eighteenth century to the fifteenth and eleventh centuries, in an interconnected genealogy of reimbodied thoughts and gestures.

By contrast, the other colophon added to Wang Xuehao's painting offered an entirely different means of viewing painting, one in which the image indexed not the traces of past painters but the surfaces of an ancient bronze object. View-ing Wang Xuehao's landscape image, Ouzhuang neglected to project himself through the various brushwork citations that captivated Zhang in favor of a desire to touch the Taoling tripod in a directly tactile manner.

A Surface Response

In 1845, a man named Ouzhuang became ecstatic over a surprise gift—a rubbing of the text-bearing surfaces of the Taoling tripod (fig. 39). The rubbing was composed of three simple sections of paper that had been wetted and pressed to adhere tightly to the words cast around the outer rim and inner surfaces of the ancient bronze. Then an ink pad was tapped against the papered vessel surface to produce an impression of the text in negative. Removed, dried, backed with more paper, and remounted, these rubbings were enough to make Ouzhuang exclaim in his accompanying inscription, "I've had this rubbing just a short time, but can't imagine ever being happier than I am now."

Ouzhuang had no direct access to the Taoling tripod, which had been housed on the island of Mt. Jiao since its 1802 donation to the Dinghui Temple by Ruan. But he had seen its rubbings in the collections of friends and longed for one himself. As he wrote in his inscription to the rubbing, "The Zhou tripod collected at Mt. Jiao in Zhenjiang and the Han tripod given by Ruan Yuan are two famous auspicious bronze vessels. Many times I've seen rubbings at the desks of friends, and for many years I've sought a copy to purchase myself, without any luck."

His desires went unfulfilled until the occurrence of an "uncanny effect [arising from] metal and stone," as he put it.[51] His friend Qian Xitao had a

Fig. 39 Ouzhuang, colophon to Wang Xuehao, *Presenting the Tripod at Mt. Jiao*, 1803 (fig. 21), 1845. Ink on paper, overall handscroll dimensions with mounting: 35.6 × 967.7 cm.

father-in-law who was stationed in the city of Zhenjiang. At Qian's request, his father-in-law procured a rubbing of the nearby Taoling tripod, and eventually it was delivered to Ouzhuang. After receiving this treasure, Ouzhuang then did something that might seem unexpected, given his attachment to it. He mounted it to another kind of image altogether, Wang Xuehao's landscape painting *Presenting the Tripod at Mt. Jiao.*[52]

The narrative built by connecting these two different kinds of images—a painting and a rubbing—would appear to be quite clear. Separately, each documented a moment in the life of the Taoling tripod, a celebrated object within the culture of early nineteenth-century epigraphic scholarship. Together, they amplified the story of the Taoling tripod, allowing a viewer to see and understand it from more than one kind of evidence.

What is worth remarking on here is Ouzhuang's lack of interest in the literati brushwork paradigm celebrated by Zhang Xianghe and Wang Xuehao. Rather than focusing on the qualities of Wang's brushwork and his deft manipulation of the brush gestures and concepts of earlier artists, Ouzhuang responded to the tripod that the painting documented. He was primarily driven by an epigraphic interest in the body of the tripod, not by a brushwork interest in the body of the painter. Wang's painting was valuable to him because he wanted to be physically closer to the object depicted at its center, though Wang had made it barely visible in the scope of the majestic landscape. To facilitate this, Ouzhuang added a contact rubbing of the Taoling tripod, literalizing the tactile connection between the painting and the object by means of a type of image that had a direct indexical relationship to the surfaces of that object.

Today, when Wang's handscroll is unrolled from right to left, a viewer is met first with Ouzhuang's rubbings and inscription, then the landscape painting, and last Zhang Xianghe's inscription. Modern audiences may perceive this to mean that Ouzhuang's rubbing simply prefaces the main event of Wang Xuehao's painting. The handscroll is likewise currently cataloged and exhibited under the painting's title and author, while the rubbing falls under secondary documentation. In the general modern hierarchy of Chinese art history, the gentlemanly arts of painting, poetry, and calligraphy command greater attention than rubbings, which are understood as mere reproductions.

However, among nineteenth-century scholarly elites, this configuration of the handscroll's sections gave pride of place to the rubbing, attesting to the importance of such images to this generation. Literati of this period increasingly established intellectual standing among their peers through the discourse and exchange of information about ancient bronzes and steles. In this environment, a well-preserved vintage rubbing of an ancient monument could certainly be as important as a painting, or even more so. As a result of the rising value of epigraphic scholarship, the arts of the brush became increasingly interconnected to the arts of epigraphy, and the visual culture surrounding the Taoling tripod is a case in point. Ouzhuang's action, of seeing a landscape painting and appending a rubbing, blurred the boundary between referent and image, expanding the purview of the epigraphic aesthetic first made visible in the shift to clerical styles of calligraphy by announcing the turn to a sense of touch that focused on the surfaces of objects rather than the bodies of past literati.

As early nineteenth-century painters and their audiences brought their epigraphic interests in the ancient, anonymous, and materially degraded inscriptions of the past to bear on the brush arts, they shifted from a hierarchy of brushwork styles that celebrated famous historical brush masters to one that valued material sources from the deep and anonymous past. The unpretentious styles and unadulterated classical pedigrees these antiquities boasted allowed liberation from overprescribed canons of brushwork. Traditional modes of citing canonical brushwork lineages in the Chinese literati arts of calligraphy and painting involved the layering of historically referential styles, subject matter, composition, and texts. Understanding these references marked one's rightful inclusion in elite culture. Repeating these references in one's own work, artists networked their personae through the stylistic identities of past painters and therefore established their place within that tradition.[53] By appropriating the "awkward and archaic" lines carved and cast in ancient material remains, literati artists posited new brushwork modes that offered more direct possibilities for intimacy, both with the traces of the past and among friends in the present. Rubbings were key to this new mode of viewing and relating to the past, as the contrasting reactions of Ouzhuang's and Zhang Xianghe's colophons to Wang Xuehao's painting show.

The next two chapters describe the manners by which some scholar-artists, liberated by the tactile immediacy of this new paradigm, began to apply the epigraphic aesthetic to a multitude of media, further questioning the dominance of brushwork by positioning rubbings as the primary model for image-making among literati. Chapter 4 turns to Liuzhou (1791–1858, given name Yao Dashou, also called "The Epigrapher-Monk"), who began to merge the two practices of rubbing and painting into single images to develop composite or "full-bodied" rubbings (*quanxing ta*).[54]

Tactile Images

In 1834, the painter and government official Tang Yifen (1778–1853) created a rambling album of landscapes, figures, and flora at the request of his friend Li Xingyuan (1797–1851).[1] In one image (fig. 40), two men stand in a wintry copse, facing a large stele from opposite sides. Each figure cranes his head toward the surface of the monumental stone in an attempt to discern some meaningful trace of ancient text. But Tang omits any depiction of a stele inscription, leaving the stone face represented as unpainted paper and these two roughly outlined men eternally peering into a mute void. Curiosities perpetually unsatisfied, instead they seem to settle for looking through the stone to find each other. Tang's inscription introduces the two transfixed epigraphy aficionados as the monk Liuzhou (1791–1858) and the scholar Wu Tingkang (1799–1888)[2]: "My friend in Hangzhou, the Monk Liuzhou, is addicted to epigraphy. Ruan Yuan's *Epigraphy Gazetteer for Zhejiang Province* has been out for some time now, and Liuzhou has added another volume that reads like part of the original. Wu Tingkang of Tongcheng shares the same obsession as Liuzhou, and hides himself away in a minor governmental role, [so that] the two can go around together investigating stone and metal [sources]. Struck by the memory of this, I made this painting."

Tang's recollection makes clear that the younger generation of scholars who came of age in the Jiaqing and Daoguang periods of reign, including Wu and Liuzhou, were still enraptured by epigraphy and endeavored to carry on the serious investigation of epigraphic source materials. Tang's inscription also shows just how important Ruan Yuan still was to the field, even in his retirement. Any scholarly contribution to epigraphy studies in Zhejiang was measured in relation to Ruan's benchmark, the eighteen-volume *Epigraphy Gazetteer for Zhenjiang Province*. Tang's comments explicitly link the quality of Liuzhou's scholarship to that of the legendary senior statesmen, highlighting the manner in which

Fig. 40 Tang Yifen, detail from *Landscapes and Flora*, for Li Xingyuan, 1834. Ink and color on paper, 25 × 33.7 cm. Shanghai Museum. Photograph by author.

Liuzhou's supplementary volumes complemented the contents of the original tome. Ruan, who had just turned seventy, would soon meet Liuzhou and become one of his most avid fans.

While Liuzhou's scholarly footprint came nowhere near that of Ruan Yuan, by the 1830s, he cut a recognizable figure among the literati of Hangzhou, as evidenced in another leaf of Tang Yifen's album (fig. 41). Tang's small land-scape sketch shows Li Xingyuan encountering Liuzhou and Wu Tingkang on a causeway along West Lake. Li, who commissioned this album, had just finished the *jinshi* examination and was about to take up his first provincial posting as director of studies in Guangdong. He would have an impressive governmen-tal career as governor or governor-general of half a dozen provinces, a service record on par with Ruan Yuan's own.[3] But in this image, the figure of Li defers to Liuzhou, taking a deep bow in the direction of the monk and his companion. Tang's inscription calls attention to this while feigning an air of self-deprecation:

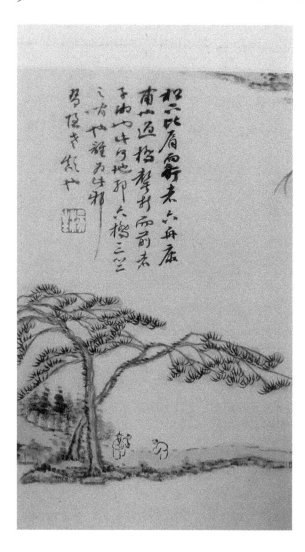

Fig. 41 Tang Yifen, detail from *Landscapes and Flora*, for Li Xingyuan, 1834. Ink and color on paper, 25 × 33.7 cm. Shanghai Museum. Photograph by author.

"That's Liuzhou and [Wu] Tingkang there walking shoulder to shoulder under the pines. Crossing the bridge, a voice calls to them; it's Zixiang [Li Xingyuan] there ahead. Where is this? Somewhere between [West Lake's] six bridges and the three Mt. Zhus. Who painted this? Just old Yinqin [Tang Yifen]."

Liuzhou's popularity revolved around one skill in particular, an innovative new technique for making ink rubbings called composite or "full-form" rubbing (*quanxing ta*). This work earned him the moniker "the epigrapher-monk," and the greatest antiquities collectors in the region, including Ruan Yuan, wanted Liuzhou to produce images of their collections. Full-form rubbings combined selected aspects of both painting and rubbing practices to produce images that provided the sense of a three-dimensional form in a two-dimensional depiction. Viewing them was like being in the presence of the original vessel, as several collectors proclaimed. Full-form rubbings accomplished that sense of fully embodied presence by taking advantage of the tactile logic that underpinned both rubbings and

paintings. When, in 1845, someone like Ouzhuang reacted to Wang Xuehao's landscape painting of the donation of a bronze by attaching to it a rubbing of that bronze, he acted on this shared tactile logic to blur the boundaries between rubbings and painted images. But Liuzhou took this impulse further, into a new practice that merged both media in a singular image-making process, creating evocative depictions of antiquities enlivened by painting to convey to viewers the ineffable sense of a direct encounter with an original object. Like Chen Hongshou (see chapter 5), Liuzhou's various intermedial experiments exemplify the turn toward tactile thinking that characterized the impact of the epigraphic aesthetic on early nineteenth-century Chinese art.

The Epigrapher-Monk

Liuzhou was not born into the elite classes of highly educated scholar-officials, which made his rise to fame among them all the rarer. Born in 1791 as Yao Dashou in Haichang (modern-day Haining), Zhejiang Province, Liuzhou was from a family of little means. He left home at the age of nine to live at Baima Temple in Haining, where he became a disciple of the monk Song Xi. It was there that he received his core education in Buddhism, history, and calligraphy. At seventeen, he was tonsured and began his mendicant life, which led him to various residencies across the lower Yangzi River region, including the Yanjiao Temple in Huzhou, the Jingci Temple in Hangzhou, and the Canglang Pavilion in Suzhou.[4] His purposes in these places were at least twofold. On the one hand, the priorities of a Buddhist practitioner motivated his temple travels—he wanted to commune with the sangha and expand his understanding of the dharma. On the other hand, his desire to visit, study, and make rubbings of famous ancient bronzes and other inscribed objects also prompted his travels. Monasteries housed many inscribed classical objects. Over the course of his career, the conceptual foundations of these two primary commitments—epigraphy and Buddhism—intertwined in his full-form rubbing practice to emphasize the body as a site for the transmission of knowledge.

Liuzhou began making rubbings as early as 1813, when he depicted a Zhou-dynasty bronze in the collection of his friend Chen Yun.[5] But it was not until 1821, after meeting Ma Fuyan, that he began to experiment with full-form rubbings.[6] Contemporaries recognized Ma Fuyan as the pioneer of the composite-rubbing method, and written accounts of Ma's 1798 image of a Han-dynasty washbasin are the first records of the technique. But few works by Ma survive, and his social circle was limited in comparison to the one that Liuzhou crafted over his career. Therefore, Liuzhou has become the figure most closely associated with the rise in popularity of full-form rubbing technique.

The fundamental full-form rubbing technique that Liuzhou learned from Ma Fuyan began with a faint outline image of the vessel, which was sketched

from the shadow cast on paper by a strong light source in front of the object. Next, selected surfaces from the corresponding side of the vessel illuminated in the outlining process were rubbed into the boundaries of that outline. Each rubbing part was arranged so that together they began to coalesce into an image of the original object as it would be perceived when displayed in real space. Last, in those areas where natural discrepancies arose between the various rubbing sections as they were forced into the outline, painted texturing was added to mimic the rubbing's appearance and complete the transition from disparate sections of rubbing to a full composite simulacrum.[7]

Epigraphy aficionados lauded such images for the accuracy of their depiction and for their ability to convey a sense of actual presence of the original bronze. As Xu Han (1797–1867) would later write upon seeing a group of full-form rubbings of bronzes and their inscriptions made by Liuzhou, "They are detailed beyond all expectation, as they exist in a person's mind, and are rubbed from the original vessels, without the slightest discrepancy."[8] For Xu, Liuzhou's image combined the bronze's conceptual ideal with its physical presence. Ruan Yuan echoed Xu's comment about accuracy and presence in his description of one of Liuzhou's full-form rubbing images of the Mt. Jiao tripod (fig. 42): "The dimensions [of the image] are true; I've held the original in my hands."

This sense of the true presence of the original was achieved in such images not despite, but because of, various forms of artistic manipulation involved in making them. The image Ruan described was made with a combination of rubbing, in-painting, and woodblock printing, all extra processes that moved beyond the immediate truth of the rubbing's contact with the object. But for Ruan, this did not matter. His tactile memory of supporting the original vessel in his hands confirmed that the visual experience Liuzhou's composite image provided was startlingly close to an experience of the real thing. As he elaborated in the rest of the inscription, Liuzhou's rubbing even "clarified" the original, therefore improving his memory of the tripod.

Since its inception in the late eighteenth century, authors used the phrase "full-form rubbing" to cover an array of different techniques blended in various permutations to produce an image that conveyed the visual and tactile senses of a real antique object in a two-dimensional format. Liuzhou used at least three different combinations of techniques in the works he called full-form rubbings. These included fully rubbed images, images that integrated both rubbing and additional in-painting, and images that merged rubbed portions (generally the inscription) with woodblock prints of the vessel done from drawings and original rubbings.[9] The choice of which option to use could depend on factors such as the shape of the vessel or the degree of oxidation obscuring its inscription but ultimately revolved around the priority of making the clearest and most effective image for audiences hungry for epigraphic evidence.

As early as the 1790s, artists and epigraphy aficionados such as Weng Fanggang were beginning to experiment with combinations of rubbings and paintings in the same handscroll to produce an understanding of a single object from multiple perspectives. In 1791, Weng commissioned Luo Ping to paint an image of an ink-grinding stone once owned by the Song-dynasty calligrapher and antiquarian Mi Fu. But this was only one kind of primary evidence within the context of Weng's larger handscroll, which contains a series of additional representations—rubbings of the stone, textual descriptions, and a collaborative painting involving five different painters that emulated different texture methods associated with canonical painters—each of which combined in the whole to create what has been called a "fictive reality," a strategy that accounted for the multidimensional manifestations of the valued object.[10]

Likewise, Ruan Yuan's appetite for ancient objects motivated him to search for new ways of depicting them as early 1803. The handscroll *Accumulated Antiquities* (see fig. 22) shows Ruan seated among his collection of antique bronzes in what appears to be a typical collector-portrait painting. But

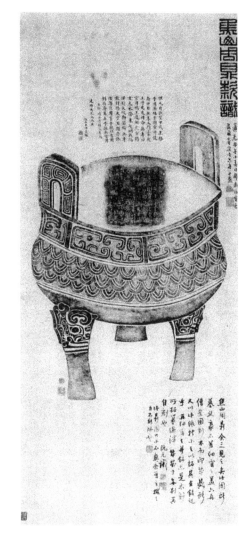

Fig. 42 Liuzhou, composite rubbing and woodblock print of the *Mt. Jiao Tripod*, undated. Ink on paper, dimensions unknown. From Zhejiang Provincial Museum, *Liuzhou*.

the image marks the first time that specific, identifiable antique bronzes were portrayed in such collector-portraits. Additionally, rubbings of over ninety of the objects from Ruan's Jigu Studio were appended to the image, reinforcing its emphasis on the representation of actual objects rather than generic types.[11] Both Weng Fanggang's and Ruan Yuan's handscrolls demonstrate that the greatest intellectuals of the early nineteenth century were searching for new ways to fully convey specific sensory experiences of revered ancient objects. Full-form rubbings offered them a means of satisfying this urge though a technique that conveyed both visual clarity and tactile sensation.

The earliest examples of full-form rubbings by Liuzhou's hand date to the 1820s, but his work of the 1830s is the most canonical.[12] It was at this time that he began some of his signature innovations on Ma's methods. Ma Fuyan invented the basic full-form rubbing technique, creating images that were tactile, by nature of the rubbings, and visual, because they organized those rubbings to appear as a three-dimensional object standing in real space. But Liuzhou's extensions of that technique astonished viewers. He used two techniques in particular to animate the tactile-visual space of full-form rubbings and create an uncanny playground for visual and perceptual immersion: doubling the vessel image within the same picture space and commissioning the addition of painted figures and flora into the rubbing compositions.

These innovations, along with the other requisite scholarly talents of calligraphy, poetry, painting, and a command of historical allusion, elevated Liuzhou's status among his contemporaries. By the late 1830s, as Tang Yifen's album demonstrates, he was a darling of the Qing empire's wealthy collector and scholar-official circles, and it was at this time that he earned the sobriquet "the epigrapher-monk" from none other than Ruan Yuan. A renowned poet and former aide to Ruan, Chen Wenshu, first wrote to introduce Liuzhou in the late 1830s. In passing, Chen used this phrase, "epigrapher-monk," and Ruan, inspired by both Chen's phrase and Liuzhou's talent, penned the following poetic line: "Once I went to West Lake in search of refined talents, and found poetry recited by lamplight at Nanping Temple. This travelling philosopher of Tiantai, [we] also call the epigrapher-monk of Nanping."[13]

Ruan's encomium explained his thoughts by connecting Liuzhou to his personal experiences in Liuzhou's hometown of Nanping, Zhejiang Province, as well as to the history of poet-monks there:

> In the early Jiaqing era, I wrote an inscription for the Seven Dynasties of Poets Hall in Nanping, and among the poems I enjoyed reading from the generations of monks there was the line, "After the evening bell and before an endlessly bright moonrise / Somewhere deep in Nanping, a poem is recited by lamplight." Now Liuzhou of Nanping is expanding our understanding of epigraphy like a bodhisattva; his collection and his rubbings both plentiful and full of essential truth. Yunbo Chen wrote me to tell of him, calling him the "epigrapher-monk," yet another talent to add to the famed of West Lake.[14]

Ruan, who by this time was already retired from official service and living in Yangzhou, still loomed large in the world of epigraphy and literati arts. Liuzhou must have been thrilled to have made this social connection. He embraced his new name, as did his friends. Chen Wenshu wrote a new set of five poems to rhyme with Ruan Yuan's, and on the occasion of Liuzhou's fifty-ninth birthday,

Guan Tingfen (1797–1880) wrote a cycle of ten poems harmonizing with Ruan's original, attaching them to a portrait of Liuzhou by Fei Danxu. Each of Guan's poems highlighted one of Liuzhou's erudite talents, from the study of Han-dynasty stele inscriptions to the knowledge of ancient bronzes, from his collection of famous calligraphy, including a Tang-dynasty handscroll by Huaisu, to his inscription of inkstones and seals.[15] But of these skills, it was the full-form rubbing that catapulted him to fame, and a closer look at key full-form rubbing images from Liuzhou's career reveals the innovative appeal these rubbings had for this epigraphy-mad generation.

Uncanny Antiquity

Liuzhou would not meet Ruan Yuan until 1838, when he was invited to make composite rubbings at Ruan's Jigu Studio in Yangzhou.[16] But Ruan Yuan's epigraphy endeavors formed a foundation for the younger scholar's early experiments with full-form rubbings even before he befriended the senior official. Among the monastic collections of inscribed antiquities that repeatedly attracted Liuzhou was that of the temple at Mt. Jiao in Zhenjiang, a place he visited on four separate occasions between 1830 and 1840 for the express purpose of studying the Taoling tripod and the Wuzhuan tripod, monumental bronzes paired there by Ruan Yuan a generation earlier (see chapter 3).[17] Through his studies of these tripods, Liuzhou began to develop one of his primary innovations on Ma Fuyan's full-form rubbing technique: the uncanny doubling of the object image within the same picture plane.

By the time he rubbed his 1839 study of the Taoling tripod, Liuzhou had fully realized his techniques (fig. 43). The short handscroll appears to show two tripods standing next to one another with their lids off. Liuzhou positioned the first lid image right side up and leaning against the tripod body so that it clearly displays its cast inscription. He arranged the second lid upside down, resting on its three capped-loop handles behind the second vessel image. The images of the bronzes are nearly identical in form, though one is turned with two legs toward the viewer, while the other is rotated with two legs away from the viewer. Three horse-hoof feet support each bronze, rising to rounded legs under low, curved bellies and ridged bands around the waist. A cast inscription runs in a loop above each waist, while two sturdy rectangular handles rise up above the squared rims.

The composite-rubbing forms appear to be displayed on a table or shallow ground plain, otherwise undepicted, in front of the viewer. Each section of the bronze rubbing image, from the angle of the handles to the positioning of the lid and the recession of the legs, reinforces a unified perspectival logic. This choice, combined with the seemingly different inscriptions on each vessel, suggests these are two different vessels within the same consistent picture space. In fact, they are two different rubbings of the same object, as the frontispiece title and

Fig. 43 Liuzhou, composite rubbing of the Dingtao tripod, 1839. Ink on paper, 25 × 663 cm. Zhejiang Provincial Museum.

inscription by Ruan Yuan make clear: "Fine Rubbing of the Han-dynasty Ding-tao Tripod. Originally, I bequeathed the Western Han-dynasty Dingtao tripod to Mt. Jiao to be together in the same place as the Zhou tripod [there]. In 1839, The epigrapher-monk Liuzhou made this fine rubbing [of it], and from it one can see the form of the entire vessel . . . looking at this is as if looking at the original vessel."[18]

Notably, Ruan's inscription makes no mention of the tripod's doubling.[19] Instead, he focuses on the image's effect: an understanding of the entire vessel form. By entirety, Ruan meant not only the front and back of the vessel or the top and bottom of the lid. He also meant the full inscription was made clear. Ruan's sense that this image offered a more complete view of the bronze was equally based on textual and visual depiction, and redoubling was essential to the complete view of the text in the round.

For an understanding of how different this full-form rubbing technique was, compare it to Ouzhuang's rubbing of the same object, attached to the beginning of Wang Xuehao's 1803 handscroll painting *Presenting the Tripod* (fig. 39). Ouzhuang's prized rubbing captured the cast inscriptions in an isolated strip of text, only allowing viewers to think about the words in relation to one another. In contrast, Liuzhou's composite rubbing clearly depicts the relationship between the inscription and its support, describing the cast text, the body of the vessel, and the interior and exterior of the lid together in a cohesive image. It emphasizes the relative scale of the inscription in relation to the vessel as well as the inscription's proper perpendicular orientation to the ground plane. Thus, the image replicates the necessary viewing action of contorting one's body to read

the inscription by craning the head to the side to follow the path of the text as it travels in a loop to meet its own beginning. While Ouzhuang's image forces the bronze text into a more modern textual organization of vertical columns, Liuzhou's image refuses the order of printed text, returning instead to a simulation of the original vessel's surface order.[20]

Han Chong's (1783–1860) description of viewing Liuzhou's rubbing of the Zhou-dynasty vessel at Mt. Jiao highlights this sense of seeing the object in the round as well as the tactile nature of the image: "When I opened the clasp [of this handscroll], the thunder and clouds rolled away. Dragon patterns circle this vessel's rich swells, forming [the image of] a Zhou ritual ware as never seen before . . . with his hand grasping a pad and a hammer, Master Liu pressed through its mountain snows, caressing each protrusion and gap to read these wondrous words, going directly to the mountain monks to seek out the true vestiges of the past."[21]

Han's remarks focus on the patterns that "circle this vessel's rich swells," responding to the dimensionality of the flat image in his hand and to the fact that Liuzhou's doubling of the vessel permits this circle's full visibility. Praising the physicality of the epigrapher-monk's contact with the original bronze, of his "caressing" the uneven surfaces of its "protrusions and gaps," Han shows visual understanding of the full-form rubbing image and instigates a tactile imagination of Liuzhou's own interaction with the bronze.

Liuzhou designed his image to stir viewer responses like Han Chong's by capitalizing on the immediate and intimate relationship of rubbings to their referents. This indexical and relic-like relationship of the rubbing to the original object has been described in scholarship as a "manufactured skin peeled off the [stone or bronze] object," an apt tactile metaphor that deserves expansion and revision.[22] If a singular rubbing like Ouzhuang's can be seen as a skin, then by extension of the metaphor, Liuzhou's composite image, involving multiple rubbings and in-painting, can be understood as the artful arrangement of those skins in a cohesive and separate pictorial space to reconstruct the corporeal body of the referent object, including the visual illusion of its three-dimensional presence as well as the tactile sensations of its surfaces. But what would the corporeal status of this zombie-like object be? Do its skins sense the world as a body would? Do viewers interact with it as if it were a body with its own capacities to sense? From the evidence of various colophons and inscriptions appended to rubbings, it seems that rubbings might best be described as images of suspended sensory perceptions rather than skins. Early Chinese thinkers qualified sensations as relations that existed between subject and object, rather than as the properties of one or the other. This is what Liuzhou's composite rubbings offer their viewers: the sensations of an object that is no longer present. They are direct apprehensions of the world, captured in ink on paper.

Seasonal Flowers, Everlasting Inscriptions

Over the same ten years that Liuzhou visited the tripods at Mt. Jiao, refining his skills on these monumental bronzes, his reputation blossomed throughout the lower Yangzi River region. By the mid-1830s, collectors were already seeking Liuzhou's expertise for the documentation of their collections. In 1835, Chen Jian (1786–1839), then serving as governor of Jiangsu Province, invited Liuzhou to spend time at the Canglang Pavilion in Suzhou.[23] While there, Chen requested that Liuzhou create a handscroll of his collection of antique bricks with molded inscriptions. The resulting image, *Floral Offerings in Ancient Bricks* (fig. 44), was one of Liuzhou's earliest combinations of full-form rubbings with painted flora. As with his uncanny double images, Liuzhou's juxtaposition of flower painting and rubbings combined the serious study of antiquity with an alluring fictive space.

Liuzhou selected twelve of the bricks in Chen's collection, rubbing the text-bearing surfaces of each in an arrangement of alternating vertical and horizontal forms along the paper. Each brick is an architectural fragment bearing the ancient name, place, and date to which it once belonged. The arrangement of these rubbed texts therefore constitutes a miniature historical progression, presenting a visual equivalent to the books about epigraphy collecting published by these same authors (see chapter 2). But Liuzhou moves this handscroll beyond the status of documentary work by selectively rubbing the side and back edges of each brick along diagonals to create orthogonal lines, filling in the spaces between with painted ink when necessary. As with his rubbings of the Mt. Jiao bronzes, this technique establishes a relatively consistent perspectival illusion throughout the handscroll, whereby the bricks appear as three-dimensional objects on an undefined ground plane receding within the image. However, Liuzhou moved one step further with this handscroll: he left the top face of each brick undefined,

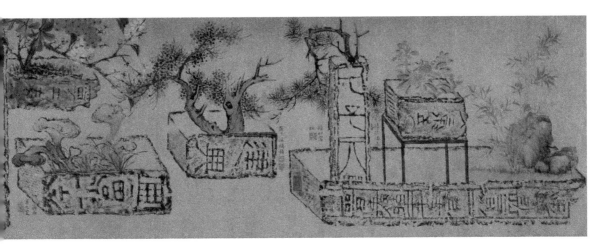

Fig. 44 Liuzhou et al., *Floral Offerings in Ancient Bricks*, composite rubbings of ancient bricks with in-painted flowers by various artists, 1835. Ink and color on paper, 25 × 141 cm. Zhejiang Provincial Museum.

as an open expanse of paper into which Chen's friends could then add various painted flora. The images of the aged relics, with their fragmented edges and abraded surfaces, became the sites of new growth, a network of ancient objects blossoming by means of the network of contemporary friends that embellished them. Through this illusionism, the flat surfaces of the brick rubbings are unified into a tabletop garden and relic-scape.

Huang Jun (1775–1850) began this progression of in-painted bouquets with a vignette of rocks and bamboo growing forth from the interior of a long molded brick from the Jin dynasty (265–420) and painted in the style of the Yuan-dynasty painter Ni Zan. Continuing down the length of this brick, two more bricks are rubbed to appear as if they nestle within the first. One of these fragmented rubbings bears a truncated text, "[Yuan]kang fifth [year]," and is supported on a small table. Orange calendula blooms from it. The other, a rubbing of a slender vertical brick, carries only a partial inscription of two characters, rubbed in an incomplete manner so that the lower half is occluded by the side of the long brick within which it appears to stand. A withered pine branch painted by Yongqiu, bends up and over its lip, splitting to the left as a second offshoot peeks out from behind the brick. Yongqiu paints the smaller branch so that it disappears behind the brick body while simultaneously appearing to be continuous with one of the characters cast in the brick surface. More contributions follow: a *lingzhi* mushroom by the monk Shushi); a trio of flowering plum, fir, and pyracantha berries by Yao Ding; a Taihu stone by Seng Yuqiao; a narcissus by Chen Kanru; a blossoming plum by Ji Yuji; an orchid by Liuzhou himself; and a rock among grasses by Song Xi, Liuzhou's monastic teacher.[24] Each painter responds both to the open rectangle of brick that Liuzhou provides and to the painting of his collaborators,

interweaving branches, stones, and blossoms among the trace images of worn earthenware.

Their miniature compositions therefore contain two different representational logics. As rubbings, each is an indexical reproduction of its referent, in a one-to-one ratio, and has the added aura of direct contact with the original antique object. As paintings, each is an imaginative permutation of brushwork and wash that draws on the compositional schema of preceding painters. While both of these modes of representation may appear to challenge each other, a similar tactile appeal conjoins them: one evokes the touch of the antique object, while the other is the product of the painter's hand. In this handscroll, the various practices of epigraphy, collecting, painting, and calligraphy are bound together into one cohesive image by means of touch, simultaneously networking a dozen friends with one another and with the past.

Ancient bricks with molded inscriptions were among Liuzhou's favorite antiques. There is no record that he hollowed out such bricks to create actual planters, as depicted in the painting. But it was common practice to modify ancient bricks to make inkstones, an action that redoubled the tactile appeals of the antiquities. Liuzhou alluded to this in an inscription on one such inkstone, a new acquisition that excited him for historical reasons. It was from the Zhengming era of the Liang dynasty, and he already possessed in his collection a brick from the Kaiping era of the same dynasty. "Uniting these two friends," he writes, "my ink dances in the shadow of the brush, tilling this square inch."[25] The bricks, personified as friends, became the sources of both antique authority and of new ink "tilled" from contact with their ancient surfaces.

Liuzhou frequently combined brick rubbings and painted flora. In one such image, a fan painted and rubbed for the Hangzhou collector Cheng Hongpu, he elaborated on his innovation: "This is neither a stone made by the laws of nature nor a brick turned out by a brick-maker. This is the result of poured and daubed ink, and relies on the downy crown [of this brushtip]. Muweng [Cheng Hongpu] likewise ignores all methods, knowing his rebirths and his fate. Forgetting the difference in our ages, we travel together, meditating on poetry and painting."[26] Acknowledging the strange newness of his images, Liuzhou likened them to a methodless approach to painting, one that relied less on emulating canonical painters than on the realizations of an enlightened heart-mind, one aware of both its previous and future (Buddhist) lives.

Miniature Figures and Monumental Bronzes

Collaborative in-painting became a signature practice in Liuzhou's work, which expanded to include figure painting as well. The results of combining figure painting with rubbings produced the entirely new effect of making the rubbed simulacra monumental in scale, confounding the relationship between the

Fig. 45 Liuzhou and Chen Geng, *Cleaning the Lamp*, composite rubbing of a bronze lamp in the shape of a goose foot with portraits of Liuzhou, for Cheng Hongpu, 1836. Ink and color on paper, 31 × 69.5 cm. Zhejiang Provincial Museum.

viewing body holding the handscroll and the indexed body of the object rubbed. This effect is most apparent in the image that brought Liuzhou the most fame among his contemporaries, his 1837 handscroll *Cleaning the Lamp* (fig. 45), also painted for Cheng Hongpu.

In 1836, Wu Tingkang introduced Liuzhou to Cheng Hongpu in Hangzhou. Cheng was one of the premier bronze collectors of the early nineteenth century and a close enough friend of Ruan Yuan to have made him the gift of an inkstick in the shape of a stele. Cheng invited Liuzhou to his Bronze Drum Studio in Xin'an to view over one thousand of his collection objects. As Liuzhou would later recall in an inscription on Cheng's portrait, when they first met, they "recognized each other as if from a prior life, and taking one another by the shoulder they went walking together into the forest [of letters], disappointed that they hadn't met earlier."[27]

Their fruitful collaboration ranged from full-form rubbings of Shang- and Zhou-dynasty bronzes to images of bricks with in-painted flowers. It also led to one of the most commented-upon works of Liuzhou's career, *Cleaning the Lamp*. In this short handscroll, Liuzhou repeated his technique of juxtaposing two rubbings from two sides of the same object, a bronze lampstand shaped like a goose foot. He also repeated the strategies of manipulating the arrangement of the composite rubbings and applying in-painting to unify the set of individually rubbed skins into a collective simulation of the real object. As in his other work, he organized the overall composition around a cohesive perspectival logic to give viewers the

impression of observing the object in a gently receding picture plan, as if it were on a table in a scholar's studio. But with *Cleaning the Lamp*, he extended these practices by animating the picture space around the rubbing. No longer simply understood as documenting selected surfaces of an object, the full-form rubbing image served as a picture in which human interactions could occur.

In the first composite rubbing of this brief handscroll, he shows the lamp-stand foot down, the position in which it was meant to be used. A likeness of Liuzhou, painted over the rubbing by the artist Chen Geng (fl. mid-nineteenth century), leans against the bronze goose leg, gazing at and caressing its surfaces. The second rubbing depicts the lampstand upside down. Here, the small figure of Liuzhou crouches over the cast inscription to clean out any detritus that may have settled in the inset lines of the text, as if preparing them for the clearest possible future rubbings.

Observing the small figures of Liuzhou interacting with the rubbings, a viewer experiences two simultaneous and contradictory responses to the hand-scroll. Each rubbing is understood by its very nature to represent the lampstand on a one-to-one scale. As life-size renderings of the lampstand, they convey the original object's scale and portability. A hand holding the painting is commensurate with a hand holding the original object. But within the picture, the rubbings become monumental in scale, dwarfing the body of the human caretaker, whose small hands are transformed to equal in size the individual characters on the bronze. Touching the rubbed image of the bronze, the small portrait of Liuzhou points directly at the source of this disjuncture in systems of representation: the capacity of a rubbing to be understood both as a simulacrum of an object and as an object in its own right. This composite rubbing-and-painting breaks down such ontological boundaries, and in the process it offers viewers a vivid sense of visual and tactile intimacy with the ancient vessel.

Cleaning the Lamp captured the attention of Liuzhou's contemporaries more than any of his other images. When Ruan Yuan bestowed the nickname "epig-rapher-monk" on Liuzhou, he cited the line "poetry by lamplight" from a poem that not only mentioned Nanping, Liuzhou's home, but also directly referenced the lamp image. In a similar homage, He Shaoji wrote an essay and three long poems about Liuzhou's lamp rubbing image, lauding his efforts at clarifying the inscription for later scholars. His preface begins, "Liuzhou used a needle to scrape and felt padding to form an impression, making the words bright and distinct, as if the vessel were newly pulled from the mold." In the poems that follow, he reiterates the same themes:

> A needle that liberates frozen words and strokes submerged grime, reveal-ing flowers for each season;
> A precious rubbing that finally bequeaths to us what has been so hard to read . . .

I have long wanted to make true comparisons of the nature of these things
 locked in bronze, and in this image its ancient and virtuous body is clear
 and pristine.[28]

As evidential research scholars, these viewers were primed to seek in
Liuzhou's rubbings new ways of clarifying ancient texts. In his description
of *Cleaning the Lamp*, He Shaoji notes that many famous epigraphy schol-
ars before had commented on this famous lamp, but until Liuzhou carefully
cleaned away the "frozen words and strokes submerged grime," each of these
learned men had misunderstood the real content of the inscription. While schol-
ars purported to prioritize the information found in the texts on such objects,
they were not immune to the fetishistic appeals of these object-bearing images.
Liuzhou's combination of paintings and rubbings indulged those desires while
maintaining scholarly airs. The diminutive twin figures of Liuzhou painted by
Chen Geng illustrate this overt longing for ancient bronze objects that drove the
production, accumulation, and publication of rubbings among epigraphy schol-
ars in the early nineteenth century. Their actions tell us as much—one caught
in the awestruck act of simply caressing its surfaces for the pleasure of their
touch, the other absorbed in the act of cleaning out the characters to better read
them. Liuzhou illustrates these dual motivations primarily though the shift
in scale. The bronze produces awe in the first Liuzhou by physically dominat-
ing the image of his body, while the miniaturized form of the second Liuzhou
allows him access to the fine grooves of the cast characters, focusing the tip of
his needle to a point so minuscule and precise that it was only possible in this
fictional world.

Embodied Images

As the previous images demonstrate, the perspectival organization of Liuzhou's
full-form rubbings in a unified picture plane brought optical clarity to them,
while the relic-like status of rubbings bestowed tactile indexicality on them.
Combining these two types of sensory information, Liuzhou documented and
portrayed his subjects for viewers in a way that reproduced the feeling of being
in the presence of the original object. The embodied nature of these reproduc-
tive efforts became all the more acute when the rubbed object was Buddhist in
origin, as in Liuzhou's 1836 painting *Paying Homage to the Buddha* (fig. 46).

In this short handscroll, Liuzhou combines his full-form rubbings of a small
Buddhist shrine with Chen Geng's figure paintings of Liuzhou and two other
monks, one dressed in blue and the other in tan. Based on the size of the rubbings,
the original shrine would have stood only about twenty-five centimeters high.
But in the fictive space of the handscroll, the shrine dwarfs all painted bodies.
Within the painting, the once-miniature shrine takes on the proportions of a full

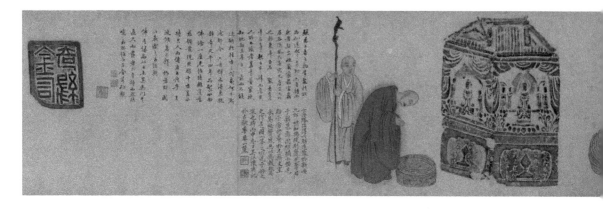

Fig. 46 Liuzhou and Chen Geng, *Paying Homage to the Buddha*, composite rubbing of small stone shrine with portraits of Liuzhou and two monks, 1836. Ink and color on paper, 27 × 264.5 cm. Zhejiang Provincial Museum.

life-sized statue, and the figures of Maitreya, the future Buddha, and their flanking bodhisattvas rise to meet the downcast eyes of the very figure that reproduced them within the image. In the process, the painting visualizes two issues at the heart of epigraphic reproduction: the corporeal status of the rubbing in relation to the rubbed object and the imaginative projections such rubbings inspired in the people who made them.

The rubbing portion of the handscroll includes two full-form rubbings, each of which reproduces two sides of an Eastern Wei–dynasty stone-carved Buddhist shrine sculpture dated to the year 537. In each set of rubbings, one side of the shrine faces the viewer parallel to the viewing plane while the adjacent face is rubbed to conjoin with the first and points away from the viewer along an orthogonal line that recedes to the left, following the directional flow of the handscroll. Within this picture space, Chen Geng painted four iterations of two monks standing before or kneeling in obeisance to the two images of the sculpture. One monk in a russet-colored robe, Liuzhou, appears four times, once in each pairing, while two monks—the first in a blue robe with a red lacquer tray and small basin, the second in a tan robe with a gnarled wooden staff—are each repeated twice. The sequence begins with an image of Liuzhou painted standing in profile, hands clasped, facing the front side of one pair of these conjoined rubbings while an image of his blue-robed friend turns his back to the viewer to better focus on Liuzhou's ritual efforts. The next image of Liuzhou rotates his body to face the adjacent side of this same full-form rubbing, as if he were making his way around the tiny-sculpture-made-large, one face at a time. In this appearance, he kneels on the woven reed cushion in front of him, hands intertwined in a mudra gesture. His blue-robed companion, back still turned to us, offers Liuzhou the contents of the small basin—water to cleanse his hands. Moving to the second set of rubbings, a new companion monk faces out toward the viewer and simply stands beside Liuzhou, looking on as the epigrapher-monk

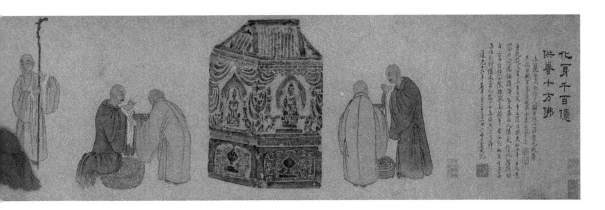

takes a fully prostrate position in front of the shrine image. Finally, the fourth image of Liuzhou shows him partly raised up, head still nodding toward the last face of the shrine rubbing that he has now fully circumambulated in reverence. The doubling of the object and the redoubling of the figures in this image offer a subtle spatial and temporal dimension to the viewing experience. Though the rectangular picture plane of the handscroll remains static, moving right to left through it, we rotate in a circle around the two-dimensional depiction of the three-dimensional object, seeing each side of the sculpture along with Liuzhou and his companions.[29]

An inscription by Liuzhou prefaces the image, beginning with a couplet clearly referencing the Buddhist concept of bodily incarnation: "One thousand, one hundred, one hundred million incarnations; To the Buddhas of the ten directions, I make offerings." Liuzhou follows this by explaining that he requested Cheng Geng paint the figures with this couplet in mind.[30] From the beginning, then, this image intended to impress on viewers a sense of Liuzhou's religious devotion. His couplet commits him to making offerings to the Buddha in this life and every other life. He is shown doing just that, four times over, each visualization of his body corresponding to an incarnate moment of offering. In addition to these devotionals, the very act of producing an image of the Buddha was an offering, and it brought good karma, meaning that in the creation of the rubbings for this handscroll, Liuzhou redoubles the act of faith he is shown to be performing in the image.

The combination of rubbing and painting in this handscroll served the priorities of Liuzhou the Buddhist as well as those of Liuzhou the epigrapher, as a second impression and inscription following the primary image makes clear. This latter impression, of a large seal carved by Liuzhou, bears the words "uncanny effect [arising from] metal and stone," a phrase that merges his epigraphic pursuits with his Buddhist ones. For Liuzhou, his discovery of the stone shrine

was an inevitable result of his previously accumulated karma, as he elaborated
in an inscription following the impression:

> I've collected inscriptions of over one thousand [Buddhist] sculpture
> inscriptions from the Six Dynasties, Tang, and Song periods, and made
> an album of them. When I was younger, I went to the stone caves at
> Longhong, searching out sculptures to rub. I obtained more than three
> hundred rubbings, but sadly, I collected not a single stone . . . and now,
> to obtain this ancient object that is over one thousand years old, and in
> such good condition . . . must truly be an effect arising from actions in a
> previous life. Therefore, I've carved these four characters, so that those
> who later own this might know my devotion could not be impeded.[31]

According to this logic, each act of rubbing a Buddhist object added to both
Liuzhou's Buddhist and epigraphic karma. Moreover, the word he uses, effect/
causation (*yuan*) has additional valences in Buddhist terminology. Its use in the
sense of "effect" is tied to ideas about preexisting conditions that produce indi-
rect results in the world, linking it to notions of karma and destiny. It is also used
to describe worldly associations or attachments. But within Buddhist discussions
of consciousness, it is the connection made by the mind to the world's sensory
phenomena, an act of perception or objectification.[32] In this sense, the four words
of Liuzhou's seal point to the fundamental role that sensory acts played in the
production of knowledge about both epigraphy and Buddhism. Through sens-
ing the world, one understood it, and Liuzhou designed his full-form rubbing
images to replicate this experience of direct apprehension for viewers.

His contemporaries commented on their experiences of handscroll through
the same themes. Both Han Chong and Tang Yifen wrote odes about this image.
Each long poem incorporates the phrases of Liuzhou's opening couplet while
emphasizing the sense of touch, the act of reproduction, and Buddhist faith. For
Tang Yifen, the stone sculpture, which had long lay dormant, was only activated
again by Liuzhou's attention and touch. Tang's ode begins, "one day it arrived
in the hands of the Canglang Monk (Liuzhou), who worshipped, caressed, and
prayed to this wondrous thing." Han Chong echoed these ideas in his own ode,
writing: "By chance he wiped away the grit from this broken shrine / so the light
of its great wisdom toward heaven now shines" as well as "Holding it, great joy
and happiness return / caressing it, hunger and fatigue are forgotten / Cleans-
ing one's hands, a fine impression of it is rubbed / iridescent ink to transmit it
for later generations."

Meditations on practices of reproduction complemented the tactile imag-
ery in both Tang's and Han's poems. As the poetic images of Han's ode further
described the situation, they also reinforced the shift in scale that makes Liuzhou's
image so effective:

It has been two thousand years since the dharma came to China.
[The Buddha's] innumerable incarnations saved those who suffer the seas
of pain.
The living, wanting to repay this kindness, look up to the Buddha in front
of their eyes.
Sculptures of wood, stone, precious metals, and jade, each and every one
carved and cast as offering.
The greatest stand many meters long, chiseled high into peaks and cliffs.
The smallest are only a few inches in size, their thrones supported by blue-
green lotuses.[33]

Tang elaborated on the theme of reproduction but added a further thought on
the epigraphy scholar's role: "To obtain Buddhahood one reproduces the Buddha's
form. This principle is correct, and not just subjective speculation. Gentleman
[Liuzhou] treasures antiquity without treating the Buddha glibly, and [from this
relationship] strange effects/perceptions [*yuan*] unexpectedly arise."[34]

Buddhist belief was tied to notions of reproduction. In some sects, even
the reproductive act of speaking the Buddha's name once, with sincerity, could
ensure escape from the cycle of rebirth, as the speech act brought knowledge
of the Buddha into the world. When Liuzhou reproduced Buddhist objects like
his shrine in full-form rubbing images, faith and antiquarianism went hand in
hand. Liuzhou's uncanny images of the Buddha manifested more images of the
Buddha, in new perceptions that had real-world consequences for viewers.

Fragmented Pasts

The status of Liuzhou's hybrid artworks in relation to other kinds of knowledge
preoccupied him from time to time. On occasion, he presented his artwork as a
lesser sort of knowledge in relation to the time-honored literati skills of poetry,
painting, and calligraphy. In other moments, he asserted that the value of study-
ing inscriptions made by humble, unnamed artisans from the past eclipsed the
knowledge to be had from the more established literati arts. He grappled with
this ambivalence most clearly in a subset of rubbed composite images that he
generally titled "century" images (*baisui tu*) (fig. 47).

These were composite rubbings in the sense that many different surfaces were
selectively rubbed into an arrangement as a single image. But unlike his other
full-form rubbings, Liuzhou's century images did not aim to produce the full
semblance of a single three-dimensional object. Each of the rubbings came from
separate sources, ranging from molded roof tiles, cast coin molds, engraved steles,
calligraphy models, and tombstones. Additionally, each rubbing was presented
as a flat surface, and they coalesced into a collectively flat collage, without the
addition of shading or modeling.

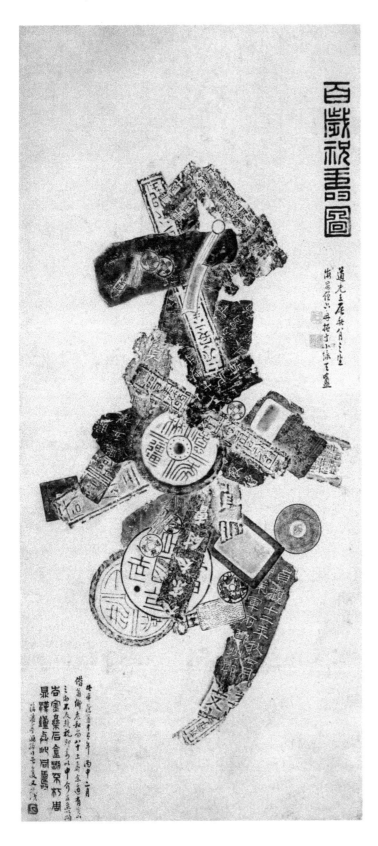

Fig. 47 Liuzhou, *Wishing a Century of Long Life*, composite rubbing in the shape of the character *shou* ("longevity"), for Abbot Jie'an on his eighty-second birthday, 1836. Ink on paper, 135 × 60.5 cm. Shanghai Museum.

Sometimes, these collages formed large, ragged monoliths of no discernible order. Other times, the outer boundaries of a word were first outlined in faint tracing lines, with rubbings then arranged to fit within them, producing a piece of calligraphy with "strokes" formed by the many antique fragments of the past. The outline of the word "longevity" (*shou*) was his most common choice, and in keeping with the word, Liuzhou gave such images as birthday gifts.[35] The name he gave these works, "century" images (*baisui tu*), also suited this purpose, as it punned on the words "year" (*sui*) and "fragment" (*sui*): a hundred fragments of that past as the hundred years of a well-lived life.[36]

Liuzhou made one such composite birthday rubbing in the form of the word "longevity" for the eighty-second birthday of Abbot Jie'an of Mt. Jiao (fig. 47). The poem he inscribed on the image in archaic clerical script references the famous bronzes of Mt. Jiao (see chapter 3 and earlier in this chapter), reading, "auspicious metals and joyous stones, these unyielding *varja* cannot break / a Zhou tripod and a Han brazier, each endures in longevity."[37] In his poem, Liuzhou ties wishes for the monk's long life to the survival of the ancient bronzes he cared for and then compounds his wishes by comparing these epigraphic sources to the *varja*, a Buddhist term relating to adamantine metals and stones and the inde-structible wisdom of Buddhist enlightenment, often visualized as a thunderbolt scepter.[38] This poetic mixture of pre-Buddhist bronzes with Buddhist terminol-ogy is matched by an image that illustrates none of these things directly. Instead, the large *shou* character image is made up of a variety of rubbings, including those of early coins, Han-dynasty bricks and steles, later inkstones, and a poem by the Ming-dynasty scholar Wang Shizhen.

In his inscriptions on other composite-rubbing longevity images, Liuzhou further extended connections between the Buddhist body, epigraphic sources, and the material survival of traces from the past. "Do not overlook one's contempo-raries while loving the ancients; over a thousand autumns may separate us from them but we take the same joy in spring," he begins, highlighting the funda-mental literati value of communion with the past. Continuing, his tone becomes more mournful and self-reflective: "[Making] tracing-copy rubbings with rattan paper is an insignificant skill, reflecting only jagged edges where there is limited truth to be had / My occasional caressings of these last five years are [but] monks' robes, patched and broken all over / People ask me where these came from: a leaky room full of scars where words are meditated upon."[39] On another of these images, he echoes the sentiment that his skill at making rubbings is only a humble one, writing, "Accumulated bronzes and collected stones; I call this 'One Hundred Years.' It doesn't amount to an essay, only a little bit of wisdom."[40]

While comments like these gesture toward humility wrapped in melancholy, elsewhere Liuzhou refers to his practice as an intentional alternative to the lite-rati tradition. In an inscription on one of his brick inkstones, he writes, "The wealth and value of the brick have been preserved for a thousand autumns. The

wealth and value of the literati is like mist and clouds passing in front of one's eyes. I take Tao Kan (259–334) as a teacher, who moved stacks of tiles to practice diligence."[41] As Ruan Yuan had stated before him, and as the obsessive work of many epigraphy aficionados of this generation attested, epigraphy offered more direct access to the past than existing exemplars of literati culture. This sense of direct access derived from the durability of clay, stone, and metal materials, as well as from the anonymity of the original artisans who inscribed or cast texts onto these objects from the Shang, Zhou, or Han dynasties. Ancient concrete objects made by those with no subsequent historiographies were less likely to be corrupted by either the physical changes that affected weaker media like paper and silk or by the generations of textual recension that created scribal errors, warping the words of renowned figures from the past.

Liuzhou's "century" images can be understood as a visual microcosm of the perceptual and philosophical issues that made epigraphy central to evidential research. After reducing knowledge to its primary components—those frag-mented objects of the past that can be considered true because of their material authenticity and their historical modesty—how does one conglomerate this evidence to form a body of knowledge? What shape would that knowledge take? Seen in this way, these particular composite rubbings become evidential research essays composed of specific tactile experiences with authentic objects spanning millennia of knowledge and culture. The topics of the essays are their forms: longevity, as built from direct experiences with the past.

Later in the nineteenth century, these kinds of composite-rubbing collages came to be called the "eight brokens" (bapo). Many art historians credit their combination of fragmentation, ancient source material, and trompe l'oeil style to Western influence, and they read them as images that meditated on the traumas of the mid-nineteenth century, when the Taiping Rebellion and the Opium Wars brought about a cataclysmic destruction of life as well as the widespread erasure of historical knowledge in the many private libraries and collections destroyed then.[42] However, for Liuzhou, who pioneered the practice of bapo before it had that name, in a time before these wars, mourning was not the primary motivation. Instead, Liuzhou's composite-rubbing practice used the combined senses of touch and vision inherent to this mode of image-making to make the past an imme-diately perceptible experience that was felt with the body as it was understood with the mind. Through the combination of various strategies such as selective rubbing, in-painting, ground-plane manipulation, doubling, and the addition of figures to monumentalize the rubbed objects, Liuzhou created uncanny and immersive sensory experiences that reincarnated bronzes and stones for faith-ful devotees.

Liuzhou's peers responded to his images with enthusiasm, understanding them as equivalent to being in the presence of the real objects they reproduced. A

biography of Liuzhou written by Jiang Baoling in the mid-nineteenth century stated that Liuzhou's full-form rubbings "conveyed shadow and light, as well as concave and convex, like the true [objects] in all respects."[43] The epigraphy scholar Chen Jieqi (1813–1884) even remarked that with the innovation of full-form rubbings, early nineteenth-century practitioners surpassed their ancient predecessors in the art of antique rubbings, a sentiment rarely voiced among later literati, who held the ancients up as incomparable exemplars to which contemporary scholars could only aspire and, if lucky, match.[44]

Comments such as Jiang's may seem to prioritize the visual accuracy of Liuzhou's rubbings. But it was not just a replication of the visual experience that Liuzhou and his contemporaries were after; tactility was equally important. Liuzhou's comments, and those of his contemporaries mentioned earlier in this chapter, make it clear that the direct contact between these images and their referents determined their success. Liuzhou reiterated this tactile thinking in many ways, the most obvious of which were the in-painted figures he commissioned from Chen Geng, which were often depicted in the act of touching the rubbings, images that had, in turn, touched the real objects. Even the seals he added to his images sought to make this point about touch: several seals were inscribed with the words, "a rubbing by Liuzhou's hand," laying emphasis on the hand to call attention to his direct manipulation of this new form of knowledge. A rubbing provided proof of direct contact with the object, and the in-painting eased the vessel's transformation from a three-dimensional tactile object into a two-dimensional visual representation. Both were driven by a desire to convey a sense of true bodily experience.

The next chapter turns to Chen Hongshou's interests in a similar set of issues. As Chen embraced the epigraphic aesthetic, he used it to question the dominance of brushwork canons in the literati arts, like many of his peers. He also turned his new tactile thinking to the full range of literati media, beginning with calligraphy and seal carving before moving to the less common art forms of finger painting and teapot construction. In each of these mediums, he commemorated his interpersonal relationships by concretizing them in objects that offered primarily tactile experiences, producing artworks that are best described as tactful.

A Tactful Literatus

Among the various scholars Ruan Yuan brought up in his network, Chen Hong-shou (1768–1822) best exemplifies the turn toward touch that epigraphy inspired in the literati arts. Inscription, materiality, and an emphasis on the physical intimacy that art objects created between friends characterize Chen Hongshou's oeuvre. The artworks he produced across a variety of media sometimes attested to new friendships. Other times, they commemorated the building of new residences or libraries. Frequently, they documented the reunion of old friends. But as this chapter argues, in their consistent relation to touch, the works of Chen Hongshou aimed to intimate his presence when he was absent, acting as metonymical placeholders for his body in a network of bodies articulated by touch—a network of tactful literati.

Of all his contemporaries, Chen Hongshou's production spanned the broadest material spectrum, including stone seals carved in the style of Han-dynasty inscriptions, brushed calligraphy in clerical scripts derived from steles, and most notably, finger painting and teapot production. While calligraphy was a requisite art for any lettered elite, seal carving was a rarer practice, and the arts of finger painting and teapot crafting were even less common, with only occasional precedents among literati from the Ming dynasty onward.[1] Chen's preference for these brushless arts underscores the increasing emphasis this generation placed on the tactile nature of artworks, a shift that created alternatives to overdetermined orthodoxies of brushwork while still connecting literati to one another through a shared relationship to the past.

The Iron Brush

Chen was born in 1768 in Qiantang, a wealthy district of Hangzhou along West Lake's northern bank. After the death of his mother in 1782, and due to the

itinerant nature of his father's work, in 1784, Chen and his brother went to study with his maternal uncle, Xu Lian (d. 1786), in nearby Haichang (modern-day Haining). The Xu clan was famous in the late Qing era for its many scholarly sons. Through his education there, Chen was incorporated into a larger network of Zhejiang scholars, including his lifelong friend and fellow seal carver Chen Yuzhong (1762–1806). The older Chen (no family relation) was a seal aficionado at a young age, and in his teens, he had begun to earnestly study the carving techniques of two of Hangzhou's most notable literati, Ding Jing and Huang Yi. The younger Hongshou took his cue from Yuzhong, who would later describe their relationship with the apt metaphor, "two heart-minds imprinted on one another [like seals]."[2]

After his uncle died, Chen began to build relationships within his extended family and social circles. In these next few years, he made several visits to Nanjing to see the poet Yuan Mei at his Suiyuan Villa, a hub of artistic exchange among the educated elite of the lower Yangzi River delta. As with most young men of his class and education, Chen's introduction to elite circles like Yuan's came through the connections of family, friends, and marriage. In this case, both his paternal grandfather and his wife's grandfather were close with Yuan Mei.[3] He also spent significant time in these early years with the scholar Zhu Peng (1731–1803) and his student Li Fangzhan (1764–1816), traveling with them while he wrote poems and began to experiment with carving seals.

One of Chen's earliest dated seals was carved as a birthday gift for his wife's brother, Gao Rijun (1772–?). Cut in 1793, the double-ended stone features relief carving on one end and intaglio carving on the opposite end (fig. 48). On the relief-carved side, the characters *ri* ("day"/"sun") and *jun* ("profound depth"/"dredge") spell out Rijun's given name. But their composition also reveals the ways that seal carving encouraged linguistic play. In cutting the second character, Chen divided the radical from its core phonetic component, making three equal columns out of two original characters. The final impression could then be read either as Rijun's name or as the three words *ri* ("day"/"sun"), *qun* (name of mythical emperor Yao's father), and *shui* ("water"). Indulging in the visual and semantic flexibility of written language was a hallmark of seal carving, an art form that encouraged experimentation with the boundaries of legibility as a means of testing a viewer's linguistic knowledge. A carver like Chen Hongshou, who was well educated in philology and epigraphy, could play with the reorientation of character composition and orthography to excavate extra depth from the names of his friends and relatives.

Seal carving was the first scholarly art Chen Hongshou began to master. Though only a few hundred of his seals remain today, he carved over a thousand in his lifetime, crafting each seal to suit his relationship with its recipient. On the sides of most stones, he also added personal inscriptions. Sometimes, these included only a simple date and name; other times, he wrote a narrative that attached memories of specific events to the concrete object, often using phrases or poetic

Fig. 48 Chen Hongshou, impressions of a double-ended seal for Gao Rijun, 1793. Red seal paste and ink on paper, dimensions unknown. From Kobayashi, *Chūgoku tenkoku sōkan*, vol. 16.

lines that referenced both the immediate past and archaic sources. In this sense, his seals used many of the same strategies of networking that characterized the brush arts, even including their reinscription at later reunions. Within the epigraphic aesthetic of the early nineteenth century, seal carving was yet another medium literati used to extend their explorations of language's many roots while simultaneously shoring up their social capital among influential scholars and officials.

As with paintings and calligraphy, the shared appreciation of seals cut by renowned carvers was a means of networking. Among the first documented interactions between Chen and one of his closest friends, the poet Guo Lin, was their meeting in the first month of 1792 to appreciate a seal by Xi Gang, one of the two most respected seal carvers still alive at that time. Over the course of their friendship, Chen carved at least fifty seals for Guo, more than any of his other friends. These seals represented a physical record of their relationship, and that friendship was called to mind each time the seals were used. The loss of even one seal was deeply felt. As Guo Lin later wrote in his record of Chen's seals, "[Chen Hongshou] carved maybe forty or fifty seals for me. One was stolen, others were lost in a fire at an inn along the Qing River. I only have these left, and so I've collected them all in one case and am writing a record of them."[4]

Chen found his footing as a young scholar within Hangzhou's central artistic circles, forming an early network of friends that would support him throughout his lifetime and concretizing his relationships with them through art objects, especially seals. As his social circle expanded, so did his production of seal carving. Later in 1792, Chen was lucky enough to meet Xi Gang at a gathering hosted by He Yuanxi at the edge of the West Lake. Guo Lin was there, as well as Chen's friends Zhu Peng and Li Fangzhan, who may well have been key to gaining him entry to He's social circuit. A dozen or so fellow Hangzhou art world luminaries were at the gathering, which He Yuanxi christened "The Deshu Hall Poetry Recitation Society."

Fig. 49 Chen Hongshou, *Gentleman Who Faces This in Desolation* seal for Xi Gang, 1796. Carved Qingtian stone, 2.5 × 2.6. × 6.1 cm. Shanghai Museum. From Lai Suk Yee, *Art of Chen Hongshou.*

By 1796, Chen was close enough to the master seal carver and landscape painter Xi Gang to be able to carve a seal for him (fig. 49). The five-character text Chen cut for Xi reads "gentleman who faces this in desolation" and was done in what he described as a "Han-dynasty" style. In a long colophon inscribed along two of the seal's vertical faces, Chen Hongshou further explained the reason for the seal's creation. Huang Yi had carved a seal for Xi Gang at his previous residence, the Cuilinglong Hall. But ten years ago, when Xi Gang moved, the seal was lost, and he still remembered it, "like the [fading] cries of the *luan* or the phoenix," lamenting that, "in his chest there remains a thousand acres of felled timber."[5] By recarving a seal that paid homage to Huang Yi's original, Chen Hongshou remediated Xi's affection for Huang and inserted his own presence into the relationship between these two senior literati artists and seal carvers.

Xi and Huang, along with the earlier Hangzhou seal carvers Ding Jing and Jiang Ren, would later be credited with establishing a new Zhejiang school of seal carving, with Chen Hongshou and Chen Yuzhong designated as its premier second generation of carvers. During his lifetime, Chen's peers already described him as the natural inheritor of Ding Jing, Jiang Ren, and Huang Yi. As Guo Lin put it in his preface to a compendium of Chen Hongshou's seals, "The style of Huang Yi is superior in its rich simplicity and Jiang Ren's is superior in its graceful style. Huang Yi and Jiang Ren are unalike and yet they are utterly alike in the ways they surpass the [limits of the] hand and the heart-mind. My friend Chen Hongshou continues and unites the manners of both [Huang and Jiang]."[6]

When Chen first met Huang Yi in 1795, he was too humble to make such a claim himself. The older gentleman had briefly returned from his official position in Shandong to his native Hangzhou, and while there Chen was able to present Huang with one of his carved seals. A year later, Chen described his esteem for the man in an inscription along the side of another seal, made for Liang Baosheng: "Of those in my home province who practice this art, after Ding Jing, I carry Huang Yi closest to my heart. Last winter, I visited him and made him a seal in the style of Han-dynasty governmental seals."[7]

At the beginning of this inscription, Chen took on a self-deprecating tone: "My nature is awkward and direct, and what I carve responds to my fixed ideas." Referring to his own work as "awkward" (zhuo) reinforced the central position this conceptual term held for literati who engaged in the epigraphic aesthetic. Huang Yi, Ruan Yuan, and Qian Du all described the style of early carved calligraphy and images with the word zhuo (see chapters 1 and 2). It stood for a disavowal of later ornate or embellished styles, which had to be unlearned in order to return to the supposedly unspoiled styles of calligraphers from the dawn of Confucian civilization. Carved and cast objects from the past, as well as their rubbings, provided the most immediate access to these more authentic and unassuming ancient exemplars. Chen's description of his seal carving as zhuo performed this disavowal of skill in the same medium through which he and his peers often came into touch with the authentic traces of the early past—stone. Carving new stones with metal tools, Chen was able to directly emulate the styles of the distant past as well its materials, in effect bypassing the brush altogether.

Chen's surviving calligraphy in ink on paper shows a similar fascination with the material specificity of stone inscriptions. Although Chen had a distinct running script style that he used for communication with his friends and for colophons to paintings, like his contemporaries, he chose to invest himself more fully in clerical-script styles that drew from a variety of newly discovered epigraphic sources. When he wrote calligraphy in clerical script, Chen turned to models from Han-dynasty steles, archaic bricks, carvings on cliffs, and ancient seals. Sometimes, specific steles formed the model. The characters in the undated couplet "When facing the sages, books become the honored guests; In the wind and rain, bamboo trunks are like the flute and drum," written for his friend Huang Jun, drew their strong structural symmetry and emphasis on right angles from the *Si San Gong Shan Stele* (dated 117) (fig. 50). The *Cao Quan Stele* and the *Ritual Implements Stele* were also favorite models for Chen. From these, he learned to reconfigure the balance of words by elongating horizontal strokes and compressing interstices between parallel strokes.[8]

Calligraphy with brush on paper is traditionally considered the wellhead of all literati arts.[9] As Guo Lin explained in his introduction to Chen Hongshou's collected seal impressions, "Seal carving, though a minor art, is the son of ink

Fig. 50 Chen Hongshou, calligraphy couplet for Huang Yun, undated. Ink on paper, 161 × 36 cm. Lanqian Shanguan Collection, National Palace Museum, Taiwan. From Xiao Jianmin, *Chen Mansheng yan jiu*.

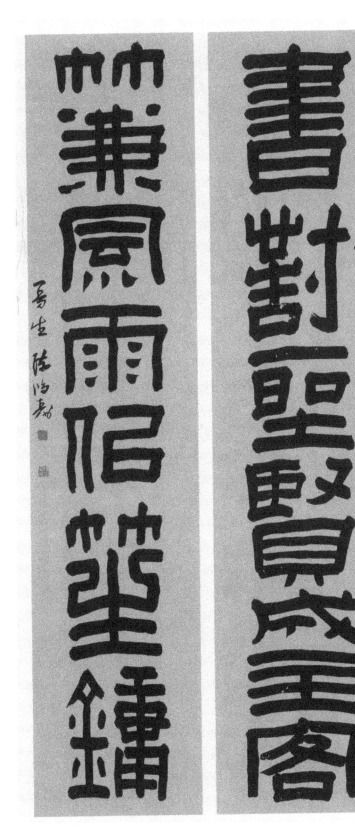

Fig. 51 Chen Hongshou, calligraphy couplet for Chen Shilin, 1816. Ink on paper, dimensions unknown. Republican period lithographic reprint. From Xiao Jianmin, *Chen Mansheng yan jiu*.

and brush."[10] Although Chen may have first learned a facility in literati arts with ink and brush on paper, seal carving eventually eclipsed the use of the brush in his artistic practices. It became his primary art form, and the "iron brush," the name by which the art of chisel-carved seals was also known, acted as the model for all his artistic production. This is most evident in the ways he deviated from his epigraphy models. When most calligraphers emulated the styles of the *Cao Quan* and the *Ritual Implements* steles, they repeated the characteristic diagonal strokes, which modulate and then end in fat, triangular tips, a visual feature that reveals the existence of brush-on-paper drafts pre-dating the carved words. A brush applied to paper easily dips, presses, and then releases to form varied line widths and shapes, from fat to lean or pointed. But stone does not react in this way to the chisel. To carve stone characters with the same features as works on paper requires intent and effort in the face of the stone's resistance. Chen's epigraphically styled calligraphy eschewed details derived from brushwork, even when it drew from steles carved with such features, like the *Cao Quan* and the *Ritual Implements* steles. Instead, he kept his brush straight and squared, favoring strokes that emulated the material nature of stone rather than ink and paper. Chen did not search for the brushstroke behind the ancient chiseled words—he made a chisel of his brush.

Chen's mature calligraphy style transcended specific stele models. He chose to mix the orthography of several stele styles together with the awkward script forms found on ancient bricks and the early cast inscriptions of bronzes to create hybrid works untraceable to specific sources. This hybridity is evident in a couplet written for his cousin Chen Shilin: "Warming mountains signal spring as cooling water announces dusk; Thin calligraphy carved in stone—a wintry poem describing the clouds" (fig. 51).[11] Characters like "signal" and "spring" bear the archaic orthography of cast-seal scripts and ancient bricks. Words like "describe" are organized according to the fashion of carved steles from the late Han era and the early Six Dynasties period. And the long, unyielding diagonal strokes of words like "dusk" come from cliff-carved calligraphy like the Northern Qi examples at Mt. Tai.

Chen's brother-in-law Gao Rijun described Chen's preference for epigraphy in his 1817 preface to his collected seals. Gao wrote, "Chen Hongshou exhausted the origins of [calligraphic] writing and seal carving, searching out the mysteries of metal-and-stone, his heart-mind in [correct] correspondence with the ancients and his eye blind to everything extraneous."[12] Gao's comments emphasize that the basis of Chen's motivation to turn toward epigraphy was the feeling that other forms of literary arts had been fully explored, leaving few depths left to plumb. His choice of words also marks a subtle sensory emphasis, downplaying vision in favor of the authority of the heart-mind, the bodily center through which all other senses were processed.[13]

Carved seals offered an advantage that the brush arts lacked. Chen's turn to the carved and cast materials of the past meant he could short-circuit the tired genealogies of ink and brush on paper to find a more direct, raw, and immediate source of tradition while still maintaining the authority of the past. This move was in line with the logic that defined Ruan Yuan's treatise on epigraphic calligraphy (chapter 1) as well as Huang Yi's material explorations of stone and metal source materials (chapter 2), and it was recognized by his peers. Zhao Zhichen described Chen's work in his 1820 preface to a compendium of Chen Hongshou's seals with high praise and aligned his assessment with the fact that seal carving was a more open field of linguistic experimentation:

> The iron brush [of seal carving] is an ancient practice, and each [practitioner] follows their own experiences; there is no regulated set of forms. To pursue this artform one must read widely from the ancient writings of past dynasties . . . internalizing and applying [this knowledge] in one's hand. . . . Chen Hongshou has committed to his heart-mind many thousands of reams of calligraphy, repeatedly immersing himself in [the study of] Qin and Han seals of bronze and stone, in both governmental and private [styles], and when he sets his knife to work, he's able to unite these in a synthesis, one that originates from his own psyche/spirit, permeating even a mere inch of stone with grace.[14]

Han-dynasty bronzes and seals were the models Chen most frequently cited in his colophons. His inscription along the side of his brother-in-law's seal described its impression as "after the manner of Han-dynasty seals," and in his dedications on numerous other seals, he variously referred to "Han-dynasty bronze seal-carving method," "Han-dynasty bronze chiseling methods," "Han-dynasty seals of office," "Han jade-carving methods," or simply, "after the Han-dynasty methods." On occasion, he also cited seal styles of the Qin dynasty or the Six Dynasties period (220–589). More rarely, he named specific later masters like the Ming-dynasty carver He Zhen (1522–1604). At times, his allusions to Han-dynasty material culture reshaped the very form of his seals, as with a long vertical composition carved for Yuan Tingdao's (1762–1810) Five Inkstone Hall (fig. 52). Rather than the conventional square arrangement of three characters in two columns, Chen stacked all three in a long rectangle of relief-carved words, imitating the raised inscriptions on Han-dynasty bricks (see fig. 44), objects frequently converted into inkstones by his peers.

Through his connections and his growing reputation in Hangzhou circles, Chen Hongshou was eventually introduced to Ruan Yuan, whom he would serve as an aide for over a decade. They may have been introduced as early as 1793, when Hangzhou scholars like He Yuanxi and Zhu Peng were drawn north to help Ruan Yuan catalog the epigraphic resources of Shandong Province during his

Fig. 52 Chen Hongshou, *Five Inkstone Hall* seal for Yuan Tingdao, undated. Carved Qingtian stone, 2.3 × 1 ×
2.5 cm. Shanghai Museum. From Lai Suk Yee, *Art of Chen Hongshou.*

term as education commissioner there. But records indicate Chen did not begin
to work directly with Ruan until 1795, when Ruan moved south to Hangzhou
to take on the role of provincial education commissioner of Zhejiang.[15]

Over the following two years, as a member of Ruan's coterie of aides and
scholars, Chen traveled throughout Zhejiang, accompanying Ruan and helping
him conduct regional examinations of would-be officials as well as recording
his various cultural and governmental interactions. As Ruan put it in his 1799
introduction to *Brush Notes from the Lesser Canglang Pavilion*:

> I lived in Shandong for two years. I scaled Mt. Tai, and I looked out
> over the Bohai Sea. I performed sacrificial rites at Queli, and had over
> a hundred fine scholars record over a thousand pieces of epigraphy. At
> the end of 1795, I was transferred to Zhejiang. Recollections of what I
> experienced there [in Shandong] over those two years sometimes come
> to me and then are suddenly forgotten. Those things I can still remem-
> ber are like the remnants of the first scent of tea from a cup half-drunk,
> faintly recorded across various essays. He Yuanxi and Chen Hongshou,
> who have travelled with me, helped me to organize and edit my writ-
> ings from that time in what follows, which I've called *Brush Notes from
> the Lesser Canglang Pavilion*.[16]

Chen Hongshou and He Yuanxi were two of Ruan Yuan's ever-present aides
during his time as education commissioner in Zhejiang. In the process of compil-
ing and organizing records of Ruan's poetry, gatherings, and writings, they were
incorporated into Ruan's world, traveling with him to cities like Jiaxing and

Huzhou to help administer exams as well as participating in outings at the start of
the new year to view plum blossoms or peach blossoms at places like Tonglu and
Jiuli. They were not just there as scribes; they also wrote poems to commemorate
Ruan's various cultural projects, like the recarving of a Northern Song–dynasty
rubbing of the *Stone Drum Classics* for the Hangzhou prefectural academy.[17]
Chen helped Ruan compile a compendium of poetry by Zhejiang natives, total-
ing over three thousand poets, titled *Record of the Royal Envoys of the Two Zhes*.
Naturally, he also carved seals for Ruan and his friends, one of which, dated to
1797 and inscribed with one of Ruan's studio names, "Lesser Langhuan Immor-
tal Hall," still survives (see fig. 7). Years after Ruan retired and Chen died, Ruan
would note that Chen was the most prolific seal carver among his aides, and he
bemoaned the fact that in his late years, he was left with only one of the seals
Chen had carved for him.[18]

Ruan became governor of Zhejiang in 1799, and Chen advanced both politi-
cally and socially under Ruan's further supervision and cultivation. In 1801, Ruan
named Chen one of the scholars of the Explicating the Essence of the Classics
Residence, a center for the study of the Classics through an evidential research
curriculum that he established in Hangzhou. There, at the intellectual heart of
Hangzhou, Chen became further entwined with Zhejiang's notable families,
many of whom also had sons in Ruan Yuan's service. Chen's family connections,
which were already well rooted, became even stronger, and he gained valuable
administrative experience under Ruan, participating in important governmental
operations such as piracy suppression along the Zhejiang coast in the summer
of 1800.

Over this time, Chen increasingly gravitated toward seal carving. The art form
was well suited to the involved political and social networking Chen undertook
at this point in his career. The fifteen-year period of 1793 through 1807 marked
Chen's ascendence from student to government official, and it is no coincidence
that this was also the period of his most intense seal production. His seals bonded
him to Ruan Yuan, Guo Lin, Xi Gang, and Huang Yi, as well as to the poet Chen
Wenshu, his distant cousin and one of Ruan's favorite aides. He carved for the
sons of the Xu clan, his maternal cousins, and for the Qian brothers, Qian Lin,
Qian Mei, and Qian Du, another literati family of poets and painters from the
Qiantang district of Hangzhou. Seals were carved to commemorate the life events
of these young men as they came into their own. When they purchased their
own personal residences or built their pleasure gardens and libraries, new seals
were cut to mark the occasions. Parties were held to write poems about old seals
and inscriptions as well, with Ruan's collection providing many prime examples.
The physical examination of ancient objects proved irresistible to these epigra-
phy scholars, who were brought up under the influence of evidential research.
When, in the summer of 1798, Chen and Hu Jing (1769–1845) examined a seal
in Ruan's collection, Hu Jing's poem on the event began, "Crimson words of an

ancient seal topped with a *pan* dragon nob, a cluster of red clouds suddenly in my hand."[19] Folding tactile experience into a poetic metaphor laced with Daoist overtones, Hu highlighted the pleasures and principles of this art form for his generation.

Chen's seal-carving production reached its height in 1802, a year in which he carved over twenty seals for various friends and acquaintances.[20] This was the same year that Chen traveled northward with Sun Shao (1752–1811) and Zhang Jian (1768–1850), two more of Ruan Yuan's protégés, to take the capital-level examinations. He passed the exams, was awarded the title of presented scholar (*jinshi*), and received his first official posting to Guangdong.

Boneless Flowers and Brushless Landscapes

In the first decade of the nineteenth century, Chen Hongshou's involvement with other arts grew as his individual political career took form. Seal carving for his mentors and contemporaries had helped him secure his network of confidants, but two new art forms—painting and customized teapots—eventually supplanted seals in Chen's practice. His painting output increased first, and from his extant artworks and written records, it seems his painting was most prolific during the fifteen-year period following his ascension to the status of presented scholar. Meanwhile, his teapot production did not take root until his 1811 posting as district magistrate in Liyang, Jiangsu Province. As with his seal carving, a tactile thinking guided his investigation of both new mediums.

Chen's individual political career began with promise, but it was quickly derailed before it could blossom. Late in the summer of 1802, as Chen made his way south from Beijing to assume his first post in Guangdong, he stopped by his hometown of Hangzhou. Lingering there until the last few months of 1802, he prepared for his departure further south by visiting with friends to enjoy their company and congratulations. During this time, his father, Chen Jing, passed away. Obliged to observe a proper Confucian mourning period, Chen released his posting to another official, a decision that stalled his advancement for several years.

During this time, Chen stayed around Hangzhou and continued to work within Ruan Yuan's coterie until Ruan's own father died in 1805. When Ruan left his post as governor to mourn in Yangzhou, Chen was forced to find new patronage, first as an aide to Nayancheng (1764–1833) and then to Tiebao (1752–1824). Nayancheng finally brought Chen south to Guangdong, where the Manchu official was posted as governor-general of Guangdong and Guangxi in 1805. Only a few months after arriving, Nayancheng was dismissed on corruption charges. Chen then returned north to serve with his cousin Chen Wenshu, who was acting as aide to Tiebao, the governor-general of Jiangsu and Zhejiang. From 1806 through 1808, Chen stayed with Tiebao, excelling at his work in coastal

defense and waterway management until the late spring of 1809, when Tiebao was summoned to the capital and excused from his post under accusations of mismanagement.[21] Whereas Tiebao was reassigned to the distant outpost of Urumqi, in the new western provinces, Chen, who had accompanied his patron to Beijing, finally received another independent appointment to serve as district magistrate of Ganyu County (1809–11), Jiangsu Province.

Over this tumultuous period, Chen began to experiment more with painting.[22] As with his calligraphy and seal carving, the epigraphic aesthetic was a catalyst for this new practice. However, it manifested in ways that were less direct than in the work of his contemporaries Huang Yi and Qian Du (see chapter 3). Rather than emulating the broken lines and eroded surfaces of steles as transmitted in rubbings, Chen chose to diminish the brush's presence by taking up "boneless" method in his bird-and-flower works and finger-painting methods in his landscapes. These techniques were not immediately sourced from epigraphic materials, but both were rooted in the broader interest epigraphy inspired. Boneless method emphasized washes rather than classical brushwork lines. Like a rubbing, boneless method distributed the sense of touch across the surface of a depicted object. Finger painting made a more direct appeal to the body's sense of touch, rejecting the brush as an intermediary and focusing instead on direct bodily contact with the media of ink and paper.

Even in his earliest paintings, Chen's interests tended toward the unorthodox. He neglected the styles of typical exemplars, such as the four Yuan-dynasty landscape painters who formed the heart of the so-called southern school of painting, a lineage defined by Dong Qichang in the seventeenth century that still had clout among eighteenth- and nineteenth-century painters. Instead, he preferred to cite more recent, and often more avowedly antiestablishment, painters. His painting inscriptions most frequently listed Ming-dynasty and early Qing-dynasty artists like Shitao (1642–1707), Jin Nong, Yun Shouping (1633–1690), Xu Wei (1421–1493), Chen Chun (1483–1544), and Shen Zhou (1427–1509) as inspiration. In part, this stemmed from his preference for the genre of flower painting over landscapes. While literati held many flower painters in high regard, as a whole, the genre was less burdened by genealogical expectations than landscape.

In his earliest album of flower paintings, dated to 1802, Chen pontificated on his newfound practice: "Hao [Jing] said, 'All concept is in the lack of concept; All method is in non-method.' In my opinion, painting is not about trying to be different from other painters, or pursuing technical precision, but about slowly, stroke by stroke, aiming toward a unity with the ancient past."[23] Chen's choice of source is curious. While his line from Hao Jing (1223–1275) comes from a discussion on painting and calligraphy, Hao was less known as an aesthetic philosopher than as an early neo-Confucian scholar and follower of Zhu Xi (1130–1200). In Chen's time, Hao was looked upon favorably by the Qing rulership for his ambassadorial efforts to convince Southern Song rulers to make peace with the Yuan

emperor. This paved the way for his *Continuation of the History of the Later Han Dynasty* to be included in the Qianlong emperor's grand encyclopedia of knowledge, the *Complete Libraries of the Four Treasuries Project*.[24] From this quote, it is apparent that Chen understood his explorations of painting to take place within a spectrum of ideas established by historians and philosophers as much as by painters and collectors. As if to further emphasize his distance from painting lineages and his connection with seal carving, Chen's citation of Hao's maxim most likely came from a book about seal carving by the Ming-dynasty carver Xu Shangda, in which the author discussed Hu Jing's painterly debates of artisan skill versus literary concept in painting through an analogy to seal carving.[25]

Elsewhere, Chen made the connections between his brush painting and his seal carving even more explicit. On the side of an 1805 seal carved with the words "Chan Painting and Calligraphy," Chen wrote:

Though painting and calligraphy are lesser skills, they are illuminated by spirit, can sustain the body, and [lead to] awakening just like the disciplined actions of Chan [Buddhist] instruction. From the Song dynasty onward, [painters] like Zhao [Mengfu], Wen [Zhengming], and Dong [Qichang], all have proven themselves part of the *Treasury of the True Eye of the Dharma*. As for my own indulgences in calligraphy and painting, though I am incapable of following the ancients, I've used the [carving] knife to accumulate my understanding, and am therefore striving to meet Chan principles, knowing that the sages of the past won't deceive me.[26]

Chen's exegesis of Hao Jing's quote and his meditation on the Chan Buddhist nature of painting and calligraphy both promoted process-oriented discovery over skills training. According to Chen, "slowly, stroke by stroke," but without rote method, one can eventually approach a manner of painting that compares with that with the past. Likewise, in Chen's comparison between Buddhism and the brush arts, his painting is a spiritual practice akin to the action-based realizations sought by Chan monks. Within this metaphor, painters are like the famous monks whose case studies (*gong'an*) were handed down in books such as *Treasury of the True Eye of the Dharma*. For Chen Hongshou, this meant that copying the images of past painters was less productive than taking their principles as guides to one's own realization, which, for Chen, came in the action-oriented process of carving.

Chen's advocacy for the carving knife as a vehicle for revitalizing brushwork knowledge had no direct correlation to the kinds of painting techniques he preferred. Instead of the epigraphically-inspired marks of his contemporaries, his painting showed a strong resistance to the fetishization of the brushmark, an impulse evident in his preference for two techniques that diminished or even did away with the brush—"boneless" method and finger painting.

Chen Hongshou first mentioned boneless method in his 1802 flower album, writing on a leaf titled "Autumn Grasses" that he "pictured the scene after the boneless method of Xu Xi (886–975)."[27] Boneless method was neither flat wash nor line. It struck an ambivalent position somewhere in between these techniques. Classical literati painting composition began by defining forms with faint outlines, followed by texture strokes and washes that built from light to dark and often ended with a final, darker outline around the emphasized forms. These outlines and texturing strokes maintained distinctly linear manners to convey the nature of the tool that made them, the brush. Reading the brushmarks like calligraphy, audiences saw the painting as a series of choices that indexically recorded the painter's actions and ideas.

Linear brushwork was fundamental to the existence of form in a painting. Traditionally, washes were only applied to already delineated forms or to open areas in order to change their tones or colors. Boneless technique, however, did away with these linear rules, depicting form by means of wash alone. The technique therefore challenged the indexical model of more calligraphically oriented painting. Boneless images, lacking linear directionality, made tracing the brush's actions and, by extension, the actions and gestures of the painter, very difficult.

Boneless method can also be seen as a type of material exploration. It starts with an addition of pure water to select areas of the paper, priming the support so that later brush actions on it diffuse and lose their directionality. The application of ink or pigment within the saturated surface of the paper investigates the absorptivity of the wetted areas in contrast with the unsaturated areas. For the painter, boneless method enabled a probing of the material nature of paper and water rather than an assertion of the painter's brush line.

Of Chen's remaining paintings, the flower albums are the most compelling and the most plentiful. They show Chen's experiments with the boundaries of existing brushwork languages as he tested the difference between line and wash in the depiction of relatively common auspicious flora. His 1810 album of twelve leaves, painted for Yuan Tingdao at his Five Inkstone Hall, includes a radish bunch painted with boneless technique (fig. 53). Washes of green and blue, touched with light umbers, cluster at the top of lightly textured pink tubers that taper to wet taproots. As if to emphasize the use of washes to depict form in boneless style, Chen ties the bunch together in a wandering ink line that flexes, swells, and nearly disappears into the greenery of the radish tops. This line is the only element of the composition that comes close to classical calligraphic brush line. Chen's inscription alongside makes a playful jab at the social nature of his artwork: "I take this down to the corner to sell it for a buck; I prepare myself in rouge to pen gifts for these gentlemen." Alongside the obvious gender play that makes cosmetics of his painting pigments, Chen's make-up metaphor reinforces the use of boneless technique to convey surface sensations. Last, his addendum to this inscription, "Rouge is also written as *rouge*," noting two distinct characters

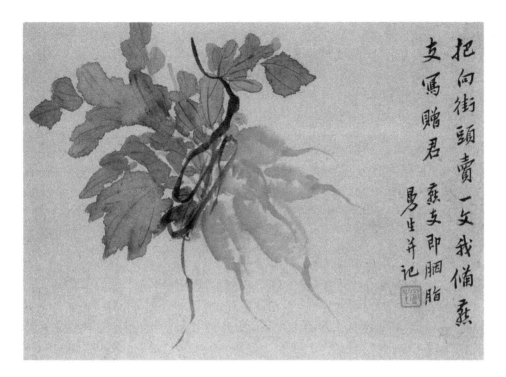

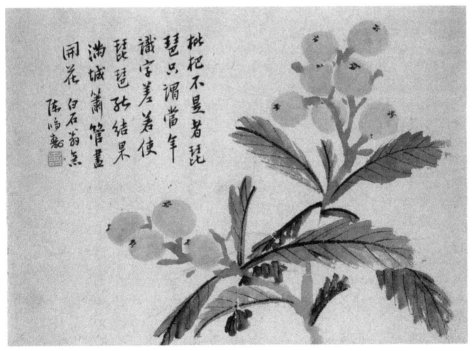

Fig. 53 Chen Hongshou, leaves from *Album of Flora* for Yuan Tingdao, 1810. Ink and color on paper, each leaf 26.7 × 37.5 cm. Shanghai Museum. From Lai Suk Yee, *Art of Chen Hongshou*.

used for writing the same word, also indulges in the linguistic pleasure of philology, a practice central to the evidential researchers of his generation.

Another album leaf from the same set depicts loquats and takes a similar interest in the alternative naming of what is depicted. As with the radishes, Chen lets boneless washes do most of the work of depiction. Branches are wet, wandering growths more than lines. Leaves extend from lush lizard-green tones at their centers to parched brown edges, dissolving into the surrounding sunlight rather than being hemmed in by hard outlines. Only the thin leaf ribs carry a dark line weight similar to the calligraphy of Chen's inscription, which reads, "The Loquat [fruit] (*pipa*) is not the pipa [instrument]; they only called it that back then because they hadn't yet learned the word. If a pipa [instrument] could grow fruit, then flowers will soon be spouting from the ends of all the flutes in town."[28]

Chen's boneless method centered around doing away with outline in particular. In two separate 1812 albums of flora he wrote, "Studying Shen Zhou's [painting], I've gotten rid of the [outline] structure," and "I've used the general idea of Wang Wei's [painting], and gotten rid of the [outline] structure."[29] This boneless method was not limited to flower paintings either. In a 1815 blue-and-green landscape painting for Xu Nai'an, Chen wrote, "Occasionally I've studied the boneless method of Yang Sheng, but I'm not sure if the result here reaches a semblance of his spirit or not."[30]

Chen's flower paintings show his most direct exploration of boneless method as a diminishment of the brush. But this critique of brushwork continued in his landscape painting style and especially in his finger painting. Chen's 1810 painting *Begets Lotuses, the Second Image* is his most accomplished finger-painting landscape to have survived (fig. 54). According to the painting's colophon, the patron, Cang Sisheng (1776–after 1820) dreamed that he saw his poetry inscribed on the walls of an old monastery in the mountains, but instead of his chosen sobriquet, the poems were inscribed with a new moniker, "Begets Lotuses" (*Lianyin*). Cang changed his name to accord with his vision, and he commissioned two paintings to illustrate the dream in honor of his name change, one from Chen Hongshou and one from the Zhenjiang-based painter Zhang Yin (1761–1829).[31]

Like Chen, Cang Sisheng's official career involved him in governmental hydraulic projects around the lower Yangzi River area, including coastal defense. He held various positions in Suzhou, Taicang, Tongzhou, and Suzhou. Though he does not appear to have been a consistent player in Chen's life, he was well connected with Chen's circle of close friends, including Sun Xingyan and Xi Peilan (1776–?), who wrote a colophon and frontispiece for the painting, respectively. If Chen did not meet him through these friends or through office, then any number of personal connections may have brought them together. Cang's father was a 1771 imperial graduate who served in the Hanlin Academy and worked on the *Complete Library of the Four Treasuries* project. His mentors included Liu Yong and Zhu Gui, two of Ruan Yuan's own early patrons.[32]

Fig. 54 Chen Hongshou, *Begets Lotuses, the Second Image*, 1810. Ink and color on silk, 23.5 cm × 143.5 cm. Guangdong Museum (Guangzhou Lu Xun Memorial Hall).

Chen's composition for Cang's dreamscape is rather reduced and consists of three roughly interlocking parts: a brief prelude of treetops that sets the foreground, a pair of craggy peaks between which two double-storied temples nestle, and a final low forest that leads to the bank of a calm waterway, where a small stand-in figure for the patron looks out over a band of lush lotus leaves dotted with occasional blush-colored blossoms. The simplicity of Chen's approach stands in contrast to Zhang Yin's depiction of the same theme (fig. 55). Chen makes great use of spare marks, painting jagged outlines and textures or casually daubing washes with his finger in medium to light tones of ink, constructing a loose but evocative landscape riddled with suggestion and the heavy, humid air of the south. By contrast, Zhang's composition begins with a set of meticulously organized, low, rolling hills stacked around a brilliant red group of sharply delineated temple structures before transitioning to a distant set of parabolic mountains that then disappear in his signature combination of dense texturing and subtly graded washes of dark forest greens, gentle umbers, and light blues.

 In Chen's inscription, he feigns a casual attitude toward his composition, writing that he was only "entertaining himself in the use of Qieyuan's [Gao Qipei]

finger [painting] method." Gao Qipei (1660–1734) was Chen's most immediate finger-painting predecessor. He turned to finger painting after losing function in his right hand, pivoting from this physical impediment to invent a mode of brushless painting. While Gao claimed to have pioneered the technique, in fact, painters stretching back to the Tang dynasty were said to have painted with their fingers. It was often associated with drunks, hermits, Daoists, eccentrics, and even mental instability, as was the case with the Ming-dynasty painter Wu Wei (1459–1508). In Japan, eighteenth-century painters like Ike no Taiga (1723–1776) mixed brush and finger painting freely, considering them to be part and parcel of the core techniques of Chinese-style literati painting (Jp. *nanga*).[33]

For these painters, as for Chen Hongshou, finger painting did away with the brush as intermediary altogether, allowing for the artist's physical and mental presence to more directly present itself to audiences in a raw, bodily form of mark making. As a critique of entrenched brushwork theory, it offered Chen a deviation from the norm that was as great, if not greater, than the boneless technique.

The Well of the Past

In the spring of 1811, Chen Hongshou was transferred to Liyang, in Jiangsu Province. Over the next five years as Liyang's magistrate, Chen earned a reputation as a beneficent official and advocate for the county. When drought struck in 1813, Chen successfully appealed for relief funds. He also led an initiative to rewrite the *Liyang County Gazetteer*, updating the documentation of the county's historical, geographical, economic, and political importance. But in the larger arc of history, Chen's presence in Liyang is most directly associated with the hundreds, perhaps thousands, of teapots he produced there in collaboration with craftspeople like Yang Pengnian.[34]

The earthenware vessels he and Yang made together used a local clay called "purple sand" (*zisha*). Once refined, the clay had a smooth, buttery texture and a deep maroon-brown color. When fired, the wet clay transformed into a variety of rich brown tones with smooth matte surfaces. Literati considered *zisha*'s

Fig. 55 Zhang Yin, *Begets Lotuses*, 1811. Ink and color on paper, 32.5 cm × 293 cm. Guangdong Museum (Guangzhou Lu Xun Memorial Hall).

physical properties ideal for preparing tea. With tea leaves measured into these vessels and boiling water added to steep them, the rewet fired clay bodies returned momentarily to a darker shade of brown before the excess tea water dissipated into vapor. The appearance was almost alchemical; the fired clay bodies seemed to expand and contract and even briefly reclaim the nature of their prefired clay as the fundamental physical transformations of phase change played across their surfaces for tea audiences. *Zisha* pots were also said to cure over time so that they became better at delivering flavor with each steeping, absorption, and meeting of friends for tea.

Zisha clay had been popular for tea vessels since the Song dynasty, with primary production based in the town of Yixing, in Jiangsu Province, the major

source of the material. Liyang, which lay a day and a night's journey from Yixing during the Qing dynasty, seems to have been a secondary source of *zisha* clay, and compositional analysis of teapots made by Chen Hongshou and Yang Pengnian indicates that they were constructed from clay of more or less the same chemical content as those from Yixing. Chen was introduced to *zisha* teapots well before his transfer to Liyang. As early as the Ming dynasty, Yixing potters such as Gong Chun (fl. during the Zhengde era, 1506–1520) and Shi Dabin (fl. during the Wanli era, 1573–1620) signed their wares, creating brand names that were highly sought after by well-to-do literati and merchants.[35] One of any number of Chen's friends may have provided a more direct interaction with *zisha* pots. Sun Yuanxiang (1760–1829), a fellow protégé of Ruan Yuan, had governed Yixing for a time. While there, he commissioned teapots inscribed with his poetry. This may have set the most direct example for Chen Hongshou.[36] Wu Qian (1733–1813), a Haining native who Chen probably met during his early education there, wrote a two-volume history and description of Yixing's *zisha* pottery production in 1786, *Famed Pottery of Yangyi*, Yangyi being an older name for Yixing. A set of five poems Wu included in his book about another mutual friend Tang Zhongmian (1753–1833) indicates that Tang commissioned a *zisha* teapot in the manner of an antique vessel before Chen started his own similar productions.[37]

While Chen was not the first to engage with *zisha* teapot production, the completeness of his engagement eclipsed that of his predecessors. Chen's involvement with *zisha* teapots elevated the craft from a prized local product to a literati object. Until Chen, no official had taken such a direct interest in producing and designing the pot shapes. Nor had any literati so invested efforts in integrating the teapots with the more esteemed arts of calligraphy, epigraphy, and painting. Ruan Yuan expressed his sense of Chen's continuity between the mediums by saying, "I once held Mansheng's teapots in equally high regard as Xi Gang's and Wang Xuhao's paintings."[38]

This literati sensibility across media hinged largely on Chen's personalization of his pots so that they bore the kinds of social and historical allusions that bonded elites to one another through the enjoyment of a mutual knowledge of the past. This happened in a variety of forms, from antique shapes to stylized inscriptions and poetic content. In Chen's hands, and under the epigraphic aesthetic of the early nineteenth century, *zisha* teapots became yet another medium through which the touch of the past could be explored and relived. Like seal stones, this medium demanded contact to be properly used, and Chen designed his teapots around this direct appeal to touch for his epigraphically influenced peers.

On one of the earliest teapots he produced, from the fall of 1812, Chen had the following tactile couplet inscribed in his characteristic clerical-script style: "Offering water with the left hand, and liquor with right, I study both the [Daoist] immortals and the Buddha, bringing both hands together" (fig. 56). Cutting these words in this style onto the side of the clay rechanneled the

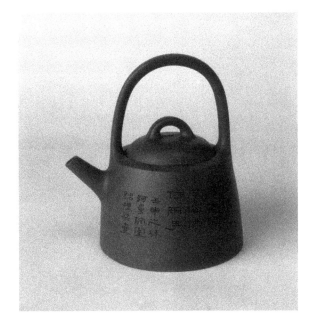

Fig. 56 Chen Hongshou and Yang Pengnian, inscribed teapot with handle, 1812. Zisha clay, 14.3 × 11.1 cm. Hong Kong Museum of Art. Photo supplied by the Hong Kong Museum of Art.

calligraphic models found on stone steles back into a similarly earthen material. Likewise, the shape of this particular vessel signaled connection with the literati past. When Chen Hongshou, Guo Lin, Gao Rijun, and Wang Hong collaborated to produce a catalog of Chen's teapot designs in 1813, this form was the first listed, under the title "Stone Waterpot." Chen's poem, inscribed alongside, elaborated: "Formed into a waterpot, patted into shape; I made this, not Zhou Tong." Chen's blunt poem positions him as the maker, disputing all other claims to the hand of another, and specifically any claims it might be the famed teapot in the shape of an archaic waterpot that Zhou Tong (fl. late eleventh century) crafted for his friend Su Shi.

The book Chen and his friends made, *Research on the Nature and Spirit of Pottery*, included twenty line drawings by Wang Hong of teapot forms designed by Chen Hongshou, and the book featured poems by Chen and Guo Lin printed alongside in Guo's calligraphy. The actual forming of the pots was likely done entirely by the artisans of Liyang, and especially Chen's closest potter-collaborator, Yang Pengnian. Beyond archaic waterpot forms, they also named shapes after ancient bronze ritual vessels, cast mirrors, and clay roof tiles. They named others with auspicious natural shapes, such as the moon, a pearl, or clouds. They frequently asserted religious overtones as well. A vessel shape titled "Joined Dippers" had the appearance of two rice measures, one inverted on the other, so that the pot's center flared outward, giving a hexagonal profile to the otherwise square form. The rice measure shape was also the metaphorical name given to two constellations, and Chen's accompanying poem raised these common agricultural tools to their celestial Daoist dimensions, making a sea of stars out of

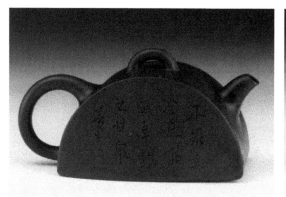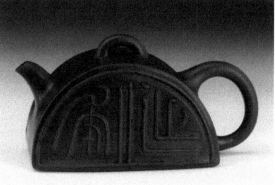

Fig. 57 Chen Hongshou and Yang Pengnian, inscribed teapot in the shape of a Han-dynasty roof tile (left and right sides), undated. Zisha clay, 7.4 × 4.3 × 6.9 cm. Shanghai Museum. From Lai Suk Yee, *Art of Chen Hongshou.*

the tea poured from it: "The Northern Dipper above, the Southern Dipper below; stars flowing between."

The associations between tea, Daoism, and Chan Buddhism dated to the earliest descriptions of tea appreciation. The first treatise written on the beverage, *The Art of Tea,* by the Tang-dynasty poet Li Yu, included many references to Daoist imagery and concepts of longevity, clarity, or immortality. One origin story for tea attributed its arrival to China via Bodhidharma, the patriarch of Chan Buddhism, and Chan monks incorporated tea into a variety of ritual practices in China and abroad in Japan. Among the offerings sealed into an early ninth-century crypt below the Famen Temple in Shaanxi was a set of gilt-silver tea preparation implements. By the Song dynasty, tea drinking had become a requisite elite activity, a popular poetic trope, and a theme in literati landscape painting. By the Qing dynasty, its commingled associations with Daosim, Chan Buddhism, and literati culture were inextricable from one another.

Chen's pots played off these associations and more. They were highly personalized, not just in their inscriptions but also in their forms. One prime example, a design called "Prolonged Life," adapted a design found on the ends of Han-dynasty roof tiles (fig. 57). The two characters in this phrase, *yannian,* are molded into one semicircular side of the teapot, while on the other side, a poem by Chen Hongshou links tea to longevity: "By not pursuing everything, only then can life be prolonged, drinking from the sweet spring." Together, the poem and the teapot promise the immortality of Daoist hermits in the form of an ancient architectural ornament embellished with clerical-script calligraphy, visual and textual allusions that place the object squarely within the generic languages of literati culture. But the effect was further compounded by the fact that the characters *yannian* were also Wang Hong's chosen sobriquet. Each time friends poured tea from this pot, then, an interlaced set of referents activated one another in a

collective experience of personality (Wang's name), of friends absent or present (Chen's poem and calligraphy), and of the authority of the Han-dynasty roof tile as a marker of the deep past.[39]

Chen's personalized teapots were capable of conveying the bodily presence of the literati whose names adorned them. They gave physical form to the metaphorical names embraced by these scholars, acting as metonyms for the literati themselves. Chen frequently took advantage of the interplay between literati names and teapot forms to create visual-to-textual games. For instance, Chen's 1816 teapot in cube form bears his inscription: "Square-Mountain and Jade River: the relationship between these two gentlemen is as faint as this" (fig. 58).[40] "Square Mountain," a posthumous name for the Song-dynasty poet and Chan Buddhist practitioner Chen Zao (fl. late eleventh century), also describes the square form of the teapot. "Jade River," another name for the Tang-dynasty tea aficionado Lu Tong (fl. early ninth century), references the light-green liquid the pot held when filled. Though "Square Mountain" and "Jade River" lived centuries apart, Chen's poem implies a relationship between them despite the constraints of time. Lu's poem "Seven Cups of Tea" was, in fact, frequently cited by Song poets like Su Shi, a friend of Chen Zao. Just as the body of the vessel can hold the tea, Chen implies, so can the body of a scholar hold the words of the earlier poet. Chen's teapot gave concrete form to the names of these figures, just as his poem alluded to the processes of literati citation as a way to reimagine and reembody the past.

The shapes of Chen's teapots could reference specific local, historical, and epigraphic sources as well. In the process of rewriting the *Liyang County Gazetteer*, Chen came to know three ancient inscribed stone wellheads in the area. One bore a long inscription dated to 811 and was located by the city's western gate on the grounds of an old Buddhist temple. Another from the Tang dynasty was found in Zhugui village, just north of Liyang. Last, an early twelfth-century wellhead carved with the running script words "Drawing from the Past Spring" was located in Liyang, though it had been displaced from its original spring source. Chen took special interest in these local objects of epigraphic value. The same design features that made the wellhead ideal for drawing water—circular body, slightly curved shoulder, and faintly raised lip—proved equally beneficial for the functions of a teapot. Chen mimicked the shape of one hydraulically optimized object in the miniaturized form of another. He crafted many *zisha* vessels in the shape of these wellheads. On several, he reinscribed the 811 text in full. On one, he elaborated on the phrase "drawing from the past" to write the following analogy between the knowledge of the ancients and water, simultaneously alluding to the aid he provided Liyang during the drought: "A well that nurtures without being exhausted, this is the merit of drawing from the past" (fig. 59).[41]

Chen was so taken with this metaphor of the well that he also redoubled it in a calligraphy couplet in ink on paper: "To draw from the well of the past,

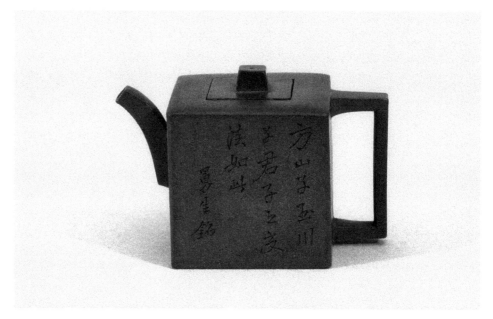

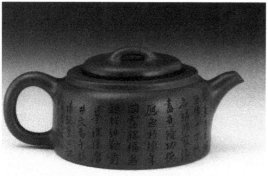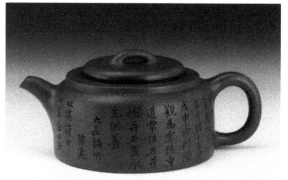

Fig. 58 Chen Hongshou and Yang Pengnian, inscribed square teapot, 1816. Zisha clay, 8.6 × 13.3 cm.
Collection of the Art Museum, The Chinese University of Hong Kong. Gift of Bei Shan Tang, Acc. No.
1983.0018.

Fig. 59 Chen Hongshou and Yang Pengnian, teapot in the shape of a Tang dynasty well (left and right sides),
1815. Zisha clay, 6.6 × 6.1 × 10.1 cm. Shanghai Museum. From Lai Suk Yee, *Art of Chen Hongshou.*

one must tend to the rope; In the pool of my chest, layered clouds begin to
appear" (fig. 60). The first line cites a poem from Han Yu's (786–824) eleven-poem
sequence, "Recollections of Autumn." Han was, in turn, referencing a story from
a first-century BCE collection of tales about philosophers, *Garden of Stories*, in
which the early philosopher Guan Zhong (early seventh century BCE) is quoted
to have said, "A short rope cannot draw from a deep well, and when knowledge
is limited one cannot discourse with the sages; the intelligent scholar is able to

draw from observations of the world, the wise scholar to distinguish those things without boundaries, and the sage recognizes the animating spirit behind all." Chen uses these lines to reinforce the values of the ideal evidential scholar, one who cultivates a deep understanding through observation rather than dogmatically relying on orthodox texts to reveal the truth of the world. What is more, the two characters of the first line, *jigu*, likely allude to the name of one of Ruan Yuan's residences, the Jigu Studio, famous for its collection of ancient bronzes (see chapter 1). Chen's second couplet line comes from the poem "Gazing at the Mountain," by the Tang-dynasty poet Du Fu (712–770), in which an aspiring scholar speaks of his determination to succeed through the metaphor of ascending, and even becoming, the famous Mount Tai. When juxtaposed, both lines seem to ask how can one cultivate an independent knowledge like the sages of the past? And, in that cultivation, how can knowledge become an internal, embodied resource?

Chen Hongshou's collaboration with potters to customize teapots for his network of fellow literati was the culmination of his tactile practice of art making. The teapots expanded the possibilities of literati-inscribed media beyond the fundamentals of paper, silk, and stone. They gave physical form and expanded dimensions to the chosen sobriquets of friends, acting as their physical embodiments. They also extended the aesthetic appreciation of the antique past to social spaces and sensory experiences beyond those normally designated to the scholar's study. Unlike other common literati objects, such as inkstones, wrist rests, or brush pots, teapots had no direct application in the processes of writing or painting. Nor had they before been elevated to objects of aesthetic appreciation and investment, as they did under Chen's guidance and Yang Pengnian's skill. His teapots formed in antique shapes and with stylized classical inscriptions animated the past through the sensation of glowing-warm clay that produced emerald-green beverages to be consumed and tasted over the tongue as they enervated the mind and heated the body from the inside out.

A Tactful Literatus

One way to describe Chen Hongshou's artistic production is to position it as the inevitable result of the chains of textual and visual citation that sustained elite literati culture. To understand Chen's work in this way involves the identification and unpacking of each subtle textual nod to the past. This is how most historians approach later Chinese visual culture, as a dense set of signifiers to be read and translated into their intended meanings, and some of that approach has been continued in this chapter. But the presumption many early nineteenth-century scholars held was that these signifiers had lost their potency, having been progressively hollowed out by each subsequent recycling. Such a narrative sets the stage for the rise of Chinese modernization in the late nineteenth century

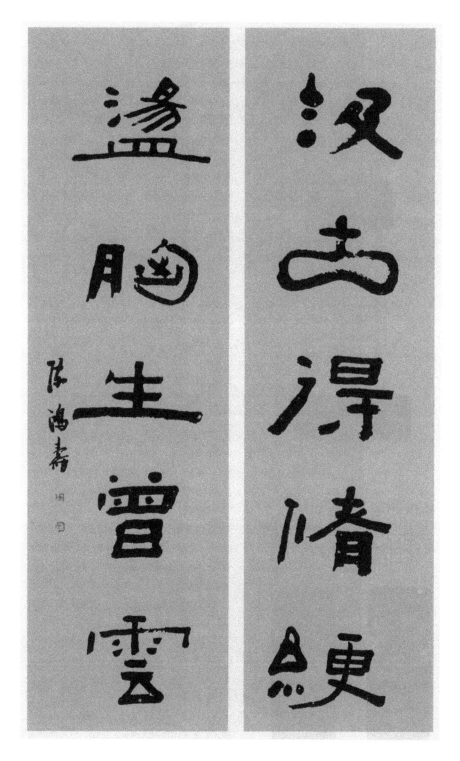

Fig. 60 Chen Hongshou, calligraphy couplet, undated. Ink on paper, dimensions unknown.
Republican period lithographic reprint. From Xiao Jianmin, *Chen* Mansheng *yan jiu*.

and early twentieth century, with its progressivist presumption that the past was something to be overcome, not venerated.

To some, Chen's work might fit this modernist narrative. It is certainly dense with citations of classical poets, politicians, painters, calligraphers, and philosophers whose names, much less their nicknames and sobriquets, seem arcane to a modern reader. These references were used to impress his fellow elites and to bond with them through objects that brought to mind their shared cultural knowledge. But this reading of his work presumes the arrival of modernity in a way that obscures Chen's strategies for combating overdetermined meanings in his own day. Moreover, it denies the possibility that some versions of classicism, such as the epigraphic movement of the late eighteenth and early nineteenth centuries, could be radical in nature and seek to change the culture that incubated them.

Chen's artworks were not simple repetitions of archaic languages; they used archaism to challenge the status quo, and his interest in artifacts from the deep past was almost entirely directed toward the production of new artworks, across a range of mediums. The arc of Chen Hongshou's artistic development over the late eighteenth and early nineteenth centuries demonstrates the need felt by this generation to seek out alternatives to tired orthodoxies of brushwork and even to resist the fetishization of brushwork altogether. Rather than the brush, from the start, Chen's preferred instrument was the chisel. He transferred his handling of the "iron brush" from seal carving to calligraphy and teapot production, and he kept standard brushwork at bay in his paintings by preferring "boneless" and finger-painting techniques. Chen may not have set out to organize his various artworks though the sense of touch, but his interest in moving beyond the brush to a more direct manner of embodied image-making revealed a tactile thinking inherent in the study of epigraphic sources.

The ultimate goal of these art objects was to bring Chen closer to the friends who supported and appreciated him. He crafted each object to suit each relationship, playing subtle games such as molding teapots into visual representations of sobriquets, which gave bodily forms to very personal metaphors. Chen's final medium was also the most explicitly craft oriented. His collaboration with a craftsman like Yang Pengnian can be seen in continuity with what Dorothy Ko has identified in the seventeenth and eighteenth centuries as an increasingly meaningless social boundary between the classes of craftspeople and scholars, which led to greater continuity between practices associated with the mind, like scholarly research, and those that were physical and embodied, like making art objects. Literati textual scholarship became a more craft-like process over this time, and artisan crafts took on scholarly dimensions, preparing a pathway for the rise of evidential research in the eighteenth and nineteenth centuries.[42] This literati-artisan model Ko describes, when activated in an early nineteenth-century visual culture defined by the epigraphic aesthetic, allowed tactile knowledge to

equal classical forms of textual knowledge as the primary means through which literati artworks appealed to their viewers.

Before this book concludes, one last chapter considers the limits of the nineteenth-century literati preoccupation with touch through an examination of a text by Ruan Yuan and a group of artworks by Qian Du. One describes the images formed through an explicit absence of human touch. In the others, touch is paired equally with the other senses to convey direct apprehension.

CHAPTER 6

The Limits of Touch

What are the greater implications of the early nineteenth-century turn to touch described in the preceding chapters? How does articulating this development help us better understand the status of the senses in the literati arts in China? To begin to answer these questions, this last chapter turns to two cases that complicate the notion of touch as the favored sense among literati artists of the early nineteenth century, beginning with Ruan Yuan's five-volume book, *Paintings in Stone*. The subjects of the book's collected poems and descriptions were the "truly trace-less paintings" Ruan found in slabs of patterned marble extracted from the mines of Dali, in Yunnan Provence. The term "trace" was heavily weighted with historical, art historical, and religious connotations, but fundamentally, it applied to physical evidence of previous human contact.[1] Rather than being produced by human touch, Ruan Yuan named the heavens as the maker of these stone paintings. Yet he also identified specific painters whose work the heaven-made marbles resembled. If tactile thinking was central to the production and reception of literati artworks in Ruan Yuan's social circle, then exploring the conditions under which he limited this sense allows us to better understand the relationship of touch to larger artistic and epistemological frameworks.

Likewise, by paying close attention to a poem inscribed on a painting and a teapot made by Qian Du, who was a notable early nineteenth-century artist and member of Ruan Yuan's extended network, it becomes clear that while references to touch played an important role in the reconfiguration of the literati arts at this time, artists also sought to engage other forms of sensory perception to create artworks that evoked bodily experience. These included references to sight, certainly, but also to sound, smell, and even taste, sensations that operated not in opposition to but together with the dense array of historical and textual

citations considered foundational to the literati arts. Acknowledging this may seem to threaten the argument about this generation's turn to touch laid out in the previous chapters, yet it allows us to begin to see a larger history of the literati arts in which attention to the senses was as crucial to the success of an artwork as citational references to historical texts or genealogies of the past. If we consider the exceptional rise of touch in this period as a particular sensory emphasis linked to the central importance of rubbings to evidential studies, then perhaps Qian Du's commingling of sensory and textual experience in artworks represents the default position of the senses in the literati arts. This is an exciting proposal, as it encourages a fresh understanding of the literati arts in early modern China, one in which intellectual and embodied forms of knowledge operated in tandem to engage their audiences.

Ruan Yuan's *Paintings in Stone*

During his last provincial post, as governor-general of Yunnan and Guizhou from 1826 to 1835, Ruan Yuan resided in Yunnan's capital city, Kunming. His primary concerns there included managing the borders with Burma, Vietnam, and Laos, as well as relations among the various ethnic minority groups of the region, which were often in conflict internally, with one another, or with the empire. Already in his early sixties at the time of his arrival, and moving into his early seventies upon his departure from this post, Ruan was in physical decline, impeding his ability to walk with ease. He was likewise denied many of the social and cultural pleasures of his earlier, more cosmopolitan postings.[2] Scholars rarely found their way to Kunming, located as it was at the far edge of the Qing territories. Nor were ancient remnants of early imperial history common in this territory, which had only been incorporated into China during the thirteenth-century Mongolian unification. Left to this difficult and isolated job late in his life, Ruan turned to the marble picture stones of Dali as at least one means of satisfying his social and cultural needs. Through them, he contemplated the fundamental nature of what makes an image. With them, he was able to stay connected with his friends across the empire, capitalizing on these novel objects of literati attention. As Zhang Zhaocen (fl. early nineteenth century) and Ruan Changsheng put it in their preface to *Paintings in Stone*, "Friends in painting and verse are rare in Yunnan; friends are found instead in stone."[3]

Dali sits on the western shore of Erhai Lake, below the slopes of the Diancang Mountains, west of Kunming, and halfway to the border with Burma. It is the last major town before the Tibetan plateau begins its steep ascent to the northwest, and as early as the Ming dynasty, it gained renown for its large deposits of marble. Ruan described his awareness of the appeals of Dali marble in his preface to *Paintings in Stone*: "After several years in Yunnan I had seen quite a few [Dali stones]. [Seeing them] was as if smoke and clouds were [really] passing in

front of one's eyes. When I happened to come to Mt. Diancang, Zhang Zhaocen personally went to the quarries to select and buy stones for me."[4]

These stones were the silver lining to his post in Yunnan, and Ruan was taken with them for the realistic landscape images that could be found in them. Relying on help from the local official Zhang Zhaocen, who became his primary supplier at the quarry of Mt. Diancang, Ruan identified hundreds of these stones with painterly attributes, ordered them to be inscribed with poetic lines, and sent them across Qing-dynasty China to various family members, former aides, poets, seal carvers, and officials, such as Chen Wenshu, Ruan Fu (1801–1878), Yilibu (1772–1843), and Qin Enfu (1760–1843).[5] The book he later published in his retirement, *Paintings in Stone*, gathered Ruan Yuan's collected writings and inscriptions—along with those of his friends—on the naturally occurring landscape images he saw in slabs of Dali marble.[6]

In the preface to *Paintings in Stone*, Ruan traced a genealogy of stone screens through various records of their appreciation by famous past literati. The tradition of seeing painted images in natural stone patterns was, like so many cultural traditions, rooted in Tang- and Song-dynasty literati cultures: "[Discussions of] stone paintings are rare in ancient times, and [only] begin with the 'Mountain Forest' stone screens of the Tang-dynasty poet Yuan Zhen and the monk Wumen. Ouyang Xiu had the 'Pine Forest' stone screen. Su Shi had the 'Moon Stone Winds through the Forest' inkstone screen. Each of these was a Mt. Gu stone [from Zhejiang]. Di Yong had the 'Cloudy Forest' stone screen, and the *Qingyi Record* [by Tao Gu] lists the 'Jade Lohan' stone screen. None of these was a stone from Yunnan."[7]

A picture stone's source mattered. Song-dynasty scholars enjoyed stone screens that came from Mt. Gu in Zhejiang. But Dali stones did not begin to be noticed for their painterly qualities until the Ming dynasty. This was in part due to the later incorporation of the territory into China proper. But as he continued his historiography, Ruan hinted at another reason: "Chen Jiru's *Nigu Record* lists a stone screen that looks like a painting in the Dong [Yuan] and Ju[ran] style, titled 'Late Thoughts alongside Mountain Rivers,' and this may be a Dali stone. Li Rihua's *Six Inkstones and Two Brushes* talks about a circular Dali stone screen that looks similar to [paintings by] Jing [Hao], Guan [Tong], Dong [Yuan], and Ju[ran]. This is definitely a Dali stone from Yunnan."[8]

As Ruan attempted to identify the earliest mention of a stone from Dali, he revealed that resemblance to canonical landscape painting was their central appeal. Other stones may look more or less like images, but Dali stones resembled the great painting styles of Dong Yuan or Juran. For these reasons, he continued, the stones were enjoyed by emperors and literati alike through the seventeenth and early eighteenth centuries.

Paintings in Stone focuses very little on Dali's geography or on marble as a natural resource. The subjects of mining, the finishing processes of planing

and polishing, and all other specific technical concerns warrant no mention. Aside from Zhang, a team of artisans must have helped Ruan select, organize, inscribe, and ship his favorite pieces. But his interest only picked up at the point when the stones were already transformed into presentable planar formats, the moment when a painterly and poetic eye could be turned to the geological grains and patterns of each surface to identify those that most resembled the canonical textures and compositions of literati landscape painting or the metaphors of classic poems.

Ruan described his process: "Some [stones] I inscribed with *yong* poems in order to send to friends or to leave to my descendants. I selected those that had the concepts of classic poems and paintings, instinctively picking them as I spoke the poems and directing each to be engraved as such."[9] Once these natural formations were assigned their poetic and painterly analogs, Ruan ordered their inscription and subsequent mounting into wooden panels or freestanding screen frames so that they could be presented as gifts for friends, again demonstrating the primary role inscribed art objects played in social networking. Many friends and relatives responded with poems of thanks, which were later included in Ruan's book.[10] Ruan's introduction and the overall structure of the book make clear that his primary motivation was to create gifts for his existing family and social networks.

The *yong* poetic tradition was a particularly apt choice for these gifts. *Yong* poetry developed in the Yongming reign period (483–93) of the Southern Qi dynasty (479–502) as a means for courtiers to publicly demonstrate their intelligence. Through close observation and description of a single object, elites at court conveyed their understanding of language and of the world at large. Well-crafted poems revealed a well-crafted mind, and they were a means of accumulating merit among the upper classes. But, as Meow Hui Goh argues, *yong* poems were not only about conveying a semblance of the objects of the world. Through these acts of description, the world's objects became real.[11]

Applying Goh's insight to the stone paintings Ruan had inscribed with *yong* poetry allows us to understand them not just as thoughtful gifts but also as a means to discuss and negotiate the uneasy relationship between perceptions and descriptions. If a natural object manifests patterns that remind a cultured literatus of landscape painting images or of ekphrastic passages from famous poetry, then which came first? Do we experience the world through the archetypes provided by poetry and painting or through our memories and perceptions? The answer *Paintings in Stone* seems to offer is, both.

Each entry in Ruan's book begins with a title that designates one of his stones as the natural manifestation of a famous poem or landscape painting style. Descriptions of the stone's finished dimensions and features follow, then complete references to the famous poems or paintings end each entry along with anecdotal additions by Ruan. Colophons and poems of thanks by other

scholars are also sometimes added, simulating the kinds of cultural accretions more easily added to other literati gifts such as handscrolls. Though they existed only as texts, these entries enveloped the natural stone surfaces in the immaterial cultural strata of historical and poetic allusion. The second entry of the book is as typical as any:

> *Rain Coming to Summer Mountains*. A square stone, one half *chi* by one half *chi*, with a band of ten dark blue-green peaks crisscrossing the center. Under the peaks, clouds rise suddenly. Above them, dark clouds are heavy with rain. This should be titled with the lines from Xu Hun's poem: "Clouds begin to rise off the stream. . . . Rain is coming to the mountains." Many Song and Yuan painters made images of *Rain Coming to Summer Mountains*. In my personal collection, I have a small album of Gao Kegong's landscapes with a leaf of *Rain Coming to Summer Mountains* as marvelous as this stone.[12]

Rain Coming to Summer Mountains is among the most frequently cited titles in Ruan's text. At least one example of a Dali stone attributed to Ruan Yuan and inscribed with this title exists (fig. 61). Though it is uncertain if the stone is the same one mentioned in the text, it does seem to conform in many ways to Ruan's description.[13] Impurities in the original limestone have been compressed in the metamorphic processes of marble formation to produce an oscillating gray-green pattern crisscrossing the stone vertically and horizontally. Ruan's description reads such patterns at times as land and at times as clouds. The purer white marble at the base and top of the composition are seen as clouds and mists. In this mode of viewing, the colored marble veins are also like ink, and the pure marble like raw silk or paper.

One lesson Ruan continuously drew from the Dali stones described in his book is that the patterns of the natural world distilled in the various human traditions of painting or poetry can be recognized again in actual natural phenomena, and they can even be surpassed there. On the topic of pigmentation in Dali stones, he wrote, "The colors of these stones are full of the five prime colors [of painting]. For instance, 'Cloudy Waters' stones are comparable to the painting methods of [the Tang-dynasty painter] Wu Daozi. But they are even more naturally commingled, as if produced by the Heavens and beyond all capacities of ink and brush."[14] The book may have been based around a will to see classical painting styles and poetic images in the natural patterns of planed marble, and to share that vision with fellow elites, but according to Ruan, the brush-based products of the human hand will never compare to those made by nature's hand.

He expresses a similar sentiment at the end of the first entry, about a stone he titled "Spring Dawn over Mists on the Xiang River." Ruan compares what he sees in the stone to both Zhao Mengfu's method of adding color washes to paintings

Fig. 61 Ruan Yuan, *Rain Coming to Summer Mountains*, undated. Marble with carved and inked inscription, 40.8 × 38.7 × 1.2 cm. Courtesy of the East Asian Library and the Gest Collection, Princeton University Library.

and the following couplet by the Tang-dynasty poet Liu Zhongyuan (773–819): "Mists dissipate as the sun comes through, not another person in sight; only the clank and creak of my boat oars sounds off the green landscape." Elaborating on the resonances between the natural marble object and Liu's poetry, Ruan continues, "This stone is the exact likeness of that [poetic line]; it visualizes the words 'mists dissipate' in a way that raw silk or ink cannot even approach."[15]

This awe of nature that Ruan often reiterates therefore contains a critique of the art of painting, which can never quite equal the evocations of a poetic image or the original visual phenomena of the natural world. The other two prefaces to *Paintings in Stone* echo Ruan's sentiments. The first, cowritten by Ruan's supplier, Zhang Zhaocen, and his nephew and adopted son, Ruan Changsheng, is appended to Ruan Yuan's preface. Unlike Ruan Yuan's preface, theirs is entirely in verse, imitating the Tang-dynasty poem set "The Thirty Rhymes." Like Ruan, however, they create a genealogy of stone paintings that includes both literary references to famous poets like Su Shi and Ouyang Xiu and visual references to canonical painters like Dong Yuan, Mi Youren, Ma Yuan, and Xia Gui. They begin with a theme common to all three prefaces—the parallel between painting and poetry, and how both fall short of the natural world: "Painters can paint scenes as marvelous as the feelings of poems; but the limits of man's abilities begin with understanding the work of the Heavens."[16]

Their verses go on to describe the beauty of marble's natural crystalline structures as if it were illuminated from within: "Lamplight shining through

melted wax pooled under candle flame. A deep blue-green color that is truly jade-like, shimmering like stars with real bronze." The following footnote elaborates: "Little sparkling bronze stars become visible in the stone if it is rubbed, each with the essence of bronze."[17] This brief citation is the only explicit tactile reference among the three prefaces to *Paintings in Stone*. Throughout the text, only an absence of touch is emphasized. As Ruan takes pains to describe, Dali stones are crafted by nature and untouched by man.[18]

When Wu Rongguang (1773–1843) added his preface to Ruan's book, he reinforced the logic that painting was inferior to poetry and that both paled in comparison to the natural world.[19] Wu began his argument more philosophically, starting with the idea that viewers see the natural world through the idealized images they remember from poetry and painting and that classical poets and painters naturally did this best: "Between the heavens and the earth, our scenes of the profound and the boundless, the grand and the deep, the soaring and the flowing, all come from poets and are elaborated on by painters; those scenes that painting cannot approach, poetry sometimes grasps."

His text goes on to describe the inevitable frustration this causes for literati painters:

> In landscapes there are those that are true in scene and those that are true in concept, and neither is comparable with nature. As for those [painters] that have in the past pored over [Wang Wei's] *Wangchuan Villa* and [Li Gonglin's] *Longmin Villa*, or Dong Yuan's *Mists and Clouds over Southern Rivers* . . . painting these hills and valleys in their chest, though they may appreciate the unpredictable changes of brush and ink and the concavities of washes, their work still won't resemble the original scene or even the poems of the two Xie's, Cen, or Meng. Their paintings are based on traces. How could they be like trace-less paintings? And how is it that traceless paintings can give proof to poetic imagery? The patterned stones that come out of Yunnan's Diancang Mountains . . . [that] Ruan Yuan has selected . . . and named with the brushwork of classical painters and the poems of ancient poets. . . . I can exclaim are both true in their scenes and true in their concept, as well as being truly trace-less paintings that give proof to poetic imagery.[20]

For Wu Rongguang, the Dali stones that Ruan found were ur-images, possessing all of the best qualities that poets and painters sought in their work but could never fully obtain. Only the natural world could produce such images that were both true in scene (to the eye) and in concept (to the mind). They were images of the world produced by the world, without human intervention. Or, as Ruan put it, "Each stone is naturally endowed with marvelous [images], like the still uncarved and unbroken primordial chaos [at the start of the world]. Even in all

of the many books on calligraphy and painting there is nothing like these styles, nor do they exist in the hundreds of true traces of Song and Yuan paintings and calligraphies that I've seen."[21]

How curious, then, that Ruan began each entry by attaching to these natural images the names of canonical painters and poets. Despite his celebration of the "touchless" hand of nature, and in seeming contradiction to the above sentiments about the absence of nature's style in Song- or Yuan-dynasty painting, Ruan consistently contextualized his experience of each stone by recognizing in it the style of a famous painter or the metaphorical imagery of a famous poet. As much as their heavenly origins situate these images beyond historical genealogies and beyond the constraints of chronological thinking, Ruan felt obliged to reinsert them into familiar histories. To understand Ruan's thinking about this is to understand the fundamental concerns of this generation and, in particular, the critique of the brushwork canon that has defined so many works in the previous chapters of this book.

The stone paintings of Dali offered Ruan and his peers a unique lens through which to reexamine their visual cultures. As objects that simultaneously resembled canonical literati landscape imagery and existed beyond the hand of human creation, even beyond human time frames, these pieces of marble had the potential to short-circuit the entire system of stylistic emulation, of paintings "based on traces," as Wu Ruongguang put it, that had sustained literati visual culture over the previous millennium. In this sense, the same critiques of tradition Ruan brought forward in his two essays on calligraphy, "Southern and Northern Schools of Calligraphy" and "Northern Steles and Southern Letters," structure the approach he and his friends took to the stone paintings.

Indeed, the entries of *Paintings in Stone*, though not descriptions of epigraphic sources, are structured like those in Ruan's epigraphic investigations. Each entry begins with a title, followed immediately by measurements and physical assessements that characterize the stone as a specific, concrete, and unique object. This specificity extends to the analysis of the natural landscape compositions as well, producing a mode of description that exceeded the level of compositional analysis generally found in catalogs of painting: "Wintry Forest Stone Screen: eight *cun* and four *fen* high, six *cun* and eight *fen* wide, a moist white quality of stone, like jade; to the lower center, two layers of shady forest; to the left side, red coloring like the beginning tones of a clear daybreak; to the right side, under the forests, deep within the underlayers, an accumulation of jade-colored dots, producing [an effect] like Dong Yuan's method for painting pines and firs."[22]

Treating his Dali stone paintings as he would treat a stele or a bronze, Ruan brought the mindset of an evidential research scholar to this novel material. But these marble images operated at the opposite end of the spectrum from ancient steles and bronzes. Instead of the fragmentary, eroded objects of epigraphy research, these stone paintings were understood as wholly unified. Rather

than recording the various imperfections visited on an object by time's damaging effects, as he did in his studies of steles or bronzes, Ruan's entries pondered these stones as perfectly formed, perfectly legible primordial images created beyond the constraints of historical time.[23]

Like bronzes and steles, however, the durable nature of these stones was to thank for the truth of the images found in them. In his preface to *Paintings in Stone*, Wu Rongguang discusses the material of Dali marble with the same logic Ruan Yuan used to justify the study of ancient inscriptions in his calligraphy essays, writing, "Silk lasts five hundred years. Paper lasts for a thousand. Though one might treasure and protect them, they rot and disintegrate anyway. But these stone paintings will last for eternity, carrying on their knowledge in unlimited fashion, carrying on a rare true reflection of reality for eternity."[24]

Just as Ruan saw the clerical script of ancient steles as a way to circumvent the overburdened genealogies of calligraphy, the stone paintings of Dali trumped the painting tradition, offering a glimpse of form that returned to the "uncarved block" at the center of cosmic creation. Ruan's friends saw it similarly. Two of Chen Wenshu's poems to Ruan in thanks for his picture stones meditate on the idea of an immortal painter at Mt. Diancang responsible for these images. His "Second Ode to the Immortal Painter of Mt. [Dian]cang," begins by musing, "The moon may be cultivated, and the stars can be grown; [just as] the clouds carve jade seals from great forest caves. Stone paintings from the mountains, marvelous beyond all measure, must be the work of some immortal." The immortal painter of stones that Chen concocted had powers akin to the natural forces that shape the moon and stars or to the clouds that sculpt the earth. Furthermore, the poem elaborated, when the painters of the human world wrote discourses on painting, it was the "boundless knowledge" of this immortal that they sought. The knowledge of all the revered painters of the past, Chen proposed, had its source in the greater principles of the natural world.[25]

Ruan's insistent likening of the stone images to canonical paintings and poems did not advocate for a return to the brushwork canon and its self-sustaining vocabulary of stylistic citation. Instead, his objective was to reassert the value of apprehending the fundamental principles of the world that these patterned stones naturally possessed. These stone images were "beyond all capacities of ink and brush." They found true resonances with the world that "raw silk or ink cannot even approach," signaling that the hand of heaven was their maker. As Chen's ode further indicates, the aim of the gentlemanly painter was to try to capture, even if only in some small way, the patterns that these stones naturally manifested. The ability to do this had originally distinguished the work of those painters and poets who had become canonical. Ruan's inscriptions on these stones indicated his admiration for them as well as a tacit disavowal of the later recycled emulations of canonical brushwork and poetry that made the arts stale. Like the epigraphically influenced work of Huang Yi, Chen Hongshou,

Liuzhou, and many of the other literati artists described in this book, Ruan's text sought to return a direct and unmediated contact with the world to literati visual culture. While the appeals of immediate, tactile contact with real objects provided that intimacy within the epigraphic aesthetic, touch was not the only means to achieve this apprehension of the world's principles. It could be a found in direct knowledge of heaven's patterns, as in Ruan's paintings in stone, images crafted by the hand of nature itself to convey pure principle.

Qian Du and the Senses of Literati Art

Alternatively, that directness of experience could be achieved through a more balanced appeal to all the body's senses, as sought by Qian Du, a peer of the central subjects of this book who was known among them as a painter and a poet. Qian's artwork did reflect some of the increased attention to epigraphic sources and tactile sensations. "Antique and awkward" frequently counted among the aesthetic terms he used to describe his painting, and in his published writings on art, he advocated that artists look to the carved Han-dynasty figural images of the Wu Family Shrines (see figs. 25 and 26). However, he was not an epigraphy scholar, nor was he an advocate for epigraphy per se. Instead of a dominant emphasis on touch, Qian cemented his connections to his peers through evocations of the other shared pleasures of literati culture, both intellectual and sensuous, just as often as he cited stone sources. The following poem on one of his blossoming plum paintings attests to this and allows us to think about the role of touch within an expanded literati engagement with the senses and the past:

> In this grass hut, as the snow clears off, a wind knocks at the door; [snow-flakes like] flowers drift through the air between patches of clear sky and clouds.
> People follow mountain birds up to jagged precipices, [where] the monks befriend wild gibbons, [both] chanting through the clouds on sleepless nights.
> The icy mount, with its wintry aroma, is cast in troubling shades—dense clouds that stand in contrast against the open blue vault of heaven.
> In the dead of a moonless night, my clogs echo through the mountains; at the base of a stele, I scrape away [grime] [to reveal] a fine fragmented text.[26]

At first glance, the poem's literati language is familiar enough. Like Qian Du's paintings, the poem roots itself in the common tropes of literati art and adds just enough specificity to assert his individual voice. A common way of reading it would be to recognize and list its historically laden phrases as a series of references to the past poets and texts that define canonical literati discourse. For example, the words "mountains" and "clogs," translated separately above, are

found next to one another in the original poem, a citation of the posthumous name of Xie Lingyun (385–433), a Six Dynasties writer famous for his innovative landscape poetry. When later poet-painters like Qian Du used the phrase "mountain clogs," they aligned their own work with Xie Lingyun's historical reputation. By the early nineteenth century, Xie's legacy had been so frequently invoked that Qian's line easily would have been read by contemporaries as, "In the dead of a moonless night, I hear Xie Lingyun [Mountain Clogs]."

When later poets used the alternative names of past poets like this, they borrowed both the historical specificity of the poet's name and the sensorial dimensions of its metaphors, simultaneously inhabiting each to create a poetic image that appealed to viewers in terms that were directly understood in the body as much as in the heart-mind. Reading the words of Xie's moniker in Qian Du's poem as poetic metaphor, a central theme within the poem begins to emerge, that of images concealed to the eye but revealed by the other senses. The rustle of the wind at the door presages the arrival of a friend. The sounds of monks and gibbons betray their existence behind a veil of clouds. The smell of the cold identifies ominous portents. The sound of clogs reveals a man in the dark night. An ancient text is made apparent by tactile attention to a decaying monument. To visualize any of the images in this poem is to imagine them through another sense altogether.

Qian Du's most affecting image of an unseen presence comes from the coda to the poem, which explains that it was inspired by the memory of a friend's visit: "In the first month, after the snows receded, a friend came up to the cold mountains, with fragrances still clinging to his wintry clothes and sleeves. I composed this poem, and in the third month, during the rains, I suddenly recalled my former travels, so I sketched out a cut branch of mountain blossoming plum as if it were tenderly uncurling among the mists and lush foliage."

Arriving from the milder valley below, where the plum blossoms were already in bloom, this traveler carried their scent with him on his clothes as he arrived. Without seeing the blossoms for himself, Qian Du understood this sign of the coming spring by the wafting fragrance still clinging to the sleeves of his friend. Reading the poem and its coda alongside the original accompanying painting further reinforces the theme by inverting it. Seeing the image of blossoming plum branches gives form to the sensations of cool fragrances, forest sounds, and the echoes of scholarly bodies.

It may seem appropriate to think of a sensory reading of this poem and its painting as depicting the experiences of its maker, Qian Du. But that approach limits the intended dimensions of the artwork and misunderstands the role played by the senses in literati art. References to sounds, sights, smells, and touches were not just to those of their maker. They existed interhistorically and transcorporeally. Qian Du combined multiple historically specific moments within the single artwork: the day he painted the blossoming plum and inscribed

the poem, his memory of an earlier visit from a friend, and the fifth-century voice of Xie Lingyun, not to mention the other citations he embedded in the work. However, an artwork like this was expected to take on new colophons and poems from later viewers. With each new line of verse or commentary, a new voice and a new body were added to the artwork, attesting to the capacity of the artwork to facilitate reembodiment by later viewers. The sensory images Qian Du cited and those he added were especially crucial to this networked mode of bodily engagement.[27] In most art historical writing about literati art, colophons and reinscriptions are analyzed to track an artwork's collection history. But if we recast those writings as new sensory experiences inspired by the original artwork, and even intended by the original artists, we begin to understand the literati arts in surprising ways—as combinations of suspended sensory experience and textual citations that convey a unified apprehension of the world across time and space. What would a history of Chinese art look like if centered around the capacities of such artworks to interweave future viewer experiences together with the maker's perceptions and the imagined sensations of the past? Another artwork by Qian Du on the same theme as the poem, blossoming plum branches, allows us to explore these concepts and the intermedial aspects they encouraged within the literati experience.

In 1816, while Qian Du was visiting his friend Chen Hongshou at Liyang, he collaborated with the potter Yang Pengnian to make *Cold Jade Pot*, a tea vessel he dedicated to his sister (fig. 62). On one side, the inscribed image of a blossoming plum painting by Qian Du stretches across the surface of the semicircular teapot. Its incised branches reflect the same dry brushwork of Qian Du's paintings on paper. But on this teapot, the organic lines do not stop at the boundary edge of the flat, fanlike face. Instead, they take advantage of the object's dimensions, extending over the top of the vessel to wrap around the spout from which tea was poured. The poem, written on the reverse in seal script, reads:

Cold Jade Pot.
One branch, then two branches, of azure dragon shadows,
A thousand dots, then ten thousand dots, of spring vapor traces,
Suddenly I remember Western Spring deep in the winter snow,
As the swishing sound of oars reaches my humble hut door.

The first two lines of the poem reinforce the connection between image and object, creating parallel metaphors that link the branches and circular petals of the blossoming plum image with the linked shadows cast by swirling tea leaves and the rolling boil of spring water. The commingled smells and colors of the tea are then further joined by the poem's sonic memory of the sound of oars announcing a visitor's arrival by boat, like a knock at the gate. Such references naturally would have resonated with the sounds of tea preparation. The

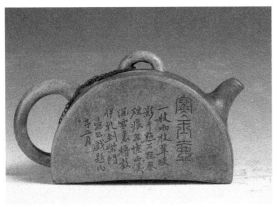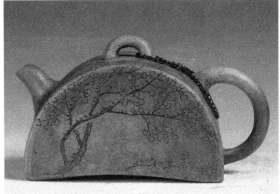

Fig. 62 Yang Pengnian and Qian Du, *Cold Jade Pot* for Qian Lin (left and right sides), 1816. Zisha clay, 8.5 ×
16 cm. Tianjin Museum. Image provided by Tianjin Museum.

transfiguration of Qian Du's text and image into a three-dimensional tea vessel
activated its poetic and visual metaphors in a highly planned interplay between
image, word, and object, with each aspect reinforcing the other. Whenever the
vessel was used again for the preparation of tea, by Qian Du's sister or a later
owner, these metaphors reactivated. Holding the warm side of the teapot, fingers
gliding along the shallow marks of Qian Du's transferred brushwork on either
side, a host might remember Qian's original visitor coming in out of the cold of
the deep snow to share a cup of tea. As they poured the light-green broth from
the fragrant spout wrapped in images of blossoming branch tips, their reactiva-
tion of the object would bond present experience with past memory in a concrete
but open-ended series of sensations, incised brushmarks, and poetic verse. Qian
Du may be primarily remembered by art historians as a painter and a poet, but
above all, he was an artist of the literati experience, someone who aimed to rein-
force his relationships with others by creating objects that bonded him to them
through reference to shared knowledge and activities, regardless of medium.

Expanding from this example, we might consider the broader lessons that
this sensory history offers Chinese art, especially literati art. Despite the highly
inscribed nature of literati artworks, and their frequent allusions to historical
events, people, or places, they were designed to engage the senses as much as
the intellect. And, despite later art historical tendencies to separate work in one
medium from another, literati artists naturally worked intermedially. The ideal
literati artwork engaged its audiences by promising a high potential for network-
ing, and it achieved that promise through complex imbrications of sensory and
intellectual experience. By combining images, poetry, and inscriptions, literati
artists created new objects in a variety of mediums that merged history, memory,
and sensory phenomena to produce a collective knowledge across bodies and time.

Epilogue
Modern Horizons

A reverence for epigraphic materials catalyzed fundamental changes in the literati arts of early nineteenth-century China, producing an epigraphic aesthetic across many different mediums. This prompted a reorientation of artistic attention among elites toward a new experience of touch, one that enabled this generation to evacuate older biographically oriented genealogies of style and replace them with new lineages based in concrete, material evidence from the ancient past. The tactile thinking embraced by this generation only increased the capacities of literati artworks to fulfill their primary function—the concretizing of social bonds among elites. From the brush arts of calligraphy and painting to the carved arts of seals, printed books, and teapots, tactful literati began to appeal to each other though the sense of touch as much as they had previously relied on citations of canonical textual and visual languages. Touch was immediate, intimate, and, most importantly, allied with dominant forms of classical knowledge.

This specific historical turn toward touch may be aligned with the epigraphic cultures of the late eighteenth and early nineteenth centuries, but the ideas that emerge from a sensory history of this period give us pause to reconsider the fundamentally embodied nature of literati aesthetics. Likewise, the ramifications of this argument reverberate in the later developments of modern visual and material culture. This book closes with speculations in these directions, offering a way to understand the crucial contributions early nineteenth-century artists offer to the larger narratives of Chinese art history.

This is the first stand-alone study of early nineteenth-century Chinese art. The period has long been neglected by historians of early modern Chinese art, who rarely extend their field of study beyond the death of the Qianlong emperor in 1799, an event that marked the end of a golden age of artistic production within the court and disrupted patronage circles outside of it. Likewise, scholars of modern Chinese art largely begin their stories in the 1850s, grounding their narratives in relation to the Opium Wars (1839–42, 1856–60) and the Taiping Civil War (1850–64), events that fundamentally redirected the path of Chinese history. The first set of wars resulted in the forcible imposition of globally oriented trade policies favoring Western nations. The other war killed tens of millions and displaced just as many, rupturing the economies of China's heartland and fracturing Qing-dynasty control over the empire. Over the next half-century, the Qing government struggled to regain economic or political stability, eventually falling to revolutions that established the Republic of China in 1912. For most art historians of China, early nineteenth-century artworks fail to attract interest because they offer only pale reflections of the luxury and innovation of the eighteenth century and do not anticipate the coming changes of modern China. Sensory history has offered a way around one of these hurdles by tracking the development of tactile thinking from its roots in the eighteenth-century scholarly priorities of evidential research. But what of the major political and economic changes on the midcentury horizon?

Scholarship on the early phases of China's modernization has greatly expanded over the last generation, showing that late nineteenth-century artists in the new cosmopolitan melting pot of Shanghai began to challenge normative ways of painting, patronage, and self-marketing. Increasingly professional and self-aware, they foregrounded the commodity statuses of their artworks and cultivated appealing artistic personae to suit a rapidly changing marketplace. Painters like Ren Bonian (1840–1896) took up the underappreciated but commercially viable genres of bird-and-flower images and portraiture. Stylistically, he relied on visually engaging color washes that simulated the play of light on surfaces rather than the kinds of ink-heavy brushwork favored by earlier literati. In the mid-1850s, Ren Xiong (1823–1857), another Shanghai-based artist, created one of the most striking self-portraits in all of Chinese painting history, inscribing it with a scathing inscription that vented his frustrations with the traditions of literati painting and the general decay of the Qing-dynasty world.[1] The visual effects of an epigraphic aesthetic on the brush-based arts of Shanghai artists have been described by many in the work of Zhao Zhiqian (1829–1884) and Wu Changshuo (1844–1927), who were famous for their clerical-script calligraphy, seal carving, and paintings of flora, which share a boldness and intensity both in color wash and archaic line.[2] Beyond Shanghai, recent scholarship identifies similar trends in Guangzhou-area artists active during the 1840s, like Ju Lian and Ju Chao, whose bird-and-flower paintings directly fed into Shanghai styles,

and Su Renshan, whose eccentric landscapes employed iconoclastic brushwork in reaction to canonical painting models.[3]

Antiquities and other classical artworks handed down in private family collections for generations came onto the open market following the midcentury turmoil, where they were swept up by merchant elites, foreigners, and a new group of scholar-officials who adapted Western learning for Chinese needs. Wu Dacheng (1835–1902), for instance, studied Western cartography and oversaw the establishment of new Western-style military academies while building an impressive collection of ancient artworks. When Wu cataloged his collections, he combined the old technology of rubbings and the new technology of photography, producing visually precise composite rubbings that maintained the aura of antiquity.[4]

The modern Chinese publishing revolution began in the cosmopolitan atmosphere of the new treaty ports as well. Publications such as *Illustrated News from the Lithography Studio* (1884–89) reported on a combination of global and local contemporary events, as well as topics from classical Chinese culture, modern fiction, and global novelties, all accompanied by sensationalized lithographic illustrations.[5] Art-specific periodicals like *Light of the Divine Nation* (1908–12) reproduced classical paintings and calligraphy with the new technologies of halftone process and collotype.[6] These publications reshaped the visual imaginations of their readership with novel images that created new viewing practices and altered older ones. Viewing painting and calligraphy had classically involved the audience's projection into the imagined body of the painter, providing an experience of psychological depth that depended on judging the absorptivity of ink into paper. In contrast, photolithographic reproduction reduced brushwork's depth to the single, flat, optical moment of a picture. This paved the way for the coming reorientation of painting around scientifically based optical realism, an idea that would dominate discussions of art in twentieth-century China.[7]

Yet each of these changes in visual and material culture associated with the rise of modernity in China began earlier in the nineteenth century, as the chapters of this book demonstrate. Voices questioning the visual and material roots of literati brushwork canons included Ruan Yuan, Huang Yi, Chen Hongshou, and many others. A relinquishment of the calligraphic brushwork favored by literati painters to instead revel in the pleasures of color washes and boneless techniques that better depicted light on varied surfaces defined Chen Hongshou's painting before it did that of Ren Boren, Zhao Zhiqian, Ju Lian, or Ju Chao. The same can be said for the integration of seal carving, painting, and clerical-script calligraphy later practiced by Wu Changshuo and Zhao Zhiqian. Even the later reduction of brushwork to a flattened, optical experience in photo-based illustration can be traced to the early nineteenth-century evacuation of brushwork in Huang Yi's reproduced rubbings. When the editors of Chinese magazines in the 1910s introduced techniques like the halftone process and collotype to readers,

the closest comparable analog they knew in terms of accuracy and authenticity was double outlining, the same technique promoted by Huang Yi in 1800.[8]

From this perspective, the material and visual cultures of mid- to late nineteenth-century Chinese culture show greater continuity with the early nineteenth-century literati arts described in this book than disavowals of them. Early nineteenth-century literati sowed the seeds for the formal and conceptual changes associated with modern Chinese imagery well before the semicolonial intervention of Western powers during the Opium Wars or the upending of elite, cultured networks during the Taiping Rebellion. Yet the narrative of modernity as a break with the past driven by exposure to non-Chinese visual cultures persists in the study of Chinese art. Nowhere is this more evident than in the treatment of nineteenth-century artists. The logic of modernity demands rupture. But what, if anything, is given up between the early nineteenth century and the late nineteenth century?

The most obvious answer to this question would be a valorization of the past. A critique of the immediate past was certainly crucial for early twentieth-century advocates for the reform of Chinese painting. But even that answer is only partly true, as is evident in Xu Beihong's (1895–1953) 1918 essay "Methods for the Improvement of Chinese Painting":

> The deterioration of Chinese painting studies has reached its peak today. Throughout the world, the principle of civilization is to avoid degeneration, and only Chinese painting is today fifty paces behind where it was twenty years ago, five hundred steps behind where it was three hundred years ago, four hundred steps behind where it was five hundred years ago, a thousand steps behind where it was seven hundred years ago, eight hundred steps behind where it was a thousand years ago. The passiveness of our people is really pitiable. How then was painting studies allowed to reach this ruined state? On the one hand it was conservatism. On the other hand, it was the loss of an independent set of artistic skills.[9]

Xu grounded his logic in an idea of skill and progress based in optical realism, a priority he internalized while studying in art academies abroad, first in Tokyo and later in Paris. But he did not denounce art from the past outright in his essay. Xu Beihong built his vision for modern painting with a selective narrative, embracing some aspects of historical art and casting others aside. The artists who he believed most deserved reproach were those from the immediate past, the nineteenth-century literati who, in his mind, abandoned technical skills cultivated by Song-dynasty painters in favor of conservative aesthetic ideals like the "antique and awkward." Throughout the Republic of China period, reformers heavily criticized epigraphy scholars of the eighteenth and nineteenth centuries because they were associated with the generation of Qing-dynasty

scholar-officials who, preferring to study ancient stones and bronzes, failed to save the dynasty from collapse.[10] This accusation shaped the entire nationalist view of early modern painting, and it has continued to obscure the study of the early nineteenth century until only very recently.

Historical consequences aside, the modern suggestion that literati of Ruan Yuan's generation were bound by tradition neglects to understand the terms of their antagonism toward the canon. Early nineteenth-century artists posed challenges to the hierarchies of received knowledge that were as radical as early twentieth-century artists, if not more so. Instead of returning to the visual realism of the Song dynasty, as painters like Xu Beihing would advocate, early nineteenth-century artists questioned the entire brushwork paradigm in order to return the arts to the roots of Chinese culture in the Han dynasty, the Six Dynasties period, and before. If they were traditionalists, then the tradition they pursued was underpinned by a deeper questioning of the past than that of the modernists that followed.

Glossary of Names

Throughout the text and footnotes life dates are given only if known.

(Emperor) Ai of the Han dynasty 漢哀帝 (r. 7–1 BCE)

Bai Juyi 白居易 (772–846)

Bi Yuan 畢沅 (1730–1797)

Cai Yong 蔡邕 (132–192)

Cang Sisheng 倉斯升 (1776–after 1820)

Chen Chun 陳淳 (1483–1544)

Chen Geng 陳庚 (fl. mid-nineteenth century)

Chen Hongshou 陳鴻壽 (1768–1822)

Chen Jian 陳鑾 (1786–1839)

Chen Jieqi 陳介祺 (1813–1884)

Chen Kanru 陳坎如

Chen Wenshu 陳文述 (1771–1843)

Chen Yun 陳均

Chen Yuzhong 陳豫中 (1762–1806)

Chen Zao 陳慥 (fl. late eleventh century)

Cheng Hongpu 程洪溥

Chu Suiliang 褚遂良 (596–658)

Cui Rushi 崔儒眡 (also called Cui Moyun 崔墨雲) (fl. late eighteenth–early nineteenth centuries)

Dai Zhen 戴震 (1724–1777)

Ding Jing 丁敬 (1695–1765)

Dong Bangda 董邦達 (1699–1769)

Dong Qichang 董其昌 (1555–1636)

Du Fu 杜甫 (712–770)

Duan Songling 段松苓 (1745–1800)

Fang Xun 方薰 (1736–1799)

Fei Danxu 費丹旭 (1801–1850)

Fu Zhijing 傅指精

Gao Qipei 高其佩 (1660–1734)

Gao Rijun 高日濬 (1772–?)

Gong Chun 供春 (fl. during the Zhengde era, 1506–1520)

Gu Chonggui 顧崇槼

Gu Kaizhi 顧愷之 (345–406)

Gu Luo 顧洛 (1763–1837)

Guan Tingfen 管庭芬 (1797–1880)

Guanxiu 貫休 (832–912)

Guan Zhong 管仲 (early seventh century BCE)

Gui Fu 桂馥 (1736–1805)

Guo Lin 郭麐 (1767–1831)

Han Chong 韩崇 (1783–1860)

Han Yu 韓愈 (786–824)

Hao Jing 郝經 (1223–1275)

He Yuanxi 何元錫 (1766–1829)

He Zhen 何震 (1522–1604)

Heshen 和珅 (1750–1799)

Hong Gua 洪适 (1117–1184)

Hong Liangji 洪亮吉 (1746–1809)

Hongren 弘仁 (1610–1663)

Hu Jing 胡敬 (1769–1845)

Huang Jun 黃均 (1775–1850)

Huang Shugu 黃樹穀 (1710–1751)

Huang Yi 黃易 (1744–1803)

Hui Dong 惠棟 (1697–1758)

Huichong 惠崇 (965–1017)

Ike no Taiga 池大雅 (1723–1776)

Ji Yuji 計魚計

Jiang Fengyi 江鳳彝

Jiang Kui 姜夔 (1155–1221)

Jin Nong 金農 (1687–1764)

Kong Luhua 孔璐華 (1777–1833)

Kong Qingrong孔慶鎔 (1787–1841)

Kong Shangren 孔尚任 (1648–1718)

Li Changgeng 李長庚 (1750–1808)

Li Dongqi 李東琪 (fl. late eighteenth century)

Li Fangzhan 李方湛 (1764–1816)

Li Liufang 李流芳 (1575–1629)

Li Song 李嵩 (fl. 1190–1230)

Li Xingyuan 李星沅 (1797–1851)

Li Yijin 李伊晉

Liang Baosheng 梁寶繩

Liu Kang 劉康 (d. 23 BCE)

Liu Yong 劉墉 (1719–1805)

Liu Zhongyuan 柳宗元 (773–819)

Liuzhou 六舟 (also called Yao Dashou 姚達受) (1791–1858)

Lu Fei 陸飛 (1719–after 1778)

Lu Sheng 陸繩

Lu Tong 盧仝 (fl. early ninth century)

Lu Wenchao 盧文弨 (1717–1796)

Lü Dalin 呂大臨 (1046–1092)

Luo Ping 羅聘 (1733–1799)

Ma Fuyan 馬傅岩

Nayancheng 那彥成 (1764–1833)

Ni Zan 倪瓚 (1301–1374)

Niu Yunzhen 牛運震

Ouyang Xun 歐陽詢 (557–641)

Ouzhuang 區莊 (fl. nineteenth century)

Qi Huangshan 崎黄術

Qian Daxin 錢大昕 (1722–1804)

Qian Dongshu 錢東墅 (1768–1833)

Qian Du 錢杜 (1763–1844)

Qian Yong 錢泳 (1759–1844)

Qin Enfu 秦恩復 (1760–1843)

Ren Bonian 任伯年 (1840–1896)

Ren Xiong 任熊 (1823–1857)

Ruan Fu 阮福 (1801–1878)

Ruan Yuan 阮元 (1764–1849)

Ruan Changsheng 阮常生 (1788–1833)

Seng Yuqiao 僧予樵

Shao Jinhan 邵晉涵 (1743–1796)

Shen Rong 沈容 (1771–1843)

Shen Zhou 沈周 (1427–1509)

Shi Dabin 時大彬 (fl. during the Wanli era, 1573–1620)

Shitao 石濤 (1642–1707)

Shushi 漱石

Song Xi 松溪

Su Shi 蘇軾 (1037–1101)

Sun Shao 孫韶 (1752–1811)

Sun Xingyan 孫星衍 (1753–1818)

Sun Yuanxiang 孫原湘 (1760–1829)

Tang Yifen 湯貽汾 (1778–1853)

Tang Zhongmian 唐仲冕 (1753–1833)

Tao Kan 陶侃 (259–334)

Tiebao 鐵保 (1752–1824)

Wang Chang 王昶 (1725–1806)

Wang Chen 王宸 (1720–1797)

Wang Hong 王鴻

Wang Hui 王翬 (1632–1717)

Wang Jian 王鑑 (1598–1677)

Wang Jiu 王玖 (1745–1798)

Wang Niansun 王念孫 (1744–1832)

Wang Shimin 王時敏 (1592–1680)

Wang Su 王愫 (ca. 1700–1763)

Wang Wei 王維 (701–761)

Wang Xianzhi 王獻之 (344–386)

Wang Xizhi 王羲之 (303–361)

Wang Xuehao 王學浩 (1754–1832)

Wang Yu 王昱 (1662–1748)

Wang Yuanqi 王原祁 (1642–1715)

(King) Wen of the Zhou dynasty 周文王 (r. 1056–50 BCE)

Wen Boren 文伯仁 (1502–1575)

Wen Peng 文彭 (1497–1573)

Wen Zhengming 文徵明 (1470–1559)

Weng Fanggang 翁方綱 (1733–1818)

Wu Changshuo 吳昌碩 (1844–1927)

Wu Dacheng 吳大澂 (1835–1902)

Wu Qian 吳騫 (1733–1813)

Wu Rongguang 吳榮光 (1773–1843)

Wu Tingkang 吳廷康 (1799–1888)

Wu Wei 吳偉 (1459–1508)

Wu Yan 吾衍 (1272–1311)

Wu Yi 武億 (1745–1799)

Wu Zongai 吳宗愛 (1650–1674)

Xi Gang 奚岡 (1746–1803)

Xi Peilan 席佩蘭 (1776–?)

Xie He 謝赫 (late fifth–early sixth centuries)

Xie Lingyun 謝靈運 (385–433)

Xie Yong 謝庸 (1719–1795)

Xu Beihong 徐悲鴻 (1895–1953)

Xu Han 許瀚 (1797–1867)

Xu Lian 許煉 (d. 1786)

Xu Nai'an 許乃安

Xu Shen 許慎 (30–124)

Xu Wei 徐渭 (1421–1493)

Xu Xi 徐熙 (886–975)

(King) Xuan of the Zhou dynasty 周宣王 (r. 827–782 BCE)

Yan Song 嚴嵩 (1480–1567)

Yan Yuan 顏元 (1635–1709)

Yan Zhangming 嚴長明 (1731–1789)

Yan Zhenqing 顏真卿 (709–784)

Yang Pengnian 楊彭年 (fl. early nineteenth century)

Yao Ding 姚鼎

Yi Bingshou 伊秉綬 (1754–1816)

Yilibu 伊里布 (1772–1843)

Yongqiu 擁秋

(Emperor) Yuan of the Han dynasty 漢元帝 (r. 49–33 BCE)

Yuan Mei 袁枚 (1716–1798)

Yuan Tingdao 袁廷檮 (1762–1810)

Yude 玉德 (d. 1809)

Yun Shouping 惲壽平 (1633–1690)

Zhai Jichang 翟継昌 (1770–1820)

Zhang Jian 張鑑 (1768–1850)

Zhang Tingji 張廷濟 (1768–1848)

Zhang Xianghe 張祥河 (1785–1862)

Zhang Xu 張叙 (1690–1776)

Zhang Xun 張塤 (fl. late eighteenth century)

Zhang Yin 張鉴 (1761–1829)

Zhang Zhaocen 張肇岑 (fl. early nineteenth century)

Zhao Guolin 趙國麟 (1673–1750)

Zhao Wei 趙魏 (1746–1825)

Zhao Yue 趙鉞 (1778–1849)

Zhao Zhiqian 趙之謙 (1829–1884)

Zheng Jitang 鄭際唐 (fl. late eighteenth century)

Zheng Xuan 鄭玄 (127–200)

Zheng Zhijin 鄭制錦 (fl. late eighteenth century)

Zhou Tong 周種 (fl. late eleventh century)

Zhu Gui 朱珪 (1731–1807)

Zhu Peng 朱彭 (1731–1803)

Zhu Weibi 朱為弼 (1771–1840)

Zhu Wenzao 朱文藻 (1735–1806)

Zhu Xi 朱熹 (1130–1200)

Glossary of Foreign Terms

(Chinese unless otherwise noted)
baojia 保甲, household-reporting system
bi 筆, brushmark
bian 遍, differentiate
biyi 筆意, brush intentions
baisui tu 百歲圖, century images
bapo 八破, eight brokens
Dao xue 道學, School of the Way
er 而, and/furthermore
gong'an 公案, case studies
gu ti fu 骨體膚, bones, body, and skin
guzhuo 古拙, antique and awkward
Han xue 漢學, Han (dynasty) learning
hao 好, affinity
ji 跡/迹, traces
jiahu 賈胡, traders from the northwest
jinshi 進士, presented scholar
jinshi xue 金石學, epigraphy
jun 浚, profound depth, dredge
kaozheng xue 考證學, evidential research
kuotian 廓填, fills within the outline of the character
le 樂, taking pleasure
li 理, relational patterns
Lianyin 蓮因, begets lotuses
mo 摸/摹, touch, caress, copy
muke 幕客, aides
muyou 幕友, aides
nanga (Jp.) 南画, Chinese-style literati painting
penjing 盆景, potted scenes
pipa 枇杷, loquat
pipa 琵琶, Chinese lute
quanxing ta 全形拓, full-form / composite rubbing
que 缺, lacking
qun 夋, name of mythical emperor Yao's father
ri 日, day/sun
ru 儒, Confucian

shi 逝, passing of time, death

shui 水, water

shou 壽, longevity

shuanggou fa 雙鉤法, double-hook method, generally translated as "outline method"

sui 歲, year

sui 碎, fragment

Taoling tripod 陶陵鼎

tianmo 填墨, filled in with ink

tuanlian 團練, local militia

wen 文, writing/literature/civility

wenren 文人, literati / lettered person

wu guan 五官, five sensory officials

Wuzhuan tripod 鄦専鼎 (also 無専鼎)

xin 心, heart-mind

xin xue 心學, School of the Mind

yi 異, differentiate

yuan 緣, effect, causation, perception

yu yi 愉佚, pleasure and ease

zhi 知, knowing

zhuo 拙, awkward/unstudied

zisha 紫砂, purple sand (clay)

Notes

Introduction

1. Ledderose, "Aesthetic Appropriation";
McNair, "Engraved Calligraphy."

2. The first inscription can be found after
Ruan Yuan's frontispiece to Liuzhou's 1839
full-form rubbing handscroll of the Dingtao
tripod in the Zhejiang Provincial Museum (see
fig. 43), and it is transcribed in Zheijang
Provincial Museum, *Liuzhou*, 33. Ruan's second
inscription comes from a full-form rubbing
hanging scroll in a private collection, and it is
reproduced in Wang Yifeng, "Guzhuan
huagong," 111.

3. The lack of interest in visual realism
within the elite arts of China is a complicated
topic, but it is most fundamentally described in
Fong, *Images of the Mind*. More recent
research, such as Kleutghen's *Imperial Illusions*
as well as Kile and Kleutghen's "Seeing
Through Pictures and Poetry," provides context
for the reception of visual illusionism and
optics from Western sources within and outside
of the Qing dynasty court in the seventeenth
and eighteenth centuries. While many of the
techniques of visual realism were available to
artists and artisans of the period, they were not
widely popularized.

4. For recent work in this period on similar
issues of paintings merged with rubbings, see
Matteini, "Story of a Stone," and Hatch,
"Epigraphic and Art Historical Responses."

5. A phenomenon described in full in
Elman, *From Philosophy to Philology*, as well as
in Sela, *China's Philological Turn*.

6. Previous art historians of China have
duly identified this epigraphic aesthetic in the
early nineteenth century, but their attention
has been confined almost exclusively to
calligraphy. While scholars agree on the
importance of the epigraphic school of
calligraphy (see Chuan-hsing Ho, "Calligraphy
of the Mid to Late Qing Epigraphic School" for
a recent overview), the spread of an epigraphic
aesthetic to other media has been debated. The
landscape painting of the epigraphy scholar
Huang Yi is an example. His contemporaries
associated his painting style with Dong
Qichang's orthodox brushwork lineage, not his
epigraphy studies. Nor did he describe his
painting directly as epigraphically influenced.
For a brief period in the early twentieth
century, scholars began to describe the style of
Huang Yi's painting in relation to his epigraphy
studies. From the 1930s to the 1990s, however,
scholarly interest in epigraphy studies declined
dramatically for political reasons. During this
time, it became fashionable to blame the
backward-looking antiquarian tastes of scholars
of the late eighteenth and nineteenth centuries
for the downfall of imperial Chinese culture in
the face of modernization and imperialism. As
such, studies of the stylistic relationship
between his painting and his epigraphy
materials have been underdeveloped. Li Ming,
"'Jinshixue.'"

7. Early nineteenth-century Chinese art
has been considered a creative nadir by scholars
since the first Western-style surveys of Chinese
art history were written, including those by
Chinese authors. Books like Fenollosa's *Epochs
of Chinese and Japanese Art* (1912) place the
zeniths of Chinese painting at the end of the
Tang dynasty and the beginning of the
Northern Song period, after which a slow
decline set in. The biases from these early
assessments, which were based on principles of
stylistic development and novelty, carried over
into most mid- to late twentieth-century
scholarship, including important works like
Lee's *History of Far Eastern Art* (1982) and
Cahill's *Compelling Image* (1982), which both
assert that the early to mid-eighteenth century
was the last period of painting in the imperial
era worth scholarly attention. Notable
exceptions to these opinions include Brown and
Chou's *Transcending Turmoil* (1992) and Wan's
Bing fei shuailuo de bainian (2008), both of
which offer corrective overviews of nine-
teenth-century painting. But even these works
prefer to focus on mid- to late nineteenth-cen-
tury changes and struggle to articulate what
early nineteenth-century Chinese artists had to
offer the history of art aside from a few small

pockets of innovation such as the Jingjiang School based in Zhenjiang.

8. Throughout the book, I use the word "apprehension," and sometimes the word "perception," to describe this conjoining of sensation and cognition. Perception is perhaps more commonly used in English, but it skews toward the cognitive, so I use apprehension as frequently as I can for its preferable tactile etymology. The use of apprehension builds on the ideas of both Geaney, in *Epistemology of the Senses*, and Rošker, in *Searching for the Way*. Geaney suggests that sensation and perception as they are understood in Western philosophy are not the best words to describe the knowledge associated with the senses in early Chinese philosophical texts. She offers Wittgenstein's "aspect perception," the direct understanding of a thing *as* something, as an approximate parallel, as it avoids understanding the senses as processes of taking in raw data (sensation) and interpreting them (perception). Both Geaney and Rošker emphasize that in early thought, the phenomena of the world were not divided into objects with separate traits that belong to them. Phenomena like sounds and colors exist in their own right, not as the properties of objects. Geaney, *Epistemology of the Senses*, 13–14, 31–34; Rošker, "Chinese Theories of Perception," 21–26.

9. I looked to Russell's *Tact* (2018) for some of my wording here. Although my book focuses more closely on visual and material dimensions of touch, and it takes place in a different culture, his description of tact as a practice of social navigation in the essay genre of nineteenth-century Britain has many parallels with early nineteenth-century Chinese literati arts.

10. Ruan Yuan held the governorships of Zhejiang, Jiangxi, and Henan, as well as governor-generalships of Hu Guang, Guangdong and Guangxi, Yunnan and Guizhou. In 1838, he attained his highest imperial rank as grand secretary of the Tiren Pavilion, serving in the Qing imperial palaces in Beijing. An outline summary of Ruan Yuan's political career is given in B. Wei, *Ruan Yuan*, xv–xvii.

11. For full lists, see Wang Zhangtao, *Ruan Yuan nianpu*, 1037–61; B. Wei, *Ruan Yuan*, 329–35.

12. B. Wei, *Ruan Yuan*, 63, 69, 212.

13. The population of Qing-dynasty China had swollen over the eighteenth century, but the number of government positions had not grown accordingly. Well-qualified young degree holders could wait for years, even decades, before finding an appointment at some low-level provincial post.

For general coverage of the period, see Rowe, *China's Last Empire*. For the specific conditions of competition and factionalism this situation provoked, see S. Han, *After the Prosperous Age*, and Polachek, *Inner Opium War*. Rowe's *Speaking of Profit* offers a biographically focused description of the period's administrative and social dilemmas through the figure of Bao Shichen.

14. Another major network of epigraphic knowledge for this generation centered around Weng Fanggang (1733–1818), and he and Ruan shared many connections. See Matteini, "Story of the Stone," for an insight into Weng's circle of friends.

15. McNair, "Engraved Calligraphy," 113–14; Ledderose, "Aesthetic Appropriation" 231–33.

16. Wu Hung, "On Rubbings," 37, 58–59.

17. "Stone paintings" is a literal translation of the words *shihua*. For the sake of variety, I sometimes use the term "picture stone" or "stone image" in this book, taking advantage of the breadth of the word *hua*, which is not only used to describe paintings. Modern scholars also sometimes refer to these objects as "dreamstones," though dreams do not figure at all in the Chinese reception of them.

18. In the field of Chinese studies, historians of literature have taken the lead in imagining the senses as a useful hermeneutic, emphasizing sound in particular. Recent histories such as Goh's *Sound and Sight* (2010) and Keuleman's *Sound Rising from the Paper* (2015) reveal the aural dimensions of Chinese poetry and novels, and the repercussions of these sonic aesthetics on the construction of communal values and experience. Nelson's article "Picturing Listening" is the earliest article on a sensory topic in literati art that I know of, and Jonathan Hay's *Sensuous Surfaces* is as close as any book in the field comes to a sensory history, though its methods are primarily grounded in affect theory. A recent cluster of innovative work on optics and the Chinese appropriation of Western visuality during the seventeenth century through the early twentieth century has tended toward theoretical frameworks of social history and the history of science rather than sensory history. See Kleutghen, *Imperial Illusions*; Kile and Kleutghen, "Seeing Through Pictures and Poetry"; Gu, *Chinese Ways of Seeing*.

19. Two recent multiauthor volumes edited by Classen and Howes demonstrate the impressive breadth of interdisciplinary scholars who currently work in the field of sensory history and sensory studies. The six-volume series *Cultural History of the Senses* (2014), edited by Classen, organizes its contributions chronologically, from antiquity through the twentieth century, while the four-volume series *Sense and Sensation* (2018), edited by Howes, gathers critical and primary sources in order to introduce the field and groups its chapters topically: geography and anthropology; history and sociology; biology, psychology, and neuroscience; art and design. Howes's essay "Expanding Field of Sensory Studies" (2013), published on his website, sensorystudies.org, provides a good overview of sensory studies, his preferred name for the field, which he locates at the intersection of anthropology and history. Smith's *Sensing the Past* (2007) offers an accessible book-length introduction to sensory history, the preferred name for the field among social historians. For an exemplary demonstration of sensory history's ability to articulate the gap between individual feeling and collective opinion in which the ideas that structure society and culture are tacitly justified, see Smith's *How Race is Made* (2008), a highly effective description of the construction of postbellum American racism through period-specific discourses of the senses.

20. Geaney, *Epistemology of the Senses*, 13–17, 19, 31–35, 44–45. Geaney draws from the thinking of Confucius, Mencius, and Xunzi in particular.

21. Rošker, "Chinese Theories of Perception," 21–26; Geaney, *Epistemology of the Senses*, 13–14.

22. Blake, "Perception and Its Disorders in Early China," 34–39; Rošker, "Chinese Theories of Perception," 21–26; Rošker, *Searching for the Way*, 4.

23. Goh, *Sound and Sight*, xv–xvi.

24. Nylan, *Chinese Pleasure Book*, 34–45.

25. Aside from being referred to as "bones, body, and skin," descriptions of the sense of touch also sometimes referred to "form" (*xing*), "limbs" (*zhi*), or "torso" (*shen*).

26. Wu Hung, *Ruins*, 63. Wu goes on to offer a taxonomy of four different kinds of trace in Chinese culture, 64–91.

27. Classen, *Deepest Sense*, 141.

28. The closest works in existing scholarship that offer a description of the senses are Rošker, "Chinese Theories of Perception"; Geaney, *Epistemology of the Senses*; Rošker, *Searching for the Way*.

29. Rošker, *Searching for the Way*, 102, 107.

30. John Hay, "Boundaries and Surfaces," 168–69.

31. Jonathan Hay, *Sensuous Surfaces*, 77–89. Hay references Brian Massumi's concept of skin as a "mesoperceptual apparatus" to describe touch's reach throughout the body and its collaboration with vision.

32. Harvey, *Sensible Flesh*, 1–21; Classen, *Deepest Sense*, xi–xvii; Smith, *Sensing the Past*, 8–18.

33. Gu, *Chinese Ways of Seeing*; Christine Ho, *Drawing from Life*.

34. The intellectual dimensions of literati art and the predominantly text-based approach to viewing were perhaps best articulated by Wen Fong in catalogs such as *Images of the Mind* and *Beyond Representation*, where he makes the case for the fundamentally abstract and linguistic qualities of Chinese painting and calligraphy. Clunas elaborates on the relationship between depiction, diagramming, painting, and writing in *Pictures and Visuality*, 108–10. The idea that painting and calligraphy are primarily "read" by a viewer like texts has been most recently rearticulated in Hearn, *How to Read Chinese Paintings*, 3–5.

35. Jonathan Hay, *Sensuous Surfaces*, 77–89.

36. Ko, *Social Life of Inkstones*, 190–201.

37. For the analyses of painting as a medium for construction of identity, I have often looked to John Hay's "Boundaries and Surfaces of Self and Desire in Yuan Painting" and "Surface and the Chinese Painter."

38. For a discussion of the importance of *ru* identity among eighteenth-century philologists, see Sela, *China's Philological Turn*, 5–10.

39. See the group of essays presented at the University of Pennsylvania Museum conference "Current Directions in Yuan Painting," published in *Ars Orientalis* 37 (2009), especially Silbergeld, "Yuan 'Revolutionary' Picnic," Vinograd, "De-Centering Yuan Painting," and Harrist, "I Don't Believe in the Literati."

40. Ko, *Social Life of Inkstones*, 191–201.

Chapter 1

1. Ruan Yuan, *Xiaocanglang bitan*, v.3:3b–5; Wei, 62–64.

2. The sudden rise of philology among scholars and elites from the 1770s onward is described in Sela, *China's Philological Turn*.

3. Wei's biography, *Ruan Yuan*, is the most complete description of Ruan in English. In Chinese, Wang Zhangtao's *Ruan Yuan nianpu* offers the most complete chronology of Ruan's life, while Sun Guanghai's "Ruan Yuan yanjiu huigu" lists the diversity of work on Ruan from before 2006.

4. Ledderose's "Aesthetic Appropriation" offers a concise description of Ruan's essays.

5. B. Wei, *Ruan Yuan*, 17, 29, 33–47.

6. While Song- and Ming-dynasty neo-Confucian scholars of the School of the Way (*dao xue*) and the School of the Mind (*xin xue*) advocated for direct access to the past, like their later Qing counterparts they sought this directness through the intuition or innate knowledge of the heart-mind rather than the careful study of material recensions. Sela, *China's Philological Turn*, 93–96.

7. As quoted in Elman, *From Philosophy to Philology*, 29.

8. As translated in Sela, *China's Philological Turn*, 61. For a broad discussion of epigraphy's use by philologists, see chapter 3 in Sela, *China's Philological Turn*, 55–81.

9. For a comprehensive history of this intellectual shift, see Elman, *From Philosophy to Philology*. For sections on epigraphy in particular, see 6–9, 29–30, 49–53, 103–4, 225–34. For a discussion of the reliability of Han steles, see Brown, "Han Steles." The debates over the *zuo* and *gongyang* commentaries of the *Spring and Autumn Annals* stand out as the clearest use of evidential scholarship for political purposes. The *zuo* commentaries were the basis for neo-Confucian governmental training, but during the early Qing dynasty, the *gongyang* commentaries were dated by philologists to an earlier period, one closer to the time of Confucius. This constituted a challenge to orthodox understandings of Confucianism, especially as the *gongyang* commentaries presented Confucius as an "uncrowned king," while the *zuo* commentaries portrayed Confucius as a sage-like teacher. Calligraphic style was central to the philological argument that underpinned the *gongyang* commentaries' claim to an earlier date. The two positions were known as the "old text" and the "new text" schools, with "old" and "new" referring to calligraphic styles rather than absolute dating. After the death of the Qianlong

emperor in 1799, Hong Liangji famously chose language from the *gongyang* commentaries to make his accusations against the corrupt palace servant, Heshen. See Elman, *Classicism, Politics, and Kinship*, 284–90; Elman, "Imperial Politics and Confucian Societies"; Nivison, "Ho-Shen and His Accusers."

10. As articulated in Elman, *Classicism, Politics, and Kinship* as well as Sela, *China's Philological Turn*.

11. Wang Zhangtao, *Ruan Yuan nianpu*, 40–41.

12. Zhang Junling, *Zhu Yun, Bi Yuan, Ruan Yuan*, 134–35; Wang Zhangtao, *Ruan Yuan nianpu*, 31, 36–37.

13. Weng had a close friendship with Huang Yi before his tenure as education commissioner for Shandong Province from 1791 to 1793, and Weng's inscriptions on Huang Yi's collected ancient rubbings are more prolific than Huang Yi's own. Weng also appears to have been made aware of Ruan as early as 1784. Wang Zhangtao, *Ruan Yuan nianpu*, 17.

14. See Liu, Nylan, and Barbieri-Low, *Recarving China's Past*, and Richard, *Rethinking Recarving*, for a variety of viewpoints on the Wu Family Shrines and Huang Yi's role in their discovery and preservation.

15. It is also referred to as the *Xiping Stele Fragment* and by the names of its larger corpus of steles: the *Xiping Stone Classics*, also called the *Hongdu Stone Classics*, *Yizi Stone Classics*, and *Han Stone Classics*.

16. Including a colophon to the set of rubbings illustrated in fig. 10.

17. Ruan discusses Huang Yi's collection as his inspiration in multiple places; see Ruan and Bi, *Shanzuo jinshi zhi*, v.1: preface 2,1a; and Ruan's colophon to Huang Yi's Song dynasty rubbings of the *Fan Shi Stele* (Beijing Palace Museum Collection). A discussion of Ruan's preface to *Shanzuo jinshi zhi* can be found in Zhang Junling, *Zhu Yun, Bi Yuan, Ruan Yuan*, 135.

18. Bi Yuan was a renowned epigraphy aficionado. His mentors as a younger official were the evidential scholars Hui Dong (1697–1758) and Zhang Xu (1690–1776), who attuned him to Han Confucian studies in particular. Before Bi Yuan left Zhejiang, he served as the matchmaker for Ruan and his new wife Kong Luhua, and Bi Yuan's name appears alongside Ruan Yuan's at the opening of the *Epigraphy Gazetteer of Shandong Province*.

Zhang Junling, *Zhu Yun, Bi Yuan, Ruan Yuan*, 73; B. Wei, *Ruan Yuan*, 61–64.

19. Ruan and Bi, *Shanzuo jinshi zhi*, v.1: preface 2, 1a–2a. Dates for most of these collectors are uncertain.

20. B. Wei, *Ruan Yuan*, 62–63.

21. Qian Daxin in Ruan and Bi, *Shanzuo jinshi zhi*, v.1: preface 1, 1b.

22. Ding Jing was Hangzhou's foremost seal carver, and he was a pioneer of several novel carving techniques, including the *chongdao* style, in which each stroke of the character inscribed was cut with the blade in a single smooth movement. Before Ruan wrote his account of the carved and cast monuments of Zhejiang, Ding Jing's *Record of Engraved and Cast Texts of Wulin* (prefaced in 1782) gave the most comprehensive overview of Hangzhou's stone and metal relics from earlier dynasties. Shan, "Luo Ping's Interactions," 91.
Jin Nong also developed his own distinctive calligraphic style based on brushwork models from Han-dynasty inscribed stele, especially those done in clerical script. This style would later be referred to as "lacquer script," though Jin Nong did not call it by any particular name.

23. Qian Du, *Songhu huazhui*, 30a–b.

24. Although the Xiling Seal Carving Society was not founded until 1904, its founders traced a continuous lineage back to Ding Jing.

25. B. Wei, *Ruan Yuan*, 61.

26. Ruan Yuan, *Liangzhe jinshi zhi*, v.1:1a–1b.

27. For a summary of the growth of the gentry class in the Qing era, see Rowe, *China's Last Empire*, 109–15. For the rise in independently hired aides, see Folsom, *Friends, Guests and Colleagues*. For Ruan Yuan's cultural production in Zhejiang, see B. Wei, *Ruan Yuan*, 67–69.

28. A summary of research on the Explicating the Essence of the Classics Residence is given in Sun Guanghai, "Ruan Yuan yanjiu huigu," 11–12.

29. Translated from Ruan Yuan's handwritten version of "Record of Explicating the Essence of the Classics Residence," which is attached to set of landscape paintings by Wang Xuehao and Xi Gang in the collection of the Tianjin Museum. The "Record" is also published with slight variations in Ruan Yuan, *Yanjing shi erji*, v.7:15a–16a.

30. Ruan Yuan, *Yanjing shi erji*, v.7:15a–16a.

31. According to Sela, the philological turn of the late eighteenth century can be most easily seen in the sudden increase in scholarship on works like the *Shuowen jiezi* around 1770. Sela, *China's Philological Turn*, 85–90.

32. B. Wei, *Ruan Yuan*, 70; Ruan Yuan, *Yanjingshi erji*, v.7:15a–16a.

33. For an investigation of the Sea of Learning Hall, see Miles, *Sea of Learning*.

34. Ruan shared the responsibility of combatting these pirates with the provincial commander-in-chief Li Changgeng (1750–1808), as well as with Yude (d. 1809), governor-general of Fujian and Zhejiang. While Li proved to be a capable official who worked closely with Ruan in piracy suppression, Yude was quite the opposite. He was entrenched in factional politics and made efforts to thwart Li and Ruan's policies. For a summary of Ruan's tactics and handling of piracy, see B. Wei, *Ruan Yuan*, 81–108. For Manchu-Han court politics, see Polacheck, *Inner Opium War*.

35. A summary of Ruan's work in Shandong and Zhejiang is found in B. Wei, *Ruan Yuan*, 59–73.

36. See S. Han, *After the Prosperous Age*; S. Han, "Changing Roles of Local Elites."

37. For a summary of Ruan's granary reform and social welfare, see B. Wei, *Ruan Yuan*, 181–98. For private funding of local welfare, see S. Han, *After the Prosperous Age*, 75–102.

38. See Sela's point about this in relation to Qian Daxin's scholarship. Sela, *China's Philological Turn*, 69.

39. The entire suite of paintings and calligraphy, made from 1799 to 1802, is currently mounted as one handscroll in the Tianjin Museum of Art.

40. Wang Zhangtao, *Ruan Yuan nianpu*, 45.

41. Clunas's *The Social Art of Wen Zhengming* describes gift exchange among Chinese elites. DeCoursey-Clapp's more recent book *Commemorative Landscape Painting in China* expands research of reciprocal gift giving among Chinese elites, and Ko's *The Social life of Inkstones* accounts for the ways objects such as inkstones blurred the boundaries between artisans and literati in the Ming and Qing periods.

42. "Jade and gold" was an alternative poetic description of stone and metal, or the materials of epigraphy studies. As cited in Ruan Heng, *Yingzhou bitan*, v.7:40b.

43. Sela's analysis of eighteenth-century philological networks uses Genette's term

"paratext" to discuss the literati accumulation of inscription and commentary on books, and the term applies equally well to inscribed objects like these inkstones. Sela, *China's Philological Turn*, 77–78.

44. Lu Miaomiao, "Guo Lin nianpu," 66, 101, 102.

45. Ruan's essays have been the subject of numerous articles and studies. For the most recent work in Chinese, see Zhang Junling, *Zhu Yun, Bi Yuan, Ruan Yuan*.

46. Both original essays can be found in Ruan Yuan, *Yanjing shi sanji* v1:1a–6b and 6b–9b. An alternative translation of "Southern and Northern Schools of Calligraphy" can be found in Mei's "Pictorial Mapping," 235–36.

47. Barnhart, "Wei Fu-jen's Pi Chen T'u," 16.

48. The development of greater character-ological dimensions of viewing and making calligraphy in the Tang through the Song dynasty are described in McNair, *Upright Brush*, especially chapter 1, "The Politics of Calligraphy." In Ruan Yuan's day, calligraphy was still understood in characterological terms, as described in Ledderose, "Aesthetic Appropriation."

49. Qian Daxin made more or less the same point a generation earlier in his preface to Bi Yuan's *Record of Metal and Stone [Inscriptions] of Shaanxi*. Sela, *China's Philological Turn*, 61.

Chapter 2

Adapted from Michael J. Hatch, "Outline, Brushwork, and the Epigraphic Aesthetic in Huang Yi's Engraved Texts of the Lesser Penglai Pavilion (1800)," *Archives of Asian Art* 70, no. 1 (April 2020): 23–49. Republished by permission of the publisher, Duke University Press.

1. Ho Peggy, "Jinshi yinyuan," 235.

2. Yang Guodong, "Huang Yi shenghuo nianbiao jianbian," 377–78. Luo Ping was the subject of a major exhibition in 2009. See Karlsson, Murck, and Matteini, *Eccentric Visions*. Very little scholarly work has been done on Xi Gang. A brief biography appears in Brown and Chou, *Transcending Turmoil*.

3. Zheng Zhijin was from Lishui, in Jiangsu Province. His life dates are uncertain, but in his chronology of Huang Yi's life, Yang Guodong notes that Zheng was a 1760 *juren* and was given the position of salt controller before

taking several subsequent governmental roles, including department magistrate of Shenzhou, prefect of Baoding, and provincial administration commissioner for the metropolitan area. See Yang Guodong, "Huang Yi shenghuo nianbiao jianbian," 377, 391.

4. Huang Yi's rise to prominence in art history in English can be traced from Wu Hung, *Wuliang Shrine* to Liu, Nylan, and Barbieri-Low, *Recarving China's Past*, as well as from E. Hsu, "Huang Yi's *Fangbei* Painting," to Tseng, "Mediums and Messages," and Tseng, "Retrieving the Past." In 2009, the Beijing Palace Museum held an exhibition of Huang Yi's collection of prime examples of Han- and Wei-dynasty calligraphy rubbings, accompanied by a symposium titled "Research on Huang Yi and Epigraphy Studies." The catalogs for the exhibition and for the symposium essays (published in 2010 and 2012, respectively) present a comprehensive overview of Huang Yi's calligraphy, painting, and career in epigraphy scholarship. For a summary of prior work on Huang Yi, see Qin, "Ganzhi yu ganwu."

5. For a slightly alternative translation, see E. Hsu, "Huang Yi's *Fangbei* Painting," 244.

6. The phrase "traders from the northwest" (*jiahu*) originates in the *History of the Later Han*. Here, it is likely a citation of the second-to-last line of a Song dynasty poem, "Yugu Pavilion," by Weng's idol, Su Shi: "I avoid the path of the monkey [official] and the crane [immortals]; [instead] happily traveling off to become some trader from the northwest." Trans. Yan Weitian, via correspondence.

7. According to Yang Hu in "Gugong cang 'Xiao Penglaige jinshi wenzi,'" the 1800 edition is the one from which later editions were republished, first in 1834, and second in an undated Guangxu-era edition. However, a single copy of an edition of uncertain date exists in the Beijing Palace Museum collection; it lacks the 1800 preface by Qian Daxin, some of the colophons, a prefacing poem by Weng Fanggang, and several of the reproductions. Yang argues that because Qian Daxin's preface, dated 1800, only lists reproductions found in the undated Palace Museum edition, he must have been looking at this version when he wrote it, meaning the Palace Museum edition predates the 1800 edition. Yang Hu, "Gugong cang 'Xiao Penglaige jinshi wenzi,'" 339–40. Given that the 1800 edition became the

standard and was still published within Huang Yi's lifetime, I use 1800 as the publication date.

8. The rubbings were presented in five volumes and included the following ten steles: *Stone Classics Stele* fragment, Wei-dynasty *Gentleman's Stele*, Han-dynasty *Zhu Gentleman's Stele*, Han-dynasty *Lingtai Stele*, Han-dynasty *Qiao Gentleman's Stele*, Han-dynasty *Wang Yazi Stone Watchtower*, Wei-dynasty *Fan Shi Stele*, Han-dynasty *Mount San Gong Stele*, Han-dynasty *Wu Family Shrine Pictorial Stones*, Han-dynasty *Zhao Gentleman's Stele*.

9. Huang Yi, *Xiao Penglaige jinshi wenzi*, preface 1a. Qian Daxin's preface was written for the 1800 edition. See Yang Hu, "Gugong cang 'Xiao Penglaige jinshi wenzi,'" 339–40.

10. Weng's inscription was included in the earliest draft edition of *Engraved Texts*, dated to the 1790s (339). The phrase "so that other gentleman might find affinity with them" is also used by Huang Yi in *Engraved Texts* during his description of the *Fan Shi Stele*. The same verb *hao*, "find affinity with," was used by early Chinese thinkers like Xunxi to relate the senses to their objects of sensation.

11. Wang Chang, *Huhai shizhuan* v39:1a.

12. My translation is modified from the version translated in Chang and Frankel, *Two Chinese Treatises on Calligraphy*.

13. Shen describes the use of this method to produce the famous Tang copy of Wang Xizhi's *xingrang tie* in Shen, *Traces of the Brush*, 3, 5–8. Yu-jen Liu describes early twentieth-century attitudes toward the technique in "Second Only to the Original," 81–82n61. For a further discussion of the history of the *xingrang tie*, see Kern, "Made by the Empire."

14. For a discussion of the aesthetic of ruination in Chinese visual culture, see Wu Hung, *Story of Ruins*.

15. Among the earliest antiquarian books to include illustrations were Lü Dalin's (1046–1092) *Kaogu tu* (completed in 1092) and the imperially produced *Xuanhe bogu tu* (compiled early 1100s). The earliest surviving examples of these illustrations are a seventeenth-century edition of the *Kaogu tu* and the 1308–11 *zhida* edition of the *Xuanhe bogu tu* at Academia Sinica in Taiwan. The illustrations from the eighteenth-century *Siku quanshu* edition of the *Xuanhe bogu tu* are the clearest and are generally the ones used in current scholarship. They were supposed to have been taken from a Song-dynasty imprint. Y. Hsu argues that these illustrations of objects alongside their inscriptions in rubbing format created a new visual experience in the Song dynasty. Y. Hsu, "Antiquaries and Politics," 233. Closer to Huang Yi's time, Chu Jun produced reproductions of epigraphic rubbings in reduced size in his 1736 *Jinshi jing yan lu*. Tseng argues that Chu's interest in the materiality of language, and in particular signs of erosion or breaks, was in keeping with the priorities of authenticity advocated by evidential-research scholars, and that it shifted attention from the calligraphy on the steles to the steles as tangible objects. See Tseng, "Between Printing and Rubbing," 255, 267–69, 273, 275–76.

16. Concerning this topic in early calligraphy theory, see Barnhart, "Wei Fu-jen's Pi Chen T'u." The development of greater characterological dimensions of viewing and making calligraphy in the Tang through the Song dynasties are described in McNair, *Upright Brush*, especially chapter 1, "Politics of Calligraphy." Early nineteenth-century commentators still saw calligraphy in characterological terms, as described in Ledderose, "Aesthetic Appropriation."

17. While the purposes and effects of choosing outlines are the subjects of this chapter, one possibility left unpursued is that readers may have used these outline images to further replicate the original texts. Given the general uses of outline method, perhaps here they were meant to be filled in by the reader so that they resembled fully brushed calligraphy. It is also possible they were meant to be used in the recarving of new steles of these rubbings. However, this idea must remain speculative, as no evidence exists to support it, nor does Huang Yi direct his reader to particular uses of the outline images.

18. Wang Qingwei, "Huang Yi shike xue chengjiu chutan," 310. The technique itself was probably not difficult for printers to replicate. After all, finer lines were required to produce the folds and designs of figural images in illustrated books. This insight was offered by Soren Edgren, the scholar of rare Chinese books, in conversation on March 5, 2014.

19. Wang Qingwei confirms that after Huang Yi's book, outline method was picked up and used in many other epigraphy books by scholars in the nineteenth and twentieth centuries, including Zhang Derong, Yu Tongbai, Pan Zuyin, Xu Weiren, Ye Zhixian, Zhao Zhiqian, Yang Shoujing, and Luo Zhenyu.

Wang Qingwei, "Huang Yi shike xue chengjiu chutan," 311.

20. Fan Shi died during the Eastern Han era, but his stele was erected after the Han dynasty. Fan Shi is listed in *Hou Han shu* and his stele is listed in Hong Gua's *Li shi*. Brown, "Han Steles," 195n51.

21. Commemorative stones were erected as early as the Zhou dynasty, but steles saw an increased production and standardization in the Later Han period. They ranged from one to three meters in height and were erected in public locations; they were sometimes erected with state funds but often were the product of collective sponsorship. For a general description of the rise of steles and their uses, see Wong, *Chinese Steles*, 25–42. See also Seiichi, *Shodō zenshu*, 2:30–36. Wu Hung describes the function of steles as monuments in his *Monumentality in Early Chinese Art*, 21–42.

22. Starr, *Black Tigers*, 3–8.

23. Song-dynasty antiquarianism is a field of research unto itself. Regarding court use of antiquities, a recent cluster of work has been done on Emperor Huizong's catalogs of antiquities, including Ebrey, *Accumulating Culture*; Louis, *Design by the Book*; Moser, "Ethics of Immutable Things"; and Y. Hsu, "Antiquities, Ritual Reform." For an example of the use of clerical script by Northern Song literati, see Chu, "Calligraphy of Li Kung-lin," 58–61.

24. In his essay "On Rubbings," Wu Hung likens the rubbing to a skin because of its direct physical contact with the object. He goes on to describe the principal technique of rubbing connoisseurship as detecting ruination, a topic he later expands on in his book *Story of Ruins*. For a thorough description of the techniques and materials of rubbings, see Starr, *Black Tigers*. Although rubbings reproduced their objects with directness, skepticism about authenticity of the objects themselves existed due to the habit of recarving steles. See the debates over recarving in Richard, *Rethinking Recarving*, especially Bai's critique and the responses by C. Liu and Nylan.

25. Wu Hung, "On Rubbings," 58–59.

26. Lu Hui-wen, "Hanbei tushu chu wenzhang," 131–35. There is little biographical information about Cui, who was also known as Cui Moyun. This is the only mention of him in Yang Guodong's chronology of Huang Yi's life, and his name does not appear in official records. See Yang Guodong, "Huang Yi shenghuo

nianbiao jianbian." Cui is, however, listed as the artist in charge of the front images for the 1859 *Jining Metropolitan Area Prefectural Gazetteer*, including eleven maps and eight landscape images, with accompanying poems by Pan Zuyin and Pan Benji. See Xu Zonggan, *Jining zhili zhou zhi*, v1: 49–104.

27. Li Dongqi, a local Jining scholar whose father was also an epigraphy hobbyist, met Huang Yi through their shared passion for the study of ancient inscribed monuments in the area around Jining. Li and his father share a short biography in the 1859 edition of the *Jining Metropolitan Area Prefectural Gazetteer*. See Lu Hui-wen, "Hanbei tushu chu wenzhang," 48n30; Xu Zonggan, *Jining zhili zhou zhi*, v6: 2397.

28. Aside from being epigraphy aficionados, the majority of these men were public officials who served in the Hanlin Academy or in the grand secretariat at some point during their government careers. Lu Wenchao was a historian, official, and scholar from Zhejiang Province. He earned a *jinshi* degree in 1752, after which he was posted to the Hanlin Academy as a junior compiler, eventually moving on to a position as education commissioner in Hunan. He was a close friend of Qian Daxin and a proponent of evidential studies. See Sela, "Qian Daxin," 80, 150. Zhang Xun was a poet and a 1765 *juren* from Jiangsu; he was also a close friend of Weng and participated in Weng's celebrations in honor of the poet Su Shi. I Lo-fen, "Jing guan zhen shang," 68, 72–73, 81. Zheng Jitang earned his *jinshi* degree in 1769, and in his career, he served as an academician reader-in-waiting in the grand secretariat in the palace as well the commissioner of education for Shanxi Province. Of these individuals, Bi Yuan had the most prolific career, taking the first-place *jinshi* degree in the palace-level examinations of 1760 and serving as governor of Shaanxi, Henan, and Shandong, as well as governor-general of Hu-Guang. He was also a prominent patron of young, up-and-coming scholars and produced important works of evidential scholarship, epigraphy studies, history, and philology. Guy, *Qing Governors and Their Provinces*, 212–15; Hummel, *Eminent Chinese*, v2: 622–25. Yan Zhangming was a drafter at court, first for the grand secretariat and then for the grand council. He was also a protégé of Bi Yuan.

29. One possible reason for Huang Yi's choice to refrain from filling in the characters is

that the prints from his book may have been used to carve reproductions of the original steles. Weng's preface may allude to this purpose. On the culture of recarving at this time, see C. Liu, "'The Wu Family Shrine' as a Recarving of the Past."

30. Wu Hung, "On Rubbings," 37; E. Hsu, "Huang Yi's *Fangbei* Paintings," 248, 256n72.

31. As Tseng and E. Hsu have written, Huang's accounts of his trips conveyed both documentary descriptions of specific historical topographies and psychological accounts of his journey through such landscapes. The circulation of Huang's painted albums through specific social networks further expanded and validated his personal experience through their inscriptions. Tseng calls these "acts of remembrance," arguing that they made Huang's albums a site for consolidating personal experience of specific monuments from the deep past as part of collective cultural memory. Tseng, "Retrieving the Past, Inventing the Memorable," 36–41. For analysis of his twelve-leaf "Song-Luo" album, currently in the collection of the Tianjin Museum of Art, see Tseng, "Retrieving the Past, Inventing the Memorable," and E. Hsu, "Huang Yi's *Fangbei* Painting." See also Wang Qingwei, "Huang Yi shike xue chengjiu chutan." See also Tseng, "Mediums and Messages," for analysis of another album of twenty-four leaves currently in the collection of the Beijing Palace Museum.

32. Mei, "Pictorial Mapping," 28–36.

33. This emphasis on the affective potential of surfaces in the decorative arts of late imperial China has been described in Jonathan Hay, *Sensuous Surfaces*. For a discussion of ruination as the focus of rubbing connoisseurship, see Wu Hung, "On Rubbings," 58–59.

34. This argument borrows from Marks's discussion of intercultural cinema of the 1980s and 1990s. Marks describes the strategy of using extreme close-up shots of the surfaces of objects to compress the optical distance that otherwise maintains a sense of difference between the body of the viewing subject and the body of the seen object. This forces the eye to sense the object through the imagined capacities of touch, which she calls "haptic visuality," a term that draws from the art history of Alois Riegl as well as the work of Gilles Deleuze and Félix Guattari. Marks, "Video Haptics and Erotics," 1–13; *Touch*, chapter 1. In this book, I prefer "tactile" to "haptic," though the two naturally overlap.

This avoids confusing Western art historical terminology with Chinese terms.

35. The epigraphic aesthetic is described in Ledderose, "Aesthetic Appropriation of Ancient Calligraphy"; it is elaborated upon in Tseng, "Mediums and Messages," and Chuan-hsing Ho, "Calligraphy of the Mid- to Late Qing." For a historiography of the perceived connections between epigraphy and painting in the nineteenth century, see Li Ming, "Jinshi xue.'"

Chapter 3

Adapted from Michael J. Hatch, "Epigraphic and Art Historical Responses to *Presenting the Tripod*, by Wang Xuehao (1803)," *Metropolitan Museum Journal* 54, originally published by the Metropolitan Museum of Art, New York. Copyright © 2019. Reprinted by permission.

1. Lefebvre, "'Image des Antiquités Accumulées," 71.

2. In the seventeenth century, calligraphers such as Fu Shan advocated using Han-dynasty sources to inspire visual changes in calligraphy. But it was not until the eighteenth and nineteenth centuries that the extreme mutations of an epigraphic aesthetic manifested in calligraphy and painting. For a discussion of the relationship between epigraphy and calligraphy in the evidential research movement, see Elman, *From Philosophy to Philology*, 234. For a discussion of the ways in which Yangzhou painters such as Jin Nong and his student Luo Ping made material references to carved stone images, see Berger, "Public Spectacle and Private Devotions."

3. Citation and translation from C. Li, "Bamboo Paintings of Chin Nung," 65. The location of the painting on which this inscription was made is not known. Figure 23 presents a comparable painting of bamboo in outline method from the same period of Jin Nong's career.

4. The metaphor was perhaps most famously described in Su Shi's eleventh-century inscription on the bamboo paintings of Wen Tong: "after Wang Ziyou called bamboo 'gentleman,' the whole nation referred to it that way. Today, only Yuke [Wen Tong] is able to represent this gentleman's form with ink. In his conduct Yuke is solemn yet elegant, wise and loyal. More than [any] of his contemporaries [he] cultivates and educates himself, polishing and cleansing morning and night, all in the

hopes of befriending him [bamboo]. This gentleman is simple yet unyielding . . . snow and frost or wind and rain . . . this gentleman remains unaffected . . . dwelling together with others he does not lean on them." From Egan, *Word, Image, and Deed*, 287.

5. There are debates about the existence of an epigraphic aesthetic in the paintings of Huang Yi, who never directly alluded to such an intent. Huang Yi's contemporaries associated his style with Dong Qichang's orthodox views on painting. It was not until the early twentieth century that Huang Yi's epigraphy studies were seen to have an influence on his painting. Then, from the 1930s to the 1990s, scholarly interest in epigraphy studies declined dramatically, because it became fashionable during this time to blame the backward-looking antiquarian tastes of scholars of the late eighteenth and nineteenth centuries for the downfall of imperial Chinese culture in the face of modernization and imperialism. Li Ming, "'Jinshi xue,' shanshui hua he huihua shi."

6. The second character, *zhuo*, is often also translated as "humble," "inept," or "unrefined."

7. Slightly modified translation from E. Hsu, "Huang Yi's *Fangbei* Painting," 244.

8. Qian, *Songhu huayi*, v.1:76. The carved stones of the Wu Family Shrine that Qian Du cited were part of a family memorial constructed in the mid-second century in what is now southern Shandong Province. Scholars had known about them since the eleventh century through rubbings and textual accounts, but the location and identification of the stones were lost at some point after the Song dynasty. It was only after 1786, when the engraved stone fragments of the shrine were rediscovered, that they rose to dominate the curiosity of late eighteenth- and early nineteenth-century scholars. Several of the stones are first mentioned disparately in the eleventh century by Ouyang Xiu in *Record of Collected Antiquities*; some of the stones were first grouped in the twelfth century by Zhao Mingcheng in *Records of Metal and Stone*; and the full shrine grouping was done later that century by Hong Gua in his *Explications on Clerical Script* and *Supplement on Clerical Script*. See C. Liu, "Perspectives on the 'Wu Family Shrines,'" 23–25; Nylan, "Addicted to Antiquity," 536–37.

9. Wang Shimin (1592–1680), Wang Jian (1598–1677), Wang Hui (1632–1717), and Wang Yuanqi (1642–1715).

10. Hatch, "Qian Du, Zhang Yin," 22–24.

11. Berger, "Public Spectacle and Private Devotions," 48.

12. Matteini, "Beyond the Invisible," 72.

13. Trans. from Lau, "Ding Jing," 61–62; modified slightly for clarity.

14. See Vinograd's similar reading of the Ding Jing painting in *Boundaries of the Self*, 102.

15. Trans. Schmidt, *Harmony Garden*, 469–70, 491–92n108–25.

16. Wang Zhangtao, *Ruan Yuan nianpu*, 303–4.

17. Wang Zhangtao, *Ruan Yuan nianpu*, 292. The tripod is also sometimes referred to as the Dingtao tripod.

18. Poems were written about the event by luminaries including the outspoken statesman Hong Liangji, the poet Chen Wenshu, and the collector, official, and poet Weng Fanggang. Later reproductions of the object were made in printed books and in rubbings made by epigraphy experts such as the monk Liuzhou (see next chapter).

19. It is uncertain whether Wang was present at this event of the tripod's donation. Neither his inscription nor the other extant accounts of that day mention who was there. Given the three months that passed between the event and the painting's inscription, it is likely that he was not a direct witness. In this case, his image relied not on an eyewitness account but on the tropes of landscape painting and the iconography of Zhenjiang scenery, and Mt. Jiao in particular.

20. See Wu, "On Rubbings," for a discussion of the materiality of rubbings and their relationships to their original referents.

21. Ruan Yuan, *Jiguzhai*, v.9:7b. It is uncertain how the Taoling tripod came into Ruan Yuan's possession. In the two major texts that Ruan pens about the vessel, he does not mention its acquisition.

22. As early as the Northern Song dynasty, literati traveled to see the most famous inscription preserved at Mt. Jiao, "Inscription on Burying a Crane" (*Yihe ming*), dated to 514.

23. The emperor's building campaign has been described as part of a "cult of imperial monuments" promoted by the court in the Qing dynasty. Mei, "Pictorial Mapping," 105. In 1779, the Qianlong emperor ordered the construction of the Wenzong Pavilion at Mt. Jin, one of only three locations in southern China to house a copy of his grandest cultural project, the *Comprehensive Library of the Four*

Treasuries, an encyclopedia of historical books that comprised the sum total of approved knowledge in the Qing empire.

24. Zhang Yanchang, *Jinshi qi*, v.1:*ding* 9–11.

25. It is notable, given this attention to place names, that he omits the name of the temple that housed the tripod. The Dinghui Temple on Mt. Jiao was among the oldest Buddhist temples in the region, but in Ruan's poem, the famous location is important only because it serves as the repository of an ancient ritual vessel capable of such feats as separating clouds from cliffs. When Ruan alludes to the temple, he mentions only its "bolted doors." That Ruan Yuan knew of the Denghui Temple's history and held the institution in high esteem is clear. In 1813, he built a library for the monastery there. Wang Zhangtao, *Ruan Yuan nianpu*, 575, 577.

26. Wu Hung, *Monumentality*, 4–11.

27. For the relative importance of text and decoration on cast-bronze vessels in the late Shang and early Zhou periods, see Wu Hung, *Monumentality*, 53–56.

28. The stories of Xu You and Chaofu have been told in various forms. One of the earliest accounts is included in *Gaoshi zhuan* (Biographies of Lofty Scholars), by the third-century scholar and physician Huangfu Mi. Xu You's story is memorably recorded in *Zhuangzi*, section one, "Free and Easy Wandering." See Watson's classic translation *Chuang Tzu, Basic Writings*.

29. "The Han Taoling Tripod. Cover inscription: incised inscription of fifteen large characters and four small characters. Vessel inscription: seventeen large characters and sixteen small characters": "The Xuzhuan Tripod. Ninety-four characters." Ruan Yuan, *Jiguzhai*, v.9:6–7; v.4:28a–28b.

Ruan Yuan was not the first to organize a study of ancient inscribed objects in this manner. Chu Jun's *Record of Viewing Bronzes and Stones*, first circulated in 1736, reproduced rubbings in printed form in order to intensify the indexical relationship of the reader with the original objects. See Tseng, "Between Printing and Rubbing."

30. It was from Liu Kang's honorary title, Prince of Dingtao, that the tripod got its title, "Taoling Tripod," or the "Tao Mausoleum Tripod."

31. Arguments for the revision centered particularly on dating the name Nanzhong, which was cast into the Xuzhuan tripod and

was also used in two poems of the *Classic of Poetry*, "Bringing out the Chariots" and "Changwu." Dai, *Mao Zheng shi kaozheng*, v.2:3b–4a; Ruan Yuan, *Jiguzhai*, v.4:29a.

32. Weng, *Jiaoshan dingming kao*.

33. Clunas, *Superfluous Things*, 46–49.

34. The Xuzhuan tripod's history was described by Ruan Yuan in *Jiguzhai*, v.4:28a–30b. Wu Changshuo repeated this story in the inscription to his 1902 composite rubbing and painting of the Zhou tripod at Mt. Jiao, now in the Zhejiang Museum collection.

35. Early steles and bronzes were choice pieces of evidence for evidential research arguments. The age of these objects conferred authenticity, and the material solidity of their texts reduced the likelihood that they had been polluted through multiple recensions, in the manner of printed versions of early texts. For Ruan's concept of the authenticity of early cast and inscribed calligraphy, see Ruan Yuan's two essays on calligraphy, as described in chapter 1. For the reliability of inscriptions on Han-dynasty monuments, see Brown, "Han Steles." For the use of rubbings in evidential research, see Elman, *From Philosophy to Philology*, 6–9, 29–30, 49–53, 103–4, 225–34.

36. See chapter 1, n9, for a discussion of the debate over the *zuo* and *gongyang* commentaries of the *Spring and Autumn Annals* as an example of the destabilizing possibilities of evidential research.

37. Hong, *Gengshengzhai shi xuji*, v.9:4a–5b.

38. As described in his long poem "Song tonggu cang Jiaoshan jishi" (Record of the Gift of a Bronze Drum to Mt. Jiao). Zhang Jing, *Erzhuzhai wenchao*.

39. Mei, "Pictorial Mapping," 98–211; Mei, "Zhang Yin 'Jingkou san shan tujuan,'" 200–206.

40. Wang Zhangtao, *Ruan Yuan nianpu*, 59–60.

41. The history of the West Lake painting is complex and relates to a large gathering of scholars hosted by Ruan Yuan on West Lake in Hangzhou to explicate the Classics. The current handscroll includes a 1799 painting to which later 1800 and 1802 paintings by Wang were added, as well as the addition of an 1800 painting by Xi Gang and inscriptions by Liu Yong and Ruan Yuan. For a discussion of the event, see Wang Zhangtao, *Ruan Yuan nianpu*, 207–9, and 237 for a reference to at least one of the additional paintings, titled *Lake Zhu Thatched Hut*. The studio portrait, dated to

1803, is titled *Langhuan Immortal Hall* and is currently in the collection of Michael Shih in Taiwan; see Kaohsiung, *Shibian xingxiang liufen*, v.1:112–13. The collaborative portrait of Ruan Yuan is dated to 1808 and is currently in the collection of the Nanjing Museum.

42. In his inscription on a painting now in the Hebei Provincial Museum, Wang cites a Wang Meng painting he once saw in the collection of Ruan Yuan. See *Zhongguo gudai shuhua tumu*, v.8:69, 冀1-205.

43. One of the earliest biographies of Wang can be found in Jiang, *Molin Jinhua*, v.8:1a–3a. A short biography by Yan Bing, dated to 1846, also follows Wang's treatise on painting, as compiled by Zhang Xianghe and published in 1876. Brief accounts of his life can be found in Fu and Fu, *Studies in Connoisseurship*, 336–37; Brown and Chou, *Transcending Turmoil*, 43–44. Both of their accounts are based on Jiang Baoling's biography. In Chinese, as in English, there is little dedicated scholarship to Wang Xuehao. One useful summary of his life and thoughts on painting is Lu Jiaheng, "Wang Xuehao ji qi shanshui yishu." The "lesser" Four Wangs included Wang Yu (1662–1748), Wang Su (ca. 1700–1763), Wang Chen (1720–1797), and Wang Jiu (1745–1798).

44. See introduction, n7, for a discussion of the bias against Chinese painting of the early nineteenth century and its roots in the new enlightenment styles of art history written in China and the United States during the early twentieth century.

45. Wang Xuehao, *Shannan lun hua*, 1b.

46. Wang Xuehao, *Shannan lun hua*, 2a.

47. In *Battle Formation of the Brush*, a treatise on calligraphy attributed to Lady Wei (272–349), the bodily vocabulary of brushwork was already made clear in the use of terms such as "bone" and "flesh" to describe line direction and absorptivity of ink. Although Lady Wei lived during the Six Dynasties period, Richard Barnhart has dated the text to between 618 and 678. In painting theory, the second of Xie He's (late fifth–early sixth centuries) six laws of painting also used the metaphor of "bone" to describe the structure of brushwork. Barnhart, "Wei Fu-jen's Pi Chen T'u," 15–17.

48. Although Zhang Xianghe's colophon comes later than Ouzhuang's, it does not reference the first colophon, and the two do not appear to be intertwined in a way that necessitates they be analyzed in chronological order.

For flow of argument, Zhang's colophon is best analyzed at this point in the chapter.

49. For Wang Hui's copy, see China Guardian Auctions, June 18, 2018, lot 412. The Beijing Palace Museum also has a painting that was once attributed to Huichong and given the title *Spring in Jiangnan*. See *Zhongguo gudai shuhua tumu*, v.19: 188-9, 京1–574.

50. This term also likely carried with it Buddhist connotations of a master-disciple relationship, as was common in Chan Buddhism. That the first painting mentioned by Zhang Xianghe, *Lake Zhu Thatched Hut*, was written on the back of Buddhist sutra paper lends weight to the Buddhist analogy as well.

51. This same phrase was used by Liuzhou to describe his relationship to a Buddhist sculpture that he rubbed. See chapter 4, fig. 46.

52. One currently unresolved aspect of this story is the identity of Ouzhuang and, in particular, the means by which he might have come to possess this painting in 1845, four years before Ruan Yuan died. If his colophon were written on the work while Ruan Yuan owned it, Ouzhuang would have respectfully acknowledged Ruan as he signed his name, as was customary when writing an inscription on someone else's property. This makes Ouzhuang the likely owner at this point. The question of what Ruan Yuan did with the painting between 1803 and 1845 is also uncertain. Presumably, after being gifted this painting, Ruan Yuan would have held on to it. However, no inscription or seals by Ruan are attached to the painting, and he does not mention the work of art directly in his various writings, only the event of donating the tripod. This is not unusual for literati paintings, especially those given as gifts. But it does raise the possibility that Ruan never accepted the painting or that it was never given to him. While this may cast some doubt on the painting's authenticity, its style is quintessentially that of Wang Xuehao, and the surrounding evidence that supports its claim to authenticity are strong. Hypothetically, the painting may have been separated from earlier inscriptions by Ruan and others, but there is no evidence to point one way or the other.

53. See John Hay, "Boundaries and Surfaces," 125–26, 156–57, 166–69, where he discusses fourteenth- and seventeenth-century painting as two periods of intense interest in self-representation, in which paintings are conceived as the boundaries where definition of

self occurs, like a Lacanian screen where the self is imagined as it is seen by the other. Likewise, see Jonathan Hay, *Sensuous Surfaces*, 40, as well as *Shitao*, 277–81 for a description of literati subjectivity in terms of *ren*, a networked form of self, and *shen*, an individual and bodily form of subjectivity.

54. Bai, "Composite Rubbings in Nineteenth-Century China," 299.

Chapter 4

1. According to the last leaf, the album was commissioned in 1834 by Li Xingyuan to be given to a friend's father, Qiuxian. In 1850, Tang reinscribed the second to last leaf with another poem.

2. The antiquarian Wu Tingkang served as a district-level official in Zhejiang and wrote the *Illustrated Catalog of Ancient Bricks from the Mutao Studio* (Mutao xuan guzhuan tulu). He also revived the career of the seventeenth-century poetess Wu Zongai (1650–1674), as part of the trend of celebrating the biographies of virtuous women among later Qing-dynasty literati. H. Wei, "From Private Live to Public Performances," 141–75.

3. Li Xingyuan acquired his *jinshi* degree in 1832 and was placed as Guangdong director of studies in 1835. He later went on to be a governor or governor-general of several provinces, including Shaanxi, Gansu, Jiangsu, Yunnan and Guilin, and Jiangsu and Jiangxi. He also fought in the Opium Wars.

4. As summarized by Sang, "Liuzhou yu zaoqi quanxingta," 9.

5. Liuzhou, *Baosu shi jin shi shu hua bian nian lu*, v1:4a.

6. Xu Kang, *Qian chen meng ying lu*, v2:21a. As cited in Shan, "Liuzhou yu zaoqi quanxingta," 9.

7. Wang Yifeng, "Guzhuan huagong," 109, offers a description of multiple methods of making a full-form rubbing; Starr, *Black Tigers*, offers an overview of the materials and techniques of rubbings.

8. Xu Han, *Pangu xiaolu zazhu*, v12:24b. As recorded in Liuzhou, *Liuzhou ji*, 310.

9. Wang Yifeng, "Guzhuan huagong," 112–13.

10. As described in Matteini, "Story of the Stone."

11. Lefebvre, "'Image des Antiquités Accumulées,'" 62.

12. Wang Yifeng, "Guzhuan huagong," 107–9.

13. Chen's poem is recorded in Liuzhou, *Xiaolv tian'an yin* cao, v.3, and republished in Liuzhou, *Liuzhou ji*, 178.

14. Liuzhou, *Baosushi jinshi shuhua biannian lu*, v.2:4a–b. See also Liuzhou, *Liuzhou ji*, 281. Ruan's search for talent may refer to his *Liangzhe youxuan lu* (Record of the Royal Envoys of the Two Zhes), a publication of poetry by Zhejiang natives. Ruan gathered this poetry with the help of his aides during his tenure as director of studies in Zhejiang.

15. Chen's poem is recorded in Liuzhou, *Xiaolv tian'an yin* cao, v.3, and republished in Liuzhou, *Liuzhou ji*, 178. Guan's poem is recorded in Liuzhou, *Liuzhou ji*, 304.

16. Sang, "Liuzhou yu zaoqi quanxingta," 12.

17. Sang, "Liuzhou yu zaoqi quanxingta," 11.

18. Transcription can be found in Zhejiang Provincial Museum, *Liuzhou*, 33.

19. Liuzhou does not make reference to a doubling in his first inscription either, which comes just before the image. But he does refer to the fact that the lid and the body come from two separate bronzes. Liuzhou's comment reads, "In the late summer of 1839, returning by boat from Yuanjing, I stopped at Haixi Hall on Mt. Jiao to avoid the heat. Dripping with sweat, I made this rubbing in summer's ebb and flow. On the lid the inscription indicates this is an eleven-*jin* vessel, while on the body it says ten. This discrepancy in sizes undoubtedly means that this is a combination of two vessels. I consult the monk Miaoquan to see whether or not this is true." See Zhejiang Provincial Museum, *Liuzhou*, 33.

20. For Jonathan Hay's description of "surface order," as well as the idea of a "surfacescape" as a "topography of sensuous surface," see Jonathan Hay, *Sensuous Surfaces*, 63–68.

21. Han Chong, *Baotiezhai shi lu*, 59a–b. See also Liuzhou, *Liuzhou Ji*, 294; Zhejiang Provincial Museum, *Liuzhou*, 44.

22. Wu Hung, "On Rubbings," 30.

23. Liuzhou, *Baosushi jinshi shuhua biannian lu*, v.1:34b.

24. Many of these figures are underdocumented. One exception is Chen Kanru, who is portrayed in Huang Shen's painting of this monk with an inkstone—titled *Huang Shen Gifts an Inkstone to Kanru* (Huang Shen Kanru

pengyan tu)—in the Beijing Palace Museum collection.

25. Liuzhou, *Xiaolvtian'an yin cao*, v.3, as republished in Liuzhou, *Liuzhou ji*, 170.

26. Liuzhou, *Xiaolvtian'an yin cao*, v.3, as republished in Liuzhou, *Liuzhou ji*, 166.

27. As cited in Sang, "Liuzhou yu zaoqi quanxingta," 13.

28. He, *Dongzhou caotang shichao*, v.6:9a–12a; v.7:13b. Scans via ctext.or (accessed July 28, 2021).

He Shaoji's poems are styled after another poem about the bronze written by the early eighteenth-century poet Li E, titled "Ode to the Han Bronze Goose-foot Lamp, for Bancha" (Han tong yanzu deng ge wei Bancha fu). See also Liuzhou, *Liuzhou ji*, 310–13.

29. The two are perhaps the abbots of Ruyi Temple, Fu Zhijing and Qi Huangshan, as mentioned in Liuzhou, *Baosushi jinshi shuhua biannian lu*, v.2:2b. See also Liuzhou, *Liuzhou ji*, 59.

30. All inscriptions to the image are reproduced in Zhejiang Provincial Museum, *Liuzhou*, 63–66. They are also transcribed in Liuzhou, *Liuzhou ji*, 257.

31. All inscriptions to the image are reproduced in Zhejiang Provincial Museum, *Liuzhou*, 63–66. They are also transcribed in Liuzhou, *Liuzhou ji*, 257.

32. In the first sense as a translation of the Sanskrit *pratyaya*. In the second sense as the translation of the Sanskrit *ālambana*. Charles Muller, "緣" *Digital Dictionary of Buddhism*, http://www.buddhism-dict.net/cgi-bin/xpr-ddb .pl?q=緣 (accessed July 28, 2021).

33. Han Chong, *Baotiezhai shilu*, 67a–68a. See also Liuzhou, *Liuzhou ji*, 289.

34. Tang, *Qinyinyuan shiji*, v.23:635–36. See also Liuzhou, *Liuzhou ji*, 289.

35. He gave them to Ruan Yuan, among others, as recorded by Xu Kang, *Qianchen mengying lu*, v2:21a. See transcription in Zhejiang Provincial Museum, *Liuzhou*, 56.

36. "Longevity" (壽shou) may also have formed a pun with "rust" or "engrave" (鏉 shou).

37. Reproduced and transcribed in Zhejiang Provincial Museum, *Liuzhou*, 56.

38. Charles Muller, "金剛" in *Digital Dictionary of Buddhism*, http://www.bud dhism-dict.net/cgi-bin/xpr-ddb.pl?q=金剛 (accessed July 28, 2021).

39. Liuzhou, *Xiaolvtian'an yin cao*, v.2, as republished in Liuzhou, *Liuzhou ji*, 154.

40. Liuzhou, *Xiaolvtian'an yin cao*, v.3, as republished in Liuzhou, *Liuzhou ji*, 167.

41. Liuzhou, *Xiaolvtian'an yin cao*, v.3, as republished in Liuzhou, *Liuzhou ji*, 172.

42. For an overview of the history of *bapo*, see Berliner, "Roots and Branches of Bapo."

43. Jiang, *Molin jinhua*, v.18:14b–15a.

44. Chen Jieqi, "Colophon to an Album of Liuzhou's Rubbings of Shang Zhou and Han Vessels," as recorded in Liuzhou, *Liuzhou ji*, 317–18.

Chapter 5

1. Gao Qipei (1680–1734) is frequently cited as the first practitioner of finger painting, though, as Klass Ruitenbeek argues, there are records of the practice going back to the eighth century. Joan Stanley-Baker describes an alternative genealogy of ink painting in the *nanga* tradition of Japanese painting, in which finger painting and brush painting were frequently commingled, as in the work of Ike no Taiga. See both essays in Ruitenbeek, *Discarding the Brush*.

As for seal carving, Jason Kuo traces the origins of the art as a literati practice to the Yuan dynasty, when Wu Yan (1272–1311) wrote the first treatise on seal carving and artists like Wang Mian were said to have carved soapstone seals for friends. In the Ming dynasty, Wen Zhengming's son Wen Peng (1497–1573) became well known for his seal carving, as did He Zhen. Each of these men was later named to the two Ming-dynasty schools of seal carving—Wu and Hui. But it was not until the late eighteenth century, around Hangzhou, that a new "Zhe" school of the craft was popularized by Ding Jing, Jiang Ren, and their followers, like Huang Yi and Chen Hongshou. Kuo, "Word as Image."

2. As quoted in Xiao, *Chen Mansheng yanjiu*, 127, 236. Xiao notes that Chen Yuzhong's colophons to two different seals give two different dates for meeting Chen Hongshou, 1784 and 1786.

3. Xiao, *Chen Mansheng yanjiu*, 11.

4. Guo, *Lingfenguan za zhu*, v.3:19–20, as quoted in Xiao, *Chen Mansheng yanjiu*, 129.

5. Full transcription can be found in Lai, *Art of Chen Hongshou*, 128.

6. Guo, "Zhongyuxianguan yinpu xu." As quoted in Xiao, *Chen Mansheng yanjiu*, 332.

7. Kobayashi, *Chūgoku tenkoku sōkan*, v.16:122–23. As quoted in Xiao, *Chen Mansheng yanjiu*, 245.

8. Xiao, *Chen Mansheng yanjiu*, 99.

9. Liu Yiwen of the Shanghai Museum see Chen's calligraphy as the origin point of his carving. Yiwen Liu, "Paintings and Calligraphy of Chen Hongshou," 19.

10. Guo, "Zhongyuxiangguan yinpu xu." As quoted in Xiao, *Chen Mansheng yanjiu*, 332.

11. Reproduced and transcribed in Xiao, *Chen Mansheng yanjiu*, 416.

12. Yu, *Lidai yinpu xuba huibian*, 426.

13. Geaney, *Epistemology of the Senses*, 16–17, 19.

14. Han, *Lidai yinxue lunwenxuan*, 427.

15. Xiao Jianmin argues that Chen Hongshou traveled north in 1793 with He Yuanxi to serve under Ruan Yuan there. This conclusion appears to be drawn from Ruan Yuan's preface to his book *Xiao canglang bitan*, a record of his two years in Shandong (1793–95), as recorded with the help of his two traveling companions Chen and He and completed after Ruan's move to Zhejiang. The syntax of the passage is ambiguous, but Xiao's own chronology of Chen's life indicates no activity in Shandong between 1793 and 1795, only travels in and around Hangzhou. This suggests that Chen did not enter into Ruan's service until his 1795 move to Zhejiang. Xiao also cites a later comment that Chen makes about his twelve years serving Ruan and subtracts these twelve years from 1805, the year of Chen's departure from Ruan's service, to reach 1793 as their initial date. Despite this, I still tend to side with the textual evidence from 1793 to 1795 that indicates Chen was still in Hangzhou. Xiao, *Chen Mansheng yanjiu*, 12, 240.

16. Ruan Yuan, *Xiaocanglang bitan*, preface:1a. Scans via ctext.org (accessed July 15, 2021).

17. Xiao, *Chen Mansheng yanjiu*, 243–49.

18. Xiao, *Chen Mansheng yanjiu*, 129.

19. Hu, *Chongyatang shi miao*, v.2:2. As recorded in Xiao, *Chen Mansheng yanjiu*, 252. Similarly, Ruan Yuan and nine friends gathered in 1802, and each wrote a poem about one of ten Qin, Han, and Six Dynasties seals in Ruan's collection. Ruan Yuan, *Yanjingshi siji shi*, v.6:837. As recorded in Xiao, *Chen Mansheng yanjiu*, 279–81.

20. W. Sun, "Studies on Chen Hongshou's Life and Art," 119.

21. Xiao, *Chen Mansheng yanjiu*, 15.

22. His first recorded painting, dedicated to Zhao Yue (1778–1849), is dated to early 1799. Chen also carved two seals for Zhao. His first extant painting is dated to the ninth month of 1799. It was made for Qian Dongshu (1768–1833), son of the famous philologist Qian Daxin, as an emulation of a landscape by the late Ming painter Li Liufang (1575–1629). It now belongs to the Shanghai Museum.

23. Reproduced in Hayashida, *Chin Kōju no shohō*, 18–24. As recorded in Xiao, *Chen Mansheng yanjiu*, 276.

24. For a study on Hao Jing's neo-Confucianism, see Soffel and Tillman, *Cultural Authority and Political Culture in China*.

25. Xu Shangda, "Gong xie" (Craft and Literary Concept), in Xu Shangda, *Yinfa cantong*. The other potential source for the quote is Yang Zhen, "Hao Jing lun shu" (Hao Jing's Theory on Calligraphy), in Yang Zhen, *Shu pin*.

26. Xiao, *Chen Mansheng yanjiu*, 299. *Treasury of the True Eye of the Dharma* is a twelfth-century compendium of Chan Buddhist *gong'an*, teachings outside of the dharma that take the form of case studies, usually centered around paradoxes or action.

27. Reproduced in Hayashida, *Chin Kōju no shohō*, 18–24. As recorded in Xiao, *Chen Mansheng yanjiu*, 276.

28. The album is currently in the Shanghai Museum. The line Chen Hongshou quotes comes from a story about the Ming-dynasty painter Shen Zhou, whose friend accidentally brought him a pipa instrument instead of the fruit and then sent the above line in apology. All inscriptions transcribed in Xiao, *Chen Mansheng yanjiu*, 317.

29. Xiling yinshe, *Jinshi zhi yun*, 3–14. As cited in Xiao, *Chen Mansheng yanjiu*, 322–23.

30. Reproduced in Lin Shuzhong and Nie Weigu, *Haiwai cang Zhongguo lidai minghua*, v.8:114. As cited in Xiao, *Chen Mansheng yanjiu*, 337.

31. This was a somewhat common reason to change one's pen name. A painting by Chen's contemporary Zhai Jichang (1770–1820), titled *Dreaming of Flowers* and dated to 1807, recounts a similar dream scenario by Wang Guozhen, who commissioned the painting to record the event. Commissioning paintings was also common on such occasions. Zhai's painting is in a private New York collection. On personal paintings that commemorate new personal

names, see De Coursey Clapp, *Commemorative Landscape Painting*.

32. Ren, "Mengjing tushuo," 15.

33. Ruitenbeek, *Discarding the Brush*, 20; Stanley-Baker, *Discarding the Brush*, 72–74.

34. It seems hard to believe that, in addition to Chen's other work, he could have overseen the production of thousands of teapots. Yet several pots appear to be numbered, including an example in the Flagstaff Museum numbered "1,379" and another in the Shanghai Museum numbered "2,611." For so many pots to have existed with so few actually numbered suggests that the numbers on these pots may have some alternate meaning, though I am at a loss to say what that is.

35. Xiao, *Chen Mansheng yanjiu*, 140–43. M. Lu, "Study of Chen Hongshou," 180. It is also entirely possible that clay was brought from Yixing to Liyang for Chen to form and fire there.

36. Xiao, *Chen Mansheng yanjiu*, 143.

37. Wu Qian, *Yangyi ming tao lu*, v2:22.

38. Xiao, *Chen Mansheng yanjiu*, 129.

39. A second example of this same teapot design with the same poem is dedicated by Chen to the painter Shen Rong (1771–1843), revealing the flexibility of these objects as open forms that could slide in and out of registers of meaning, just like the metaphorically laden sobriquets they were modeled after. See Lai, *Art of Chen Hongshou*, 266–69, for images of both pots, which are in the Shanghai Museum. A third design for this same motif situates the words *yannian* on the base of the teapot, each word flanking the diagram of a goose in flight, which could only be seen when the pot was picked up and tipped for pouring. Classical pronunciation of the word *yan* made homophones of the verb "prolong" and "wild goose." This configuration was drawn by Wang Hong in the 1813 teapot catalog, and the Shanghai Museum collection also includes an example.

40. The authenticity of this teapot has recently been called into question because of two issues: it is the only teapot dated to Chen's last year as magistrate in Liyang, and the side inscription directly mentions Yang Pengnian, making it the only one of their collaborative pots to do so (normally, Yang's seals were only impressed on the bottom of the vessels). While these might make for a rare teapot, I disagree that this must make the pot inauthentic, especially as the authors of this assessment agree that the pot is otherwise authentic to

early nineteenth-century modes of construction. Yee and Bartholomew, 114–16.

41. Xiao, *Chen Mansheng yanjiu*, 166–72. The first line is also a quote from *The Book of Changes*.

42. As argued in Ko, *Social Life of Inkstones*. Chen's use of *zhuo* as a disavowal of skill becomes all the more conspicuous in light of Ko's argument. In a time when the boundaries between artisan and literati classes were blurring, *zhuo* could also act as a defensive mechanism to reinforce them.

Chapter 6

1. For an overview of the term's valences and a general taxonomy of the various types of "traces" valued in Chinese material culture, see Wu Hung, "Ji: Traces." A later version of Wu's argument appears in Wu Hung, *Story of Ruins*, 61–92. For the Buddhist connotations of the word, see Charles Muller, "迹" *Digital Dictionary of Buddhism*, http://www.buddhism-dict.net/cgi-bin/xpr-ddb.pl?q=迹 (accessed August 5, 2021).

2. For a summary of Ruan's time in Yunnan and Guizhou, see B. Wei, *Ruan Yuan*, 165–80.

3. Ruan Yuan, *Shi hua ji*, preface:3a. This trope also clearly references the story of Tao Yuanming bowing to a stone, which is more clearly cited later in this poem.

4. Ruan Yuan, *Shi hua ji*, preface:1b.

5. While Ruan states he went to Dali almost immediately upon arriving in Yunnan, the earliest dated entries are from 1828. Ruan Yuan, *Shihua ji*, v.1:30b.

6. Ruan's preface is dated to 1832, while he was still in Yunnan, but it was only published in 1840, during his retirement in Yangzhou.

7. Ruan Yuan, *Shihua ji*, preface:1a.

8. Ruan Yuan, *Shihua ji*, preface:1a.

9. Ruan Yuan, *Shihua ji*, preface:1b–2a.

10. Chen Wenshu's poems feature prominently. See Ruan Yuan, *Shihua ji*, v.2:19b–20b; v.3:8a; v.5:2b–4a.

11. Goh, *Sound and Sight*, chapter 3.

12. Ruan Yuan, *Shihua ji*, v.1:1a–1b.

13. The inscription on the Gest Library stone names the same theme, "Rain Coming to Summer Mountains," but rather than attributing the work to Gao Kegong, the inscription cites Huang Gongwang. Throughout *Paintings in Stone*, Ruan associates "Rain Coming to Summer Mountains" with Gao and not Huang.

This makes a direct relationship between the Gest Library's object and Ruan's text questionable. However, the fact that Ruan's description nevertheless seems to match the pattern on the Gest stone points to the fact that correlations between stones and exact landscape compositions were less important than the general will to confirm immediate recognition of painting themes in stone patterns.

14. Ruan Yuan, *Shihua ji*, preface:1b.

15. Ruan Yuan, *Shihua ji*, v.1:1a.

16. Ruan Yuan, *Shihua ji*, preface:2a.

17. Ruan Yuan, *Shihua ji*, preface:3a.

18. A conceit that clearly conceals the artisan processes of mining, cutting, and finishing appropriate stones for his visions.

19. Later the governor-general of Hu-Guang, and a former aide to Ruan Yuan.

20. Ruan Yuan, *Shihua ji*, preface:1a–2a.

21. Ruan Yuan, *Shihua ji*, preface:2a.

22. Ruan Yuan, *Shihua ji*, v.2:1a.

23. In one entry, titled "Reading a Stele," Ruan even describes the natural formation of the image of a stele on one stone. Ruan Yuan, *Shihua ji*, v.4:32b.

24. Ruan Yuan, *Shihua ji*, preface:2a.

25. Ruan Yuan, *Shihua ji*, v.4:2b–3b. Another poem by Chen, thanking Ruan for sending the "Five (Primordial) Colors Cloud Stone Screen," reinforces a Daoist reading of the stones, understanding them as self-generated from internal forces. In his poem, Chen asserts, "The essence of clouds in the sky is rooted in stones (of the earth), deeply penetrating its surfaces and mixing with its veins; In the stone's marrow the Five (Primordial) Colors Cloud is formed, a single cloud, a single color, mixing in the aether," Ruan, *Shihua ji*, v.5:2b–3a.

26. The inscription comes from a painting that was at one time in the collection of the Liaoning Provincial Museum but is now lost. Its image was reproduced in *Bai mei ji* (1926), and the original poem was also inscribed in Qian, *Songhu huazhui*, 17–18, with some slight differences in word choice. Qian Du was

particularly known for his paintings of blossoming plum branches.

27. Jonathan Hay describes literati subjectivity in terms of *ren*, a networked form of self, and *shen*, an individual and bodily form of subjectivity. The focus of his argument is on the capacities of luxury decoration to delight the bodily self. See Jonathan Hay, *Sensuous Surfaces*, 40, as well as Jonathan Hay, *Shitao*, 277–81.

Epilogue

1. Wue's *Artworlds* describes the commercialization of the status of the artist. For a study of Ren Xiong's painting, see Cahill, "Ren Xiong and His Self-Portrait."

2. Brown and Chou, *Transcending Turmoil*, 240–47, 256–79; Wan, *Century Was Not Declining in Art*, 201–11.

3. Koon, *Defiant Brush*.

4. See Bai's work on Wu Dacheng, including "Composite Rubbings in Nineteenth-Century China" and "Wu Dacheng he ta de tagong."

5. Wue, "Chapter Three—Shanghai Illustrations: Images and Readers," in *Artworlds*, 109–57. Wasserstrom and Nedostup, "Shanghai's Lens on the New(s)."

6. Yu-jen Liu, "Second Only to the Original," 77–78.

7. See Gu, *Chinese Ways of Seeing*, especially chapter 1, "Open-Air Painting and the Modern Chinese Painter," chapter 2, "Optical Vision and New Modes of Depiction," and chapter 3, "Inventing Tradition through Open-Air Painting," 16–114.

8. Yu-jen Liu, "Second Only to the Original," 77–78.

9. Xu Beihong, "Zhongguohua gailiang lun" (On the Improvement of Chinese Painting), 1920.

10. Especially from 1930 onward, according to Li Ming, "'Jinshi xue,' shanshui hua he huihua shi."

Bibliography

Bai, Qianshen. "Composite Rubbings in Nineteenth-Century China: The Case of Wu Dacheng (1835–1902) and His Friends." In Wu Hung, *Reinventing the Past*, 291–319.

———. *Fu Shan's World: The Transformation of Chinese Calligraphy in the Seventeenth Century.* Cambridge, MA: Harvard University Asia Center, 2003.

———. "The Intellectual Legacy of Huang Yi and His Friends: Reflections on Some Issues Raised by *Recarving China's Past*." In Richard, *Rethinking Recarving*, 286–337.

———. "Wu Dacheng he ta de tagong" 吴大澂和他的拓工 [Wu Dacheng and His Rubbing Workers]. In Qin Ming, *Huang Yi yu jinshixue lunji*, 197–223.

Barnhart, Richard. "Wei Fu-jen's Pi Chen T'u and the Early Texts on Calligraphy." *Archives of the Chinese Art Society of America* 18 (1964): 13–25.

Berger, Patricia. "Public Spectacle and Private Devotions: Buddhist Art in Eighteenth-Century Yangzhou." In Karlsson, Murck, and Matteini, *Eccentric Visions*, 40–49.

Berliner, Nancy. "Roots and Branches of Bapo." In *The 8 Brokens: Chinese Bapo Painting*, 9–36. Boston: MFA Publications, 2018.

Blake, Susan. "Perception and Its Disorders in Early China." In *The Senses and the History of Philosophy*, edited by Brian Glenney and José Filipe Silva, 33–49. New York: Routledge, 2019.

Brown, Claudia, and Ju-hsi Chou. *Transcending Turmoil: Painting at the Close of China's Empire, 1796–1911.* Phoenix: Phoenix Art Museum, 1992. Exhibition catalog.

Brown, Miranda. "Han Steles: How to Elicit What They Have to Tell Us." In Liu, Nylan, and Barbieri-Low, *Recarving China's Past*, 180–95.

Bush, Susan, and Hsio-yen Shih, comps. and eds. *Early Chinese Texts on Painting.* Cambridge, MA: Harvard University Press, 1985.

Cahill, James. *The Compelling Image: Nature and Style in Seventeenth-Century Chinese Painting.* The Charles Eliot Norton Lectures, 1978–79. Cambridge, MA: Harvard University Press. 1982.

Chang, Ch'ung-ho, and Hans H. Frankel, annot. and trans. *Two Chinese Treatises on Calligraphy.* New Haven, CT: Yale University Press, 1995.

Chen Hongsen 陳鴻森. "Weng Fanggang zhi Huang Yi shouzha ce kaozheng" 翁方鋼致黃易手札冊考證 [Textual Analysis of an Album of Letters from Weng Fanggang to Huang Yi]. *Zhengxue* 正學 3, no. 9 (2015): 282–95.

China Guardian Auctions. *Da guan: Zhongguo shuhua zhenpin zhi ye, gudai* 大观：中国书画珍品之夜,古代 [Grand View: Chinese Paintings Highlights, Classical]. Sale cat., Zhongguo Jiade guoji paimai youxian gongsi 中国嘉德国际拍卖有限公司 (China Guardian Auctions), Beijing, June 18, 2018.

Chu, Hui-liang J. "The Calligraphy of Li Kung-lin in the Classic of Filial Piety." In *Li Kung-lin's Classic of Filial Piety*, edited by Richard Barnhart, 53–72. New York: Metropolitan Museum of Art, 1993.

Chuang, Shen. "Ming Antiquarianism, an Aesthetic Approach to Archaeology." *Journal of Oriental Studies* 8, no. 1 (1970): 63–78.

Classen, Constance. *The Deepest Sense: A Cultural History of Touch.* Urbana: University of Illinois Press, 2012.

———, ed. *A Cultural History of the Senses.* 6 vols. London: Bloomsbury, 2018.

Clunas, Craig. *Superfluous Things: Material Culture and Social Status in Early Modern China.* 2nd ed. Honolulu: University of Hawai'i Press, 2004.

Dai Zhen 戴震. *Mao Zheng shi kaozheng* 毛鄭詩考正 [Verification and Correction of the Mao and Zheng Commentaries on the *Classic of Poetry*]. 4 vols. Reprinted in *Daishi yishu* 戴氏遺書 [The Collected Works of Master Dai], edited by Kong Jihan 孔繼涵. 1777.

De Coursey Clapp, Anne. *Commemorative Landscape Painting in China.* Princeton, NJ: Princeton University Press, 2012.

Deleuze, Gilles. *Francis Bacon: The Logic of Sensation*. Minneapolis: University of Minnesota Press, 2004.

Dodgen, Randall A. *Controlling the Dragon: Confucian Engineers and the Yellow River in Late Imperial China*. Honolulu: University of Hawai'i Press, 2001.

Ebrey, Patricia Buckley. *Accumulating Culture: The Collections of Emperor Huizong*. Seattle: University of Washington Press, 2008.

Egan, Ronald. *The Problem of Beauty: Aesthetic Thought and Pursuits in Northern Song Dynasty China*. Cambridge, MA: Harvard University Asia Center, 2006.

———. *Word, Image, and Deed in the Life of Su Shi*. Cambridge, MA: Council on East Asian Studies, Harvard University, 1984.

Elman, Benjamin A. *Classicism, Politics, and Kinship: The Ch'ang-chou School of New Text Confucianism in Late Imperial China*. Berkeley: University of California Press, 1990.

———. *From Philosophy to Philology: Intellectual and Social Aspects of Change in Late Imperial China*. Cambridge, MA: Council on East Asian Studies, Harvard University, 1984.

———. "Imperial Politics and Confucian Societies in Late Imperial China." *Modern China* 15, no. 4 (October 1989): 379–418.

———. "Naval Warfare and the Refraction of China's Self-Strengthening Reforms into Scientific and Technical Failure, 1865–1895." *Modern Asian Studies* 38, no. 2 (May 2004): 283–326.

———. *On Their Own Terms: Science in China, 1550–1900*. Cambridge, MA: Harvard University Press, 2005.

Fenollosa, Ernest. *Epochs of Chinese and Japanese Art: An Outline History of East Asiatic Design*. New York: ICG, revised 2000 edition.

Folsom, Kenneth. *Friends, Guests, and Colleagues: The Mu-fa System in the late Ch'ing Period*. Berkeley: University of California Press, 1968.

Fu, Marilyn, and Shen C. Y. Fu. *Studies in Connoisseurship: Chinese Paintings from the Arthur M. Sackler Collection in New York and Princeton*. Princeton: Princeton University Press, 1973. Exhibition catalog.

Fu, Shen. *Traces of the Brush: Studies in Chinese Calligraphy*. New Haven, CT: Yale University Art Gallery, 1977.

Geaney, Jane. *On the Epistemology of the Senses in Early Chinese Thought*. Honolulu: University of Hawai'i Press, 2002.

Goh, Meow Hui. *Sound and Sight: Poetry and Courtier Culture in the Yongming Era (483–93)*. Stanford, CA: Stanford University Press, 2010.

Gu, Yi. *Chinese Ways of Seeing and Open-Air Painting*. Cambridge, MA: Harvard University Asia Center, 2020.

———. "What's in a Name? Photography and the Reinvention of Visual Truth in China, 1840–1911." *Art Bulletin* 95, no. 1 (March 2013): 120–38.

Guo Lin 郭麔. Lingfenguan zazhu 靈芬館雜著 [Various Writings from Lingfen Hall]. Jiaqing-era edition. N.p., n.d.

Guy, R. Kent. *The Emperor's Four Treasuries: Scholars and the State in the Late Ch'ien-lung Era*. Cambridge, MA: Harvard University Press, 1987.

———. *Qing Governors and Their Provinces: The Evolution of Territorial Administration in China, 1644–1796*. Seattle: University of Washington Press, 2010.

Han Chong 韓崇. Baotiezhai shilu 寶鐵齋詩錄 [Record of Poetry from the Baotie Studio]. Xunjiang junshe edition, 1849.

Han, Seunghyun. *After the Prosperous Age: State and Elites in Early Nineteenth-Century Suzhou*. Cambridge, MA: Harvard University Asia Center, 2016.

———. "Changing Roles of Local Elites from the 1730s to the 1820s." In *Cambridge History of China*, vol. 9, *The Ch'ing Dynasty to 1800, Part 2*, edited by Willard J. Peterson, 606–48. Cambridge: Cambridge University Press, 2016.

Han Tianheng 韓天衡. Lidai yinxue lunwen xuan 历代印学论文选 [Select Treatises on Seal Studies from Dynastic China]. Hangzhou: Xiling yinshe, 1999.

Harrist, Robert E., Jr. "I Don't Believe in the Literati but I Miss Them." *Ars Orientalis* 37, "Current Direction in Yuan Painting" (2009): 213–17.

Harvey, Elizabeth D., ed. *Sensible Flesh: On Touch in Early Modern Culture*. Philadelphia: University of Pennsylvania Press, 2002.

Hatch, Michael J. "Epigraphic and Art Historical Responses to Presenting the Tripod by Wang Xuehao (1803)." *Metropolitan Museum Journal* 54 (2019): 87–105.

———. "Outline, Brushwork and the Epigraphic Aesthetic in Huang Yi's Engraved Texts of the Lesser Penglai Pavilion (1800)." *Archives of Asian Art* 70 (2020): 23–49.

——— [as He Yanhui何彦晖]. "Qian Du, Zhang Yin yu shijiu shiji chuqi dui Wu pai huajia de xingqu" 钱杜,张鉴与十九世纪初期对吴派画家的兴趣 [Qian Du, Zhang Yin, and the Early Nineteenth-Century Interest in Wu School Painters]. In 古典的復興 (上海：上海古籍出版社), 22–26.

Hay, John. "Boundaries and Surfaces of Self and Desire in Yuan Painting." In *Boundaries in China*, 124–70. London: Reaktion Books, 1994.

———. "Surface and the Chinese Painter: The Discovery of Surface." *Archives of Asian Art* 38 (1985): 95–123.

Hay, Jonathan. *Sensuous Surfaces: The Decorative Object in Early Modern China.* Honolulu: University of Hawai'i Press, 2010.

Hayashida Hōen 林田芳園. "*Chin Kōju no shohō* 陳鴻壽の書法" [The Calligraphy of Chen Hongshou]. Tokyo: Nigensha, 1997.

He Shaoji何紹基. *Dongzhoucaotang shichao*東洲草堂詩鈔 [Poetry from the Dongzhou Grass Hut]. 30 vols. N.p., n.d.

Hearn, Maxwell K. *How to Read Chinese Paintings.* New York: Metropolitan Museum of Art, 2008.

Ho, Christine I. *Drawing from Life: Sketching and Socialist Realism in the People's Republic of China.* Berkeley: University of California Press, 2020.

Ho, Chuan-hsing. "Calligraphy of the Mid to Late Qing Epigraphic School." In *Out of Character: Decoding Chinese Calligraphy*, edited by Michael Knight and Joseph Z. Chang, 302–22. San Francisco: Asian Art Museum of San Francisco, 2012.

Ho Peggy 何碧琪. "Jinshi yinyuan chongdijie: Zhejiang shujia, Huang Yi yu Qingdai lishu" 金石因缘重缔结：浙江书家，黄易与清代隶书 [Zhejiang Calligraphers, Huang Yi, and the Qing Calligraphy of Clerical Script]. In Qin Ming, *Huang Yi yu jinshixue lunji*, 228–45.

Ho, Wai-kam. "Tung Ch'i-chang's New Orthodoxy and the Southern School Theory." In *Artists and Traditions: Uses of the Past in Chinese Culture*, edited by Christian F. Murck, 113–29. Princeton, NJ: Princeton University Press, 1976.

Hong Liangji 洪亮吉. *Gengshengzhai shi xuji* 更生齋詩續集 [Additional Collected Poems from the Gengsheng Studio]. 10 vols. N.p., n.d.

Howes, David, "The Expanding Field of Sensory Studies." Sensorystudies.org, 2013. https://www.sensorystudies.org/sensoial-investigations/the-expanding-field-of-sensory-studies.

———, ed. *Sense and Sensation.* 4 vols. New York: Routledge, 2018.

Hsu, Eileen Hsiang-Ling. "Huang Yi's *Fangbei* Painting." In Richard, *Rethinking Recarving*, 236–58.

Hsu, Ya-Hwei. "Antiquaries and Politics: Antiquarian Culture of the Northern Song, 960–1127." In *World Antiquarianism: Comparative Perspectives*, edited by Alain Schnapp, 230–48. Los Angeles: Getty Research Institute, 2013.

———. "Antiquities, Ritual Reform, and the Shaping of New Taste at Huizong's Court." *Artibus Asiae* 73, no. 1 (2013): 137–80.

Hu Jing 胡敬, *Chongyatang shi chao* 崇雅堂詩鈔 [Transcribed Poems from the Chongya Hall]. N.p., 1839.

Huang, Dun. "Two Schools of Calligraphy Join Hands: Tiepai and Beipai in the Qing Dynasty." In *Chinese Calligraphy*, 351–53. New Haven, CT: Yale University Press, 2008.

Huang Yi 黃易. *Xiao Penglaige jinshi wenzi* 小蓬萊閣金石文字 [Engraved Texts of the Lesser Penglai Pavilion]. 5 vols. N.p., 1800.

Huangfu Mi 皇甫謐. *Gaoshi zhuan* 高士傳 [Biographies of Lofty Scholars]. N.p., n.d.

Hummel, Arthur W., ed. *Eminent Chinese of the Ch'ing Period (1644–1912).* 2 vols. Washington, DC: U.S. Government Printing Office, 1943.

I Lo-fen 衣若芬. "Jing guan zhen shang: Weng Fanggang cangben 'Shigu zhu Dongpo shi'" 敬觀眞賞：翁方綱舊藏本《施顧註東坡詩》研究 [A Study of the Weng Fanggang Edition of the Shi and Gu

Editions of Su Shi's Poetry]. *Tsinghua Journal of Chinese Literature* 清華中文學報 14 (June 2014): 57–102.

Jiang Baoling 蔣寶齡. *Molin jinhua* 墨林今話 [Current Discussion from the Forest of Ink]. 19 vols. N.p., 1852.

Kaohsiung Museum of Fine Arts 高雄市立美術館, ed. *Shibian xingxiang liufeng: Zhongguo jindai huihua 1796–1949* 世變形象流風：中國近代繪畫 1796–1949 / *Turmoil, Representation, and Trends: Modern Chinese Painting, 1796–1949*. 4 vols. Gaoxiong: Kaohsiung Museum of Fine Arts, 2007. Exhibition catalog.

Karlsson, Kim, Alfreda Murck, and Michele Matteini, eds. *Eccentric Visions: The Worlds of Luo Ping (1733–1799)*. Zurich: Museum Rietberg, 2009. Exhibition catalog.

Kern, Martin. "Made by the Empire: Wang Xizhi's *Xingrangtie* and Its Paradoxes." *Archives of Asian Art* 65 (2015): 117–37.

Keulemans, Paize. *Sound Rising from Paper: Nineteenth-Century Martial Arts Fiction and the Chinese Acoustic Imagination*. Cambridge, MA: Harvard University Press, 2014.

Kile, S. E., and Kristina Kleutghen, "Seeing Through Pictures and Poetry: A History of Lenses (1681)." *Late Imperial China* 38, no. 1 (June 2017): 47–112.

Kleutghen, Kristina. *Imperial Illusions: Crossing Pictorial Boundaries in the Qing Palaces*. Seattle: University of Washington Press, 2015.

Ko, Dorothy. *The Social Life of Inkstones: Artisans and Scholars in Early Qing China*. Seattle: University of Washington Press, 2017.

———. "Stone, Scissors, Paper: Thinking Through Things in Chinese History." *Journal of Chinese History* 3 (2019): 191–201.

Kobayashi Toan 小林斗盦. *Chūgoku tenkoku sōkan*, v.16 (Shin 10, Chin Yoshō, Chin Kōju) 中國篆刻叢刊 第16卷 (清 10 陳予鍾・陳鴻壽) [Collectanea of Chinese Seal Carving, v.16 (Qing 10, Chen Yuzhong, Chen Hongshou)]. Tokyo: Nigensha, 1981–84.

Koon, Yeewan. *A Defiant Brush: Su Renshan and the Politics of Painting in Early 19th-Century Guangdong*. Hong Kong: Hong Kong University Press, 2014.

Kuo, Jason. "Word as Image." In *Word as Image*, edited by Jason Kuo, 17–62. New York: China Institute, 1992. Exhibition catalog.

Lackner, Michael, Iwo Amelung, and Joachim Kurtz, eds. *New Terms for New Ideas: Western Knowledge and Lexical Change in Late Imperial China*. Leiden: Brill, 2001.

Lai Suk Yee, ed. *The Art of Chen Hongshou: Painting, Calligraphy, Seal-Carving and Teapot-Design*. Hong Kong: Shanghai Museum, Nanjing Museum and Art Museum, and the Chinese University of Hong Kong, 2005. Exhibition catalog.

Lai Suk Yee and Terese Tse Bartholomew. *The Bei Shan Tang Legacy: Yixing Zisha Stoneware*. Hong Kong: The Art Museum, The Chinese University of Hong Kong, 2015. Exhibition catalog.

Lau Chak Kwong. "Ding Jing and the Foundation of the Xiling Identity in Hangzhou." PhD diss., University of California, Santa Barbara, 2006.

Ledderose, Lothar. "Aesthetic Appropriation of Ancient Calligraphy in Modern China." In *Chinese Art: Modern Expressions*, edited by Maxwell K. Hearn and Judith G. Smith, 212–45. New York: Metropolitan Museum of Art, 2001.

———. *Mi Fu and the Classical Tradition of Chinese Calligraphy*. Princeton, NJ: Princeton University Press, 1979.

Lee, Sherman E. *A History of Far Eastern Art*. 4th ed. New York: Harry N. Abrams, 1982.

Lefebvre, Eric. "L' 'Image des antiquités accumulées' de Ruan Yuan: La représentation d'une collection privée en Chine à l'époque pré-moderne" [Ruan Yuan's "Accumulated Antiques Image": The Representation of a Private Collection in Premodern China]. *Arts Asiatiques* 63 (2008): 61–72.

Li, Chu-tsing. "The Bamboo Paintings of Chin Nung." *Archives of Asian Art* 27 (1973/1974): 53–76.

Li Ming 李明. "'Jinshixue,' shanshuihua he huihuash—cong Huang Yi 'Fangbei tu' tanqi i" "金石学," 山水画和绘画史—从黄易《访碑图》谈起 [Epigraphy, Landscape Painting, and Art History: Talking from Huang Yi's *fangbei* Paintings]. In Qin Ming, *Huang Yi yu jinshixue lunji*, 251–56.

Li, Zehou. *The Chinese Aesthetic Tradition.* Honolulu: University of Hawai'i Press, 2010.

Lidai huajia shiwen ji 歷代畫家詩文集 [Poetry Collections from Painters of Dynastic China]. Taibei: Taiwan xuesheng shuju, 1971.

Lidai shufa lunwen xuan 歷代书法论文選 [Selected Text of Calligraphy Theory from Dynastic China]. Shanghai: Shanghai shuhua chubanshe, 1979.

Lin Shuzhong 林树中 and Nie Weigu 聂危谷, eds. *Haiwai cang Zhongguo lidai minghua* 海外藏中国历代名画 [Renowned Paintings from Dynastic China in Foreign Collections]. Changsha: Hunan meishu chubanshe, 1998.

Liu, Cary Y. "Perspectives on the 'Wu Family Shrines.'" In Richard, *Rethinking Recarving*, 20–51.

———. "'The Wu Family Shrine' as a Recarving of the Past." In Liu, Nylan, and Barbieri-Low, *Recarving China's Past*, 23–97.

Liu, Cary Y., Michael Nylan, and Anthony Barbieri-Low, eds. *Recarving China's Past: Art, Archaeology, and Architecture of the "Wu Family Shrines."* Princeton, NJ: Princeton University Art Museum, 2005.

Liu, Yiwen. "Paintings and Calligraphy of Chen Hongshou." In Lai Suk Yee, *Art of Chen Hongshou*, 19–22.

Liu, Yu-jen. "Second Only to the Original— Rhetoric and Practice in the Photographic Reproduction of Art in Early Twentieth-Century China." *Art History* 37, no. 1 (February 2014): 68–95.

Liuzhou 六舟. *Baosushi jinshi shuhua biannian lu* 寶素室金石書畫編年緣 [Edited Chronology of Epigraphy, Calligraphy, and Painting from the Baosu Studio]. 2 vols. Facsimile reproduction in *Shike shiliao xinbian*, v.10:357–93. Preface 1850. Edition unknown.

———. *Liuzhou ji* 六舟記 [The Collected Works of Liuzhou]. Hangzhou: Zhejiang gu ji chu ban she, 2015.

———. *Xiaolvtian'an yin cao* 小綠天庵吟草 [Draft Copy of Poems from the Small Blue Sky Hut]. 4 vols. Reproduced in *Liuzhou ji*, 105–209.

Louis, François. *Design by the Book: Chinese Ritual Objects and the Sanli tu.* New York: Bard Graduate Center, 2017.

Lu Hui-wen 盧慧紋. "Hanbei tushu chu wenzhang—cong Jining zhouxue de Hanbei tan shiba shiji houqi de fangbei huodong" 漢碑圖書出文章—從濟寧州學的漢碑談十八世紀後期的訪碑活動 [Essays from the Library of Han Stele—A Discussion of Late Eighteenth-Century Stele-Searching Activities Based on the Han Steles at the Jining Prefectural School]. *Taida Journal of Art History* 美術史研究集刊 26 (2009): 37–92.

Lu Jiaheng 陆家衡. "Wang Xuehao ji qi shanshui yishu" 王学浩及其山水艺术 [The Landscape Art of Wang Xuehao]. *Zhongguo shu hua* 中国书画 [Chinese Painting and Calligraphy] 5 (2006): 4–16.

Lu Miaomiao 鹿苗苗, "Guo Lin nianpu" 郭麐年谱 [A Chronological History of Guo Lin]. MA thesis, Shanghai University, 2011.

Lu, Minghua, "A Study of Chen Hongshou and His Art of Zisha Teapots." In *The Art of Chen Hongshou: Painting, Calligraphy, Seal-Carving and Teapot-Design*, 179–98.

Matteini, Michele. "Beyond the Invisible: Luo Ping's Biography, c.1765–1799." In Karlsson, Murck, and Matteini, *Eccentric Visions*, 66–77.

———. "The Story of a Stone: Mi Fu's Ink-Grinding Stone and Its Eighteenth-Century Replications." *Arts Asiatiques* 72 (2017): 81–96.

McNair, Amy. "Engraved Calligraphy in China: Recension and Reception." *Art Bulletin* 77, no.1 (March 1995): 106–14.

———. *The Upright Brush: Yan Zhenqing's Calligraphy and Song Literati Politics.* Honolulu: University of Hawai'i Press, 1998.

Mei, Yun-chiu 梅韻秋. "The Pictorial Mapping and Imperialization of Epigraphic Landscapes in Eighteenth-Century China." PhD diss., Stanford University, 2008.

———. "Tianxia mingsheng de sijiahua: Qingdai Jia Dao nianjian zizhuanti jiyou tupu de xinqi" 天下名勝的私家化：清代嘉、道年間自傳體紀遊圖譜的興起 [Privatizing the Imperial Landscape: The Rise of Pictorial Autobiographies and Travel Memoirs in Early Nineteenth-Century China]. *Taida Journal of Art History* 美術史研究集刊 41 (September 2016): 303–70.

———. "Zhang Yin 'Jingkou san shan tujuan': Daoguang nianjian xin jingshixue feng xia de jiangshan tuxiang" 張崟《京口三山圖卷》: 道光年間新經世學風下的江山圖像 [Chang Yin's Handscroll Chin-k'ou san-shan t'u: Landscape Imagery and the New Statecraft School of the Tao-kuang Period (1821–1850)]. Guoli Taiwan daxue meishushi yanjiu jikan 國立台灣大學美術史研究集刊 [Taida Journal of Art History] 6 (March 1999): 195–239.

Miles, Stephen. The Sea of Learning: Mobility and Identity in Nineteenth-Century Guangzhou. Cambridge, MA: Harvard University Press, 2006.

Moser, Jeffrey. "The Ethics of Immutable Things: Interpreting Lü Dalin's 'Illustrated Investigations of Antiquity.'" Harvard Journal of Asiatic Studies 72, no. 2 (December 2012): 259–93.

Muller, Charles. Digital Dictionary of Buddhism, http://www.buddhism-dict.net.

Nelson, Susan. "Picturing Listening: The Sight of Sound in Chinese Painting." Archives of Asian Art 51 (1998–99): 30–55.

Nivison, David S. "Ho-shen and His Accusers: Ideology and Political Behavior in the Eighteenth Century." In Confucianism in Action, edited by David S. Nivison and Arthur F. Wright, 209–43. Stanford, CA: Stanford University Press, 1959.

Nylan, Michael. "Addicted to Antiquity." In Liu, Nylan, and Barbieri-Low, Recarving China's Past, 513–59.

———. The Chinese Pleasure Book. Princeton, NJ: Princeton University Press, 2018.

Polachek, James W. The Inner Opium War. Cambridge, MA: Harvard University Press, 1992.

Qian Du 錢杜. Songhu huayi《松壺畫意》[Songhu's Ideas About Painting]. In Hushu Qian shi jia ji《湖墅錢氏家集》[Collected Works of the Qian Clan from Hangzhou], edited by Qian Xibing 錢錫賓, vol. 11. 1896.

———. Songhu huazhui《松壺畫贅》[Songhu's Superfluous Comments About Painting]. In Hushu Qian shi jia ji《湖墅錢氏家集》[Collected Works of the Qian Clan from Hangzhou], edited by Qian Xibing 錢錫賓, vol. 11. 1896.

Qin Ming 秦明. "Ganzhi yu ganwu: Huang Yi yanjiu de huigu ji zhanwang" 感知與感悟: 黃易 研究的回顾及展望 [Perceptions and Reflections: Retrospect and Prospect of Huang Yi Studies]. In Qin Ming, Huang Yi yu jinshixue lunji, 398–421.

———, ed. Huang Yi yu jinshixue lunji 黄易与金石学论集 [Proceedings from the Symposium on Huang Yi and Epigraphy]. Beijing: Gugong bowuyuan chubanshe, 2012.

———, ed. Penglai suyue: Gugong cang Huang Yi Han Wei beike teji 蓬莱宿约: 故宫藏黄易汉魏碑刻特集 [The Promises of Penglai: The Palace Museum Collection of Huang Yi's Engravings of Han and Wei Stele]. Beijing: Zijin cheng chubanshe, 2010.

Ren Wenling 任文岭. "Mengjing tushuo: 'Lianyin tu' yu 'Lianyin dier tu'—jianji Cang Sisheng de shengping yu jiaoyou kao 梦境图说: 《莲因图》与《莲因第二图》—兼及仓斯升的生平与交游考" [Images Explicating Dream Scenes: Begets Lotuses and Begets Lotuses, the Second Painting—Considerations of Cang Sisheng's Life and Travels]. Zhongguo shu hua (June 2016): 14–19.

Richard, Naomi Noble, ed. Rethinking Recarving: Ideals, Practices, and Problems of the "Wu Family Shrines" and Han China. Princeton, NJ: Princeton University Art Museum, 2008.

Rošker, Jana. "Chinese Theories of Perception." In The Senses and the History of Philosophy, edited by Brian Glenney and José Filipe Silva, 21–32. New York: Routledge, 2019.

———. Searching for the Way: Theory of Knowledge in Premodern and Modern China. Hong Kong: Chinese University of Hong Kong Press, 2008.

———. Traditional Chinese Philosophy and the Paradigm of Structure (Li 理). Newcastle upon Tyne: Cambridge Scholars Publishing, 2012.

Rowe, William T. China's Last Empire: The Great Qing. Cambridge, MA: Belknap Press of Harvard University Press, 2009.

———. Speaking of Profit: Bao Shichen and Reform in Nineteenth-Century China. Cambridge, MA: Harvard University Asia Center and Harvard University Press, 2018.

Ruan Heng 阮亨, Yingzhou bitan 瀛舟筆談 [Notes from a Boat on the Ocean]. In

Ruan Yuan, *Wenxuan lou congshu* [Collected Books from the Wenxuan Hall], v.91–100. 1842 edition. Harvard Library. Scans via ctext.org. Accessed July 15, 2021.

Ruan Yuan 阮元. *Jiguzhai zhongding yiqi kuanzhi* 積古齋鐘鼎彝款識 [Inscriptions on Bells, Tripods, and Bronze Vessels from the Jigu Studio]. 10 vols. N.p., 1804.

———. *Liangzhe jinshi zhi* 兩浙金石志 [Epigraphy Gazetteer for Zhejiang Province]. Beijing University Library, n.d.

———. *Liangzhe youxuan lu* 兩浙輶軒錄 [Record of the Royal Envoys of the Two Zhes]. N.p., 1824.

———. *Shihua ji* 石畫記 [Paintings in Stone]. N.p., n.d.

———. *Wenxuan lou congshu* 文選樓叢書 [Collected Books from the Wenxuan Hall]. Scans via ctext.org. Accessed July 15, 2021.

———. *Xiaocanglang bitan* 小滄浪筆談 [Notes from the Lesser Canglang Pavilion]. In *Wenxuan lou congshu*, edited by Ruan Yuan, v.71–72. 1842 edition. Harvard Library. Scans via ctext.org. Accessed July 15, 2021.

———. *Yanjing shi erji* 揅經室二集 [Collected Writings from a Room for Grinding Away at the Classics—Second Collection]. N.p., 1823.

———. *Yanjing shi sanji* 揅經室三集 [Collected Writings from a Room for Grinding Away at the Classics—Third Collection]. N.p., 1823.

———. *Yanjing shi siji shi* 揅經室四集詩 [Collected Writings from a Room for Grinding Away at the Classics—Fourth Collection, Poetry]. N.p., 1823.

Ruan Yuan 阮元 and Bi Yuan 畢沅. *Shanzuo jinshi zhi* 山左金石志 [Epigraphy Gazetteer for Shandong Province]. 1796.

Ruitenbeek, Klaas. *Discarding the Brush; Gao Qipei (1660–1734) and the Art of Chinese Finger Painting*. Amsterdam: Rijksmuseum, 1992. Exhibition catalog.

Russel, David. *Tact: Aesthetic Liberalism and the Essay Form in Nineteenth-Century Britain*. Princeton, NJ: Princeton University Press, 2018.

Sang Shen. 桑椹 "Liuzhou yu zaoqi quanxingta 六舟與早期全形拓" [Liuzhou and Early Full-Form Rubbings]. In *Liuzhou: Yi wei jinshiseng de yishu shijie*, edited by Zheijang Provincial Museum, 9–19.

Schäfer, Ingo. "Natural Philosophy, Physics and Metaphysics in the Discourse of Tan Sitong: The Concepts of *Qi* and *Yitai*." In Karlsson, Amelung, and Kurtz, *New Terms for New Ideas*, 258–69.

Schmidt, J. D. *Harmony Garden: The Life, Literary Criticism, and Poetry of Yuan Mei (1716–1799)*. London: Routledge Curzon, 2003.

Seiichi Mizuno 水野清一. "Hiketsu no keishiki" 碑碣の形式 [The Forms of Stele]. In *Shodō zenshū* 書道全集 [Compendia of the Art of Calligraphy], 2:30–36. Tokyo: Heibonsha, 1971.

Sela, Ori. *China's Philological Turn: Scholars, Textualism, and the Dao in the Eighteenth Century*. New York: Studies of the Weatherhead East Asian Institute, Columbia University Press, 2018.

———. "Qian Daxin (1728–1804): Knowledge, Identity, and Reception History in China, 1750–1930." PhD diss., Princeton University, 2011.

Sena, Yun-Chiahn C. "The Song-Ming Connection in the Ming Study of Ancient Inscriptions." *Ming Studies* 70 (2014): 29–59.

Shan, Guolin, "Luo Ping's Interactions with Seal Artists and His Seal Carving Works." In Karlsson, Murck, and Matteini, *Eccentric Visions*, 90–101.

Shike shiliao xinbian 石刻史料新編 [New Edition of Historical Materials Carved on Stone]. 30 vols. Taibei: Xinwenfeng, 1977.

Shike shiliao xinbian 石刻史料新編 [New Edition of Historical Materials Carved on Stone]. Collection 4—Biographies. 10 vols. Taibei: Xinwenfeng, 2006.

Silbergeld, Jerome. "The Yuan 'Revolutionary' Picnic: Feasting on the Fruits of Song (A Historiographic Menu)." "Current Direction in Yuan Painting." Special issue, *Ars Orientalis* 37 (2009): 9–31.

Smith, Mark M. *Sensory History*. New York: Berg, 2007.

———. *The Smells of Battle, The Tastes of Siege: A Sensory History of the Civil War*. New York: Oxford University Press, 2015.

Soffel, Christian, and Cleveland Tillman Hoyt. *Cultural Authority and Political Culture in China: Exploring Issues with the*

Zhongyong and the Datong During the Song, Jin and Yuan Dynasties. Munich: Munchener Ostasiatische Studien, 2012.

Stanley-Baker, Joan. "Finger Painting in Tokugawa Japan." In Ruitenbeek, *Discarding the Brush*, 70–93.

Starr, Kenneth. *Black Tigers: A Grammar of Chinese Rubbings*. Seattle: University of Washington Press, 2008.

Stewart, Susan. *Poetry and the Fate of the Senses*. Chicago: University of Chicago Press, 2002.

Sun Guanghai孫廣海. "Ruan Yuan yanjiu huigu" 阮元研究回顧 [An Overview of Research on Ruan Yuan]. *Hanxue yanjiu tongxun* 漢學研究通訊25:3 (August 2006): 1–14.

Sun, Weizu. "Studies on Chen Hongshou's Life and Art." In Lai Suk Yee, *Art of Chen Hongshou*, 115–121.

Tang Yifen 湯貽汾. *Qinyinyuan shiji* 琴隱園詩集 [Collected Poetry from the Qinyin Garden]. Fascimile of handwritten copy, as reproduced in *Lidai huajia shiwen ji* 歷代畫家詩文集 v.20. Taibei: Taiwan xuesheng shuju, 1971.

Tseng, Lillian Lan-Ying. "Between Printing and Rubbing: Chu Jun's Illustrated Catalogs of Ancient Monuments in Eighteenth-Century China." In Wu Hung, *Reinventing the Past*, 225–90.

———. "Mediums and Messages: The Wu Family Shrines and Cultural Production in Qing China." In Richard, *Rethinking Recarving*, 260–83.

———. "Retrieving the Past, Inventing the Memorable: Huang Yi's Visit to the Song-Luo Monuments." In *Monuments and Memory, Made and Unmade*, edited by Robert S. Nelson and Margaret Olin, 37–58. Chicago: University of Chicago Press, 2003.

Vinograd, Richard. *Boundaries of the Self, Chinese Portraits, A.D. 1600–1900*. Cambridge: Cambridge University Press, 1992.

———. "De-Centering Yuan Painting." "Current Direction in Yuan Painting." Special issue, *Ars Orientalis* 37 (2009): 195–212.

Wan Qingli萬青力. *Bing fei shuailuo de bainian: Shijiu shiji zhongguo huihua shi* 《並非衰落的百年：十九世紀中國繪畫史》 [The Century Was Not Declining in Art: A History of

Nineteenth-Century Chinese Painting]. Taibei: Xiongshi Library, 2005.

Wang Chang 王昶. *Huhai shizhuan* 湖海詩傳 [Biographies of Poets Across These Lakes and Oceans], 46 vol. 1803.

Wang, Jingxian, "An Ancient Art Shines: Calligraphy from the Shang Through the Han Dynasties." In *Chinese Calligraphy*, 116–17. New Haven: Yale University Press, 2008.

Wang Qingwei 王庆卫. "Huang Yi shike xue chengjiu chutan" 黄易石刻學成就初探 [A Preliminary Exploration of Huang Yi's Epigraphic Achievements]. In Qin Ming, *Huang Yi yu jinshixue lunji*, 304–18.

Wang Xuehao 王學浩. *Shannan lun hua* 山南論畫 [Shannan's Discussions on Painting]. Compiled by Zhang Xianghe in *Zhujia huashuo* 諸家畫說 [Discussions about Painting from Various Authors], vol. 6. Chengdu: Yeshi shulin, 1876.

Wang Yifeng 王屹峰. "Guzhuan huagong: Quanxingta yishu ji qi yu Liuzhou zhi guanlian古砖花供：全形拓艺术及其与六舟之关联." [Old Bricks and Floral Offerings: The Art of Full-Form Rubbings and Its Relationship to Liuzhou] *Zhongguo guojia bowuguan guankan* 中国国家博物馆馆刊 [Journal of the National Museum of China] 140 (March 2015): 105–20.

Wang Zhangtao 王章涛. *Ruan Yuan nianpu* 阮元年譜 [Chronological Biography of Ruan Yuan]. Hefei: Huangshan shushe, 2003.

Wasserstrom, Jeffrey, and Rebeca Nedostup. "Shanghai's Lens on the New(s)—Dianshizhai Pictorial (1884–1898)—I." *MIT Visualizing Cultures*. 2017. https://visualizingcultures.mit.edu/dianshizhai/index.html.

Watson, Burton, trans. *Chuang Tzu: Basic Writings*. New York: Columbia University Press, 1964.

Wei, Betty Peh-T'i. *Ruan Yuan, 1764–1849: The Life and Work of a Major Scholar-Official in Nineteenth-Century China Before the Opium War*. Hong Kong: Hong Kong University Press, 2006.

Wei, Hua. "From Private Life to Public Performances: The Constituted Memory And (Re)Writings Of The Early-Qing Woman Wu Zongai." In *The Inner*

Quarters and Beyond: Women Writers from Ming Through Qing, edited by Ellen Widmer, 141–75. Leiden: Brill, 2010.

Weng Fanggang 翁方鋼. *Jiaoshan dingming kao* 焦山鼎銘考 [Study of the Cast Inscription of the Tripod of Mt. Jiao]. N.p., 1773.

Wong, Dorothy C. *Chinese Steles: Pre-Buddhist and Buddhist Use of a Symbolic Form*. Honolulu: University of Hawaiʻi Press, 2004.

Wu Hung. "Ji: Traces in Chinese Landscape and Landscape Painting." *Cahiers d'Extrême-Asie* 17 (2008): 167–92.

———. *Monumentality in Early Chinese Art and Architecture*. Stanford, CA: Stanford University Press, 1995.

———, ed. *Reinventing the Past: Archaism and Antiquarianism in Chinese Art and Visual Culture*. Chicago: Center for the Art of East Asia, University of Chicago, 2010.

———. "On Rubbings: Their Materiality and Historicity." In *Writing and Materiality in China, Essays in Honor of Patrick Hanan*, edited by Judith T. Zeitlin and Lydia H. Liu, 29–69. Cambridge, MA: Harvard University Asia Center for Harvard-Yenching Institute, 2003.

———. *A Story of Ruins: Presence and Absence in Chinese Art and Visual Culture*. Princeton, NJ: Princeton University Press, 2012.

———. *The Wuliang Shrine: The Ideology of Early Chinese Pictorial Art*. Palo Alto, CA: Stanford University Press, 1989.

Wu Qian 吳騫. *Yangyi mingtao lu* 陽羨名陶錄 [Famed Pottery of Yangyi]. 1786.

Wue, Roberta. *Artworlds: Artists, Images, and Audiences in Late Nineteenth-Century Shanghai*. Honolulu: University of Hawaiʻi Press. 2015.

Xiao Jianmin 蕭健民. *Chen Mansheng yan jiu* 陳曼生研究 [Research on Chen Mansheng]. Hangzhou: Xiling yinshe, 2011.

Xiling yinshe 西泠印社, ed. *Jinshi zhi yun* 金石之韻 [Resonance with Stone and Metal]. Shanghai: Shanghai shudian chuban she, 1996.

Xu Beihong 徐悲鴻. "Zhongguohua gailiang lun" 中國畫改良論 [On the Improvement of Chinese Painting]. *Huixue zazhi* 繪學雜誌 [Painting Studies Magazine] 1 (June, 1920).

Xu Dunde, ed. 徐敦德. *Xiling hou sijia yinpu* 西陵後四家印譜 [Record of Seals by the Four Later Xiling Masters]. Hangzhou: Xiling yinshe. 1998.

Xu Han 許瀚. *Panguxiaolu zazhu* 攀古小廬雜著 [Various Writings from Pangu Hut]. 12 vols. n.p., n.d. https://ctext.org/library.pl?if=gb&res=3146. Accessed July 28, 2021.

Xu Kang 徐康. *Qianchen mengying lu* 前塵夢影錄 [Record of Dream Reflections from an Impure Past]. 2 vols. n.p., 1896 preface. https://ctext.org/library.pl?if=gb&res=3117. Accessed July 27, 2021.

Xu Shangda 徐上達. *Yinfa cantong* 印法參同 [A Unified Approach to Methods of Seal Carving]. Ming Dynasty. https://ctext.org/wiki.pl?if=gb&chapter=430641. Accessed July 21, 2021.

Xu Zonggan 徐宗幹. *Jining zhili zhou zhi* 濟寧直隸州志 [Jining Metropolitan-Area Prefectural Gazetteer]. 9 vols. Taibei: Taiwan xuesheng shuju. 1968. Facsimile reprint of 1859 edition.

Yang Guodong 杨国栋. "Huang Yi shenghuo nianbiao jianbian" 黄易生活年表简编 [A Brief Chronology of Huang Yi]. In Qin Ming, *Huang Yi yu jinshixue lunji*, 372–97.

Yang Hu 杨虎. "Gugong cang 'Xiao Penglaie jinshi wenzi' banke niandai bianxi" 故宫藏小蓬菜阁金石文字版刻年代辨析 [Identification and Analysis of the Edition Dating of the Epigraphic Texts of *Little Penglai Belvedere*]. In Qin Ming, *Huang Yi yu jinshixue lunji*, 337–45.

Yang Zhen 楊慎. "Shu pin 書品" [The Appreciation of Calligraphy]. https://ctext.org/wiki.pl?if=gb&chapter=745124. Accessed July 21, 2021.

Yu Zhongjin 郁重今. *Lidai yinpu xuba huibian* 历代印谱序跋汇编 [Compilation of Prefaces and Epilogues to Seal Catalogs from Dynastic China]. Hangzhou: Xiling yinshe. 2008.

Zeng Xuemei 曾雪梅. "Weng Fanggang zhi Huang Yi shouzha ce kaoshi" 翁方纲致黄易手札册考释 [Textual Analysis of an Album of Letters Sent from Weng Fanggang to Huang Yi]. *Lanzhou daxue xuebao* 兰州大学学报 42, no. 4 (2014): 31–39.

Zhang Fuxi 張福僖, and Joseph Edkins 艾約瑟. *Guanglun* 光論 [Treatise on Light]. In *Baibu congshu jicheng* 79. Taibei: Yiwen yinshuguan. 1966. Facsimile reprint of Guangxu reign (1871–1908) edition.

Zhang Hui 章暉 and Fan Jingzhong 範景中, eds. *Gudian de fuxing: Xikejiulu cang Ming Qing wenren hua de yanjiu* 古典的復興: 溪客舊廬藏明清文人繪畫研究 [Revival of the Past: Research on the Xikejiu Hut Collection of Ming and Qing Literati Painting]. Shanghai: Shanghai shuhua chubanshe. 2018.

Zhang Jing 張井. *Erzhuzhai shi wenchao* 二竹齋詩文鈔 [Draft Essays and Poetry from the Erzhu Studio]. 2 vols. N.p., n.d. Columbia University C. V. Starr East Asian Library.

Zhang Junling 張俊岭. *Zhu Yun, Bi Yuan, Ruan Yuan: San jia mufu yu Qian Jia beixue* 朱筠, 毕沅, 阮元: 三家幕府与乾嘉碑學 [Zhu Yun, Bi Yuan, Ruan Yuan: Three Networks of Aides and Qianlong-Jiaqing Era Epigraphy Studies]. Hangzhou: Zhejiang University Press, 2014.

Zhang Yanchang 張燕昌. *Jinshi qi* 金石契 [Epigraphic Engravings]. In *Chongding jinshi qi* 重定 金石契 [Epigraphic Engravings, reprint], edited by Liu Congshi 劉蔥石. Juxue xuan 聚 學軒 [Gathered Studies Studio], 1896.

Zhejiang Provincial Museum 浙江省博物馆, ed. *Liuzhou: Yi wei jinshiseng de yishu shijie* 六州： 一位金石僧的艺术世界 [Liuzhou: The Artistic World of an Epigrapher-Monk]. Hangzhou: Xiling yinshe. 2014. Exhibition catalog.

Zhongguo gudai shuhua tumu 中國古代書畫圖目 [Illustrated Catalog of Selected Works of Ancient Chinese Painting and Calligraphy]. 24 vols. Beijing: Wenwu chubanshe, 1986–2001.

Zhou Weiqiang 周維強. "Yong Qing An Lan: Zhongmou dagong zhi xingzhu ji zhihe chen Linqing" 永慶安瀾： 中牟大工之興 築及治河臣麟慶 [The Construction of Zhongmou Dike and Linqing]. *Gugong wenwu yuekan* 故宮文物月刊 348 (March 2012): 40–50.

Zhu Qi 朱琪. "Huang Yi de Jiashi shengping yu jinshi gongxian" 黄易的家世生平与金石 贡献 [Huang Yi's Family, Biography, and Epigraphic Contributions]. In Qin Ming, *Huang Yi yu jinshixue lunji*, 350–72.

Index

Page numbers in italics denote illustrations. Endnotes are indicated by "n" followed by the endnote number.

Printed in the USA
CPSIA information can be obtained
at www.ICGtesting.com
LVHW060614150224
771786LV00001B/1